—— ADVANCE PRAISE FOR ——

Anthony Petkovich's
THE X FACTORY
Inside the American Hardcore Film Industry

"The X Factory sniffs out the wet spots of porno in America and thrusts into the industry's innermost bowels."

—*Gregory Dark, director*

"Anthony Petkovich has conducted some of the most thorough and entertaining celebrity interviews in my magazine, Psychotronic Video — and he also has done the best interviews with adult movie starlets I've ever seen!"

—*Michael Weldon, publisher/editor, Psychotronic Video Magazine*

"Ever wonder what your favourite porn stars and directors are really like? Is sex on the set of a porn film big fun or big business? How do films from the industry's so-called 'Golden Age' stack up against today's videos? The answers to these questions and more are found in Petkovich's book."

—*Dave Patrick, Renegade Editor, Spectator Magazine*

"Petkovich scrapes away the cosmetic layers of the adult industry to find the real human beings underneath."

—*Bill Margold, co-founder of FOXE (Fans of X-Rated Entertainment), creator of PAW (Protecting Adult Welfare)*

"It's always better when someone inside X writes about the industry, since outsiders — with little or no understanding of what makes a porn star tick — usually turn their 'research' into subjective freak shows that do nothing to enlighten anyone about the genre."

—*Mal O'Ree, industry critic*

"Petkovich tells a very strange story… a peek into a weird-assed planet that hovers over Hollywood like a flying saucer or distended moon. Visiting this funny world, Petkovich is like a UPI man staking out a PLO office in Cairo…"

—*Maxon Crumb, writer and illustrator*

A Critical Vision Book
First published in 1997
by Headpress
Second printing 1997
This third printing 2002

Headpress/Critical Vision
PO Box 26
Manchester
M26 1PQ
Great Britain

Fax: +44 (0)161 796 1935
Email: info.headpress@telinco.co.uk
Web: www.headpress.com

Front cover artwork: Stephanie Swift from Gregory Dark's *Sex Freaks*,
 courtesy Dark Works/Evil Angel Video.
Back cover artwork: Chasey Lain from the Dark Bros' *New Wave Hookers 4*,
 courtesy VCA Pictures.

Publisher's note: As the subtitle would suggest, this book is an exploration of the pornographic film industry in the USA. Many of the films to which the text refers have never been released in Britain — not officially, anyway — while the few that have tend to be cut, or abridged versions for cable TV. *Don't* write to the publisher for details and availabilty of films.

British Library Cataloguing in Publication Data
A catalogue record for this book is available from the British Library

ISBN 1 900486 24 5

The X Factory

**Inside the American
Hardcore
Film Industry**

Anthony Petkovich

**Critical Vision
an imprint of Headpress**

To Lelien Tien

Special thanks to Lia Baren, Joseph Carson, Patrick Collins, R.S. Connett, Maxon Crumb, Danielle, Gregory Dark, Derek Johnston, David Kerekes, John Leslie, Scott Mallory, Bill Margold, Dave Patrick, Bruce Seven, John Stagliano.

Thanks to Kris Amaral, Michael Louis Albo, Ron Bandar, Glenn Baren, John Bassett, Percy B.S., Dave Bozzo, John Cambre, Constance Carr, Michael Cates, Star Chandler, David Aaron Clark, Peter Davy, Dizzy, Vince Dutra, Lillian Garcia, Roger Gok, Roy Gordet, Russell Hampshire, Boyd Hunter, Shane Hunter, Jenny Joyce, David Kastens, Christi Lake, David Lefever, Leilani, Christian Mann, Jeff Marton, Pan Pantziarka, John Pluth, Debbie Rubio, Ranjan Santra, Kat Sunlove, Lyn Venable, Michael Weldon, Simon Whitechapel, Nick Wilson, Layne Winklebleck, Nick Yale, Mickey Zeif.

Contents

Welc@me to the X Fact@ry

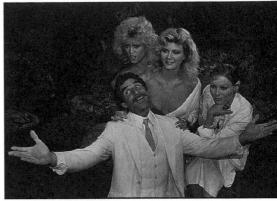

The Grafenberg Spot; Harry Reems on set with (L to R) Amber Lynn, Ginger Lynn, and Annette Haven. Photo: Dave Patrick

Writing this introduction, I realise how dated this book has already become. An inevitable fate, given the fast-paced nature of the adult film world. Los Angeles — presently the capital of porn in America — is not only a massive (yet still underground) factory of sex videos, it's also a giant warehouse of female flesh. A 1997 exposé by US News & World Report revealed an "oversupply of women" in Southern California's X industry, a surplus of young ladies who typically do "two scenes a day, four or five times a week."* From my own observations, a fresh-faced starlet might no sooner proclaim her eternal allegiance to the highly ephemeral profession of porn when she is replaced by a bevy of younger, fresher, prettier girls, all queued up and ready to burn. Scott Mallory, former editor at *Hustler Erotic Video Guide*, once told me how he'd gone on vacation for three months, only to discover a *completely* new line-up of porn starlets upon his return. This non-stop turn-over of female skin is obviously delightful in the sense that variety is, indeed, the spice of life, but such constantly shifting sands make it nearly impossible to capture the contemporary state of the profession in literary terms. Magazines, of course, are notorious for being months behind the scene — by the time a video review hits the liquor stores, a sequel to that same video is already being distributed. And a book? Well, while many of the actresses in this compilation were *once* considered ingenues, most are now either mainstays, retired, or dead.

Warning

Before you start reading the rest of *The X Factory*, please keep in mind that it is not — nor was it ever intended to be — a reference guide to adult films. If you're look-

* The same article also reported 8,000 hardcore videos produced in 1995, compared to the mere 100 features released in 1978.

ing for a comprehensive directory of titles, stars, and dates, I suggest Patrick Riley's indispensable *X-Rated Video Tape Star Index* (published by Prometheus Books). *The X Factory*, on the other hand, is intended to give the reader some insight into the porn world as experienced by insiders themselves — starlets, directors, producers, and technicians. In many ways this book contains their autobiographies, their stories, their truths.

Me? I'm no historian. Especially when it comes to porn. Yet in the sense that these interviews are *individual* histories, then, yes, I suppose you can (very loosely) consider me an historian or, better still, a biographer of sorts.

Porn and Taste

Actually, the more I write about porn, the more I realise how intensely private the experience is. A fairly obvious observation, by no means any gem of brilliance, but, nonetheless, a point not readily admitted or even realised by many porn consumers. For the pornoholic experience — whether it be through video tape, strip clubs, fantasy booths, 'dirty' magazines, or adult web sites — is not unlike the art experience. It's personal, individual, subjective. Just as beauty is in the eye of the beholder, so the depth of lust is in the groin of the aroused. Consumers rent or buy adult videos according to their own tastes. Some want to see a specific actress doing the deed. Others want to see butt fucking. Still others want to absorb ass licking, fist fucking, orgies, gang bangs, girl-girl, boy-boy, boy-dog, girl-horse... whatever. The question, therefore, really isn't what porn *is*, but what does porn mean *to you*?

Porn To Me

The Opening Of Misty Beethoven was my first sampling of porn in the cinema. Not a bad start, either. It was the Spring of '79 and — three years after its premiere in 1976 — *Misty* was still being hailed as "the best porn film ever made." Even today many critics

consider it the *Citizen Kane* of X. I saw *Misty* in, of all places, the confines of a clean college auditorium as part of a late-nite film fest. The crowd was mostly composed of horny college students — male *and* female — with several professors occasionally strolling in (drooling, undersexed housewives attached to their arms like mutated ticks). And while I quickly recognised the merits of Henry Paris' classic — the clever take on Shaw's "Pygmalion," the high production values, competent acting, engaging sex — it was Gerard Damiano's *The Devil In Miss Jones* that ultimately hooked me less than a year later.

DMJ was sharing the bill with *Deep Throat* at the Pussycat Theatre, on Sunset Boulevard, during the Fall of '79. Both films — directed by Damiano — had played there for years and would do so for years to come, before the video explosion of the mid-Eighties started shutting down porn palaces nation-wide. The Pussycats, of course, were considered the Taj Mahals of sleaze salons: wonderfully garish, powerfully raunchy, thoroughly charmed spaces wherein anything could happen. During this particular double bill, however, my eyes were pretty well glued to the screen, not least of all because *DMJ* and *Deep Throat* were two of the most talked-about porn films ever made.

But after seeing Damiano's "masterpieces" back-to-back, I couldn't fathom how the same director could have *possibly* made both films. *Deep Throat* made absolutely no impression on me; only that Linda Lovelace was the most overrated fuck star of all time. This 'classic' was a stupid comedy, filled with vaudevillian humour, reminiscent of more-stupid-than-usual episodes of *The Dick Van Dyke Show*. And on top of it all, the sex was awkward, fumbling, *totally* dissatisfying.

But *The Devil In Miss Jones* was different.

Damiano not only presented the dark, moody storyline of a woman's last gasp for carnality in hell in *DMJ*, but enlisted the talents of a porn actress whose intelligence, passion, and talent have yet to be surpassed on the blue screen. As Justine Jones, Georgina Spelvin became *the* prototype porn starlet to me. The quintessential slut. Not only did Spelvin's sharp intuition and steadfast integrity make her role as virgin-turned-whore believable, but her lust was unquenchable. She not only fucked men, women, snakes, and bananas, but performed anals and double penetrations with the sincere voraciousness of a starved cannibal unleashed in an over-crowded aerobics class. Actually, I'd never seen a double penetration before Damiano's film. It changed my life. Seriously. Though considered technically rough and plodding by today's standards, *DMJ* brought the notion of decadence to a whole new level. Damiano, aptly dubbed the "dean of porn directors," showed the viewer — at length and up close — oral sex, anal sex, and lesbianism. And what better backdrop to unveil such 'evils' than against the classical underworld of Hades? Even today I still get a major hard-on watching Harry Reems (as 'the Teacher') stick a butt plug slowly into Spelvin's hot, willing anus.

"Ugh!" she grunts as Reems sinks the crude device into her waiting rectum. Magnificent! Unlike the pathetically shoddy *Deep Throat*, this Damiano offering was definitely a classic.

As a result of my intense reaction to *DMJ*, Damiano's later work — *Beyond Your Wildest Dreams*, *For Richer For Poorer*, *The Satisfiers Of Alpha Blue*, *Fantasy* — represented, for me, a sort of mastery of Seventies/early-Eighties porn, more commonly known as the 'Golden Age'; an era formally beginning with *Deep Throat*, *DMJ*, and *Behind the Green Door*, and essentially ending with the video explosion of 1984.

Golden Oldies

Memories of the Golden Age frequently take me back to the old Presidio Theatre on Chestnut Street in San Francisco's Marina District, the neighbourhood that got shit-kicked during the 1989 Loma Prieta earthquake. Fond, carefree days of a horny college student watching X-rated films — not videos — on the wide screen.

The Presidio Theatre, like most perv-palaces, offered the patron that incomparable, *raw* raincoat-crowd experience. Showtimes, of course, were never well-defined; you'd enter a pitch black room wherein, for the first few pleasantly disorienting moments, all you could see were a pair of giants fucking on the screen like gargantuan pigs. You could be anywhere at that point: heaven, hell, Valhalla, Mars. The sickly-sweet stench of cum, cotton candy, and soda pop, however, mercilessly crash-landed you back on earth. With each step, your shoes would noisily creak as they clung to the sticky, Coke-stained floor. If you were lucky, you'd find a seat which hadn't collapsed, didn't have a hole in it, or was void of any 'spillage.' Down several rows towards the screen, you'd typically see a shoulder muscle flexing up and down — someone obviously getting his money's worth. A real turn-on, of course, would be spotting a woman ambling into the theatre with — or, better still, *without* — her mate. Ah, that was atmosphere.

Yet, for the most part, the late-Seventies and early Eighties were truly the Dark Ages of porn; a period giving birth to more sleazy, hand-held, grainy compilation movies (i.e., loops) than you could shake your dick, or rotate your clit, at. The films were typically laden with lame disco music and downright tacky male co-stars, usually sporting skin-tight bellbottom pants, silk shirts, gaudy jewellery, and long sideburns. But the biggest disappointment for me was the lighting. There's no subtle way around it: the lighting in these films *sucked*. Oh sure, the actual fucking *was* filmed, but, in many cases, you couldn't see it! Frustrating, to say the least.

But, still, many Golden Age films were loaded with imagination — and charm.

For instance, there was Svetlana's *Ultra Flesh*, a cute science fiction comedy in which males worldwide are stricken with impotence. Earth's only hope is an intergalactic superheroine — i.e., Ultra Flesh, i.e., Seka

at the pinnacle of both her career and beauty — who can set things straight with the 'power' in her pussy. There was also atmospheric, *fin-de-siècle*, Victorian decadence in the little-seen, seemingly lost *Blue Magic* (containing a standout barnyard sequence between New York tramp Merle Michaels and two subservient Mister Ed's). *Dream Girl of F* was one of the better X-rated Alice in Wonderland romps, starring John Leslie as 'F' in search of (who else?) dream girl Seka. Leslie also turned in one of the decade's best male performances as a free-spirited womaniser named Jack who effortlessly — yet with inspiring realism — melts the libidos of such star fuckers as Jessie St. James and Juliet 'Aunt Peg' Anderson in Anthony Spinelli's *Talk Dirty To Me*. Under the steady direction of Cecil Howard, surrealism and satire (in *Neon Nights* and *Platinum Paradise*, respectively) had come of age in porn. And, of course, Rinse Dream graced the porn world with his visually-arousing, socially relevant, sexually stimulating stories of science gone bad (and mad) in both *Night Dreams* (with F.X. Pope) and *Café Flesh*; the latter, considered an example of "crossover" porn — i.e., the triple combination of story, character development, and sex — which played in alternative cinemas and porn palladiums.

After seeing these films, I'd walk out of the Presideo Theatre thinking the world was my oyster. Better still, the entire world — or at least Chestnut Street — was teetering on the verge of an orgy, ready to slide at any moment into the soggy depths of Sodom and Gomorra. Sex was in the air, the atmosphere, the molecules. Keep in mind, those were the days when you couldn't readily meet a porn starlet in a theatre — so you had to use your imagination. And it preyed on your mind, too … Where did these porn starlets live? Where did they eat, meet, fuck? Did they ever visit San Francisco? Maybe some actually *lived* here. If so, where? Where did they shop? Where did they socialise? After seeing a Seka film, for example, I became her sex zombie, possessed. I'd walk that street in a heated daze, looking for a proper cunt in which to plunge, to *smoulder* my glowing poker. Seka was the white-hot focus of my burning desires. But, lo and behold, no bitches on Chestnut Street could even remotely compare.

The Eighties

By contrast, mid-to-late-Eighties porn features (arguably the 'Silver Age') were less romantic, far more heavy metal in substance. Storyline was basically thrown out for straight sex. On that point alone, one *could* say it was a downwards move.

Three distinct entities, however, truly symbolise that revolutionary period for me: videotape, Bruce Seven, and the Dark Brothers. Each brought porn to a new plateau. Some argue a higher plateau, some insist a lower one. Either way, it was most assuredly a *new* plateau (and a far more exciting one, I might add, than both mainstream film and popular music were offering at that time). Videotape — crystal-clear, close up, and

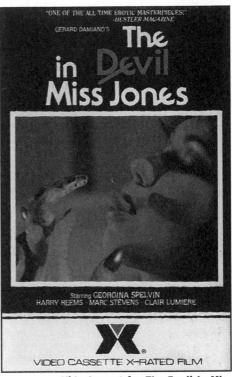

"ONE OF THE ALL TIME EROTIC MASTERPIECES."
-HUSTLER MAGAZINE

GERARD DAMIANO'S

The Devil in Miss Jones

Starring GEORGINA SPELVIN
HARRY REEMS · MARC STEVENS · CLAIR LUMIERE

VIDEO CASSETTE X-RATED FILM

Videobox art for *The Devil In Miss Jones*, featuring Georgina Spelvin.
Courtesy: VCA Pictures

personal — immediately made me a believer, especially after I'd been cheated by so many of those poorly lit Golden Age turkeys. Bruce Seven, of course, took full advantage of video's potential, making porn more real, visible, and gnarly with his highly acclaimed *Loose Ends* series. And the Dark Bros. — with *DMJ 3* and *4*, *Between the Cheeks*, and *Deep Inside Vanessa Del Rio* — helped resurrect an industry trapped in a stagnant, seemingly suicidal holding pattern, making the genre once again entertaining, surreal, comedic, and, most importantly, sleazy.

Supplying additional spice to Eighties porn were the slut-piggishness of Amber Lynn, the cheerleader freshness of Ginger Lynn, and, of course, the irrepressible trampiness of Traci Lords. Barely 16 when she started fucking on film, Lords, surprisingly enough, only worked a total of eight unforgettable — and legally unavailable — months. (See page 120.)

The AIDies

Anal sex, of course, became larger than life in the Eighties.

Twisted as it may seem, the AIDS epidemic made anal sex all the more alluring. Next to pornography, unprotected butthole banging became America's No. 1 taboo. Casual, unprotected sex was now a health hazard akin to Russian Roulette. Consequently, the gen-

Ron Jeremy interviews Seka (with her then-husband/manager at left) outside the 1981 AFAA Awards, Los Angeles.
Photo: Dave Patrick

eral consensus among the more wholesome perverts was, 'If ya can't fuck a slut-come-lately in the pooper without a rubber, why not watch strangers do it on film?' Nasty sex became equivalent to anal sex *au naturel*. Fans expressed their profound interest in dirty, unsheathed cornholing by expressing total *uninterest* in such safe sex features as the Mitchell Brothers' *Behind the Green Door 2*, which fared abysmally in the market and among critics.

Yet despite John Holmes' death from AIDS in March of 1988, stars and starlets at the time weren't required to show any AIDS test documentation to secure work. Instead, performers in the Eighties had the choice of either screwing without condoms or quitting. Most stars chose the former. Males, therefore, continued practising coitus interruptus on camera, while their female co-stars douched with oxynol 9 off screen. (AIDS testing became mandatory among sex performers in the Nineties; see Brittany O' Connell interview, page 134.)

Next to Bruce Seven and the Dark Bros., producer Hal Freeman was a major circus barker for anal sex in the Eighties. Freeman's glorification of ass-hammering in the *Caught From Behind* series made him both an icon and a martyr, as Freeman ultimately became a casualty of Reagan's monstrous "war on porn," otherwise known as the Meese Commission. While filming *Caught From Behind 2* in LA in 1985, Freeman was arrested for "pandering." Shortly thereafter he was convicted and, after a lengthy appeals process beginning in '86, eventually cleared of all charges in 1989. Re-

grettably, Freeman died of cancer that same year.

Spill Over

As the Eighties drew to a close, other porn auteurs made their distinctive marks in the trade, their talents successfully spilling over into the nasty Nineties. There was John Stagliano with his documentary-like point-of-view videocam, as commandeered by his happy-go-lucky alter ego 'Buttman'. Although short-lived, Jamie Gillis' *On the Prowl* series became a watershed entry in the pro-amateur galaxy. Gillis' brainstorm was to rent a limousine, throw a beautiful starlet in it, cruise the streets of San Francisco, pick up single men, and film them individually fucking the porn starlet in this cosy limo nest. Simple. Real. Private. Gillis soon hooked up with Ed Powers and, under the guise of the Nasty Brothers, conducted on-camera interviews with amateur starlets, followed by clandestine hotel room sex in the *More Dirty Debutantes* series. That video line gave birth to *countless* pro-am productions in the Nineties. Patrick Collins made the necessary marriage between business and sex with his involvement in Stagliano's company Evil Angel, eventually developing (by the mid-Nineties) into the Evil Empire, representing such porn luminaries as Bruce Seven, John Leslie, and Gregory Dark, as well as fast-rising directorial newcomers Bionca, Rocco Siffredi, and Joey Silvera.

What also spilled over into the Nineties was porn accessibility. Unlike the Seventies, it became easier to actually meet — or, at the very least, learn more about the personal lives of — your favourite actresses. Porn starlets in the Nineties were appearing in greater numbers at public gatherings (conventions, award ceremonies, adult bookstores), on the road (as feature danc-

ers), and in magazines (participating in exclusive interviews).

Factory Girls

Except in the case of Danielle (who started her career in the Eighties), the women in this compilation of interviews largely represent porn starlets of the 1990's.

Why these specific starlets? I present this particular stable of females for two reasons: (1) either I found them sexually appealing or, (2) I somehow came to meet them by chance or by reference.

The actual interviews were conducted in a number of places: hotel rooms, strip clubs, restaurants, bars, film sets, and, in one or two instances, over the phone. The success of many discussions depended on the mood or comfort of the interviewee. In some instances, I was right on the money, in others not so. Either way, grains of truth have hopefully emerged from their comments.

When I gave a sample of these interviews to Michael Weldon — publisher-editor of *Psychotronic Video* magazine — his reaction made my head spin.

"Are these articles legitimate?" Michael asked with an unusual degree of animation. "I mean, I always thought editors of adult magazines made up these kinds of interviews."

He was right — partly.

When you see magazines with layouts of nude females, many times the quotes are, in fact, *not* factual. They're faked, fabricated, fictionalised. Such is not the case here. While some of the tits in this book may be artificial, the quotes aren't. All starlet comments were recorded directly from their pretty, hardworking, industrial little mouths. Nothing has been added or taken out of context. The interviews are 100 percent *real*.

Moguls

The film directors in *The X Factory* were chosen out of personal interest. John Stagliano's Evil Angel Video produced the best shows at the time of this writing, so I focused mainly on his company. Patrick Collins and Michael Cates, once heavily involved with Evil Angel, eventually shifted their energies towards the highly successful Elegant Angel Video. Ironically enough, for all the hours I spent interviewing representatives of Stagliano's "Empire" (Seven, Leslie, Dark), I never got the chance to speak with the man himself. We did have a number of brief conversations, but nothing lengthy enough to consider an interview. Maybe next volume, eh, John?

Pictures

For photo credits, some fly-by-night companies (like BBE) wouldn't send me a single chrome, making it necessary to scrounge up images elsewhere to properly reflect starlet comments and film credits. Other companies (like Evil Angel, Elegant Angel, Video Team, and VCA Pictures) were incredibly generous with their archives, making the job of collecting images less ar-

duous and, with a wider selection from which to chose, much more gratifying. Other pictures gracing these pages — many of them rare — are by first-rate photographer Dave Patrick, who accompanied me on several interviews. And, finally, one or two snaps are courtesy of — be nice — yours truly.

Of course, you can never really have enough pictures in a publication of this type... or downright dirty ones, for that matter. With that goal in mind, I tried to pick a combination of horny, pretty, and revealing (i.e., candid) pictures of the starlets herein. Naturally, it could have been a filthier book had 'insertion' shots been allowed, or even women sucking on grotesque cocks with sperm blasting out of 'em like blood from severed arteries, but, alas, *The X Factory* was published in England. And as a result, such blatant 'eye sores' as orifice manipulation, hard dicks, penetration, and ejaculation are all missing. "Wickedness," Oscar Wilde wrote, "is a myth invented by good people to account for the curious attractiveness of others." In other words, if the "good people" instituting such laws in Parliament aren't *supposed* to be having any fun, why the hell should you?

Lights, Camera, Sex

The on-the-set articles were meant to impart a feeling of actually being there. Constantly keeping my eyes open, I took loads of pictures and tried to speak with as many participants as possible. And while I may come across as somewhat caustic in my coverage of John T. Bone's *World's Biggest Gang Bang 2*, I've never taken porn-set privileges for granted. Don't believe industry writers when they relate how much they absolutely *loathe* porn sets. Rubbish. Porn sets are a blast! As actress Nici Sterling put it, "There's a lot of waiting around to do" on a porn set and, yes, at times those sets *can* be maddeningly boring. But eventually something magical or, at the very least, memorable happens, always making it well worth the wait.

Seriously Speaking

Ultimately, porn is very much like rock 'n' roll: it shouldn't be taken too seriously. Yet unlike rock 'n' roll, porn is largely overlooked and grossly underrated as a legitimate form of expression. It's a genre not dissimilar to that of the horror film (the underdog nature of which perhaps explains many a porn starlet's fascination with 'monster' movies). The *overt* rejection of porn films, however, permits the medium to sidestep the mediocrity and pomposity that invariably go arm-in-arm with mainstream acceptance. Some folks actually call a Gregory Dark film "trash," yet similarly believe it's quite respectable to read *Playboy*, which they don't even consider pornographic material. Okay, they're entitled to their opinions — lame, snooty, and hypocritical as they may be — after all, such distinct differences in opinion are part and parcel of the subjective nature of porn. But is there *really* a difference between a shameless Italian slut getting double pen-

etrated in a loop from Europe's Private Video series, and an 'artiste' like Patricia Arquette getting fucked silly — to the point where her tits spin like pinwheels — in a David Lynch film? Is too *much* being shown, or too little? Better still, is porn a stepping stone to mainstream, or is mainstream a stepping stone to porn?

Rape and incest are, of course, two major taboos in the Nineties which distinguish the privileges afforded mainstream film from those robbed of porn. Dramatisations of rape and incest in mainstream films are, in fact, 'hardcore'; that is, you, the viewer, are expected to see these crimes as real. The scenes are fictionalised, yes, but they're scripted, acted, filmed, and edited to play as 'true-to-life'. Porn, on the other hand, is constantly covering its figurative ass in the areas of dramatised rape and incest with frequent disclaimers in the plot (such as, Starlet: "Oh these gentlemen *really* didn't rape me... it was just a fantasy of mine." And, Male star: "Oh, I really didn't fuck my *sister*, she's just my sister's *best friend*... we were just getting off on a kinky fantasy.") Keep in mind, there are no actual *laws* against showing fictionalised rape and incest in adult films, but the industry is presently plagued with doubts and fears concerning these taboos. Why? During a 1995 interview, actor-turned-director John Leslie gave me his thoughts on the subject.

"Only because if you [show those things]," said Leslie, "certain distributors won't take your movie... because they've already made deals with the district attorney. You have to remember, we're doing something that must return money so we can live and do another movie. So in that sense, there are certain restrictions you have to abide by... In video you have to be sensitive as to what's good for you, 'cause [you're] trying to make a living. [You're] not trying to make a stand... [and make your] life all about going to court. On the other hand... I should be able to do any movie I want... show anything I want. Obviously that perception of freedom is different for other people."

Indeed. While it's morally acceptable for, say, a woman in a mainstream film to get gang raped in the woods, it's criminally *immoral* to show a woman getting graphically gang raped (i.e., complete with pen-

Photo of the author
by Dave Patrick

BIOGRAPHICAL DETAILS

Anthony Petkovich is a freelance writer based in the San Francisco Bay Area. He regularly contributes to *Psychotronic*, *Hustler Erotic Video Guide*, *Spectator*, *Genesis*, and *Headpress*, and is the publisher/editor of *Liquidator* magazine.

etration) in the woods in a porn film.

Bill Margold, considered porn's official Renaissance Man (in that he has written, directed, reviewed, and starred in adult features for the past 25 years), likens such self-censorship to self-mutilation. "We, the porn community," says Margold, "cannot be as free-thinking or as creatively free as we'd like because we've castrated ourselves with rusty scissors."

A marvellous example of the above can be drawn from Margold's own former acting ventures: in *Disco Dolls and Hot Skin in 3D* — labelled by one critic as a "strange version of *Casablanca*" — Margold plays Harry Balls, a deranged kidnapper who sodomises a woman (Ingrid Irving) while simultaneously drowning her in a vat of chicken soup. The scene is timed so that Margold ejaculates just as Irving's character expires. Too bad Irving didn't play Harry's sister, then we'd have covered all the bases: sodomy, rape, murder, and incest. Because of today's creatively retentive standards, we get none of this colourful, violent drama. We're left, instead, only with a dick, a cunt and the chicken soup.

Once again, I make no excuses: *The X Factory* is far from a contemporary publication. It's somewhat dated, even before hitting the bookstores. Yet I hope you won't find the material within it any less informative or entertaining.

Anthony Petkovich
March, 1997

WHEN BARBIE DOLLS RULED THE EARTH

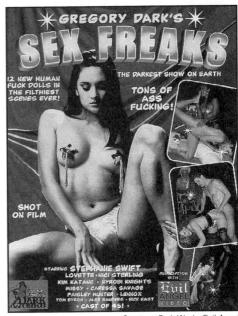

Courtesy: Dark Works/Evil Angel

ON THE SET OF GREGORY DARK'S SEX FREAKS

Bug men. Devil men. Skeleton men. Midgets. Fat chicks. Hermaphrodites. Street loonies. Ice cunts. Catwomen. Nope, it's not Batman. It's not Ripley's Believe It Or Not. Hell, it's not even The Montel Williams Show. It's none other than "The Darkest Show on Earth" — Gregory Dark's Sex Freaks.

Like a plethora of smut junkies out there, I'm a great admirer of Dark's films. So, believe me, I was *not* singin' the blues when the master of bizarre porn invited me to the set of Sex Freaks, his first feature for distributor Evil Angel and his own Dark Works Productions.

It's 12 noon as I drive up to Milt Ingley Studios in North Hollywood. On one side of the studio are quaint, middle-class Southern Californian homes, each sprouting dried-up lawns and looking like Bela Lugosi's digs during his down-and-out, morphine-hooked days. On the opposite side of the block are Mexican youths, hanging out on the street corner, blending in with the mucho unintelligible graffiti spray painted on corrugated metal walls. Fuck Beverly Hills. *This* is LA.

In the warehouse-like studio, it's not hard spotting Dark among his crew. The tallest guy on the set, Dark is wearing jet-black T-shirt, blue jeans, Doc Martens, and the dark sunglasses he's become famous for. Boxcover girl Stephanie Swift isn't too hard to spot, either. Aside from being the first ginch screwed in Sex Freaks (by incredibly sexy negrita Nyrobi Knights and Tom "my-life's-ambition-is-to-screw-each-and-every-ho'-in-the-Valley-before-I-hit-40" Byron), soft-spoken Swift is also one of Dark's many assistants on the film.

Right now Dark, Swift, and a 15-person crew are filming a non-sex scene in a plush, makeshift office. I can't help but notice a fishbowl upon the corner of the "office" desk. On closer examination, I see the fishbowl contains not goldfish, but Barbie dolls. Hmm…The office is also filled with bird cages containing not canaries but… Barbie dolls. *Barbie* dolls? — in bird cages? — in fishbowls? Way cool. Hey, now I'm curious. What the fuck *is* this movie about?

A short while later, I get my answer in the studio breakroom from porn starlet Lovette.

"The plot's basically about this perverted guy named Julio Midnight," Lovette tells me, her big, luscious, head-givin' lips nearly wrapping themselves around my tape recorder. "Julio sees good-looking girls on the street and by manipulating these Barbie dolls with a snap of his fingers, the dolls are suddenly dressed like the girls in the street. Then, by further manipulating the dolls, he makes the girls fornicate and do weird sexual things."

"What's your part in this movie?"

"I'm Sweet Meat, the one person Julio can't control. And since I've beat the game and know the rules, I tease Julio throughout the movie. Eventually, however, he's granted one wish from 'Lips', who's this sort of disembodied female entity on a television screen (a close-up of veteran porn starlet Sharon Kane's lips). Lips gives Julio a Barbie doll in my image, and that's when Julio gets to do what he wants with me." And that, dear readers, includes having six skeleton men slowly rise from their wooden coffins in Dark's "vault of whore" and methodically bone Lovette's negative

ion ejector.

I leave the breakroom and wander back into the studio. Dark is taking a break, casually practising his kickboxing against a large black drainage pole. I ask him about the Lovette skeleton gang bang the other day. His face is instantly aglow. "You should have seen it," he says, proudly shaking his head. "I mean, she was getting fucked in the ass… I mean, *fucked in the ass* [he jabs index finger into fist to illustrate] by *six* guys." *Damn!* I wish I'd been there.

Sex Freaks is a five-day shoot. And since I'm only on the set for a day, I've obviously missed a *shitload* of good stuff. Aside from the six-skeleton gang bang, I've also missed Paisley Hunter's DP* by two "bug men." Ah, Paisley Hunter. Some dish! Strawberry-blonde — with creamy skin, bite-sized nipples, and a full, cushy ass to die for — this mind-blowing nubile (of Polish-Norwegian descent) could have her way with me anytime of the day, hour, fucking *minute*!! Ja' hear that, Paiz? Anyhow, her DP is truly one of the *best* I've seen. Why? Simply because unlike many DP's — where one little piggy just sits in a fuck hole, frozen, unmoving, while the other sausage is really *wailin'* — the peters in this DP simultaneously sink in and out of Paisley's love sockets like smoking pistons. I also love Paisley's reaction to her pork plugging. As the insect men double stuff her, she slowly closes her eyes as if in the middle of a heavenly bowel movement. The camera moves from her sweet face (a strand of silky hair elegantly curling from the corner of her mouth), pulls back for a full shot of both her and the fly guys, then moves deep into the sweaty nest where those stingers are doing the deed. All in one shot, too. No jumps. No cuts. Beautiful! A DP Hall of Famer. And I missed it. Shit!

Back on the set, Lennox — brunette, olive-skinned, exotic looking, highly fuckable — is having trouble with her lines. It's a non-sex scene, once again, in the office of Julio Midnight. With the help of cue cards, however, she gets it right. Lennox plays Lucy Juicy, a pretentious performance 'artiste' ("I sing the twat political!") who eventually gets her asshole sucked and slammed by a coven of four devil men. "Stick it in my ass! Yeah! Stick it in there!" she snarls at the horny little devils. They stick her alright. Yet the gluttonous slut (is that redundant?) keeps on snarling for more. "Yeah! Fuck my ass! *Fuck* my… ugh!!… ass! Argghh! Argggh!" No problem memorising *those* lines, eh Lennox?

Just when I think I've covered all the great pussy meandering throughout the studio, Nici Sterling struts into the joint. The British babe offers me a warm smile which I can't resist. So we talk. Nici tells me how she stomped off the set the other day while filming the "catwomen" scene. Hmm… Doesn't seem to have affected the final cut, though. In this particular episode, Sterling and Missy are on collar, chain, and all fours. Their "master" (played by Alex Sanders) leads them to a sofa flanked by two "baby" men (neither under the age of 60) who suck their thumbs and crank their wrinkled flesh rattles (not a pretty sight). Yet the image of Sterling and Missy eagerly 'pawing' for kitty treats is *terribly* precious. Once fed, Nici and Missy 'thank' Master Sanders with a dynamite blow job. Sterling sucks the tip of his hot dog while Missy lathers the shaft of the blue-veined frankfurter with a mesmerising mouthwash, eventually sliding her tongue into Sanders' pit of brown

Dark and the Chinamen; *Sex Freaks*.
Photo: Anthony Petkovich

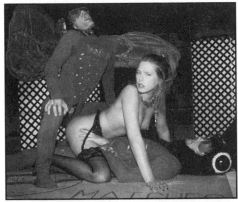

Left: Paisley Hunter meets the 'fly guys'.
Right: Lovette in the *Sex Freaks* climax.
Courtesy: Dark Works/Evil Angel

doom. Damn! Frankly speaking, I don't know *how* Sanders doesn't blast bazooka right there. But hold back he does (I suppose that's what you call "professionalism").

After my brief conversation with Sterling, I wander back into the studio — frustrated. Am I *ever* gonna witness a sex scene on this movie set? Soon enough… I'm there! Dark is ready to shoot his first sex scene of the day. Within minutes, I'm only a yard away from Lovette's hot, sweet anus. Yes!

"Give Lovette a banana," Dark tells one of his assistants. "Have her *smash* it in her face." Leaning forward in a foldout chair, Dark holds a portable monitor down between his legs as if reading a newspaper, watching every move captured by his cameras. The extent to which he orchestrates his stars' *every* sex move is what really amazes me.

"Look in the camera," he tells a naked Lovette. Eyeing the camera, she bends over, presenting her big, meaty butt for stud John Decker's perverse pleasure. "Pull her ass cheeks apart," Dark tells Decker. He does. "Lick her ass," Dark continues. "C'mon, I want to see you stick your tongue in her ass… *there* you go… look at us, Lovette… okay, play with you clit while he's doing that…" Lovette starts groaning, her eyes disappearing into the back of her skull. "Finger your ass, Lovette," Dark tells her. Meanwhile, Decker starts getting spontaneous and slaps Lovette's ass — a hard blow which echoes throughout the cavernous studio. Ms. Sweet Meat doesn't mind at all.

"I want you to lick under his balls, honey," Dark

* Double Penetration.
Basically a "DP" means the simultaneous insertion of two penises into a woman: one in her anus, one in her vagina. On page 123, Patrick Collins talks about the misnomers behind this definition. That is, a DP can also refer to a double anal penetration (two penises simultaneously inserted into a woman's asshole) or a double pussy penetration (two penises simultaneously inserted into her cunt).

instructs Lovette. "C'mon, suck his balls… get your ass out, John… Lovette, stick your tongue in his ass… c'mon… I want *nasty*…" Oh-ho! This is great! Lovette and Decker are simultaneously wailing now, her moans a tad more muffled since her teeth are wrapped around his gas station. "Suck it," continues Dark. "You wanna fuck her a little, John?" Eyelids halfway open, Decker appears in some kind of heaven. But he manages to nod. Dark grins. "Okay, let's see." The "talent" rearrange themselves on the sofa.

Decker is now doing Lovette doggie style. "Eat something, baby," Dark commands Lovette. She reaches for an unwrapped Twinkie resting in a nearby fruit basket. "Eat!" he persists. But Lovette hesitates — not from shyness, but because she's actually *lost* in the fucking.

"Oh my God!… my God!" she almost painfully moans.

As Decker slams Lovette's big, vibrating booty, Dark is relentless. "Start *eating*, baby… start *eating*…" Lovette snaps out of it. She eats the junk food in a delightfully sloppy fashion, the artificial *crème* smearing all over her lips, cheeks, and nose. Lovette and Decker then switch to the missionary position, at which point Lovette starts toying with a ripe, lush peach. It's soon pop-tart time, folks.

"Shoot that load on this peach," Lovette purrs, offering Decker her latest prop. But she's holding the peach *way* too close to her face. Unless Decker's prick has magically transformed itself into a probing alien tentacle during the course of intercourse, he ain't gonna reach the peach. Dark sees this potential dilemma. He wastes no time with his already-paid-for slime.

"Give John the peach, Lovette," Dark urges.

Lovette quickly moves the fruit down to her cunt. Decker pulls out his tube steak, aims for the peach, and heaps his genetic gunk on the once-virgin fruit. Dark is relieved.

"Okay," Dark tells Lovette, "stuff the peach in your mouth." Smiling, she holds up the peach-turned-kum-

**Posing for the *Sex Freaks* titles (L to R):
Kim Kataine, Caressa Savage and Rip Hymen.**
Photos: Anthony Petkovich

quat, stares at it, yet, once again, hesitates. "C'mon, baby, stuff it in there," repeats Dark. She puts the peach close to her lips, but is still holding back. What's the fucking problem? Dark is urgent now. "Come *on*, baby. *Eat* it!" She finally obeys.

"Umm, so sweet," she says, greedily munching the steaming sperm, the fruity pulp.

Dark wants more drama, though. "Chew! *Stuff* that peach in there! Stuff it! More!" With the proper amount of savagery, she eats the whole thing, leaving behind nothing but a raggedy pit.

Next up? A four-way girl-girl scene. Hey, I am *ready*!

The set is an impressive, semi-surreal Chinese sin den with large oval bed (flaunting big, fluffy pillows); an 'examination' table; five Chinamen (one of which is, no shit, a hermaphrodite) all wearing joke-shop goggles, eating rice, and eventually beating some Mongolian beef (or fingering some shrimp chow yechh, as the case may be); and, last but not least, four sluts in heat. Chains hang in a dungeon-like manner from the ceiling. To make matters more bizarre, raw hunks of chicken, ribs, and beef are skewered on hooks dangling from the chains. Atmospheric pink and red lighting give the set an eerie neon touch even Mario Bava would be proud of.

But what of the sluts?

Kim Kataine, Caressa Savage, Lovette, and Toni are Dark's girls — all in their tantalising twenties. Kim Kataine reminds me of a blonde, nastier version of Simone Simon from Val Lewton's *Cat People*. Her bite-sized titties are nice, natural. She also possesses a truly attractive cunt; cooze lips which aren't flappy, crinkly, or rundown. Rather, they're firm, thick, healthy. A twat you don't merely lick but *suck*, fiercely, for hours, 'til you nearly pass out from excess salt intake. Caressa

Savage looks like a meatier version of Lauren Bacall with fake tits. But she does have one awesome ass on her. Lovette? We've already anal-ysed her. But Toni? Kee-*reest*, what an ass on that one. Not a day over 20, she looks Italian or Portuguese. (She's actually half-French, half-Native American.) Um-*um*! Great faceburger. Hold the napkin on this one, please. I wanna savour every sloppy drop!

Non-sex star Rip Hymen initiates the action in this scene. Carrying an attaché-case full of voodoo dolls under his arm, Rip strolls into the chick-filled dungeon and says, "All this 'saving mankind' crap is dandy. But even the Redeemer's gotta get a little once in a while."

"Okay, play with the dolls," Dark instructs Rip. "Then Kim, Toni, Caressa, as soon as he says his lines, I'm gonna go 'Now,' and you're going to say 'Ooooh, Julio Midnight,' like you're excited, happy to see this guy 'cause he's basically transformed your minds into... (switches to exaggerated Karloff voice) *mindless sex sluts that he has use for*. You gotta say it together, though, okay? Like this: 'Julio Midnight.'"

"Julio Madness," says Kim.

"Julio Midnight," corrects Dark, who's incredibly patient considering it's 2:30 am.

"Let's practice this a bit," says Hymen. He goes through his lines, then cues the girls: "... even the Redeemer's gotta get a little once in a while..."

"Ooooh, Julio *Mad*-night," the girls simultaneously purr.

The crew bursts out laughing. Dark puts his face in his hands, starts shaking his head. "Midnight," he says. "Midnight. Try it again."

"That's a hard line," Caressa Savage calls out.

"A hard *line*?" Dark retorts, incredulous. Ten min-

Publicity shot of Kim Kataine with Chance Ryder, real-life hermaphrodite; *Sex Freaks*.
Courtesy: Dark Works/Evil Angel

utes later, however, the ladies (much to Dark's relief) get it right.

"Okay. Let's *do* it. Let's move forward," announces Dark. "Here we go. *Big Dildo is after you!* You better be careful." Dark is referring to an elephant-sized prosthetic, which ultimately drills a merciless path straight up Caressa's clam pit.

Although sundry dildos are used in this scene, Dark refuses any love toys to upstage the human factor, i.e., that necessary chemical reaction of flesh on flesh. "C'mon, Toni, get down there and *lick* a little bit," he insists of Lovette's unattended anus. "Get your *tongue* in there... *lick* her asshole... there you go."

All the girls eventually wind up in a slutfest on the oval bed. A slew of unscripted lines rise up from this dense web of sex. "Spank my *ass!*" "You guys better fuck me good!" "Put those beads in your pussy." "*Slap her pussy!*" "Ooooh, you nasty little bitch. I'm going to fuck the *shit* outta you." This particular chain of nastiness is broken, however, by Kim Kataine, who now gawks at one of the buck-toothed mock Chinaman pounding his pud. "Whew! Look at that hard cock," she exhales. The compliment goes to the goober's head. He immediately starts slapping his cock — left, right, left. *Smack! Smack! Smack!* (Ouch!) The girls are in awe.

"Catch that guy whacking his wick," Dark tells his director of photography. Then, to the hammish Chinaman: "C'mon, you gotta hit it for me. We didn't catch it on camera once." The guy starts literally *beating* his boner again. But his hat keeps falling off. "Take off your hat while you're at it," Dark tells him. "Okay, c'mon, slap it! (*Smack! Smack! Smack!*) Good. Thank you. You can put your hat on now."

The slutfest continues. And *how* exactly Dark manages to separate all that wonderfully tangled twat on the (undoubtedly soaked) oval bed is totally beyond me. "Spread your legs, Kim..." he says. "C'mon, Toni, *lick* Kim's ass... open it up... Kim, show us what it's like for Toni to eat your ass... pull it apart, Toni... stick your finger in your ass, Caressa... Lovette, I want you to stick your finger in Caressa's pussy while her finger's in her asshole... c'mon, get wilder, ladies... I wanna see more... *push* yourselves..."

For the time being, this carnival of holes comes to a standstill — breaktime for the lip lappers. But it's 5 am. It's late. And I'm bushed. A good time to make my departure. I thank Dark for inviting me to his shoot. "Glad you were able to make it," he says, graciously shaking my hand. "This film is *weird*, isn't it?"

Before I have a chance to answer, however, a French photographer breaks in: "All your films are weird, Gregory."

"No, no, really. This one's the weirdest," Dark confesses with hardcore sincerity. "The weirdest! I did this insert shot today of a guy pulling the clothes off a Barbie doll with tweezers." He chuckles like a devilish adolescent who's just fire-bombed an ant hill. "I really liked that."

Sex Freaks? The *weirdest* Dark film to date? Quite a statement. Then again, who better qualified to make it than the Darkman himself?

But what about the Barbie dolls? you ask. What's the message there? — the symbolic *meaning*? Fuck it, Sonny Jim. You figure it out. ■

L⊚vette

American Triple X

Obliging. There's a word porn writers rarely use to describe the talent. In the case of Lovette, however, the term surfaces quite naturally. Don't get me wrong. Porn 'attitude' can sometimes be a turn-on — as in the case of Amber Lynn. A dollop of sassiness can be somewhat appealing, too — as with Nyrobi Knights and Tiffany Mynx. But when you're struggling for provocative pictures and an in-depth interview on a crashingly busy film set, *no* porn-chick attitude is a joyful relief. And Lovette was there, behind the scenes of Gregory Dark's *Sex Freaks*, for whoever wanted her. Obliging. Very obliging.

But Lovette wasn't just a sweetie pie. She's actually proved herself quite the whore (that's a compliment, Lovette). In *Sex Freaks*, for example, she gorges on a semen-drenched peach, licks and laps the twats and anuses of three fellow fuckettes, and even manages to stuff in a six-skeleton gang bang during the crusty course of which her poo-poo production plant is consecutively packed by six boners. Not bad for a day's work. She's also worth checking out in Rex Borsky's *Club Anal 3* (where, in a moment of inspired lust, she sa-*macks* her own pussy with a dildo) and in *Max World* (in which she romps around Amsterdam getting fucked in the fudge-fondue pit by the ever-creepy Max Hardcore... Tobe Hooper should stick this guy in a redneck horror film... talk about yer natural loonies).

Yet with such an incredible reputation in raunch preceding her, Lovette still considers herself a tease. Sorry, but I don't buy it for a minute. After interviewing this horny Hoosier, and later watching her fuck, I quickly realised the lady's a certified, grade-A, Hollywood s-l-u-t. (I'm just sorry California can't take the credit for originally breeding her.)

On the afternoon of October 10, 1995, Lovette and I talked for about an hour, over two ice-cold Cokes, in the breakroom of *Sex Freaks*. What struck me most about this relative newcomer (aside from her terribly commendable open-door policy on sex) was her amazing insight into the, at times, highly impersonal world of porn.

Let's talk about this six-skeleton gang bang in Gregory Dark's *Sex Freaks*.
Well, it was my first gang bang. I never thought I would do anything like that. I think it's the last sex scene in the movie and it has skeleton men coming out of coffins. I did anal with every guy. I believe there are two DP's in that scene, too. Anal really turns me on. DP's, too; I love having two cocks inside of me. I never expe-

rienced a DP before this business. Now I *love* it. I never did anal before, either. That scene, though... it was a rush... there were *so* many *cocks*! At first I was really nervous because Gregory was telling me what to do, and I was trying to remember to *constantly* look at the camera, do this, do that, so many orifices to keep busy... finally I just said, "Screw it!" and kind of stopped listening to him. I think Gregory might have gotten mad at me, but I just had to tune him out to get more into the sex. And I really started enjoying it. It was hot and nasty... fantastic...

Do you have much opportunity to actually act in *Sex Freaks*?
I have more lines in this film than I've been handed in any other films. People have this preconceived notion that because I'm new in the movies, I'm going to be nervous and all clausterfucked.

Clausterfucked?
Yeah. That's my little word that I use. Like I said, it'll be the most dialogue I've done in a movie so far. In other films I've had just a few lines. Hopefully I can do a good job of it. I feel pretty comfortable with it. Actually, I'm very comfortable in front of people.

How do you feel about people on a set watching you get spam-dunked in the ass by six guys?
It's a turn-on. I like people watching me get fucked. Normally I'm kind of shy, but when there's an audience, then I kind of flip into the Lovette mode. It's a reversal. And, of course, Patti Rhodes [Dark's on-line producer] and Gregory were so nice. After I was gang banged by the six guys, it was 1:30 in the morning, I was all hot and sweating with cum all over me, and Gregory and Patti gave me a bouquet of flowers and a bottle of champagne. It was the nicest thing anyone's ever done for me. It was total respect, because after

Lovette in the middle of a 'food fuck' with John Decker in *Sex Freaks*.
Photo Anthony Petkovich

your films?
Big-Boob Brain Surgeons by Stuart Canterbury. *The Penetrator 2* by Nic Cramer, *Anal Town*, *Tinsel Town Tales*, *Max Number 8* for Max Hardcore, *The Wanderer Number 1* for Jonathan Morgan, *Nasty Nipples Volume 9* for Anabolic. *Horny Henry's Adventures*, *Fashion Sluts Number 4* for Joey Silvera, *Big Busted Babes 32*. I also did some stuff in Hawaii but I'm not sure about the titles of those yet. I'm also in *Up 'n' Cummers 33* for Randy West. I really enjoyed working for Randy. I love this whole business. But, to tell you the truth, I really miss my dancing.

When did you start dancing?
I started stripping when I was 18 to work my way through college. I always wanted to be a stripper. I was taking some business classes in Illinois and had this girlfriend there who was a dancer, really beautiful... she did some *Playboy* stuff. I suppose you might say she influenced me in terms of pursuing my career. She had fake boobs, bleached-blonde hair, big long fake nails, wore all this wild stuff, and I *hated* her because she was so pretty. I mean, she was like 43 and I was 18. And men would notice her before they'd *ever* notice me. So now *I'm* bleached blonde with fake boobs. I like the look. Actually, I was always busty. But after the dancing, my titties started to sag, so I got them fixed.

Did you actually think about getting into porn when you were younger?
My first memory of porn was when I lived with my dad who worked the night shift. My mom wasn't around. See, my dad had a satellite dish and we used to get American Triple Xstasy. And when he went to work, all the boys in the neighbourhood would come over my house — I was like 14 — and we'd switch on the television to watch dirty movies. Hardcore movies. Actually, my first memory of a porno was seeing Ron Jeremy suck his own penis in a Seka movie. Ironically enough, I've worked with Ron Jeremy.

I'm sorry.
No, it's funny because I thought for several years every man could suck his own penis. And I was surprised guys never did it.

Looks like Ron's cornered the market.
Actually, I had a very weird idea of what sex was before I even experienced it first-hand. All my knowledge

you a do a scene like that, sometimes it plays with your head, you feel like you're really being disrespected. I mean, guys spray their cum all over you and then they leave. And you're left with this... loneliness. It's almost like being fucked and then thrown away. It can play with your mind. But giving me flowers and champagne, that was the really the greatest thing anybody's ever done for me.

What sort of person were you in high school?
I was a slut. (Laughs)

In what way were you a slut?
Well, I wasn't really a slut. I was a tease.

But you just said you were a slut. So which is it? — a tease or a slut?
Well... a slut is somebody that does slutty things like sleeping around with a lot of guys. I was a tease because I dressed really wild, mainly because I wanted to rebel. I was the intelligent kid — straight A's, honour roll, student government, cheerleading. And I got so *tired* of everyone thinking that I was Miss Goodie-Two Shoes. I wanted to be *baaaad*. I mean, I was the same person, did the same things, but dressed really wildly in tight jeans and little shirts. My nickname was 'Torpedo Titties' 'cause my boobies stuck straight out. I was an overachiever in everything... except men. And I *still* like to tease guys. I always like the game of 'Can I really get this guy?', 'Am I good-looking enough?', 'Do I have the personality?' I like the chase. But once I know I can have the guy, that's it, it's over. I want something I can't obtain.

How about a rundown of some of

was from the movies… kind of kinky. I mean, I'd watch girls fucking guys' toes… weird stuff like that. So I naturally accepted all these things, that *this was sex*, what people did. Besides, my dad never taught me about girlie things. Like when I had my period, I had no idea what it was. Especially since I really didn't have a mother.

What are some of your major likes and dislikes of this business thus far?

One of the things I really like about this business is when you get on a shoot everybody's like a big family. I never really had a family growing up. So I was pretty much on my own. And working on a set, you have a lot of time to get to know people and learn something about their lives. I mean, even if it's for a short time — one day or just a couple of days — when you're on a movie set you feel like you're in a family. There's this special kind of love on a shoot, with the different mixes of emotions you see. People go through anger, boredom, start talking about their past, their dreams, hopes, goals, desires, children… I mean, it's great.

Your dislikes?

Well, I sort of feel facial cum shots are somewhat disrespectful.

See, I never did facials before this business. And to me it's almost disrespectful, because after a guy comes on your face, you have to leave it there so photographers can take pictures of it. I mean, the guys like it, yeah, but sometimes it goes up your nose, in your eyes, and you really want to take it off… but you can't. You have to keep it there for the still photos. And afterwards, when everybody goes off to do other things, you're just like… left there. That's a hard part of this business. But I suppose I'm getting pretty good protein treatments for my hair, so I really can't complain. (Laughs)

Lovette about to make herself into a banana split at the 1996 FOXE Awards, Hollywood.
Photo: Dave Patrick

How long would you like to do porn?

I'm 22 now, so I'd like to do a lot of videos. I'd *love* to be a really big, famous porn girl. I want the chance to do a lot of things… magazines and layouts. I mean, I've never been on a cover of a magazine before. I just wish people would give me the chance to do it, let me show them that I'm capable of it. And, of course, I'd like to continue dancing. I love meeting people on the road and hearing about their lives because I've had a really weird one.

It's a bit taxing being on the road, though, isn't it?

(Giggles) No. I think it's easier being on the road because you're on a schedule. You basically get up at a certain time, eat at a certain time, work out, dance, go to bed. But when you're acting in a movie like this, you could be on the set from 10 am

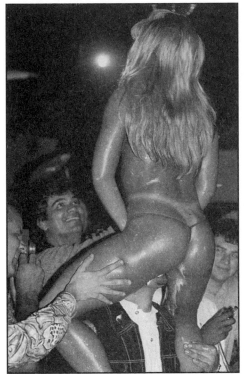

Lovette makes the fans go bananas at the 1996 FOXE Awards. Photo: Dave Patrick

until 2 am the next morning. And you might have a call time at 7 am that same day. God only knows when you're going to get into a gym, let alone eat or tan. So usually when I star in films, I gain weight because I haven't been able to exercise.

But that's all sweet meat. You don't like it?

No. (Giggles) I hate it. Making films is also fairly stressful, that's why you don't have the energy to do a lot of things you would normally do. I got used to being on the road, though. I don't live out here in California, so every day when I go to a movie set, I may be travelling somewhere different. Every day I'm looking for the shoot, getting lost. Right now I'm staying here in California, but I'm going back to northern Indiana for the holidays. I have a home there. Hopefully I'll come back in January for the CES*, though.

Aside from your gang bang in the Dark movie, what's your nastiest sex scene to date?

Oh, there's a couple of them. Again, I like the weird stuff, abnormal sex, like the DP I did with Nick East

* Consumer Electronics Show.

and Jake Williams for Joey Silvera's *Fashion Sluts 4*. I'm on the boxcover of that one, too.

Anything else you'd like to add?

I wish the guys would come and see my dance shows. They're exciting. I do fire shows and food shows, and I love to drag guys up on stage and get messy and naked with them. See, I've worked adult theatres where they show movies, so I've had a chance to develop a special kind of love for the guys that buy these movies. Believe me, the guy that's faithful to adult bookstores and video stores, he's totally serious about sex, really into it. But the typical guy who goes into a strip bar, he's kind of perverted but doesn't really want to admit it. He's more of a closet perv. It's true. I've dealt with it for a couple of years and this is what I've seen. But it's not always the suit-and-tie type of guy that's a closet perv because a lot of them can be serious perverts, too. I love perverts, guys that are into leg and foot fetishes… guys that want to be spanked. I love the kinky stuff.

Do you like to be dominated?

Yes! Actually, I was supposed to be *more* dominant in this gang bang for Gregory, but… it's hard… I lost control. I'll have to watch the film because I really don't know what I did. But the guys that buy adult videos, they *like* weird stuff. And I think they're really gonna like this Gregory Dark movie because it's different. Also, a lot of guys I've met in the strip theatres have said to me, "Well, this porn starlet only does girls. She doesn't cares about guys." Me, I *wanna* play with the guys. Like the 'A'. At first I said I wouldn't do it, because I was really scared. But now that I've gotten better at it, I can enjoy it. At first I couldn't get off on it — not unless I had something up my *cunt*. (Giggles)

How do you feel about girl-girl?

Girl-girl? It's exciting to me. I've played around with girls before on stage, but I was always kind of too shy to ever ask a girl. My first memorable experience with a girl was actually on a film… with Shonna Lynn in Bobby Hollander's *House Of Hoochie*. I never actually had a chance to taste a girl before this business and I always wanted to. I *always* wanted to.

Did it taste the way you expected it to?

It was weird. Very weird. Now I'm becoming a little bit more comfortable with it. I'm doing a four-girl scene today with raw meat in it. We're going to slap raw meat on our bodies, which I think will kind of erotic — wild sex, hot pussy, and then cold, raw meat… a perfect contrast… so sexual. But with women I have to hold back on the Lovette thing because I'm still learning about girls. I'm so scared. I mean, women are such delicate, beautiful creatures that I'm worried I'm going to hurt one. Of course, fucking a guy is a totally different story. ■

Stephanie Swift

Too Good For Porno?

Sometimes I feel consumed in a sort of "Holy Grail" quest for that too-perfect-for-smut girl. (But, shit, aren't we all?) Lemme tell ya, I *definitely* struck gold with Stephanie Swift. Aside from possessing the cute face of a nubile librarian and the hard body of a dedicated aerobics instructor, Stephanie had certain characteristics you simply wouldn't expect in your run-of-the-spill Canoga Park fuckette. Namely: manners, an education, creativity, and that seemingly lost piece of antiquity known as a soul. Too good. The girl's was just too *good* for porn. And yet by the same token, I was *terribly* pleased she picked a career in fuck instead of forestry.

Young enough to admit her own age (born February 7, 1972), smart enough to manage herself (no Ho'-llywood Dr. Caligari with filthy teeth, cheap toupee, and stale stogie running her gig), and horny enough to work for the industry's most nitro-injected directors (John Leslie, Gregory Dark, and Rex Borsky, to name a few), Stephanie was a distinct breath of fresh air in that smog-banked, gangsta-infested, mind-fuck-bitch-bloated Transylvania otherwise known as La-La Land.

In early September of '96, Stephanie invited Dave Patrick (*Spectator*'s Renegade Editor) and yours truly to photograph and interview her on the set of Michael Zen's *The Censor*. In Dave's "dirt-ball" Camaro (his description), we drove deep into that land of too many vampires and too few crucifixes, eventually pulling up to an art-deco bachelor pad heavily cloaked by the rocky yet strangely plush Martian landscape of the Malibu Hills. It was around 1 pm. A lavish catered lunch had just arrived. And to avoid appearing like a pair of total mooches, Dave and I drank warm Hawaiian Punch — while the entire crew inhaled buttery mashed potatoes, steaming string beans, juicy stuffed bell peppers, and home-made corn bread, washing it all down with tinkling glasses of lemon-brewed iced tea (Kee-*reest*, I wish we'd eaten breakfast!). Stephanie had just finished a three-way masturbation sequence with Jen Teal and Ruby, and, even though physically wiped out, was more than willing to chat with us. (Especially gracious of her, considering she had *another* three-way coming up after lunch — this time with Ruby and Stephen St. Croix.)

Wearing a cotton night-gown, heavy Cleopatra eye-makeup, and (damn it!) *no* glasses (a trait Dave and I had come to adore about Stephanie), she talked to us in the dinky backyard of the artsy-fartsy Malibu joint. It was private, peaceful setting, with an occasional cookie-cutter porn starlet sauntering past with looks of either drooling curiosity or snarling jealousy. I guess that's what they call "power of the press", hmm?

Do many fans react positively when you wear glasses in your films?
Um-hm. But recently I've had to buy a new pair of glasses because I was getting recognised too much from the ones I wear in the movies. Two days ago, however, they were broken; a girl sat on them and I was like, "Oh no!" (Laughs) But they were an old pair. I still need glasses to see. (Laughs) Most of the time I

Stephanie Swift in *Anal Anarchy*.
Courtesy: VCA Pictures

have my glasses on and I get really, really frustrated when someone just (snaps fingers) walks right by me. And then I take the glasses off a couple hours later — and I'm wearing the same makeup and *everything* — and the same person goes, "Wow, I didn't see *you* here before." And I'm just going, "You're an idiot. Get outta my face." But I do want to have laser surgery on my eyes so I can see again. It's frustrating wearing the glasses. I get headaches from them pinching my little temple right here.

What about contact lenses?
I don't like contacts. It's not easy if you have all this makeup on. I mean, even with these caterpillar eyelashes that I'm wearing today, they're heavy... a lot of pressure on the eyes.

Let's drift back a bit. What are your earliest pornographic memories?
I've been watching adult movies since I was probably 18. I watched them, looked at the girls, and said, "Pretty." Actually my first experience looking at another woman was when I was five and found a *Playboy* at my grandfather's house. After that, I knew where he kept them and would look at them. "Pretty." (Laughs) And I'd get up in front of the mirror and pretend I was one of the models... but I never masturbated. I wasn't really that sexual at the time. I was more into seeing and making everything pretty... real sassy, real prissy. But different from a conceited kind of prissy. Just very proper and formal. I suppose that's from my Louisiana background.

Born on the bayou, eh?
Um-hm. In Louisiana. I lived there for 10 years, in San Diego for 14 years, and now I've been up here (in Los Angeles) for two or three months. (Takes a mouthful of stuffed bell pepper.) This food is *really* good.

I've noticed many porn starlets don't like to perform after they eat.
Well, when you're working all day, you get really hungry, and that's around the time you want energy. But after you eat, the energy lasts about 20 minutes. Then you feel very heavy, like you want to sleep. And, of course, food is a natural sedative.

What about your childhood? Would you mind talking about that a bit?
Sure. That doesn't bother me. Basically in Louisiana, if you're a girl or a woman, you do what the man says. You're there and you're not to speak up or talk back. I went to fifth and ninth grades in California. And when I came back to Louisiana when I was like 14 to visit for a couple of months, I'd completely changed. I wasn't going to be told what to do by those men, those junior high kids. But, still, I think being in Louisiana for the first 10 years of my life was really good for me because I learned my manners. I also inherited a very strong family background from the South; everyone really cares about each other back there. As a child, I was raised in a very small city and... (smiling) I'm half Southern belle and half Californian girl.

And sex for the first time? When did that happen?
My first sexual experience was with a girl. She was my girlfriend when I was 12, up until I turned 18.

Long-term relationship.
Pretty much so, yeah. But in junior high I eventually got a boyfriend, so she kind of felt left out. But I've always been truly bi-sexual. I've always loved women. At one time I think I loved women more than men. And, as I've gotten older, because of the response I get from pleasing people in the business, I like men a lot more now. I've never had any complaints from them. (Laughs)

I believe it. But what about your pre-porn work? What sort of jobs did you hold?
I started working at 14 at a Mailboxes, Etc. type of place. We'd just pack things up or take a $1,500 cheque to the post office to get stuff for the meter. So I thought, "Wow! This is a *lot* of responsibility." I've always had a job since I was old enough to drive. But I believe sixteen is way too young for kids to drive. The proper state of mind just isn't there. Physically they can probably do it, but there are just too many psychological things going on... not enough experience in the world.

What happened after the mailbox job?
I did a lot of baby-sitting and really got into my studies because that was always important to me. I was wearing glasses in high school so I never went out, never did the things a typical teenager did. I was really into my books. I used to even read the dictionary for fun. Then during the last year of high school I worked at a bookstore. And after that job, I moved out on my own to San Diego and started dancing at The Body Shop three days a week. Great club. No table dancing, no lap dancing, and all that stuff. I don't believe in that; it's just not part of the dance industry. The theatre aspect, that's what I love. You get up on stage and take off *all* of your clothes, none of this pastie stuff. And that's how I put myself through college for two years.

Your résumé states that you studied English literature for two years. I take it that you enjoy the written word.
I love reading. I love the English language. I just love language period. I think it's very important. I also studied French as long as I've been in school.

Do you have any French in your bloodline?
Um-hm. I'm Irish, English, and French on my father's

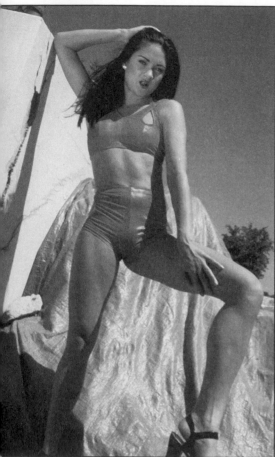

Stephanie Swift in *Delinquents On Butt Row*.
Courtesy: All Blew Shirts/Evil Angel

side, and Spanish, Filipino, and Norwegian on my mother's. Given that mixture, I can pass for anything. I'm playing Cleopatra today, so… (smiles)

You were also in the dental field. What prompted that career move?
It wasn't so much the money. I just love working with people, taking care of them. I did that from 18 until 21. Last year I just earned my RDA [Registered Dental Assistant] licence in the state of California. Then I got really busy in the film business, so I quit.

So what's the history behind the name 'Stephanie Swift'?
Well, there were two girls in high school who I thought were really pretty. One girl's first name was 'Stephanie', and the other girl's last name was 'Swift'. So I combined the two.

So where did you go after dancing at The Body Shop?

Well, when I started dancing at The Body Shop, a photographer came in and wanted to take my pictures. "I'll give you this much money," he said. And I said, "No, no, no. I don't want anybody to know what I do." Then, three months later, I'm like, "Okay!" (Laughs) I took someone with me to the shoot. He sat in the corner and read a book while I was modelling in the other room. Then I started doing more private photo shoots. After that I got into photo dating; that's where you're paid so much money to show up, take your clothes off, and let a group of people take pictures of you. I did that in San Diego, Irvine, and LA. I thought it was fun, and I got some really good pictures out of it. I still do it today, actually.

Was *Misty Rain's Anal Orgy* your first film?
That was the second. The very first was a CD ROM called *Space Sirens*. It was difficult because it took 13 hours just to do everything. The sex part, literally, for each position took maybe two minutes. But everything else — the dialogue, the simulation of the scene — took hours in order to look real. Then again, you really don't want to have sex for two or three hours at a time… it's physically almost impossible to do that every time you're in a movie.

Do you have a top-three list of your films?
Um-hm. Greg Dark's *Sex Freaks* is just… if you've seen it, you'll know it's absolutely amazing. Ultimate Video's *Palace of Pleasure* was really good. The things I've done this year are probably not going to be out until next year. But there's a Vivid movie I did called *6969 AD, Part 2* where I don't have any dialogue, but I play a cyborg and I have a fight sequence. I can't wait to see it. Right now I've done about 80 movies and… (laughs)… I just can't remember which are which. Many of them blur into one another. It's kind of fun that way, though. God, how many people are going be impressed with (exaggerated dummy voice) "I don't know." (Laughs)

Well, let's see if we can help you. What about a film like VCA's *Anal Anarchy*?
When we filmed that in Los Angeles, I was still living in San Diego and couldn't go home after my scene because I lived too far away. So I'd stick around sets until the end. And directors would just say, "Go ahead." (laughs) "You're in the scene." It was fun. I got to sing in that film, too. (Laughs) Mondo Tundra's very talented.

Why do you like *Palace of Pleasure* so much?
It was a full-scale movie done in Pasadena in this big, beautiful house. I was also one of the main characters in it, so I had a significant amount of dialogue. It was

just really neat because it was a period piece — a mixture of the Thirties and Forties.

You currently hold an orange belt in Wado Ryu, right?
Right.

When did the interest in martial arts begin?
I was in karate since I was twelve. Originally my younger brother wanted to study karate because he was watching all the ninja movies. So I had to take him to class, and finally one day I was like, "*I* wanna do it, too!" (Smiles) That was in San Diego.

Have you ever found it necessary to exercise your martial arts training in a real-life situation?
(Shakes head) I don't put myself in that type of situation. But when we spar during training we use absolutely no equipment. That's because when you're sparring in the ring, you're learning how to protect yourself. But if you're in a real-life situation, if you throw a punch on the street, you're not going to know the distance between you and your attacker if you're always wearing equipment when you practice.

Aside from porn, you've also done some work in the erotic thriller genre. Does that particular line intrigue you?
I do a lot of those films because they need realistic sensualism. There are actors and actresses out there that'll do those films and their scenes are empty. They don't have the passion, they don't have the fire that's needed to make the scene real. So with the sex films and the erotic thrillers, it's the best of both worlds. I love what I do and I'd like to be in this business for a while. I'm comfortable right now. The people who I work with, they all know who I am, they all take care of me. And a lot of the people in this business are starting to realise and listen to me when I say, "I can act. I *really* can act. Just give me the script three or four days beforehand and I'll have it (snaps fingers) like that. And we'll get it done."

What's the hardest part about doing a porn scene for Stephanie Swift?
If you can handle it, do it physically. For instance, I don't do anal. (Laughs)

Have you ever done anything for Private Video?
(Shakes head) They don't use condoms. I have three scenes out there where I didn't work with condoms, and there was a different reason for each one of those scenes. It's too personal. That's how I keep myself separate from the business. The sex I'm doing today is part of the business. It's set apart from my home life.

You've also done a lot of behind-the-scenes work. I remember you as an assistant on both *Sex Freaks* and Gregory Dark's Melvins video, but you were also a stylist and wardrobe person on *Flesh*.
I'm just the type of person who asks, "Is there anything that needs to be done? I'm not tired. Can I help?"

What about getting behind the camera and actually directing?
I will. I'd like to make different films... lots of realism... something unique. I'm going to begin my first film with the definition of pornography. To me, people take that for granted. "Oh porno this, porno that." But do they *know* what porno is? — not from what I've gathered.

What are your feelings about LA?
I like LA. It takes *forever* to get anywhere, but this (location) isn't that far from my house. I'll be home in 10, 15 minutes providing traffic is okay. But it's not that big of a deal. I don't go out at night that much, which is safe. (Smiles)

You seem very calm. Do you practice some form of yoga or is this just part of your natural personality?
I'm just real mellow. I like to save my energy for whenever I need it. If you've ever seen any of my scenes you know why.

I've found you very approachable on various porn sets.
Um-hm. You've probably seen me tired and hungry, too. When I'm hungry, I'm just wiped out, I have no energy whatsoever. And if I'm tired, I sleep. (Laughs)

Your sex scenes ring as truthful. So either you're really into your scenes or you're one helluvan actress.
I don't like faking scenes. And lately people have been asking me, "Do that come thing you do?" And at first I was like, "What are you *talking* about?" Then it dawned on me, "Oh, you really want me to come? Okay." See, the way I come is I have my legs closed, I play with my clit, and I come like a guy. My whole body just shakes and there's a lion's roar. A complete lion's roar. I did it in *Delinquent On Butt Row*. We did it in a house, located right over a racquetball court. I was hanging off the top of the court and my moans were just... *echoing* everywhere. That was pretty intense. And after I come like that, I almost fall asleep. It's like a guy coming. My orgasms are very violent. Even today after I had my orgasm, people around the set were saying, "Your head looked like it was going to explode." (Laughs)

Like *Scanners* or something?

Probably, yeah. (Laughs) Oh, and I also came in *Randy West's Up and Cummers 29*. Very rare. It's not the guy's fault that I can't come without playing with myself. I have to. That's just the way it is.

How did you discover this technique?
Well, I didn't masturbate until I was 19.

But what about the teen romance you had with your girlfriend when you were around 12?
Sex at that time was kissing, and playing, and boobs through shirts. But that was the sexiest stuff I can remember. I want to write a script around *that*, without getting into the fact that you're under age; probably about two college girls sneaking into the bathroom and kissing, being in the closet, stuff like that. I mean, I have notes, literally, from this girl which read, "I love you. I wish we could grow up so you could marry me and we could have babies." And in this fantasy of hers, I was the husband and she was the wife. I'm serious. This was intense.

Some people think porn is synonymous with evil. What's the 'Swiftean' definition of evil?
Evil? Evil is not such a bad thing. You need evil to have good. It's not a bad thing as long as you're not hurting anyone or doing anything you're not comfortable with. You have a choice between being evil or good. You can be both. Most people really don't have a problem with

Ad art for *Fresh Meat: The Series*.
Courtesy: John Leslie Productions/Evil Angel Video

porn, but they know people who do, so they won't associate themselves with the adult industry. I just saw this television talk show the other day where someone asked, "What do you think about pornography?" and "Do you believe in it?" And I was just thinking, "Do you even *know* the definition of pornography?" Any book, any form of music, any painting which depicts sexual intercourse or has sexual innuendo can really be considered pornographic. It's not just the triple-X movies. It can be the expression on a person's face. Pornography is not a negative word. It isn't. People say to me, "Oh, you're a porno star." "No," I tell them. "I'm an *adult film* star." But, still, pornography is a good thing.

What are your feelings on the word 'slut'?
It can refer to a guy or a girl. It's kind of a fun word. Playful. I don't take offence to it at all now that I've been in the business. But it's used differently in an atmosphere like high school. (Laughs) But being a slut is just a way of being creative and nasty, that's all.

And Nyrobi Knights? What's your opinion of her?
I enjoyed my scene with Nyrobi [in *Sex Freaks*]. I read a bunch of things about her, how she gets into her work, how she's very harsh. And she is. She's very harsh. She's a very strong-minded girl, and I can see how people would bump heads with her, 'cause she likes to get physical. But I get along with everybody. There's really nobody I don't get along with.

What about your family? Are they aware of your porn work?
Um-hm. And they know I'm going to take care of myself. They know I have a stable head on my shoulders. I've never had any problems with drinking, drugs, smoking, anything like that. I've never done any of that. Of course, they were completely shocked at first. When I danced at 19, an ex-boyfriend ratted on me; he told my mother, so I had to face that. And later I had to face the whole family, which took about a year to settle down. But I'm the same person. Actually, I feel much better about myself knowing I can do things other people don't. It raises my self-confidence level. Now I feel there's nothing out there I can't do.

But people have to remember the difference between having inhibitions and having limitations. I say I have no inhibitions, meaning 'I'll do anything that *I* want to do, not what you want to do.' In this business you never want to say you have no limitations because people are going to start trying to get you to have sex with an elephant. I know that's an exaggeration, but that's what it means: no limitations, you'll do anything.

Is there anything about this business which simply doesn't agree with you?
Well, if anything, it's usually with a production com-

Stephanie with clown (Tom Byron) in publicity shot from *Sex Freaks*.
Courtesy: Dark Works/Evil Angel

pany that's brand new, that's never shot adult before. They have no clue about the sensitivity needed for the actors and actresses. For instance, one time we were shooting in this tiny little apartment because I take it that (1) they didn't have a permit, and (2) they didn't want anyone going outside and drawing attention. And I just thought, "You people are absolutely ridiculous. We are professionals. You're not." I was also given the wrong directions to the shoot, so I got started off on the wrong foot, anyway. But I'm claustrophobic in some places. And in this small little room where we were shooting, there were about eight people, and I was hot, and I needed air, and I said, "I'm leaving." That's when this guy grabs me by the arm and says, "You're not going anywhere. If you didn't want to do this, then you shouldn't have accepted the job." And I'm like, "Get your hand off of me. I need air." And I wasn't leaving the shoot. I just needed to go outside and breathe. It was hot in there and I might have passed out. I guess I don't much care for folks who don't know how to deal with people period. They're insensitive. They're selfish. Now there's times when... for instance, Greg [Dark] shoots for a loooooong time... and, oh gosh, at around 5 am you get a different personality. But you *know* you're going to be there for a while. You *know* you have to rest up for it the night before. Just be prepared. And if you need a break, say, "Hey, I'm tired. I need a little break." Take five and start over.

I'm sure a lot of fans out there are grateful that you've kept your breasts 'unenhanced'.
People complain about boob jobs in this business. If you want it done to feel better about yourself, fine. Personally, I don't believe in it. I don't believe in putting unnatural things in your body. The only thing I've ever had done to myself surgically was on my feet, but that wasn't for aesthetic reasons, it was strictly physical. But I think plastic surgery has gone way out of line. People on the set today asked me, "Are your boobs real?" "Why?" I asked them. "Because they're... perfect little circles," they said. (Laughs) But you have to be real careful on sets because a *lot* of the girls have them, and you don't want to offend them because they're stuck with those breasts.

What was it like working with Max Hardcore in the *Cherry Popper* series?
You know, he... I'm friends with him, I'm nice with him, I'm polite with him, but I don't believe in everything he does. But I really can't judge him for that. I don't want to be the person to say, "You're bad. You shouldn't do that." It's just not my place. But if a person is there, and it happens to them, then that's a lesson they should learn from.

What do you do for fun?
Play with my bird. (Laughs) It's a cockatoo. I just got her. She's so funny. She says, "Hiiiiiiiiii!" (Laughs) She's in movies, actually. She's got two Vivid movies on her record now.

You've done a number of films for Vivid. How do you feel about working with them?
I love working with Vivid because they don't push your envelope of discomfort. If something is bothering you, you can feel comfortable enough to say, "I gotta stop. I don't like this." But on other sets for other companies, some folks are just like, "Oh God. Now she's got to stop. Now we have to wait. Now we have to start all over." But it's my body we're dealing with. And if I have to go to the bathroom, I'm going to stop and go to the bathroom. And then I'm going to clean up and go back to the scene, and it's going to take 10 or 15 minutes. That's life. (Laughs) A lot of production people don't really say, "Hurry up. Hurry up," but you can sense it. Especially with the ones I don't regularly work for. Maybe it's just me. Maybe it's just the fact that I don't know them. I try not to judge people and hope they don't judge me, because I'm very quiet. But people think because I'm quiet I'm unapproachable. Most of the time I'm sitting in the corner without my glasses and I can't see anything, so I'm just sitting there going, "I wish I could see. I wish I could see." (Laughs) One time on a set this girl came up to me and went (defensively) "What are you *looking* at?" And I just said, "Nothing. I can't see." (Laughs) ∎

Nici Sterling

Nice 'n' Sleazy

Nici Sterling is English. She's also a lady. And a well-educated, articulate one, at that. Nici is also a slut. Yep. You heard me right. A sa-*lutto*. Now wait a minute. Hold on. Stop screaming, "Bloody male chauvinist oinker!" just for one second, hmm? (Not that you wouldn't be absolutely *correct* in calling me that). For while I may be calling Nici a slut, she herself admits to it.

"I think most actresses doing porno *are* sluts," Nici candidly told photographer Dave Patrick and me during an exclusive interview at Sterling's LA ranch in late December 1996. "They have to be sluts," Nici continued, a whorish smirk sneaking about her sultry, California-tanned face. "I like being a slut. I love it. It's part of me. A slut is somebody who loves having sex; someone who isn't particularly choosy about whom they're having sex with. I mean, I'm somewhat choosy, but, still, I like having sex with *many* different guys and girls, doing it for the camera, being a total exhibitionist, and being totally nasty."

Thank you, Ms. Sterling. You restore our faith in that slowly-becoming-extinct species know as the hardcore, San Fernando Valley, no-nonsense, *total fucking slut.*

Of course, being British makes Nici's filmed decadence (anals, DP's, gang bangs, girl-girl orgies, fanboy fucks) all the more provocative — at least for us Yanks. That is, many Americanos have this notion that Brits are stuffed shirts. Consequently, it's an undisputed turn-on seeing British bunnies like Sarah-Jane Hamilton, Roxanne Hall, and Mrs. Sterling get stuffed far more literally than figuratively, totally obliterating all stereotypes of Victorian prudishness.

Nici, for one, has banged for such well-respecto's as Gregory Dark (*Flesh*), Patrick Collins (*Bottom Dweller 33 1/3*), Bruce Seven (*Beyond Reality*), John Leslie (*Voyeur 3* and *5*), Bionca (*Takin' It To the Limit*), and Paul Thomas (*Borderline*). Of course, if you're a Sterling aficionado, a lover of lurid sex, or simply a gang bang junkie, then you must see Nici in Anabolic's *Gang Bang Girl 15*, in which she ploughs through eight slobs on a haystack, and *Starbangers 8*, wherein her cunt and anus get conquered by *eighteen* swingin' dicks. Yowza! What a t-*ramp*!

Now Nici is making her own films with hubby Wilde Oscar — and her fans. That's right. She's spreading the word by spreading her legs. And what a spread!

And speaking of spreads…

At her lovely Southern Californian ranch, Nici was poised yet relaxed, decent yet down-to-earth during our interview. In fact, she looked better in person than on film (an outright rarity in an industry littered with automatons, mannequins, and marionettes). In a skintight latex mini skirt, Sterling was flaunting the dark skin of a beachcomber, the jumbo eyes of a comic-strip Catwoman, large ivory teeth forever smiling and good-natured, milk-chocolatey legs smooth enough to

see your reflection in, and to-die-for ass cheeks you could easily eat through an entire Charles Grodin monologue (and that's *quite* a mouthful, son). Such God-given sex appeal made it a downright treat to sit up close to Nici, drink coffee, and chat about her Hollywood adventures in ass slammings, double penetrations, and gang bangs — both on and off camera.

By the way, did you notice how I skipped all the tired British metaphors? You know, the flea-bitten language about cooze crumpets, steak-and-kidney-cunt pies, Yorkshire Pud-ings, and Keith Richards groupie machines. I avoided *all* those clichés. Not bad, eh?

Before you actually moved to America, Nici, what were your impressions of it?
Well, I'd already visited the US with my parents when I was 14. We went on a big tour of California, Nevada and some other states. And the impression it left me with was that America was filled with these hee-yuuuuge *fat* people who lived on fast food. (Laughs)

That's about the size of it. Yanks are proud of their double chins and pot bellies… just like The Sex Pistols.
(Laughs)

So when did you next visit America?
About five years ago, when [Wilde] Oscar and I were on our honeymoon. We drove from Newark, which was (smiles) disgusting… to Kentucky, which was lovely. Then we drove all the way down through Tennessee, stayed in New Orleans for a few days, drove to Texas, and ended up in Boulder, Colorado for three months because Oscar lived out there as a child. It's just a wonderful place to get away from it all. And because of

that trip, I acquired a very *different* view of America — especially Los Angeles and Las Vegas, which were all I'd originally really seen of America.

What did you think of LA and Vegas?
Like everything you've seen in the movies. You take it as it is, enjoy the good parts of it. I mean, Los Angeles is a *horrible* place — but there are good parts.

When you say 'horrible'…
(Laughs) It just is! It's big and dirty; just a sprawling mass of concrete.

Dangerous?
Yeah, but every big city's dangerous, not just LA. Before we actually moved out here, we were staying in Hollywood on Sunset Boulevard. (Smiles) It was January, it was raining, and my impression was "Uchhhh! This is a *horrible* place." And Hollywood really is *such* a dump. It's a shame, really.

Ad art for *Nici Sterling's American Fan Club Prowl.*
Courtesy: Video Team

Sarah-Jane Hamilton told me she found England a very depressing place as a youth. What were your impressions of England growing up there?
Well, I grew up in Africa, Belgium, and England. But I began living in England during my schooling years at the age of five. I went through private education… a good education. And my upbringing in England was great. I lived in the countryside, had horses, dogs, came from a big family, always went on holiday to nice places. And as a kid, I always wanted to travel places; England was just becoming too dismal. You'd look around at the people and they'd be walking along the streets with their eyes cast to the ground. Very unapproachable. The weather can be quite dull, too. But there are some very good parts of England. It depends on where you go, just like here. But England will always be home. I was born there, that's where my family is. Yet, stangely enough, I really don't miss it. (Laughs)

How much adult film work did you do in England?
A little bit. I did two-and-a-half years of magazine mod-

elling, and the usual strip-masturbation videos.

Which is pretty much all they allow over there, right?
Pretty much. You can do Electric Blue stuff, but you can't show somebody playing with a nipple for more than nine seconds. You can't show limp dicks, either. Oscar and I did a video for Electric Blue and (laughs) we couldn't do anything except rub up and down each other. But the films I did in England for Patrick [Collins] and John [Stagliano] were my first real hardcore movies.

How did you hook up with those guys?
Through a modelling friend of mine, who was also the editor of UK *Penthouse.* Her husband's Ben Dover.*

* Ben Dover was the drummer for the Bay City Rollers during their reunion in the Nineties. His association with

They put me in contact with John and Patrick because I was talking about doing a hardcore movie, but didn't know how to go about it, because you can't really do that sort of thing in England. I didn't want to go to Europe because I'd come across some bad directors and just felt like I was getting messed around. So I shot with Patrick and John. Then I shot a few movies in Sweden for a photographer whom I did a lot of work for. And after that, I came to CES in '95, met a lot of directors who said "I'd really like to shoot you," and it just left me with a very good impression of the industry. I thought it would be small and underground. I had no idea it was so huge and the people would be so nice.

And a few months later, Oscar and I came back to Los Angeles with the intention of staying two months because I really didn't know how I was going to feel about doing too many movies. And to date I've done about 150 movies — many of which were shot during my first year. So we obviously stayed much longer than two months. (Laughs) I really worked hard that first year. Now I've slowed down quite a bit. Over the last four months, for example, I've shot only six or seven scenes for my own productions.

Is that pretty much expected of actresses — to work incredibly hard their first year?
I was just in great demand. Everybody wanted to use me in their films. But I never double-booked myself. Still, I was working five, six days a week, and finally I said, "Right, I'm not going to work weekends. I'm just going to stay home on those days."

And do interviews, right?
(Laughs) Well, now I do work weekends. I work so little, why *not* work on a Saturday, as opposed to a Monday, Tuesday or Wednesday?

What do you believe are some of the drawbacks of this industry?
A couple of European films I did were bad news. Just sleazy. They take advantage of everybody. But I've been careful over here. I've been taken care of, and I think I have a good head on my shoulders.

The first time I met you was on the set of *Sex Freaks*. Rumour has it you'd walk off the set because you had an argument with Gregory Dark.
I didn't walk off the set... well... I did... but I came back. On a few occasions I just felt like I was being trod all over, treated like dirt. I just demand a little more respect. For *Sex Freaks*, I phoned Patti Rhodes

the group dates back to the late-Seventies, when he played drums for The Ian Mitchell Band, an outfit formed by several ex-members after the original Rollers split.

Cover to *Carnal Comics: Nici Sterling #1*.
Courtesy: Re-Visionary Press

before I got to the set to make sure my call time was 5 pm. "Yeah, come over at five o'clock," Patti said. And, since I don't like to hang around too much, I arrived at 5 pm. But we didn't even *start* the scene until 12 midnight. I know there's hanging around to do but, I mean, that was excessive.

Also, it was the first time I'd worked for Greg, and I'd just gotten over a cold or something, and wasn't really feeling too well. Then the scene started — and it was supposed to be an anal scene with Missy and Alex Sanders... a very Greg Dark sort of thing with dog leashes and old men and (sighs)... I wasn't really having very much fun, and Greg was shouting out orders and I really couldn't take anymore so (laughs) I just got up and walked off. I sulked for a while because I felt I'd been humiliated. But Greg and I made up, and after that shoot he used me in his next movie [*Flesh*] which was a *really* good scene. I was with four guys in that one. But on that first film, I was feeling off, he was cranky, everything was very late, and it was just a combination of things. There have been a couple of times where I've phoned in advance to make sure the call time is the same as originally discussed. And I've experienced hangin' around, and people lying to me, and then accusing me of demanding more money. And I have *never* demanded more money.

But waiting's all part of it. (Getting frustrated) It's all part of it and everyone knows it. You just have to hang around. But it's being lied to and treated badly

which I object to. And a couple of times I've walked off saying, "Stuff it. I don't want your money. I'm too pissed off to do the scene now. *You* suffer." (Laughs)

What kind of a girl was Nici Sterling growing up?

We moved around quite a lot when I was younger, so I went through various phases. Initially I was very studious. Then we moved when I was about 12, which was my first time in school without my older sister, who'd always looked after me. So I just started to rebel. Part of it was because I didn't want to move and leave my friends at that particular time. And, you know, I was reaching that age where kids want to be more independent. So I was a bit naughty for about three years, not getting good school reports, things like that.

What do you mean by 'naughty'?

Just being rude and obnoxious, a bit of a teenage punk, not getting the grades that I should have been getting — on purpose. But when I turned 14 I really knuckled down. I completely changed and became a swot.

A swot? Like a nerd or a bookworm?

Yeah. A bookworm. (Laughs) And I just studied and studied, and it paid off. I passed all my 'O' level exams. See, around the time I went to school, you'd study for two years then have one big exam. But for people who weren't very good in the examination room, it was a bad way of doing it. They've changed to a different system now, which I've heard is a bit easier.

When did your sexual 'awakening' occur?

When I was about 13 or 14. My parents lived on a British green. Very quaint. And I was beginning to fancy some of the local village boys and spending a lot of time on BMX bikes with them, riding along the village green. I had my first one when I was 14.

Your first BMX?

My first boy. (Laughs) It was at a party and it just… happened. Teenage lust. I didn't actually have a sexual relationship with a guy for a few years after that. Actually (smiles wolfishly) during that time I had a sexual relationship with a woman.

And how old were you when you met this woman?

I'd just turned 17. She was a policewoman, about four years older than me. Very butch-looking. We both kept our horses in the same stable, and spent a lot of time horse riding together. I knew she was bisexual. And one day she just came on to me, and instead of being completely insulted by it — as I thought I'd be — I was really flattered and turned on by it. It just seemed very natural. So we'd roll around in the hay (laughs) and had a very intense relationship for about six months. She helped me get through my major exam when I

was 17. She also taught me an awful lot about my sexuality — how to masturbate, how my body really feels when doing it to another woman, and having it done to me. It was a huge learning experience for me.

What eventually became of the relationship?

After spending a month studying in Spain (smiles) and playing around with guys, I broke it off. I came back and said, "You know, I really want a *dick*." (Laughs) "It's fun making love to a woman but… I like cocks." And she was absolutely *gutted* by my decision. She moved away. And being 17, 18, I couldn't quite comprehend the deepness of her love. I didn't realise how much that relationship meant to her. I was young, a bit naïve. Yeah, she actually moved away… took her horse away and left. But in all fairness, she hadn't been completely truthful with *me*, either. I thought she was mine… just like a girl-boy relationship where you go out with each other and there's nobody else. But she was bisexual and wanted a cock every now and then, too… which is what I wanted… and that's why I broke off the relationship. But oh *God* I went into a rage one

Nici Sterling and Wilde Oscar; ad art for Venom 5.
Courtesy: Vidco

time when I caught her with a guy in the house. I was just furious. It's kind of funny going through that with a woman. Now if I ever caught my *husband* with a woman I'd say, "Hey! Why didn't you invite *me*?" and jump right in. (Laughs)

You mentioned in one interview that swinging actually helped reinforce the trust in your marriage.

Yeah. Obviously in the beginning of our relationship we had a bit of jealousy because you have to get to know somebody before you experiment with your sexuality.

When did you actually start swinging?

We really weren't swingers. It had been seven or eight months into our relationship and we started talking about having a threesome, about inviting over another guy, somebody we knew. But that never seemed to work out because the guys were always too nervous. They thought, "Well, what's the catch here? Why are you asking me to fuck your girlfriend?" They'd sort of get weird. But we eventually did meet a really nice South African gentleman through a famous magazine. He was just like us — he didn't want to meet swingers because it just had a bad image to it. And we had nice, classy, intimate dinner parties at his mansion, and a lot of fun experimenting with other women, other men, and going places we hadn't been.

And as Oscar and I were building up trust, building up what fantasies we wanted to explore, we went into the pornography fantasies… fantasies of being porn stars in actual hardcore movies. We never really watched hardcore movies in England… you can't get them. The one that I did see, though, made me think, "You know, this is really *tacky*. They're all tacky." It was German, subtitled, dubbed, and… pathetic. Just bad quality.

Is there a mystique to porn stars in England?

You don't get to see that many. I think now the magazines are able to interview more porn stars and get reviews of videos, so people are learning more about porn stars over there. And I think the English think porn stars are… stars. (Laughs)

Where are most of your fans from?

I've got a huge fan following from England, but it's very difficult to keep up with them. A lot of them write to me, and I handle some correspondence through e-mail. In fact, an English fan flew out here to see me a couple weeks ago. He was planning a trip over to America and wanted to come see me in LA. But since I was working, I couldn't meet with him. I spoke with him on the phone, though.

What about *Nici Sterling's American Fan Club Prowl*? Was that your first directorial effort?

I didn't really direct it. It was my idea, yes, but I was more of a producer on it. Oscar did more of the directing because I was… performing. (Laughs) But, yeah, it was our first production. I'd been planning to do it for about a year. A lot of fans had written in saying, "I'd want to do this to you," or "I'd like to see you do this with so and so." And since the fans really wanted to be with me, I thought, "Well, why not make a movie out of it and actually *use* the fans, use their fantasies in a movie?" I had the idea about a year ago, but couldn't find a serious distributor. Then I came across Video Team and it's worked out quite well.

What does the Nici Sterling fan-fuck 'registration' process involve?

First they join the fan club. Then if they request an application form, we send it to them, they fill it out, and mail it back with a photograph of themselves. But it's not necessarily looks I'm after. Anybody can write in. People have to see that: *anybody* can fuck me, not just the good-looking people. But they also have to have a good idea in their fantasy. There should be some imagination in it; that's the deciding factor.

For the first fan club prowl, we used LA-based fans, and only allowed ourselves about three weeks to arrange it. It was tough. We shot it over two days — three scenes in a studio the first day, and three on location the following day. But in retrospect, I'm glad we did it in two days. I don't know how people can fit everything into one day. They start at 8 am and finish at 4 am. We started at 9 am with two cameramen, finished at 6 in the evening, and got about 9-and-a-half hours of footage, hard and soft. So we had tons of footage.

I'm curious, is Wilde Oscar an Oscar Wilde fan?

Yes. We're both Oscar Wilde fans. Not necessarily of his sexuality (laughs) but of his plays. I like "The Importance of Being Ernest". I had a non-entity part in that play when I was in school. There's also a book in England called *The Buccaneers* about English aristocrats marrying very wealthy New York socialites. It's full of wild affairs, fun, lies, abuse, and all sorts of crazy stuff. I'd love to do a porn version of that. We'd shoot it in England, but I'm afraid it'll be some time before we have the budget for that one.

How did you meet Oscar?

In a hotel. I was working there as a receptionist and hated it because I was trying to get into the airlines at the time. Anyhow, one day our eyes met across the lobby, and we kept phoning each other after that. His uncle worked at the hotel and was actually the matchmaker who got us together. Oscar even stood me up twice. (Laughs) But he was in another relationship at the time and wanted to finish that before we became involved. And we fell in love immediately and were engaged eight months later.

Is there a film about which you can sincerely say, "Man! I was a *total* fucking slut in that movie"?

I think the one where I'm really a great slut is *Starbangers 8*... .where I did 18 guys.

Dave Patrick: I think I like the one you did for Anabolic better.

Nici: Yeah. (Laughs) I like that one better, too. *Gang Bang Girl 15*. But, you know, when we shot that, we got into the scene, shot about 30 minutes of it, and then they realised there was no tape in one of the two cameras. I'd already *started* doing anals at that point in the film, and we had to start all over again. So what you see is actually the *second* gang bang of the day. (Laughs) But I loved it. I had a lot of fun. I'd like to do that again, I think. I certainly don't want to do an 18-guy gang bang again. That was the ultimate. That was great. I loved it. Unfortunately the finished product didn't come out as well as I'd expected. Something happened to the sound, so they put on this crummy soundtrack, and put it in slow motion. I was really into it, though. I was making sounds! (Laughs) I mean 18 guys... I was swearing, shouting, screaming. I was being nasty because somebody who's watching a gang bang loves to see the girl be nasty because it's a slutty thing to do. I'm a slut when I need to be a slut and a classy whore when I need to be a classy whore.

Did you experiment with DP's before getting regularly double-schtunked in porn?

(Laughs) Yes, but not until I came to America. I'd only ventured into anal before we moved out here. And before trying it, I thought, "No. I don't need to try that yet. I'm quite happy with the sex I'm having." Then I watched Danyel Cheeks take it in the ass while we were shooting *The Theory Of Relativity* for Patrick Collins in England, and I started thinking, "Maybe I *will* try it. She actually looks like she's enjoying it." So I tried it at home with Oscar and... um... didn't start doing it in movies immediately, but, I mean, I didn't 'save' it for anyone. I just started doing it because I wanted to do it. Now every scene I do is pretty much an 'A' scene.

Was your first DP awkward?

(Smirks) Well... the first time it *was* awkward because... well, the first two times it was with Oscar and somebody else... two different guys, both times. I won't say who because (laughs) let's just say they were both big names in porno. And one was (laughs) more 'successful' than the other. (Laughs) We tried it with both of them at their homes before trying it on video. But the first DP I did on video was for *Video Virgins 21*, for New Sensations. Then, of course, there was the Anabolic gang bang.

Patrick: We interviewed Patrick Collins about a year

ago, and he said he asked Oscar and you to come up with the most depraved scene you could think of. Did that ever happen?

Nici: It was for *Sodomania 15*, the one with the warning label on it. Oscar and I did a rape fantasy sequence. It was almost a bit too weird. I played Alex Dane's mother, and Mark Davis was my boyfriend, and I caught them playing, so I was teaching her what to do and things. Actually when I think about it, it was a fantastic scene. (Laughs)

What about your next fan-fuck film? Is that in the works?

Yes. Actually we're shooting it next week. It's called *Nici Sterling's Fan Club Prowl... Part Two*. (Laughs) I mean, I really don't want to start giving it names. I tend to think more along the line of boxcover themes. I'm probably going to do a European Fan Club some time next year. Right now the films are American-based. But if people are coming from too far away, obviously we have to pay their ticket in.

I suppose you're taking a risk with amateurs. I mean, some of them might be in terrific shape, and have very interesting fantasies, but be totally incapable of performing in front of the camera.

Yeah, but that's what makes it real. These are real people put under the same amount of stress as porn actors. And you know how everyone thinks: "I can do it. I can perform in front of anybody." And then you actually put them there in front of the camera and say, "Okay, *now* let's see what you can do?" (Laughs) And, in fact, most of them *can* do it because they're so horny. We haven't had too much of a failure rate so far, except for the two brothers in the last one. They lost it when they tried to do the DP, which is a shame because it was the first scene of the first day and it took about four hours to do. A lotta work. (Laughs)

Alicia Rio recently said in an interview that all the nerdy-looking guys she meets turn out to be the horniest, nastiest guys around.

Because they stay at home wanking all the time. (Laughs)

So you find it true, as well.

Yeah. And when I go and do promotions, a lot of the fans are the typical ones who watch a lot of porn and read a lot of magazines.

The porn trekkies?

(Laughs) But they're really the people I'm doing this for. And I'm glad I'm keeping them... occupied. (Laughs)

Any other projects in the works?

Actually, yes. I'm the new hostess of a Playboy television show called *Amateur Home Video*. It's similar to *America's Funniest Home Video*, but with adult videos. I've got a contract with them to do 10 shows starting in January. I'll be on the Playboy television about three times a week, every week, for about 10 months. Playboy is fairly enamoured with me and wants me to do more softcore versions of movies for their channels — like the ones I did for Wicked and Vivid.

Have you befriended any British porn stars while living here?

I'm friends with Roxanne Hall. In fact, she was a fluffer for my *Starbangers* gang bang. Roxanne actually got arrested in England for having public sex in England. It made all the tabloids. I've also become friends with Mark Davis. He's a nice guy. Mark spent most of his life in Canada and America, but was born in England.

Any other co-performer whom you've befriended?

I like Danyel Cheeks a lot, probably because she was the first American porn star I worked with. But she's left the business. I haven't really met any of the legends like Amber Lynn or Ginger Lynn. But I have done a lot of work for Elegant Angel, Evil Angel, Bruce Seven, John Leslie, and Rosebud.

What do you think of Bruce Seven?

Interesting guy. But I didn't really get on too well with what's-her-face.

Bionca?

Right. What's-her-face. (Laughs) I'm not really into the dominatrix scene. It's kind of hard for me. I tried it, did some stuff with Kim Wylde, which was a bit beyond me. It was fun trying it. This industry is great because you're able to go places in it. My suggestion is to try it, experiment with it, and decide whether you like it or not before saying, "Oh, I could never do that." Here you can actually *try* it and see if you like it.

Some magazine editors and writers have stated that Rocco Siffredi and Gregory Dark hate women. What's your take on that?

When I worked with Rocco he was an absolute gentleman. We had a fantastic scene with two German studs in John Leslie's *Voyeur 3*. And to this day, that's still one of my favourite scenes. Rocco was a complete gentleman. He was nasty, but just enough. He liked me... maybe because I was new and a little different. He'd also met Oscar, so maybe he thought, "I better be careful with this woman." But I've heard stories that he's punched out noses and smacked out teeth; but they were all accidents... his elbow got in the way or something. But as far as I'm concerned, he's a really nice... Italian... stud. (Laughs)

What about Dark? Do you think he's a misogynist?

Well, again, the first time I worked for him, we really clashed. But then we made up and now I like him. He's got some freaky ideas but that doesn't make him a bad person. He's just different. I think he does some wonderful stuff... There's a lot of male performers who people say hate women. I don't know if it's just because those particular male performers do so many films that it just becomes mechanical for them. But, generally, most of the guys I work with are nice. I respect them and love their work — just as I love my work.

Anything you'd care to add?

Yes. I just wanted to add my latest fantasy. I dreamt it last night. I want to fuck guys in Hyde Park in London, in the pouring rain, with the London Philharmonic Orchestra playing Mozart's Requiem in the background. (Laughs) But I think I'd be arrested just like Roxanne Hall was.

The sodomy laws are much more severe in England than in most parts of America, aren't they?

Oh yeah. Sodomy is completely illegal.* It's much easier to film public sex in other parts of Europe than England. They're much more open about it than the English. England really is still very much a little island cut off from the rest of Europe.

Last question: what's the sluttiest thing you've done off camera?

Before I even started doing movies, I did a mini gang bang with a group of British soldiers at my house in England. I was writing to them while they were stationed in Bosnia. I sent them magazines, photos, and stuff. And a *huge* number of them started writing back. It was great! Eventually some soldiers wrote back saying, "Look, we're coming back to England for a break. Can we come and screw you?" So five soldiers came out, I offered them pizza, beer, and... a good fuck. (Laughs) Yeah, that was fun. I was sort of keeping up the British end, I think. ∎

* Or rather it was. British law on this matter appears to have changed with the introduction of the Criminal Justice and Public Order Act 1994. The bill was drawn, essentially, as a means to criminalise music with repetitive beats but a little known clause also effectively decriminalised anal sex between male and female. The same rules now apply to heterosexual couples as to gay men, i.e., consenting adults only, not in the presence of a third party... As an aside, some adult magazines in Britain are now willing to accept stories with anal sex between men and women, whereas before it was strictly verboten.

Isis Nile

Down that road...

Isis Nile; videobox art for *Pussyman 6: House of Games.* Courtesy: Snatch Inc.

September 18, 1994; San Francisco; 1:30 pm

All in all, it was a sleepy, *boring* Sunday afternoon. Like every Sunday… Almost.

For the atmosphere wasn't *quite* as thick with banality at the New Century Theatre on Larkin Street — where porn starlet Isis Nile was dancing on this particular Sunday afternoon. It was Isis' first show of the day, her second tour of San Francisco, and her penultimate performance *forever* in our fair fucking city.

There are, of course, three traits which typically make a lady of X: technique, physique, and charisma. Isis had 'em all.

Her technique was, quite simply, accessibility. Unlike most headliners, Isis frequently ventured into the audience (front row, middle, and back), mingling with any patron who showed a glimmer of interest. And, whether she encountered you on stage, in a lobby, on the street, or in a bar, Isis was always very gregarious and down-to-earth. In other words, she wasn't a snob. The world was her oyster, and, to many an admirer (this author being no exception), her clam was the world.

As far as physique goes, Isis was blessed with drop-dead good looks. Indeed, an exquisite goddess capable of *resurrecting* the dead. Just one whiff of that ethereal, rose-scented, Egyptian-German pudenda would make a corpse's eyes flutter in anticipation. A mere glimpse of this 25-year-old's delicious olive skin — along with that wonderfully round, slappable ass; thick, wet lips, and huge, seemingly painted-on ruby eyes — would make any cadaver (with even *half* a stiffness in him) bubble his preservatives, the embalming fluid rushing to his prick so fast, the new-born love member would split a mummy's silver-plated sarcophagus smack in two.

And charisma? Isis *oozed* charisma. If you missed Isis' live performances, your best bet would be to catch Ed Powers' *Dirty Debutantes 28*, wherein the starlet's charm — and power — are magically captured. During her filmed interview in that feature, Isis (dressed semi-casually in charcoal blouse, polka-dotted skirt, and black heels) reclines on Powers' bed, parodies her 'Valley Girl' roots ("*Gag* me with a spoon!"), coos girlishly for expresso, and — white panties peeking out from beneath her skirt — talks with strangely attractive pretension about aiming to "stimulate an excellent response" from her lovers. What's more 'stimulating' about this clip is the way Isis turns the tables on Powers with her spell-like allure, ultimately making him the actual meat under inspection.

After Isis' clothes are shed — and a preoccupied Powers is humping away at her in the spoon position — she cleverly, seductively bombards him with questions.

"Do you like the way my pussy grabs at your cock?" she quietly asks him.

"Yeah," he hoarsely grunts between sweaty thrusts.

"You definitely like hot, wet pussy?" she continues.

"Yu-yeahhh…" his voice wavers.

"You like the way the muscles contract? — the way it chokes your cock?"

"Yu-yeahhh…"

"You like slamming your cock inside my pussy?… just nailing it"

"Yu-yaaahhhhhh!!"

Yep. Powers eventually goes mindless — at which point Isis shrewdly pops two of the best questions ever uttered in a *Debutantes* film.

"So do you like watching your own videos? Do you like remembering how other girls felt?" She punctures this sly interrogation by smiling at the camera with drowsy, horny, knowing eyes.

Like a retard losing his virginity, Powers loudly (embarrassingly) comes.

Isis Nile. *Oozing* with charisma.

And like the suddenly powerless Powers, she similarly had a handful of male patrons melting in their seats at the New Century Theatre that fateful Sunday afternoon.

After Isis' early afternoon show, I hit her dressing room. She was delighted. I wasn't too *un*delighted myself, seeing as she actually remembered my name. Then again, why not? Five months earlier I'd interviewed her in the very same room; the resulting article making the cover of the August '94 issue of *Hustler Erotic Video Guide*. Now Isis and I were happily basking in our recent success. In between a kiss or two (*very* happy basking), she insisted that I come to the 5:30 show later that afternoon.

"I'll try my best," I said, not really wanting to bum around the city for another three hours.

"Oh, no," Isis insisted, sensing my hesitation. "You *have* to come. You'll really love the show. It's going to be wild." How could I argue with an invitation like that?

We left the joint together, ultimately going our separate ways: I to a nearby Chinese restaurant to grab a bite to eat with a pal, Isis to the corner sports bar. From the information I gathered later that afternoon, Isis stayed at the bar for the entire three hours, during which time she played a few games of pool (with a number of pimply, frothing fan boys), and apparently drank a *truckload* of Yaegermeister.

Around 5:15 pm, I headed back to the Century to catch Isis' "wild" early evening show. As I entered the dance arena, the crowd (about 20 fellow pervs at best, not exactly what you'd call a sell-out) was in the midst of one giant fucking yawn. Banality had once again set in. But, considering the source of the boys' boredom — an average-looking, over-thirtyish blonde house girl named (how original) 'Angel' — they had good reason to feel groggy. Slowly, mercilessly killing the crowd with mediocrity, Angel (like most lousy dancers) was full of herself and hadn't a clue in the clue in the world that her act was just as stale as her name. This aura of triteness faded soon enough.

At 5:30 pm exactly, Isis, like a Siamese cat, crept into the unsuspecting audience, crawled onto the stage, and locked her jaw directly onto Angel's shaved pussy. The crowd was shocked. Angel was shocked. But not a soul shouted 'Fire!'

"Oh my goodness!" Angel seemed to silently squeal with widening eyes and gaping smile. "I can't bel-leeeve this is happening to me!" Isis sucked Angel's cunt like a sunstroked moggy lapping up a bowl of frosty milk. And Angel? Aside from getting the suck-off of her life, she received more tips that show than during her entire forgettable career (although she couldn't wait to bad-mouth Isis' "unprofessionalism" after the show… but we're getting to that…)

Once Isis had her fill of whisker biscuit, she was ready to play with the big boys. Angel quickly left the stage (not failing to scoop up her bounty of green backs), clearing a path for this unstoppable human fireball. Within seconds of Angel's hasty exodus, Isis ripped off her T-shirt. Her tennis shoes flew into the audience like twirling footballs, followed by a House of Pain baseball cap which whizzed over the patrons' head like a Frisbee. Then, once the faded, slightly shredded cut-offs dropped off, Isis presented us with nothing but delectable dark 'n' tender Egyptian-German flesh. And *plenty* to go 'round.

After a few proverbial spins on stage, Isis — totally nude at this point — crawled off the runway and began flirting with a handful of guys in the front row, eventually giving 'em free lap dances. Each and every lucky son of a bitch who took advantage of this priceless situation had licence to freely grab, rub, *shake* that big, fine, jiggly brown booty of hers.

But this heaven-sent freebie didn't last long.

"Isis," the house DJ (a greasy-haired hippie in his twenties) announced over the loud speaker. "You're gonna have to get back on stage.

Isis ignored him, continuing to 'toy' with the boys. And vice versa.

"Isis," the DJ repeated, "Please get back on stage."

She only smiled at him, shaking her head.

The DJ's requests became more threatening now. "You'll *have* to get back on stage, Isis."

Jokingly, she gave him the finger, then stuck the same digit in her quim.

"Bob?" the DJ heatedly broadcast to the manager. "You wanna help me *out* here?"

It wasn't long before 'Bob the manager' (who looked like a paler version of Gene Shallit, barber-shop-quartet moustache and all) coolly sauntered down to the stage, leaned over to Isis (while a fan was in the middle of inhaling her steamy dark asshole), and muttered something into her ear. Isis, however, was steadfast in her horny, 'hands-on' exhibitionism.

"No way, Bob," she flatly told him, licking her already-scented index finger. "No way."

[*Isis was acting a bit spacey around this point. Her quirkiness reflected in the way she kept babbling the same phrase ("I love you, San Francisco! I love you! Love you!") and continually missing — by a mile — high-fives she initiated with the audience. Actually, I found the whole thing rather endearing. Very real. Very unHollywood. And, of course, absolutely no provocation for what ultimately transpired.*]

At the snap of Bob's fingers, two humongous black security guards — neither seeming to possess a neck — emerged from behind the massive stage curtains, barrelled down stage, and, each grabbing her by an elbow, literally picked Isis up and hauled her pretty ass backstage. From that moment on, she was forever banned from the Century.

There are a number of reasons why Isis may have been kicked out of the New Century. According to Ar-

* Entertainment Regulations Permit & Licence Provisions.

Isis Nile in her dressing room at the New Century Theatre in San Francisco. She would be permanently expelled from the club during her next show. Photo: Anthony Petkovich

ticle 15.1*, Section 1060.9.1 of the San Francisco Police Code, 'entertainers whose breasts are exposed to view shall perform only upon a stage at least 18 inches above the immediate floor level and removed at least 6 feet from the nearest person'. Section 1060.9. of that same article states that 'no professional entertainer or employee may dance with any customer on the premises in any place of entertainment'. Ergo, by dancing in the nude, off stage, with audience members, Isis violated both sections of the city's police code. Yet while Article 15.1, section 1060.9.1, talks about exposed breasts on stage being a minimum of six feet away from an audience member, it doesn't mention exposed genitalia and/or buttocks. Being on the safe side, however, one can only assume that, yes, genitalia and buttocks do, in fact, fall under this section. Therefore, as a direct consequence of Isis' violations, the Century management may simply have feared losing its licence. (That same week, no more than a mile away, I had the pleasure of witnessing Cumisha Amado practice similar customer 'mingling' at Market Street Cinema; so why didn't the warning bells sound in that club?) Another reason for Isis' 'removal' (probably the most relevant) may have been plain ol' ego. The DJ, the manager, the owner… all such 'interested' parties basically didn't want a headline dancer making them look bad in front of the house girls. (And, of course, *nobody's* gonna flip off a house DJ — heaven forbid! — and get away with it.) There's also the financial angle to consider. From the owner's standpoint, since Isis was, for whatever reasons, drawing in a relatively small crowd, why *not* let her go? — especially if she might bring in more legal liability than cash profit. And finally, the entire conflagration may have involved a breach of contract; a written/signed agreement between Isis and the Century may have specified that Isis not perform while intoxicated, that she always remain on stage when partially or completely nude, that she im-

mediately ask, "How high?" when the DJ tells her to jump… etc… etc.

Nobody, I suppose, will ever know the actual reason for Isis' banishment from the Century. Nobody, that is, except Isis and the owners of the Century… both, conveniently, unavailable for comment at the time.

Isis pretty much disappeared after that show, being 'off limits' to anyone but house management. I, myself, never saw her again. Last I heard, she tied the knot somewhere in LA about two months after the fireworks in San Francisco.

So who exactly *was* this Isis Nile when she was at home, hmm? Let's turn back the clock.

Born October 5, 1969, Isis was raised a nice Catholic girl in Sherman Oaks, California. Her childhood was somewhat darkened by two attempted rapes in junior high (later in high school she was, in fact, raped).

After graduation, Isis (according to Isis) owned her own make-up company, while working for the 'owner' of Packard-Bell. A computer-literate, mathematical gal, Isis got used to hearing compliments such as, 'Wow, she's really intelligent and pretty, too!' Thank goodness she had the brains to enter porn.

Isis started fucking on film in July 1993, 24-years-young at the time. She peaked in porn around mid '94, did less work the following year, and had all but disappeared off the scene (off the globe, it seems) by mid '95.

The following interview was conducted in March '94 in Isis' dressing room at the New Century. It was during Isis' first tour of the city, five months before her ejection from the same club.

Best wishes, Isis — wherever you wound up…

What was it like growing up in Sherman Oaks?

I went to Catholic school and grew up in a very conservative environment where we couldn't even say a lie in the house. I was the girl who wore I. Magnin dresses in high school, whose first prom dress cost $1,000. But I've always been very head-strong. I knew what I wanted, and knew what I'd have to do to get it. But I never compromised myself, never basically fucked anyone to get ahead. And it was a shock to all of my friends and family when I went into adult films. They always thought I'd be famous and rich, but never thought I would do something quite as sexual. Actually, my family was far more accepting than my friends. But I've always been the one to come up with a plan and make it happen. Even if I get frustrated and have a setback, I'll still go after it. It's been a real transition for me, too — going from a very sexual six-and-a-half year relationship, to leaving it, and not knowing anything about sex.

You mean, you were so focused on that particular relationship that you lost touch with your own erotic

impulses?

I was so busy being trained how to feel, being trained about how I was supposed to be, that I never really *knew* who I was. I never really knew how I felt, what turned me on, what made me tick. My boyfriend wasn't dominant in the textbook sense of the word. It's just that I met him right after I turned eighteen; and I went from living with grandma, to living with a man 10 years older than me, three weeks after I met him. And we did everything from having *ménage à trois*, to having great sex all night. But it wasn't about me. It was about him — exploring his fantasies, exploring his sensations, or what he imagined his sensations would feel like... We broke up a year and a half ago. My mother always referred to it as Svengali and the Muse because I was the perfect muse. I was the perfect Catholic schoolgirl who lived with grandma all of her life, who could cook, who was very sweet, was very innocent. And then to live with this man who wasn't any of those things and who knew the game of control...

Newspaper ad for Isis Nile's final San Francisco performance at the New Century Theatre.

Did you find growing up in a Catholic school a very sexual experience or a sexually repressive one?

It wasn't that I was repressed. Two priests attempted to rape me on two separate occasions in elementary and high school. In Catholic school you don't have a junior high school. And in the eighth grade, in the confessional, a priest tried to rape me, so I grew up thinking men were vile creatures. I couldn't appreciate them because I thought they were all the same. And it took me leaving a relationship... it took me going through all the negative experiences to find my true fruition in life, my own sexuality. And I'm truly bi-sexual; I enjoy women as much as men. However, I don't look at whether someone is a man or a woman. I look at your essence, if you're intelligent, if you have something to give back to me besides how much money you have or other factors.

What was your first sexual experience?

It was a rape by my first boyfriend, whom I had thrown in jail. And if you ever saw the movie *Sleeping with the Enemy*, that's how my life's always been. Since I'm so domestic and giving by nature, because I work the way I do, and you know my potential before I know it, it's always become a dangerous obsession to become a possession, versus nurturing and loving and giving and taking. And that's how all my relationships have been up until now. That's also why I'm so hesitant about committal. I'm very gun-shy about it. I went out with one guy for six-and-a-half years. Then I went out with another guy for two-and-a-half years, and that was going back a year-and-a-half.

Do you want to talk about some of the new films you've been in? Any scenes which stand out?

I never watch my own movies. Each movie, each scene — live or on video or on film — is a first-time experience, even if I'm working with the same person. Because, once I've worked with you, I know the buttons I can push. Now I want to see how much *further* I can push you, how much hotter I can get you, how much more *involved* I can get you. And that applies to both the person participating and the audience. If it's with a partner I've already worked with, my approach is, "Okay, this is what I *know* you like, but what *else* can I do?" Peter North, for instance. I love fucking up his hair. I love licking him. I love teasing him. Marc Wallice, Randy West, Steve St. Croix, Tony Martino — I like working with them. And every time they work with me, they know, 'don't expect the same thing.' My blowjobs get better, my positions get better, my body gets harder.

And as a performer, you basically refuse to fall into a sexual rut.

Yeah, because if that's what it's all about... I mean, rent five of my videos and I'm sure you've seen enough of me. It's not about me, it's about how involved you are with me. That's why I was chosen to be the first interactive adult video on CD ROM, *The Dream Machine*. It's an interactive, two-girl CD ROM which got a lot of publicity on CNN, HBO, *Oprah*. At first they were going to put a blonde on the boxcover because everybody believes — especially distributors — that you have to have a blonde to sell the movie. That's not true anymore. People are tired of seeing the girl next door... like Savannah. It's so true. They wanna see someone whom they *can't* see next door but who is still as nice as the girl next door. And I think that's why I've done so well.

What about some of the directors you've worked with? Do any stand out from the others?

Oh yeah. John Leslie, Frank Marino, Bud Lee, Paul Thomas. Leslie is a perfectionist. But he makes movies 'cause he loves to fuck. Each one of them has a different signature. I mean, they all love to fuck, but they do it for different reasons. Paul Thomas does it almost vicariously. John Leslie does it to create a picture, a thought. He wants to leave more to your imagination, whereas Jay Shanahan wants to show it to you so you don't even have to think about it. Frank Marino, he likes seeing girls and guys have good sex, but he wants to offer you more. He wants to show what you can imagine and what you can't imagine. Stuart Canterbury... his days are very long, very gruelling. He's a perfectionist at heart, but you have to respect him for that. He tries to bring out of you what you might not be able to bring out of yourself. The guy, the director from Rosebud Video... can't think of his name (Rex Borsky)... they specialise in anal films... a guy who's out here in San Francisco... he'll push you 'til you cry. He's like, "What the *fuck* is that? That's not fucking. If that's the best you can do, go home!" And you're devastated. I mean, here you are, a porn star, and you think you're really trying to deliver the best you can. And you're mortified. But he's doing that because... you see, as a porn star, if you're really into it, if you're really trying to accomplish something, there's so much in you that you haven't even tapped into, so you automatically limit yourself. Whereas if you're lucky, you'll get a good director who'll say, "I *know* you have more. I know you're better than this. I know you can give more."

And those are the ones who give you constructive criticism. They don't just say, "What you're doing is crap," or "You don't know how to fuck."
I won't work for anyone like that. I don't need that. If someone's going to be non-constructive, then when I do a scene for them, I'm all pissed off about what they just told me. No one likes anyone yelling or screaming at them. I've been fortunate. I've never had a director yell at me. I've worked with Thomas Payne, John Leslie, and I just finished *The Bottom Dweller 2* for Patrick Collins. I've worked with the best directors in the business. And I've been very fortunate. I've seen them go off on other girls, but I can knock on wood and say, "I try and follow directions well, and I try and be the best person that I can."

I believe the only anal scene you've done was with Ed Powers.
Right. I don't do anal. I have one anal film, a collector's edition — *Dirty Debutantes 28*. Ed Powers has my very first scene and my very first anal scene. They're both on the same tape. And you see me go from natural breasts and short hair, to long hair and not-natural breasts. And I know I'm not into anal, gang bangs, or orgies.

Well I guess that rules out DP's.
DP's? Oh, God no.

There's too much going on in a scene like that?
It's not that. It's just... I can't tell you how many people would love to see me do anal over and over again. But it just can't happen. It's not so much the danger aspect, since you're working with people who are all AIDS-tested. I just can't do the pain.

Are your co-workers very paranoid about the AIDS issue?
Very. I mean, I've done movies where an entire crew, an entire cast of people has walked off the set because one person didn't have an AIDS test. It's our lives, you know. I enjoy what I do, but I'm not willing to die for it. It's a job. As soon as I go home from this San Francisco tour, I'm going to take an AIDS test. It's not because of this engagement. It's because my AIDS test is 13 days past due. But I haven't shot in 15 days. I've been dancing every single day, so I haven't had a chance to take it. But, still, people are very ignorant about the adult industry. They don't realise how often we're tested. They don't realise how cautious we really are. The most common thing we get is the yeast infection, and that's because we have to douche. After every scene we have to use the sponge, or Monostat 9, or the harsh vinegar and water which really strips the good bacteria. That's it. I mean, it's curable, and we do our Monostat 9, or whatever it is. But I'm the first girl in a long time that's done a sex show with a house girl. It's very rare. Most stars either travel with their own playmate or they're really involved with the costumes and the light and the dynamics. What they forget is that the guy in the audience could *give* a shit about the costumes. They could care less if the girl came out with Levis on. The guy comes to see the performer. They come to see how hot you are, how real you are, how approachable you are. That's why when I was in the lobby I said, "Hi, how are you doing? What's your name?" to you. Unfortunately in this industry, because we're so sought after, we really put ourselves on a higher pedestal then we're really at.

So obviously you want to be more in touch with the reality of the situation.
I want the fans, the house girls, the people to understand that I'm a real person. Whether I'm very sexual or whether I'm very nice, I'm a real person. I have mood swings, desires, anger, conflict, responsibility — all the things that everyone else has. And I have a job. It's a little different than the job they might have, but it's still just a job.

What about girl-girl scenes?
I like girl-girl because I'm truly bi-sexual. But I don't like the girls who are going to beat the shit out of me. I mean, I'm very aggressive in a sexual way, and, if

you've seen any of my shows, you'll see that live.

I recall you mentioning that same thought to one of your fans. You said you were a fairly dominant person on stage because it's all a matter of your career.

Right. But when I'm done with a show, I give all the girls my tips. I don't keep a single penny. I also give the girls more money if they haven't made enough money off tips. Like Shadey, the girl in the show you just saw me with. She made $35 off tips alone. And it's hers because this is a girl who wakes up, comes to work, and *hustles*. "Do you have a gift for me?" "Do you want some company?" I could never do that. I mean, I do lap dances once in a blue moon if I'm a house girl at some of the clubs. But other than that, I don't do them because if I were to give you all the goods now, what's left to your imagination? At first, I sunk a lot of money into my costumes. Now I've taken several steps back and put a lot of thought into imagery with no clothes, no shoes, no makeup. All of my shows now, all of them… I mean, I've taken my hair extensions out, cut my hair an inch and a half, and gone two shades darker than my normal hair colour. I've also taken my acrylic nails off and gone completely away from makeup. My show consists of no foundation. I just have a little blush, a little mascara and eyeliner because that's the person you see walking down the street.

Your name's somewhat mystical, though. With this more… realistic look, as you put it, are you sort of playing against that romanticised image reflected by your name?

If it takes clothes, makeup, acrylic nails, dildos… all that stuff to put on a good show live or on video or on film… if you can do it by being yourself, without all the dynamics, then that's hot. That's real. That's who *I* wanna fuck. I get tired of seeing girls and guys who put their makeup on with a paint roller. 'Cause I'm like: "Shit, if you look like that with makeup on, what the hell do you look like without it?"

I'm sure there have been times when, like any of us, you really didn't want to work.

Oh yeah. I'm in excruciating pain right now. I screwed up my knees in South Carolina… fucked up my back here. I can't sleep regularly, don't eat the way I normally do. But the show goes on.

How many more shows before you tend to your injuries?

I have 12 more shows, then I go to Las Vegas a half day later. I won't get a chance to get an X-ray until three weeks from now.

Taking a bit of a jump here, what are your feelings about censorship?

Rules were meant to be broken. Rules were made by those who can't handle the truth. Sexuality, bisexuality, drugs, I mean, I don't do any drugs. I don't smoke marijuana. I don't do *any* drugs at all. But what someone does as an adult with the knowledge of what they're doing is their own damn business. If someone does it out of ignorance or stupidity or coercion, that's a problem. And I think a lot of times rules are made to control the bad situation, but they effect the good *and* the bad. In some situations, you need censorship. In others, it destroys exactly what you're trying to achieve.

How does your husband or boyfriend feel about your career?

I'm totally single. You know, it's funny… when I meet a guy, I tell him exactly what I do, right up front. Recently I met a really nice guy and told him, "You know, I'm not as innocent or as controllable as I look." And he looked at me and said, "What do you mean?" And I go, "I'm an adult film star." That was the second sentence I said to him, because I won't go into a relationship with preconceived notions. Just because I can *fuck* like a maniac on film does not mean I'm not a complete nerd on a date. Because I am. I go out on a date, and I'm nervous, and I like the guy, and I can barely kiss him, let alone fuck. I'm more into trying to find my comfort zone. I mean, it's very hard to get close to me. It's very hard for me to develop feelings for a person because I've been down that road too many times. And I've been hurt by too many possessive people.

I take it you believe in open relationships, then?

At the moment. But if I was engaged or had a boyfriend, I wouldn't have a need for anyone else.

So you respect exclusivity in a relationship.

I *completely* respect monogamy. And I completely respect a fantasy. But when you turn a fantasy into reality for your own greed, for your own selfishness, I've no respect for you.

What if anything would make you want to leave the business?

When there's more egos than there is reality. I only do it for fun. And I really believe that to truly receive from someone, you must have already given. Whether it's some sort of gratification — financial, mental, spiritual, physical — you can't help but receive something back if you're *truly* giving. That's what I'm seeking. And the industry *has* changed. It really has lost a lot of its sparkle, a lot of its dynamics. But I'm not talking about finances or the quality of the pictures. I'm talking about the people in the industry.

The industry's become more commercial you feel?

It's become *very* commercial. I've never been one to go to a tourist location. I want to discover a place for myself. I want to make my own trends. I want to create the path that others enjoy; not necessarily the path they follow, but the one which they strictly use as guidelines for their own enjoyment. And if I can't do that, there's a *million* other things I can do. I don't need to do pornography. I'm only doing it because I enjoy it.

Do you read much?

I do an extensive amount of reading. Oddly enough, my favourite short stories are by Edgar Allen Poe. I really like the one where there's a carnival going on, and the two men go into a cellar full of wine. I can't recall the title...

"The Cask of Amontillado".

Right.

That was all about the sweetness of revenge.

Well, it was about revenge, but more importantly it was about the narrator, who represented the author's imagination. He was a man who wrote vicariously and, even though his own essence was not a positive one, his imagination was incredible. And no matter what anyone says about Attila the Hun, or Henry VIII, or Hitler, if you can look beyond their crimes and into their minds, it's mind-blowing. It's so impressive to uncover their thought processes, how meticulous they were. I'm not condoning what they did, and in a lot of ways I'm truly against what they did. But their individual thought processes are impressive. Hitler, for instance, fooled the public for so long. I mean, he was a German who was, in fact, a Jew. And, I don't know if you've ever read about Hitler...

Well, I read most of *Mein Kampf*. Didn't quite get through it all, though.

Originally he was a painter.

Right. In Austria.

He was a German-Jew painter.

From what I recall reading, he was raised Catholic.

No. He was all Jewish. If your mother's Jewish, you're Jewish. And he was spit upon by the Jews because he was German. And to read the different stories I've read about him, it's so ironic that as a Jew he could kill his own people. Today we see the black man, the gangster-hood shooting his own kind, killing kids. Understanding *why* this kind of activity happens is important because it allows you to move forward. If you can't explain *why* something happened, if all you care about is who did this, or who did that, you'll never correct the situation. And those are the people whom I like to read about the most... people who are truly trying to improve conditions. Even if the better is wrong, as in Hitler's case... he was trying to create one nation, one God, one liberty. His ultimate intention was to have unification. But everybody is focused on, "Well, he hated Jews, Egyptians, whomever," and they fail to see the thought process behind the man.

Have you done much writing yourself?

I'd like to eventually write my life story. Actually, I was offered to do it when I was 15 because I've been through a lot of hard knocks and survived them with a very good family. Not so much my mother and father, who were very abusive. I was really helped by my adopted parents — my grandmother, my surrogate mom, my aunt.

Making another jump here... how do you keep in shape?

(Smiles, embarrassed) If you've ever seen me, I'm not really in shape. (Laughs)

I think you're in terrific shape. What do you do? — run?

No. I dance. I go club dancing three or four times a week. I'm a hip-hop dancer. I also do jazz. This is actually the hardest type of dancing. You have pole work, floor work, sometimes you have fog on the stage... a lot more hazards. I mean, I worked with whipped cream last night on eight girls, and there was whipped cream *everywhere*. The hazards in strip dancing are far more dangerous than hip-hop.

I noticed you did your last show without any shoes on? Is that for safety reasons?

Yes. I'm the type of person who needs to be very grounded. I'm far stronger with my improvisation if I know exactly what I'm dealing with.

I think that's it. I don't know if you want to talk about any of your movies...

You know what, I don't talk about any of my movies, because I live them and...

Move on to the next one?

Move on to the next one. Right. But if you watch the progression of my films, each one has gotten that much better than the last. In an adult film magazine, Ed Powers just said how he did my very first scene. It was my *very first adult scene*. And I was so busy learning, that I forgot to enjoy myself. (Laughs) He was all freaked-out about it, too. But if you see my next scene with him seven or 10 videos later, you'll notice that I learned how to enjoy myself. I understood my tools, my assets. I'd done all my observations. You have to do it in that fashion: make an observation, a hypothesis, an experiment, then draw a conclusion. ∎

Dark World

An Interview With the Salvador Dali of Porn, Gregory Dark

Gregory Dark in late '96, on the set of
Alexis Goes To Hell. Photo: Dave Patrick

As much as Gregory Dark is surely sick of hearing (and reading) about it, *New Wave Hookers* — the 1984 porn sleeper featuring Ginger Lynn and Traci Lords — is undoubtedly his most famous work. "I watch it myself a lot to figure out why that is," laughed the tall, wiry, sunglassed Dark during a 1996 interview.

Yet since *New Wave Hookers'* debut in the mid-Eighties, Dark has refused to rest on his laurels. He's consistently triumphed in American porn with unique, innovative features which are not only wonderfully weird and satirical, but firmly grounded in the high-powered sleaze more directors in the genre should strive toward. Smatterings of Dark's bizarre tapestry *à la* LA decadence include duck men fucking the glitter off the evil Amazon women of Atlantis (*New Wave Hookers 2*), seal men having sex with fish-wagging sirens (*New Wave Hookers 4*), talking assholes (no, not Regis Philbin or Mike Wallace) trumpeting the joys of anal sex (*Between the Cheeks 3*) disembodied female lips undermining the dank fantasies of street loonies (*Sex Freaks*), spectre-like clowns mercilessly invading the psyche — and libidos — of comic strip assassins (*Flesh*), and porn starlets "confessing" their deepest, most twisted fears and fantasies during on-camera "interrogations" (*Snake Pit, Shocking Truth*).

Yet porn hasn't been the end-all for the eclectic Dark. He is, in fact, one of the few (if not the only) adult film directors to succeed in both underground and mainstream media zones. Over the past 10 years,

Dark has shot apocalyptic sci-fi features (*Dead Man Walking, Street Asylum*), at least 20 erotic thrillers (including *Secret Games, Animal Instincts, Sins of the Night*), and, more recently, music videos (the Melvins' "Bar-X-the Rocking M").

Born Gregory Alexander Hippolyte in Hollywood, Dark was raised in Beverly Hills. When Dark was only 10 years old, his father, an anthropologist intensely interested in the voodoo religion, mysteriously disappeared during a visit to Haiti. As a result, Dark has remained fascinated with voodoo all his life, despite his mother's early attempts to steer him away from the taboo religion (the director's voodoo imagery in such films as *Black Throat, Flesh, Sex Freaks*, and *Snake Pit* are testaments of his sincere attraction to the occult).

After high school, Dark's university studies took a shaky start. He enrolled in Mount St. Mary's as a freshman, yet was ousted after one semester for drug dealing, drunkenness, and trying to bed too many girls ("I guess I was a troubled youth"). Shortly thereafter, he relocated to northern California, where he received a BFA from the College of Arts and Crafts in Oakland, followed by an MFA from Stanford University. He then attended NYU's film school. After graduating from there, Dark began prolifically shooting documentaries for such sponsors as NBC News, Cambodian television, and even the UN before making his first feature film, *Hollywood Underground*, a documentary concerning the LA strip scene, circa 1980. Dark's "anti-porn" documentary *Fallen Angels* followed in 1983. *Angels* featured interviews with such starlets as Kristara Barrington and the

late Shauna Grant, as well as footage of Traci Lords from the original opening to *New Wave Hookers*.

During the filming of *Fallen Angels*, Dark met Walter Gernert (a porn distributor at the time, whom Dark interviewed in the actual film). The two quickly struck up a friendship, leading to a business partnership, and Dark's creation of the now legendary Dark Bros. While Gregory scripted, directed, and produced all Dark Bros' movies, Gernert (inheriting the pseudonym "Walter Dark") acted as executive producer. Adult magazines during the mid-Eighties flashed Dark Bros. advertising blitzes reading, "The Dark Bros. Present the Resurrection of Porn!", and "Rising from the ashes of the stagnant porn industry, the Dark Bros. breathe new life into the adult industry. Are you ready for the most extreme porn epics known to man?" The Darks portrayed themselves as garishly dressed white pimps sitting in extravagant wicker chairs, surrounded by stuffed iguanas and rubber snakes, while casually restraining sexy young black women by collar and chain. With VCA Pictures acting as their distributor, the Dark Bros. produced ground-breaking films which gave the flea-bitten porn circuit the facelift it so desperately needed during the mid-Eighties.

"I'll tell ya," recalled John Leslie during a 1995 interview, "when those Dark Bros. came along, they shook the whole business up. And, believe me, that gave everybody an opportunity to go another step. And I applaud them for that. I loved it... it was a whole different approach."

The Dark Bros. left no stone unturned — nor any worm, potato bug, and salamander which might be

lingering beneath those same stones, for that matter. Movies like *Let Me Tell Ya 'Bout White Chicks*, *Between the Cheeks*, and *The Devil In Miss Jones 3* and *4* highlighted such (then) only touched-upon subjects as interracial and anal sex. The films also uniquely incorporated satirical storylines with avant garde sets, contemporary music, and, of course, consistently dynamite-looking women.

Then in 1987, Gregory and Walter tried their hands at more mainstream films, ultimately producing *Dead Man Walking*. Gregory (directing under the name 'Gregory Brown') labelled the movie "sci-fi film noir." The well-received apocalyptic plague film was followed several years later by the more prophetic sci-fi entry *Street Asylum*, another morose futuristic action thriller, this time concerning police-state totalitarianism, mind control, and random violence.

By the late-Eighties, Walter Gernert decided to focus strictly on mainstream films, while Gregory continued making comedic, surrealistic porn under the Dark Bros. trademark. Yet while their porn partnership might have ended, Dark and Gernert began a new phase in their movie-making relationship.

In 1989 Dark and Gernert began filming erotic thrillers, a genre Dark (filming under the name "Gregory Hippolyte") passionately claims to have invented in America. "Zalman King's credited with it," Dark said during a 1996 *Psychotronic* interview, "but I did *Carnal Crimes* way before his stuff. I was developing it in '89 when there were no erotic thrillers in the US And my softcore films are really not so underground as people might think. I mean, Hollywood tries to rip me off in a wholesale fashion as often as they can."

Between 1989 and 1995, Dark bounced back and forth between surrealistic porn for VCA and erotic thrill-

Barbara Doll baits two seal men with fish in *New Wave Hookers 4*.
Courtesy: VCA Pictures

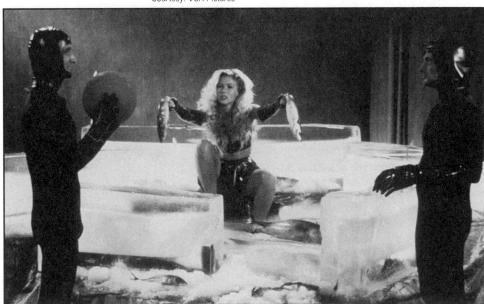

Ginger Lynn in ad art for the original
New Wave Hookers.
Courtesy: VCA Pictures

ers with Gernert. But in the summer of '95, he decided to break away from VCA ("due to creative differences"), and erected his own X-rated film company Dark Works, with internationally-renowned Evil Angel Video handling all distribution. From script content right down to ad artwork, Dark now had total control of his films.

But 1995 also marked a turning point in Dark's involvement with the erotic thriller genre. Fed up with his co-producers' stale, unprogressive approach to softcore films, Dark bowed out of his business partnership with Gernert, focusing his efforts on surrealist porn and music videos.

Accompanied by photographer Dave Patrick, I interviewed Dark in the summer of '96 at a near-empty, late-nite Van Nuys eatery. We discussed his new company at length, but I also managed to sneak in a few questions about his older films. Dark seemed astounded by the fact that Dave Patrick and I were staying at a local hotel. "Why are you guys staying here in Van Nuys?" he joked. "All you have in this city are a bunch of hookers cruising up and down the sidewalks."

Hey, Gregory, can you think of a _better_ place to interview Mr. New Wave Hooker himself?

When I spoke with Nina Hartley in 1991, I asked her if she'd ever do a Dark Bros.' movie. "The Dark Bros.," she said, "are into alienation, and I'm into de-alienation." How do you feel about that?
Well, I basically objectify the sex act a lot. And to me, sex is very peculiar to _watch_ objectively. Shooting sex films, inherently you watch these people fucking and it's really (smiles)… _strange_ if you think about it. If you take yourself out of yourself for a minute and for-

get about stuff like, "Oh, man, this is hot" or, "Oooh, I'd like to fuck that girl"… if you just step back to the side a bit and look at these people, then you're just going, "My _God_, that's a strange sort of event these people are doing." It's almost as if they can't help themselves. It's a very peculiar thing. So I say to myself, "Hmmm… let's explore what I see as a disenfranchised individual looking at these elements taking place in front of me… these human elements, these human characters participating in this sort of act. How do I react? How do I feel? What if other people felt that way?"

It's not that I'm trying to alienate men from women, or women from men. I just find the whole act of sex very peculiar… visually. Even the sounds that they make. And that's what I try to capitalise on — those moments of oddness. I mean, what if people didn't look really nice? What if the girl was really beautiful, but the guys fucking her were wearing _duck_ costumes? How would that be sexy? Or _would_ it be sexy? If you made it really nasty, would _that_ be sexy? Or would it be nasty and weird? I mean, what exactly would it imply? I'd really like to do nasty things with condoms that nobody's ever done before — like tie 'em onto people after you come in 'em, or tie 'em around girls' hair. If you have eight guys fucking a girl, for example, you could make her stick 'em all in her mouth, chew them up, and sort of… drain them. There's a lot of things you could do that are kind of disgusting.

How do you chose the leading ladies in your films? What are the criteria?

Magazine ad for the Dark Bros., circa 1986.
Courtesy: VCA Pictures

Shocking Truth 1 and *2* ad artwork.
Courtesy: Dark Works/Evil Angel

Pretty. (Laughs) They have to be pretty. That's it. Girls off the street tend to not look quite right. They're not attractive enough. Some amateur girls called me up once and said they wanted to do porno films. But they looked horrible. I didn't want to shoot them. Ultimately, people want to see really pretty women getting fucked. Not hard-looking, street-hookery women, you know?

So who are some of the nastiest women you've worked with?
That's a really interesting question because when I started making porno films, the girls were different than they are now.

In what sense?
They were more *into* having sex, getting fucked, and being exhibitionistic. Now the girls are into being prostitutes with the philosophy of how much money they can gouge you for, and being as bored as they can on the set, which I won't tolerate. But the girl that was the lead of *New Wave Hookers 3* was pretty good. What was her name…?

Crystal Wilder.
Yeah. She was pretty nasty. Who's this girl? (Points to a picture of Sondra Scream from *New Wave Hookers 2* in *Hustler Erotic Video Guide*)

Sondra Scream.
She was no good. (Laughs)

What about Chasey Lain? In *New Wave Hookers* 4 you really opened up a nasty side of her we'd never seen before.
I pushed the shit outta Chasey in that scene. What a fuckin' energy drain it was, too. It took me *hours* to shoot that scene, to get her to open up. She's a very nice girl, but she's very bottled-up. She's like a pretty stripper, right? So I told her, "Lookit, don't do the show 'cause it's going to be a long shoot. So be prepared — or don't do it. That's okay, too. Whatever you feel like." (Imitating Chasey Lain) "Oh no. I wanna do it," she told me. So it took me about three to four hours to shoot that scene with her. The first part when she was putting her makeup on was easy because, you know, she likes doing that. But her five-way with the three guys and VixXxen… she was very uncomfortable with that. She's not a girl that likes to get fucked in public. Very private. Nice girl, though.

And Vanessa Del Rio?
I liked working with her. Really easy to work with. I like working with Nicole Lace, too. She's a very nice girl; very accommodating in terms of getting the scene the way you want it.

When it first came out, *New Wave Hookers* became an instant classic.

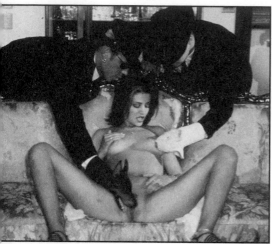

Selena with two 'men in black'; *Snake Pit.*
Courtesy: Dark Works/Evil Angel

What are your impressions of its phenomenal success?
Well, first off it had real music played by real bands that were good. It had Jack Baker and Jamie Gillis who, together, worked really well. I think the makeup was really unique at that time. And it had girls who *wanted to* get fucked... it appeared to me... in my naïvety, perhaps. I also think the sets were pretty good. My camerawork and editing were pretty good. I think I'm much slicker now, but it had a... *weird* kind of energy that I'd never seen before — and, quite frankly, have never seen since. It just seemed like the right moment in time when this girl or that girl came in; they were horny at that point in time, and never horny before that time. It was like a weird event. I mean, I shot some girls in *NWH* who were known as dead fucks. *Absolute* dead fucks. And they were fucking *hot* in this film — and dead fucks thereafter. For some reason, however, that day, they were horny.

But I also shot the film pretty much as a music video. We had these speakers out while shooting the sex scenes, and I cranked the music up on the girls to get live sound. So they were *inundated* with this music collectively. But in my opinion the general media of the film was a little outdated. I mean, the whole new wave music thing was at its conclusion in '84. Of course, the porn industry is incredibly backwards — with media, advertising, marketing. And when *NWH* came out, new wave music had already pretty much been replaced by alternative music.

How would you rate your various sequels to *New Wave Hookers***?**
I was happy with *NWH2*... really liked the girls in that one. The whole thing just came together very nicely... better than *NWH3* I thought. It was much better than *NWH1*. The girls in *NWH1* were interesting, though.

NWH4 came together pretty well, too, but I still think it's a click under *NWH2*.

What's your agenda with your new company Dark Works?
What I'm trying to do basically is explore new directions. How can you discover a new way of finding and exploring the dark side of sexuality? I mean, this is the kind of question that I keep posing myself. And I think that's what this company is about: trying to find those extremes. Of course, the films aren't always going to be completely erotic because you need to uncover stuff.

I'm also fooling around with the cross between reality and non-reality and how we see different things. There's a book called *Ways of Seeing* by John Berger, which was based on a BBC series a number of years ago. When I was in graduate school, that book always impressed me. It has a lot to do with visual erotic mnemonics and how we basically see images and how those images effect us erotically — or *not* erotically. It's a very fascinating book. There's also a book by Francis Yeats called *The Art of Memory*. She's a lecturer at Oxford on pre-Renaissance material who discovered a bunch of memory systems from the early Middle Ages onwards. And that stuff's always been interesting to me, too: how we see images, why we remember what we see, and how we translate them. There's also a writer named Georges Bataille whose work I like.

Right. *Story of the Eye.*
Yeah. The first surrealist novel. He also did commentary on Genet and de Sade... a lot of literary meanderings about their thoughts.

What about Dante? You were obviously more interested in his perspective of hell in *DMJ 3, 4,* **and** *5.*
Yeah. I wasn't really interested in the original *Devil In Miss Jones*. The concept's good, but it's not a very good film. I don't think Damiano's a real strong filmmaker. Basically, the concept is that there's no exit. It's the Sartre sort of thing, which is a very good idea. So I thought, "Let's do Dante's *Inferno* — the real thing." And that's what I sort of fooled with in *DMJ3* and *4*. *DMJ 5* dabbles more with the concept of the tarot card as a joke, the devil as a jokester manipulating reality through media images. Media images really interest me, and we worked that into the script. All that shit is scripted.

Okay, let's say you have a scene with bug men fucking women — does the script detail the fucking?
No. I just note it down and fool around with it. All the monologues are written out, though.

What's the most discouraging part about being a porn director?

Actually, *my* biggest problem today in porn are the girls. They're boring, most of them, sadly enough. They're different than they once were. Now there's this "hurry-up, hurry-up" bullshit where she's like looking at her watch, or nodding off, or thinking about doing her nails. Inherently, I think that's a big problem with the porno business. And I think that's a problem obviously with prostitution… some girls flipping 10, 15 tricks a day. At that point, they're clearly not very involved in sex. It's just a business. How many strippers do you know who really like men? I've dated three or four strippers over the years… I mean, I dated Heather Hart and she *hated* men at one point. It's simply because when these strippers are in contact with men, it's work — and the guys are disgusting. They see men at their worst. One of my former girlfriends was a dancer, and in the club where she worked, one guy went into the bathroom, shit into his handkerchief, went over to her, whipped it out, and said, "Do you mind if I eat my shit?" And she said, "No, I don't mind — if you pay me. Then you can eat your shit in front of me." I mean, these girls get to the point where they're quite disattached from men. And I *understand* that on some level, okay? See, it's all about commerce. And *that's* the problem.

And you're basically saying that attitude is prominent among the talent and the producers in this business?

I think so. My experience is that, unfortunately, a lot of people in this business have little, if any, integrity. The producers want to make shit, and the talent just want to make easy money. The girls typically say to themselves: "How else can I make $1,800 a day? Well, I can go and flat bag it… get my make-up done really nicely… get fed… all I have to do is fuck this one guy that doesn't look too bad… who I fucked already 20 or 30 or 50 or 300 times… so he's sort of like my boyfriend… *kind* of… but he's not really my boyfriend… he's just my friend who I fuck… he's my *fuck* buddy… and it's an easy pay day." And then it's *boring* — for all parties concerned.

That's another thing about your early films… refreshingly bold. Like Jack Baker's character 'Negro' in *DMJ 3*.

Yeah. (Laughs) Negro. Very racist. It was a stylised kind of comedy thing. I did the same thing with this rap music guy in a general-release movie of mine called *Animal Instincts 3*. His name is Stone Chill and he's just this mean gangster rapper who kills his manager while they're talking. The whole story is very strange. It's about this blind guy who's not really blind; he can see, but he's a voyeur. And he's convinced the world that he's blind. (Laughs) And there's this girl who's always doing odd things around him. And it's the same kind of parody on gangsters and racism that we did in films like *DMJ3*. 'Cause what happens is, it's okay if

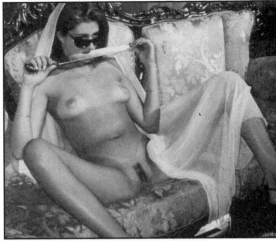

Selena reveals her *Snake Pit*.
Courtesy: Dark Works/Evil Angel

you're a *black* guy doing parodies on black gangster stuff.

Is there a mainstream film you've shot which you especially like?

I did a film a few years ago called *Street Asylum* with Wings Hauser and Gordon Liddy. That actually had a decent theatrical run. I liked the script. It was a weird film which I shot in an interesting style… sort of a precursor to Quentin Tarantino's stuff. I also did a film called *Object of Obsession* with Erica Anderson and Scott Valentine. It's a pretty good little film about a man that locks a woman away in his downtown loft, sort of as a prisoner. It's a like an updated version of *The Collector*. A pretty interesting movie.

You've also been doing a number of music videos lately. Do you think popular music is gravitating towards an underground medium like porn because rock has basically lost its edge?

Well, basically the people involved in porno are, all in all, very untalented and relatively stupid. Quite frankly, I don't think many of them *know* how to make films. Most of the directors aren't well schooled or well trained image-wise. Porno is simply another form of business to them. They're in this business just to make money. They're not making art films. I have a background in all kinds of stuff, and porno is a good place for me to experiment with art films… as long as I put the obligatory sex in them. That's why certain people gravitate towards my features. To a great degree, my audience is generally different than the normal porno-viewing audience. I mean, they wouldn't be interested in stupid, soap-opera stuff from Vivid or Wicked Pictures because that's not particularly interesting filmmaking

on *any* level. I mean, *no* ideas are involved. And I think that's why the Melvins picked me to direct their most recent video — they liked some of my bizarre ideas and know I know how to make films.

I noticed during the filming of the Melvins video that even you were disgusted by the worm sequence.

Yeah, well, this naked girl with real worms crawling all over her? I'm queasy with insects. Squirmy, wet, oozy things really bother me. I wouldn't let her wear panties, either. The prerequisite was, "If you're going to do this, you gotta be totally naked." I was very happy with her work, too. I mean, it's like the best piece of film I've made in eight years.

Any other music videos in the works?

Presently I'm doing a music video for Game Related, a black rap gangsta group from Vallejo [California]. Their new album's called *Soap Game*, and I came up with a bizarre concept for a video about a training school for pimps where the trainees get to watch the example of the 'bad' pimp [played by Antonio Fargas] on a TV screen, the pimp who gets his car stolen, who gets his money stolen by girls. BMG from New York called me and asked me if I wanted to do the project and I told them, unless I can do a concept that's going to get me other work, I don't really want to do it for some nameless rap band they're putting together for whatever reasons. So they sent me the music. And it's pretty good. I mean, if you're going make a music video, you really have to *like* the music. And I thought to myself, "If I can do a concept that's not just going to be a bunch of gangsters driving in cars with blonde bimbos hanging out with them…" I mean, that just doesn't interest me in the least. Day-to-day life is basically like that.

For *Snake Pit*, you contacted a psychologist to come up with a lengthy list of questions to ask the starlets in your film. Would you mind explaining that process a bit?

Yeah. I contacted a psychologist, got a number of types of questions, and, more or less, approached the interviews in the same way that an interrogation works.

I'm sure when people hear or read that word "interrogation", they immediately think "police-state interrogation."

Exactly. Exactly. That's what they're generally used for. When the cops interrogate you, they're trying to elicit a confession, trying to find out information which you're not easily going to give up. In other words, they're trying to break you down. And those are the kinds of questions I set up with this psychologist. If a girl started to cry, that's good — I wanted to find out what makes her tick. Because, see, I don't care about, "Well, gee, do you like sex?" or "Do you think you're really sexy?"

Dark and the Melvins on the set of
Bar-X-the Rocking M.
Photo: Anthony Petkovich

or "Show me your pussy." I don't *give* a shit about that. They'll do that sort of thing in a heartbeat. Instead, I'd ask questions like, "What is evil?" Then, nine questions later, "What is evil?" again, to get a slightly different response. And nine questions after that, "What is evil?" In other words, equating evil with evil.

The most important aspect is breaking them down and then, in a sense, allowing them to display their true ways, because you've given them licence *not* to conform to societal or even "porn-family" demands. You've given them license to admit to themselves that they're basically evil… evil whores. And once they agree to that fact — that they're useful only for the purpose of *dick* fodder, so to speak — then they're able to fully unveil their sexuality, their trampiness, their sluttiness. It's never been done in pornography because it's really not equated with sensuality or eroticism. In a lot of ways, it's the antithesis of eroticism.

You used the same interrogative procedure in *Shocking Truth*. Since you'd already experimented with it in *Snake Pit*, did the process go more smoothly this time around?

Well, out of seven or eight people, what you typically have is one or two that are *good* participants. But most of them aren't. They generally either try giving you stock answers or try being evasive. But what you *do* get to see is the discomfort of these people in their skins, which is really what fascinates me. I asked Spice — the first girl in *Shocking Truth* — questions about her stepfather, and some stuff about her mother. And at one point she got really upset and started crying. And when I asked the other girls certain questions, they just didn't know what to do, or how to answer. They're sort of on the spot, right? Which is kind of funny.

But the more I think about it, the more I believe this sort of pornography is almost too intellectual or too entertaining for the porno market — which also makes it sort of defeating to those same people. I mean, if they want entertainment, they're going to go elsewhere.

Well, have you received a lot of negative reaction about these films?

No. It's just a hypothesis I've been conjuring. But I've been thinking about it a lot, and I have a strong feeling I'm probably correct. It hasn't particularly been reflected in my numbers yet. But, let's face it, when people rent porno they want to jerk off, right? Now all of a sudden I'm dealing with a lot of issues, a lot of questions, a lot of commentaries on what we see as sexual, and what

Dark and Star Chandler are the Devil and the Devil's helper, respectively, in *Shocking Truth*. Courtesy: Dark Works/Evil Angel

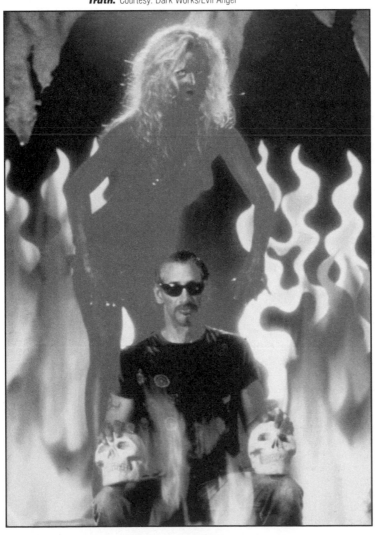

we *don't* see as sexual, and how the starlets relate to what we consider standard morality. And I think this format makes some viewers uncomfortable because then *they* begin to feel the same sort of questions that are levelled at the talent. When viewers are exposed to questions like "What is sin?" or "Where will you go when you die?", they begin to have thoughts themselves about these things.

Do you consider your erotic thrillers attractive in the sense that they're more mainstream?

No. Actually, I like doing stuff like *Snake Pit* more. (Laughs) And I also like doing stuff in music video — like with the Melvins — more than those erotic thrillers. I mean, that shit is just like network TV. Some of it's the worst, most unimaginative stuff you could come up with. Besides, I won't do another softcore movie unless I'm allowed to do what I want to do. I've done, I don't know... *twenty* of 'em. And I've told my co-producers, "Yeah, I'll do another one — if you do *my* script the way *I* wanna shoot it. I'm not going to make a remake of a movie I've already done." A lot of people want a remake of the original *Animal Instincts* or *Mirror Images*, but, I mean, I've done it... *twice*, and I'm not going to do it again. It's just endlessly tiring. Besides, I'm really not much interested in making softcore films anymore. I'm more interested in the underbelly of the human mind.

Getting back to *Shocking Truth*, is there any scene in particular which stands out for you?

Chloe getting fucked in the ass by five guys. Her interview was so strange because she's so self-abusive — and she portrayed that self-abusive nature in this sex scene. I mean, she

just got fucked insanely. It's different than the Lovette anal gang-bang in *Sex Freaks* because Chloe's scene was really sort of unpleasant. Her interview's really strange, too. Actually, her gang bang combined with the interview is about 35 minutes. I filmed her scene in this weird bedroom with skulls and voodoo shit all around. Most of sets in *Shocking Truth* are gothic-looking, with Chloe as this sort of "goth girl".

Shocking Truth is definitely much more extreme than *Snake Pit*. I used a lot of footage in it which I'd previously shot in the Melvins video; stuff like six second cuts of these dirty pigs dancing... that kind of footage. And when I asked a question, I'd use a piece of some sort of mnemonic or memory image to colour the audience's view of the question. or the answer, which is really very strange because it changes the whole tone of the movie.

In the *Shocking Truth* films you make appearances for the first time. Why the cameos all of a sudden?
I guess you'd call them bizarre cameo appearances. (Laughs) I don't know... I just decided I was the best person to do it since I asked the questions in the movies. I also asked the questions in *Snake Pit*... I just didn't leave my voice in the film.

You're also back to animals in *Shocking Truth* 1 and 2.
Yeah. (Laughs) In *Shocking Truth 2* I shot this one great scene where Missy is lying by a beautiful pool, and these men with dog masks are watching her, and they come up to her and start sniffing her. The dog masks have these tongues leering out, and the guys start licking her with the tongues while she's asleep. It's this fantasy of a sleeping woman whom you sort of... play with. And I got Missy so bizarrely fucked for so long that she goes crazy. She just flips out, and starts screaming and growling. And looking into her eyes, you can *see* that she's completely fucking gone. One of the girls in the film actually passed out. Mila... that's her name. I pulled a 'train' on her. Yeah, six guys were fucking her in the ass, one after another, and at one point she tried to stand up and just... stumbled. (Laughs) And then she totally conked out. I left all that footage in, too! Then after each sex scene, I start asking these girls questions with *spunk* all over their faces.

Were they more uncomfortable with spunk all over their faces?
No. They're just like out of it. And you can see the difference in their personality through these transformations. It's so funny. So funny. There's also a French *Penthouse* model in the film who's beautiful... *beautiful*. Her name's Daliah and she gets fucked in the ass by two different guys. It's a medium hot scene, but the domination part in the beginning with Star Chandler*

* Dark married Star Chandler in February 1997.

is really good.

Last question: what's the definition of evil to Gregory Dark?
Personally, I have no specific definition of evil. I suppose the closest I can come to defining it is dishonesty. ∎

GREGORY DARK / HIPPOLYTE / BROWN FILMOGRAPHY

Hollywood Underground (1980)
Fallen Angels (1983)
Let Me Tell Ya 'Bout White Chicks (1984)
Let Me Tell Ya 'Bout Black Chicks (1984)
New Wave Hookers (1985)
Between the Cheeks (1985)
Black Throat (1985)
White Bun Busters (1986)
Devil In Miss Jones 3 & 4 (1986)
Deep Inside Vanessa Del Rio (1986)
Dead Man Walking (1986)
Street Asylum (1988)
Between the Cheeks 2 (1990)
New Wave Hookers 2 (1990)
Carnal Crimes (1991)
Secret Games (1991)
Mirror Images (1991)
Deep Inside Centerfold Girls (1991)
Night Rhythms (1992)
Animal Instincts (1992)
Sins of the Night (1992)
The Creasemaster (1993)
The Creasemaster's Wife (1993)
New Wave Hookers 3 (1993)
Between the Cheeks 3 (1993)
Body of Influence (1993)
Mirror Images 2 (1993)
Secret Games 2 (1993)
Sexual Malice (Exec. Prod.) (1993)
Animal Instincts 2 (1994)
Stranger By Night (1994)
Secret Games 3 (1994)
Hootermania (1994)
New Wave Hookers 4 (1994)
Devil in Miss Jones 5 (1995)
Animal Instincts 3 (1995)
Undercover (1995)
Object of Obsession (1995)
Sex Freaks (1996)
Flesh (1996)
Snake Pit (1996)
"Bar-X-the Rocking M", music video for The Melvins (1996)
Shocking Truth (1996)
Shocking Truth 2 (1996)
Music video for Game Related (1996)
Living on the Edge (1997)

Christi Lake

The mind is a terrible thing to waste

Like Quentin Tarantino, Christi Lake got her start in a tiny video store before breaking into 'acting'. Similarly, Christi eventually graduated to a behind-the-scenes career. Of course, we're not talking mainstream mumbo jumbo here. We're talking slits, clits, butts, sluts, sleaze 'n' cheese. Christi, however, isn't *exactly* what you'd call a director — yet. But she did erect her own film company (Dripping Wet Pix) and was closely involved in the development stages of all its productions. At the time of this writing, Dripping Wet Pix had just spawned *Southern Comfort 1* and *2* (a Bud Lee take-off on *Cat On a Hot Tin Roof*), *Christi Lake's Anal Gang Bang* (in which Lady Lake is fucked in the ass, nine separate times, in one day… ooooch!), and *Directors' Wet Dreams* (a never-before-realised porno including the personal fantasies of directors Jim Holliday, Henri Pachard, Nic Cramer, Bud Lee, and Michael Zen). So as you can see, Christi was a very *busy* little beaver in the mid-Nineties (and just for the record, a whole lot better looking than Tarantino, too… sorry, Quent).

Yet despite Christi's involvement in the production end of 'hump,' she loved performing for the camera. Actually, she got a bit cranky when not cranking cock in front of the lens. Case in point: on the North Hollywood set of Carl Danser's *A Shot In the Pink 2*, during a lengthy lag in time (and slime), Christi could hold back no longer. "We don't get paid to fuck," she grumbled in my ear. "We get paid to *wait.*" Ah-ha. A cue for an interview if ever I heard one. And Christi was ready to spill the beans. Consequently — wearing nothing but a silk kimono and cowboy boots — the lean, mean, highly obscene sex machine from Minnesota took me aside to give me some lip.

Was the video store your first job?
Yes. I was 18 when I started. That's also when I started watching adult videos. I'd take porn films home with me, watch 'em, and sort of critique 'em for the customers. It was a regular video store that carried everything from kiddie movies to adult videos. So, when interested people would come in, and I was the only one working, and the customers had their courage up, they'd point to the top shelf where we kept the pornos and ask, "Are any of those any good?" And I'd say, "Well, it depends on what you're looking for."

What were some videos you picked?
The Devil In Miss Jones 2 was one. Hilarious film. The creativity in it was just fabulous. Even the costumes were wacky.

And this was around…?
1983.

Sounds like quite a boner inducer: an attractive 18-year-old girl helping you pick out nasty videos.
It brought a smile to some customers' faces.

What about chewing cunt? Does that bring a smile to your face?
I've always had a curiosity about girls but never had an opportunity to be with them. Boyfriends would some-

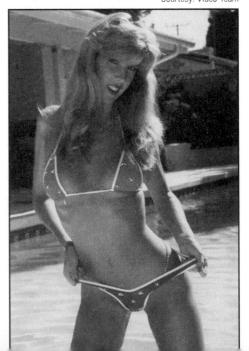

Christi Lake; *Girls Of Summer.*
Courtesy: Video Team

times say, "Wow, wouldn't it be cool to have another girl with us?" But when you'd get right down to it, they'd chicken out. Sometime down the road, however, I met up with [porn starlet] Sheena, who's also a native of Minnesota, and we dabbled with it. Now I've made a very special bond with her — along with a couple other female 'friends'. And when I came out to California, I really wanted to see how much I could do with the girl-girl thing. Originally, I was fairly selective about boy-girl. But now it's expanded from two or three different guys to about 10. And basically I've gone from doing mostly girl-girl to mostly boy-girl.

Any bad sexual experiences as a youth?

There was *one* incident as a child that kind of bothered me. Strangely enough it was with a girl. I was about 11 years old and this 16-year-old girl got me drunk, and I wound up licking her pussy in a tent. I just freaked out. I left the tent and slept in the barn with the horses that night.

How old were when you gave it up to a guy?

I was probably around 14… awkward but good, with an older gentleman in the back seat of a car.

How much older was he?

I think he was 18.

An old fart, huh?

Well, an older kid than me at the time. It started out with heavy petting, stuff like that. We were supposed to be someplace else… obviously we weren't. And, of course, we wound up staying out all night long. I really got chewed out for that one.

In more ways than one apparently.

Well, when my parents finally found us, we told them we were sitting on the car, just talking. And we *were* initially. We were just having a romantic time… you know, talking about everything in life. Then all of a sudden we started kissing, playing, petting, one thing led to another, and we wound up with our clothes off. Of course, when you're 14 or 15, you don't exactly think about birth control. Thank God nothing happened. Shortly thereafter, however, my parents put me on the pill. Very smart of them.

Generally speaking, what kind of a teenager were you?

I guess you'd call me a tomboy because I hung around with the guys. But I had an older brother who wouldn't let me date any of 'em for the life of him. But I always managed to find other boys to date… guys who were outside the pack. Ever since I was a teenager I've liked older men, too. When I was about 17, I… how can I say this?… um… I kind of 'played around' with a 23-year-old guy. The kids in my high school had no idea

Finger-lickin' good. Christi Lake in *Southern Comfort*. Courtesy: Dripping Wet Pix

what I was doing at the time because I dressed very conservatively. But underneath all those big T-shirts and jeans was a girl *dying* to get out of 'em.

What happened after the video store?

I worked in a Minnesota hearing aid factory. Worked there for eight years and quit on my eighth anniversary.

Why?

I was working with just too many chemicals.

What exactly were you doing?

Manufacturing the acrylic for the hearing aids, mixing it up, breathing the stuff in. A couple of employees got cancer within a period of two years, so I just said, "This is crazy," and quit. During that period, though, I did some amateur contests. "This is my chance," I thought, because I was free to do what I wanted, wasn't attached to anyone *per se*. And I had the ability to make my own decisions, do what was best for me. It was fun. I was also the only female in a department of ten guys. So I invited them to my first amateur contest — which was topless, of course. I sure heard about it the next day at work, though. The management kind of looked down on me for doing that sort of thing. Around that time I was also swinging, which eventually led to porn.

Whoa. Could you be a bit more

specific about your entrance into porn?

Sure. I danced in various clubs in Minneapolis, then did some modelling for *Leg Action* and other magazines. The swinging actually opened up my ability to fuck in front of others. But I also have to give Sheena a lot of credit. Around that time Sheena had already done some porn, and she told me these great stories about all the wonderful people she was having fun with in California. So I decided, "Hey, all that fucking and getting *money* for it? Good deal."

Then you made the plunge.

Yep.

Have you noticed a difference between the lifestyles in California and Minnesota?

Oh yes. Very evident. As big as the adult film business is in California, it's also very small. Word gets around quickly. In Minneapolis, people are friendly, they make their own judgements. It's like, "Do the job. If it doesn't work out, oh well. If it *does* work out, great." But out here in California you have to prove yourself constantly. It takes much more to impress people out here. I do have to say, though, that Midwestern folks are definitely more sexually repressed. Guys, for instance, are easily intimidated. Like if a guy compliments another dude's girlfriend, the boyfriend thinks he's gotta beat the guy up because he's a threat. In high school most of my boyfriends were very restrictive about how I even

Hank bangs Chanone as Christi excitedly awaits her turn in *Southern Comfort*.
Courtesy: Dripping Wet Pix

dressed. I mean, sometimes I'd wear a short skirt at night, and they'd get all jealous because people were looking at me. Ridiculous.

Let's talk about your new film *Directors' Wet Dreams*. Aside from five different directors working on it, what makes it so unique?

Well, normally a producer tells a director, "Here's a script… film it for me," which leaves very little to the director's imagination. Producers also typically say, "I want this person or that person to star in the movie," which limits the director talent-wise. So, what I've done is approach five different directors and have *them* create the fantasy they've always wanted to film. They don't have to include me in their budget, either. They can hire a girl with one guy, a girl with five guys, three girls with two guys, whatever the scene takes. The location, the design, how they want to shoot the scene, it's all up to the director. It's really just a matter of understanding that directing, by nature, is very creative. So our approach was no holds barred. We're actually thinking about doing a series in this vein. But for the first installment, we want well-known directors. Then, if all goes well, the follow-up picture will probably have one new director among a group of four better-known ones.

Do you think Nineties porn has improved in quality since mid-to-late-Eighties porn?

If we could take the time, get the bigger budgets to do porn well — just as they do on mainstream movies — then we could deliver some really wonderful stuff. But

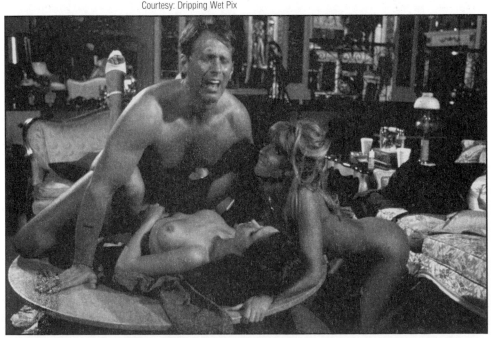

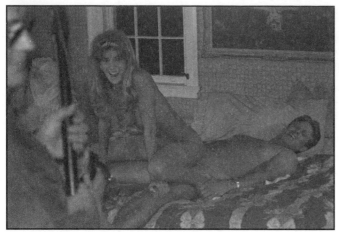

Christi and Hank have fun on the set of Southern Comfort. Photo: Anthony Petkovich

most of us don't *have* that kind of time and money. Actually, I'm also doing some mainstream work, acting stuff. I've been very lucky, too, because the producers I work with accept my porn background. They really like the fact that, when the time comes for me to drop my robe and say my lines, I'm not afraid to shed the clothes.

So what are some of the pitfalls of being a producer?
Well, there *is* one thing I've never gotten used to. When you hire someone, they shouldn't flake the job off for a better one. Some of the talent think, "Ah, they can replace me… no problem." But people are actually really depending on them. I worked in a factory for eight years, and you showed up for work on time, did your job, and went home. Simple as that. When you get hired for a job in porn, you make the same commitment. I mean, even if you're feeling miserable, you can still show up and say, "Hey, I'm miserable… but I'll do the best I can." However, because of the nature of this business, there are no contracts. I mean, how could you hold up a contract like that in court? Small claims would just laugh you right out. So when I hire talent for my films, I always make sure I'm hiring people I know, trust, and never had a problem with.

You've also worked with quite a few directors. Which ones stand out?
It was great working with John Leslie in *Fresh Meat* [*The Series*]. He filmed two scenes simultaneously while I was on the set — the boy-girl scene with me and Mr. Marcus, and a girl-girl one. Then, while the sex is taking place, Leslie also had two fully-dressed women sitting by the pool just observing it all. John's wonderful to work with. He told us exactly what he wanted and how to do it. I mean, we did what we wanted for the sex part, but Leslie told us stuff like, "Whenever

I'm not watching you guys, kind of be aware of my camera pointing in your direction." But with me and Mr. Marcus, we just kept screwing whether the camera was on us or not.

I also worked with Patrick Collins in *Sleeping Booty*. I play this innocent little girl who's all alone in her teacher's home. Then this trespasser [Wilde Oscar] sneaks into the house while I'm sleeping and fucks me. And when my teacher [Patrick Collins] comes home and catches us, he chases the guy off and takes me aside for a reprimand. But then *he* starts screwing me. It was fun being an equal participant in the film… helping make suggestions to the storyline. I suggested, for instance, to paint my toenails in the scene — afterwards finding out that Patrick has a definite foot fetish. (Laughs)

What about working with Jon Dough (*Dirty Stories 3*)?
Jon's very nice, very professional. Working for him was like bing-bang-boom — no hassles on the set, no waiting, no phones ringing, no pagers going off, no one stopping for this or that. Everything sort of clicked. Of course, when things don't click, it's like bing-bang-*oops*! (Laughs)

Who else have you worked with?
Jane Hamilton [ex-porn starlet Veronica Hart]. She's a lot of fun, always understanding of the talent. Very patient. Very much a perfectionist. She looks fantastic for her age, too. I mean, she really could still be in front of the camera, but, you know, she's more into the production end of it now.

We porn writers use the term "nasty" quite a bit in our work. How would you define that term?
People actually enjoying sex for real, losing themselves in it. People have told me, "You have to be more camera aware," because I don't look at the camera. Why? Because I'm usually having such a great *time* with my screen partner. And *that's* when I start getting nasty. I mean, when I was with Steve Drake in my first porn scene ever, we were screwing our brains out for about 15 minutes before I realised the crew was busy setting up the lights and not paying any attention to us. Steve knew, but he didn't care. I mean, he was enjoying himself, too.

Let's talk about the movie they're shooting here today. Whom do you play in this Carl Danser film?

A rich, nymphomaniacal slut named Kala Sabina.

A nymphomaniacal slut? Wow! That's sluttiness squared, isn't it?
Yes — double the power of sluttiness. In the film I have a lot of lovers, a lot of toys; even if my character can't obtain sex from the other characters, she'll get it from herself by masturbating. She also winds up killing many of her lovers in the film.

You mean we're actually going to see some honest-to-goodness *violence* in an American sex film? Hoo-ray!!
They don't show the folks actually dying, though. They just pop up as corpses.

Hmm… But you are slated to do a scene with Rebecca Lord today, aren't you? What do you think of her?

Girls Of Summer ad art.
Courtesy: Video Team

The first attraction, of course, was the body. Then, after talking with her, finding out how little attitude she has, she's really just a wonderful person. Besides, I'm a real sucker for sweethearts. I love her accent, too. Talk French to me all night long and I'll come a dozen times. (Laughs) This one guy I fucked last week, and I gushed all over his cock. I could see his eyes just light up. He was very happy with that.

I'm not surprised. Listen, when we met about six months ago, you told me you wanted to stay away from anal. Now you're doing quite a bit of it. What prompted the shift?
I just didn't want to give everything away at once. I didn't do any anal during my first nine months in the business — not even with girls. The first anal I did was for Private Video. They made me a very good offer, flew me down to Cabo San Lucas in February ['96], and let me do four anal scenes. It was like a week's vacation. A lotta fun.

You've also done several gang bangs since last we spoke.
Right. I did five guys in one movie, six guys in another, and six in my own. So, to date, I've done three different gang bangs. One is *Please Take A Number* by Cinderella. One is *Biker Gang Bang Bitches 11* for Mitch Spinelli and Plum Productions. And there's also *Christi Lake's Anal Gang Bang*, the only gang bang I've done so far that was all-anal. We filmed it at the Dry Gulch Ranch in Malibu. I did anal with three guys in one scene and anal with six guys later in another. So by the end of the day I totalled nine anals.

Yeeow! That must've hurt. Lotsa lube I imagine?
Lotsa lube. But you prep yourself very well — plenty of enemas, eating light for a couple days beforehand, salads and such. But, to me, it's really a mental thing. If you prepare for it, make yourself want it, turn yourself on, then your body naturally loosens up to it.

So really it's… mind over asshole.
Mind over asshole, right. You set your mind up for it. The mind is a wonderful thing. And the more people in the room watching my scenes, the better… especially if I'm getting fucked in the ass. ■

Chasey Lain

From Tampa, With Love

Chasey Lain is a dead ringer for a James Bond beauty. Consequently, as a matter of fiction rather than fact, if this deadly Florida-based sex bomb *were* planted in a Fleming spy thriller, she'd have the capacity to shift more than one vice in the name of that universal language called (among other things) love. Hell-bent drug lords would graciously give up their operations in Columbia — and gladly retire to Little Rock, Arkansas — just to dip their forked tongues into Chasey's squeaky clean black hole. Ruthless gamblers on the French Riviera would forsake life-long romances with Lady Luck to play their gland at Ms. Lain's glitzy, maw-inspiring Casino Royale. And a mere glimpse into those fathomless, mesmeric eyes would be reason enough for SPECTRE to forgo any megalomaniacal notions of world domination.

Yet, in actual point of fact, Chasey's fashion-catwalk looks made her the most *unlikely* candidate to invade the wild, wild world of Fuck in 1994. So innocent-looking, so sterile, so goodie-two shoes, Chasey initially came across as a shy, awkward freshman at a sorority beer bust. I was definitely in for a surprise. For as I sat in the smoky darkness of The New Century Theatre, waiting for Ms. Lain's dance show to begin on a Spring afternoon in '94, my rapidly fading attention drifted towards the X-rated video monitors positioned directly overhead. And I could *not* believe my eyes. For there, flooding several video screens, was this same, seemingly demure porn initiate burying her tongue *deep* inside Debi Diamond's brown snake pit. Hmm… I now started seriously sensing this cutie wasn't your typical Ivy League priss.

When Chasey finally *did* appear in the flesh, the dick-altering experience was worth the wait. Watching Ms. Lain watch herself on the big screen directly behind the dance stage — her sleek, undulating Cherokee figure silhouetted against a huge close-up of her own face as it inhaled a monstrous 20-ft hard-on; strobe lights flashing, making the two sequinned mannequins dangling from either side of the stage animatedly twinkle and shimmer like surrealistic stars — I found her show far more reminiscent of a cyberpunk novel than a spy thriller. The only thing missing was the ol' Moloko Plus.

Although I suspected she was somewhat nasty (e.g., witnessing her lick Debi Diamond's butthole without a bib on video), I would have never thought her psychologically capable of the torrid five-way tryst with VixXxen and three horny dudes several months later in Gregory Dark's *New Wave Hookers 4*. The confident, intrepid manner in which she handled this mondo (now-classic) drilling made me proud to admit that, yes, I was one of the first slobs to interview her.

Unfortunately, when I spoke with Chasey in her dressing room that same afternoon, her manager "Lucky" Smith was present. Very *un*lucky for me. For

while Smith did bring up some fairly pertinent observations about this spurting life of X, the long-haired, bearded scuzzo — obviously suffering from an Othello complex — kept interrupting my conversation with Chasey, weakening her already weak attention span. Such gross interjections — similarly reeking of used-car-salesman promotional sleaze — frequently caused Chasey to slavishly clam up at times. Simply put, I wasn't fond of the Smith dude. After all, let's be honest: I *didn't* drag my ass down to the Tenderloin District to record the earth-shattering thoughts of the Grand Smith Master, did I? For authenticity's sake, however, I maintained the leechman's quotes in the following interview. Just for the record, though, when a far more abridged version of this article first appeared in *Hustler Erotic Video Guide*, editor Mike Albo got so pissed at Lucky's buttinsky qualities, that he attributed each and every one of Smith's quotes to Chasey herself. Ha! Yellow journalism at its best. Me? I just thought I'd let Lucky speak for himself — and, disappointingly (yet unavoidably), Chasey, as well…

Were you born in Florida?
Chasey: No, I wasn't. But I lived there for three years and that's where I started dancing. It's nice there. They have really good clubs and there's a lot more opportunity there.

Why more opportunity?
The work there is good for a dancer. See, for a lot of young girls there, it's pretty normal for them to be dancing. It's as normal as waitressing because they're a lot more open about that sort of thing in Florida.

It must be more competitive then.
Since there are a lot of dancers, it's *real* competitive. But, for the most part, all the girls are really, really pretty. You don't find one certain kind of girl there.

What about your latest film? Anything you'd like to say about that?

I like *Wicked As She Seems*. Kaylan Nicole, one of my roommates, is in it with me. It was my second film. Kaylan is in it throughout the whole movie so we had a *really* good time doin' that. I did a girl-girl scene with her, and I also did a scene with Peter North and Tom Byron. I like Tommy. He's just real fun. He likes... (hesitates, bashfully)... the tongue up the butt. (Giggles) Um-hm. I also did Debi Diamond with a strap-on in *Covergirl*. That was fun, too. And I did a three-way with her and Marc Wallice in that one.

Debi's phenomenal. She's got an infinite supply of energy.

She *does*. She's like a wild animal. (laughs)

Chasey Lain (left) and Juli Ashton in the ad art for *New Wave Hookers 4*.
Courtesy: VCA Pictures

It's amazing. When the camera stops rolling —

She doesn't. (Laughs) Yeah, she's *wonderful* to work with. Really a fun person.

How did you get interested in X?

Well, the club I started dancing at in Florida — and wound up working at for three years — brought in feature dancers. It was The Tease Lounge in West Palms. So I'd seen a lot of the features come through. And I met Alexis [DeVell], then a little while later I met Shayla, and they invited me to California to do some photo shoots, 'cause I'd never done a photo shoot before. So I came out here, and we were just going around meeting people, and I got offered a contract, so I took it.

Lucky: And the rest is history. You're talking about a woman that's feature dancing after only three films. That's *extremely* unheard of.

Was your first film experience a very gruelling one?

Chasey: Well, we spent three days just in pre-production on *Wicked Woman*. That included getting the sets together, going around getting costumes, and going over the script, and lots of other little things.

How do you feel about women in the industry? Do you feel, on the whole, the business is run by males?

I think it's mostly a girl's industry. Usually they make all the decisions and everything.

Lucky: Yeah, absolutely. You get heat from feminists all the time about women being abused and objectified. But you name me one other industry in the United States today where women run the show. The women in the adult industry pick the sets, the locations, the people; they make three times as much money as any male —

Chasey: They pick their rates.

Lucky: Exactly. All the stuff is run by women. Sure, they get all bent out of shape because men predominantly own the companies. But that's America. Men predominantly own America — and run it. And you know what sort of pay these girls get. An average starlet makes twice as much as any male. And someone like Chasey will make... *fifty* times as much as a male.

Fifty times as much. Quite a hunk of change. But getting back to the sex part of it all, is there any girl in particular whom you've especially liked working with, Chasey?
Chasey: I *really* like working with Debi. Kaylan is a *lot* of fun, too. I've also done a scene with Alexis... she's great. I worked with her in my first movie.

Is there a girl you haven't worked with yet whom you'd really like to?
I like Julie Ann, she's pretty. But we're both under contract, so I don't think that'll happen for a while. I'm under contract with Wicked Pictures to do six pictures a year. My contract was supposed to be up in July, and I renewed it for another year. So I'll have six more coming out as well... Wicked Pictures is great. They spend a lot of money on promotion.

How do you feel about bondage films?
I did a bondage film for Bruce Seven. I was a submissive in it. I like bondage. I do a lot of bondage stuff because here in the States it's illegal to sell sex in a bondage movie, and under my contract I'm allowed to do different things. I'm just strictly doing hardcore for Wicked. But I did some softcore stuff for Andrew Blake. He does really artsy, pretty stuff. He's great. With Andrew it's usually just a lot of really pretty movements, lots of nice lighting. He just tells you what he wants to shoot, and it's *extremely* fast because he's so good. I also did some stuff for the Adam and Eve and the Playboy Channels.

Your tits look great. There's a very natural swing to them which you don't usually see in many girls who've had them altered. Are you pleased with your newest acquisitions?
(Laughs) Yeah. A lot of girls have tits that just don't move. (Squeezing her tits, giggling) They're really soft. I like 'em. I didn't want 'em too terribly big. They're not a lot bigger than they used to be. This picture here (points to poster on the wall of *The Original Wicked Woman*, in which Lain is leaning against a wall, ass to the camera, one tit exposed as it hangs like a ripe pear) was taken before my boob job. But I didn't like this angle. Everyone likes to shoot that angle, though.

Lucky: It's because your butt's so nice.

Chasey: I take care of it. (Laughs)

How long does it usually take to go through this type of surgery?
Oh, I was in surgery for a couple hours. They did them through the armpits. I couldn't raise my hands for a while. And for the next week after that I didn't do a lot of moving around because the doctors said it would be better just to stay still. But the stitches go in, and after about two weeks they go out. It wasn't too painful. As a matter of fact, about two weeks after I had surgery I went on a 14-day trip.

Dancing?
No. I was signing in Atlantic City. It was an East Coast show. We went to New York, Cleveland, and Denver for a few days. But I only had to sign autographs.

How long do you plan to stay in the industry?
Well, I started doing the movies because I wanted to feature dance. I enjoy going out and meeting the people and dancing and going to different clubs. So I plan to be dancing for a while. And I'm under contract for another year. So, there's at *least* two more years right there.

Aside from dancing, what else are you interested in?
Well, I was on a gymnastics team for 14 years, and I had several years of horseback riding lessons. I like riding horses. I just bought a house and we're decorating it now. And eventually I want to own my own company.

What sort of company?
I'm not sure. Maybe pictures, maybe something affiliated with a dance club. That would be kind of neat. We're tossing ideas around.

Earlier you mentioned that you really like dancing. Would you mind elaborating on that somewhat?
It's nice to get out of town, then you don't spend your money while you're making it — you don't have time. It's also nice to work everyday rather than once every couple of months, like when I do movies. Since I shoot a film once every two months, that leaves all those days without working. So it's nice to be dancing during those periods.

Anything in particular which you find attractive about San Francisco?
(Smirking, biting lower lip) Um... the girl over at the Mitchell Bros. (Giggles) She was really cute.

Lucky: It cost me 20 bucks. The other day we walked down to the Castro District. I mean, it's *miles* from here. It's an hour walk. So we're sitting there at a res-

taurant, getting ready to leave, and this very pretty woman walks in, and Chasey and she are kind of looking at each other in the mirror, sizing each other up, but nobody says anything. Then when we started to leave, Chasey's talking to me about how pretty this woman is. Anyhow, we went to the Mitchell Bros. last night and Chasey comes up to me and says "There's that girl from the restaurant." And I said, "You're crazy. It's not the same girl."

Chasey: (Smiling) And I said, "Yes it is. Bet you 20 bucks."

Lucky: Right. She bet me 20 bucks it was the same woman. And Chasey walked right up to her and, sure enough, it was the same woman. She works at Mitchell Bros. Cost me 20 bucks. So if you're gonna write that down, write at least that I paid her the money. (Laughs)

So you obviously like girl-girl scenes.
Chasey: (Smiling) Yeah. Well, if you're attracted to someone, I don't think it matters what sex they are.

What nationality are you?
Part native American.

Lucky: You know, that whole southern Cherokee thing.

Chasey: (Laughs)

And, just for the novelty of it, what's your sign?
(Smiling) I'm a Sagittarius.

It's said that the Sagittarian isn't always going to say the things you want to hear.

Lucky: Amen.

Chasey: (Laughs) That's pretty much hitting the nail on the head. I'm not a really private person. Usually I say things which *I* don't think are such a big deal, but other people go "Uggghhhhh! Oh my God!"

About sex?
Anything. (Laughs) Silly stuff.

Lucky: You're not going to find her in the dictionary under "politically correct."

Chasey: (Laughs)

And how do you feel about anal?
I haven't done it on film. But if the right opportunity comes along… um… (Laughs) ∎

PUSSY BUFFOON.

Pussy Buffoon.
Art: Maxon Crumb

Reflections In A Voyeur's Eye

An Interview With Porn Maverick John Leslie

M any male stars from the Golden Age of Porn have tried their hands at directing. Ron Jeremy. Eric Edwards. Michael Morrison. Hershell Savage. All proved mere drops in Hollywood's scum bucket. John Leslie, on the other hand, became one of the few male porn stars to move from mattress to director's chair and succeed as a five-star filmmaker.

Originally from the East coast, Leslie moved to California in the mid-Seventies to start what would ultimately become a prolific porn star career. During the Golden Age (a bygone era which now seems strangely innocent), Leslie starred in such classics as *Dixie Ray Superstar*, *Nothing To Hide*, *Between Lovers*, *Heatwave*, *Firestorm*, *Ecstasy Girls*, *Wicked Sensations*, *Dream Girl of F*, *Sex World*, *V - The Hot One*, and *Insatiable*. His female co-stars were definitely nothing to scoff at; they included unforgettable sirens the likes of Seka, Leslie Bovee, Constance Money, Mai Lin, and Annette Haven. And unlike the other male performers at the time (e.g., John Holmes, Ron Jeremy, Richard Pacheco, Eric Edwards), Leslie had a unique, demonic presence which supplied a seemingly inexhaustible supply of hellish steam. His intense stare could bore into his female partner's eyes like an alien deathray. He could tear a woman apart like a greasy piece of chicken. Yet as an actor, Leslie also brought a distinct intelligence to his scenes. The best example of all these traits is perhaps found in Anthony Spinelli's 1980 classic *Talk Dirty To Me*. As the film's lead character, Leslie is irreverent, foul-mouthed, polite, savage, comical, cagey and sensitive at any given moment. And when he *does* eventually nail such hot boxes as Jessie St. James and Juliet Anderson to the hardwood floor, Leslie doesn't provoke jealousy from his male audience. Rather, he garners applause. One actually *roots* for his likeable character. Sure, *Talk Dirty To Me* has perhaps been over-discussed for way too long (spawning nearly 10 sequels!). But it's still quintessential Leslie.

By the mid-Eighties — after starring in hundreds of films — Leslie became painfully aware of the smut industry's descent into the doldrums. As a result, he almost felt obligated to try his hand at directing — *Night Shift Nurses* (for VCA Pictures) being his first attempt in 1986… and a damn good one. Seeing sluts like Lois Ayres chow down gargantuan black cocks as if the things were uncircumcised fudgicles, or hussies like the underrated Dana Dylan getting strapped across squeaky hospital beds while their tight little kazoos are

savagely crammed with beef catheters, or Leslie, himself, giving enemas to scantily clad nurses… well, they marvellously exemplify Leslie's talent for capturing pure poetic sleaze.

Between 1986 and 1993, Leslie continued scripting, directing, and editing films for VCA. Some titles during this (more or less) experimental period in the ex-actor's new-found directing career included *The Catwoman*, *The Chameleon*, *Chameleons: Not the Sequel*, *Curse of the Catwoman*, *Bad Habits* and *Sexophrenia*.

Then in 1994, aiming to have more control over his films, Leslie developed his own production company An Eye For An Eye, simultaneously hooking up with world-famous Evil Angel Video to handle all distribution. His first show was the surreal, crime noir feature *Dog Walker*, followed closely behind by the acclaimed 'gonzo' entry *The Voyeur*. Both films are prime examples of Leslie's double-libido attack. That is, for audiences who find hardcore fucking more palatable with storylines and character development, *Dog Walker* is sure to please. On the other hand, for viewers who prefer sex captured just inches away from the action in the guerrilla format of hand-held cameras, the *Voyeur* series is the ticket.

On February 1, 1995, shortly after the release of his acclaimed *Fresh Meat: A Ghost Story*, Leslie took a break from editing *Voyeur 3* to join me for lunch at a Sausalito restaurant. We got a fairly private booth and — over wine and fish — talked about his films, his views of the industry, and sex in general. It was a kick in the ass for me because, quite obviously, I've always seen him as larger than life. Yet the demon I was expecting was actually a decent, personable character who enjoys talking; so much so that the poor guy nearly choked on his food a couple of times — which was as good an excuse as any for me to order another bottle of wine.

So what was the first porn film you

**At the NYC Critic's Awards, 1982.
L to R: Al Goldstein, Anthony Spinelli,
John Leslie.** Photo: Dave Patrick

starred in?

Her Coming Attractions. That's funny... Her Coming Attractions. It was made in 1975 but didn't come out until 1980. Pretty good movie, especially for the time. A one-day shoot in LA. It was also John Stagliano's first movie. He had the part of this cowboy in a fantasy situation.

So you've known John Stagliano for quite some time.

Twenty years. After we met on that film, we ran into each other occasionally. And when he started his company I encouraged him. People would ask me in interviews, "Who do you think's doing some stuff that's good?" and I'd always mention John because I thought he really was doing good work. I thought he was taking a different approach on it — and very honest as far as the sexual situations he explored. I mean, here was John, a sexual person, giving you his sort of angle on it — which happened to be very commercial.

Do you want to talk a little about Eye For An Eye Productions? For instance, what's the significance of that name?

The only reason for 'eye for an eye' is just to tell everybody, "You get what you pay for." People rip the consumer off. They're giving 'em junk. I think a lot of non-sexual people are putting movies together — producers, directors... It's not that they don't care. I don't think they *know* how to care. It's dollars and cents.

And there's nothing wrong with receiving dollars and cents for your work. But what are these people doing in a business when they have no... feelings about it? And I've discovered over the years that a lot of people I've met are *not* really sexual people — sexual relative to the genre. I'm sure their sexuality, whatever it is, is a personal thing to them. And they chose *not* to expose hardly any of it in their films. Of course, this is a very general thing I'm talking about here. But, yeah, I find that there are very few really sexual people who put these movies together. And, consequently, I think they underestimate the consumer. They don't really give a fuck what they're doing. And I'm sorry, but you close your eyes and just pick any tape you want out of these video stores, and most of them aren't really horny at all. It's not because of a story or anything. They're just not sexy. It's that simple. The people making them aren't into it, they're not inspired. They're just going by the numbers.

But, see, you must *inspire* the project. Everything must be done from inspiration. If *I'm* inspired, the people I hire become inspired. So all those things put together make it a better product. Most of the stuff, like I say, is just boring and you can't jerk off to it. You *want* to. And you try like *hell* to. But it ain't happening, man. You can even try to create little fantasies with these images. In fact, I've brought tapes home where the movie was so bad, but I liked the girl in it. So I'd just freeze the frame where she looked real good and pretend something else happened. (Laughs)

Speaking of women worthy of freeze framing, where did you discover Liquid Slater?

Voyeur 3 and *5* ad art.
Courtesy: John Leslie Productions/Evil Angel Video

(Smiles) Here in California.

What's her nationality?
I think a few different things — Oriental, Filipino, some Spanish.

Her DP in *Voyeur 2* was fantastic.
(Smiles broadly) Ain't that somethin'?

Talk about some primo beef jerky material.
Oh that's a wonderful scene. She was *so* turned on. I mean, you can *see* it. And it was quiet. See, noise has nothing to do with it, 'cause you can hear breathing. Depending on your taste, you may like someone who's quiet or someone who's noisy. But whatever the honest emotion is in that situation, that's what should be produced. That's the sort of thing we work on when I hire people for a role. We discuss it at length.

In your rehearsals?
Right. We have a week of rehearsal.

Do you shoot your movies up here in Northern California?
No. I only edit in my house. Most of the production is done in LA simply because the people are down there, that's where it happens. But that scene with Liquid Slater in *Voyeur 2* was done up here.

You seem to like living in Northern rather than Southern California.
I've lived in the Bay Area since 1981. Yeah, I like being here. I like the weather, the sun... I like San Francisco; it's a cosmopolitan city, a bit European, yet at the same time it's small. It's beautiful to look at. Everything is beautiful here. And I like the liberal nature of the area.

How long does production typically take on one of your films?
Depends on the show. *Fresh Meat* was three days.

And you were director of photography on that.
First time.

What were you up against as a director of photography... as well as director?
Well, it's just more fun. (Laughs) I can't sit still on a movie. I'm so keyed up that being the director of photography gives me something to do, although it's really physically and mentally difficult. But I know enough about movie photography to know what to do. Visually, I see my movies before I make them, so it's just a matter of executing that vision.

And you also go by a script, right?
Yeah... which gets enhanced and enlarged upon during the rehearsal, and all the way up until shooting.

It was interesting seeing Bruce Seven work. He basically has no script at all, the whole thing's pretty much improvised. Is that, more or less, the way you operate on the *Voyeur* series?

Dirty Tricks 1 ad art.
Courtesy: John Leslie Productions/Evil Angel Video

it's great hardcore material to just look at and jerk off to. You don't have to look at the whole movie. You can look at individual segments. And I think that's important at some point in this business — you shouldn't *have* to look at movies from beginning to end in one sitting. This genre must allow you to look at ten minutes of something, be satisfied, then come back another day and see something else.

But to get the real impact of feature movies like *Fresh Meat* and *Dog Walker*, you have to watch the whole thing. In *Fresh Meat*, just like in *Dog Walker*, we're dealing with the same psycho dramas, the human mind. It's just presented in a different way. *Fresh Meat* deals with our fears, prejudices, likes, dislikes, decisions. There's a big psychological meaning in the laugh track, and it's not specific. It's up to the viewers to figure out how it applies to them, because I always leave my movies open to that. I can't say, "This is the way it is," or "This means this."

Which is basically the subjective nature of art.
Exactly. The red vinyl on that barstool over there is different to you than it is to me. Maybe when I got my first piece of ass, the girl had that colour on. Maybe somebody who beat the shit out of you was wearing that colour. My whole point is that I don't like to lock the viewer into a very regimented kind of perception. That's very presumptuous. You'd have to be a genius to do that. And even geniuses would never do something like that because they know these questions are unanswered. In *Dog Walker* there's no pat answer to the story. It deals with everything we go through. There are deeper, very subjective meanings in these movies. And I do that because *I* want to have fun. I can't do them just for the sexual aspects because that's one-dimensional. That's just like me saying, "Well I'm just going to show you this, and your mind is going to go just as far as what I show you." That's ridiculous. You don't do that in music. You don't do it in literature.

A lot of people are saying *Dog Walker* is one of your best works.
(Smiles) They haven't seen *Fresh Meat* yet.

Right.
What do you think?

Between *Dog Walker* and *Fresh Meat*?
(Nods)

They're different features. You've got more of a horror thing going in *Fresh Meat*... done in a satirical vein...
Satire. Right.

And the other one is more...
Heavy.

Well, *The Voyeur* is a different approach than *Fresh Meat*, because the *Voyeur* has little vignettes with this particular character that you never see. He just observes. And I literally cut from one thing to another. There's really no segue between scenes... I just hard cut it. *The Voyeur* at times tends to be kind of heavy in its danger, with the voyeur sneaking around alleys and private homes after dark, looking through windows. Then again, the voyeur himself has a whole different demeanour when he's photographing people than he does when he's looking at them through a window. So I use all those elements.

Did you ever see Michael Powell's *Peeping Tom*?
Yeah, I did see that. And I'm going to look at it again. It's such an interesting movie for its time. Completely different than *The Voyeur*, but, again, that element of danger is what I try to find in dirty movies. I like to make it a little dangerous. Believe me, *The Voyeur* has a lot... I mean, it's not perfect in its approach. The viewers have to *allow* themselves to enjoy the illusion of the camera being the voyeur's eye, you know what I mean? It's not perfect. And some people have complained about that. They haven't really complained, but some reviewers have mentioned it. And I just tell 'em, "Look, you gotta *allow* yourself to get into it." Gimme a break. Believe me, if I'm the consumer who really enjoys the movie, I'm *not* going to sit there and say, "Oh, this is really a camera, it's not his eyes." Pa-leeze. You know what I mean? You gotta let yourself go. But the thing that's great about the *Voyeur* series is that

**Stephen St. Croix and Christina Angel in *Dog
Walker*.** Courtesy: John Leslie Productions/Evil Angel Video

**Yeah. More of a gangster, crime
element with psychological aspects
thrown in. Both are, at times, surreal.
And editing plays a very distinct role
in both.**
Yeah.

**Especially in *Fresh Meat*. That must
have taken a lot of time to edit.**
Two months for the block editing... plus the soundtrack.
I had four different tracks going in a few of those
scenes... mixed 'em down to one. In the last scene,
for instance, [where Krysti Lynn is gang-banged at
night... in an alley... in a convertible... by about seven
guys] there's an audio track with a freight train whistle,
traffic sounds, police sirens, helicopters, all brought in
at different points on four separate tracks. And it cre-
ates an illusion. But I basically did as much editing on
the entire film as I thought necessary.

**That last gang bang sequence in
Fresh Meat is great. And like you
say, it was brought to a whole new
level with all those interesting sound
effects. Generally speaking, what are
your impressions of the whole gang
bang genre?**
I love it.

**What about anal? There's much more
of that in your current films.**
That's a commercial thing that's very hot right now.
Certain times, there are places where you want anal,
and you don't get it. Other times, if someone does it,
you do it.

**You also like bar room sex scenes.
In *Fresh Meat*, for instance, there are**

several.
Well, *Fresh Meat* was so successful in that one bar
scene with Kirsty Waay because I've always loved the
position of a woman on a barstool. It's perfect. See
this one on a barstool? (Nods to twentyish, short-haired
blonde with blue jeans sitting on a barstool about 15
feet from us, her backside towards our booth).

Yeah.
I can see everything I want in that. And I've had fanta-
sies all my life about women sitting on barstools... of
how she sits there with her butt out, and someone
comes along and just sticks it in. Nothing said, you
know. And it's so graphic because of the height of the
ass and everything... perfect to hang on to.

**You also used a lot of leather and
latex in *Fresh Meat*.**
That was Joey Silvera's idea. I never even thought about
it. He said, "You oughta use latex and rubber as much
as you can through this whole movie." And I said,
"You're right. I should. Great idea." And I did. See?
That's the whole thing about inspiration. Movies are a
combined creative effort. The creativity there is... I
mean, it'd be ridiculous for anybody to take complete
credit for that kind of project. If Leonardo Da Vinci
were living today, I'd say, "Okay." But I don't think there's
anybody today who can take that kind of credit. It's a

***Dog Walker*, videobox artwork.**
Courtesy: John Leslie Productions/Evil Angel Video

combined effort.

What about some of the female talent in your new films? I noticed you like working with Eva Flowers.
Yeah. She's wonderful. You'll notice that lot of my movies have women in them that aren't typical porn women.

I know what you mean. Krysti Lynn, for instance... that great butt.
Oooh. Mmmmph.

And Lana Sands has those cute little titties... that sexy overbite.
What about that ass?

Fantastic.
Yeah. See, I don't find generic-looking women in porn very exciting.

Generic in the sense of someone like Savannah, who was...
A cartoon.

Yeah.
Savannah in the beginning was very nice. But when you start getting into these blow-up dolls... it doesn't turn me on. I generally look for personality when I look at... I mean, obviously I have to like their appearance,

something about their being which I find really exciting. Tori Welles, for instance. (Thinking) Tori Welles... When I met her, it just blew me away. I said, "This is one of the most incredible women that have *ever* graced the industry," because her presence is big time. You must *look* at her. You can't help it. She walks away and you *see* her. She's so dynamic. Her presence is incredible. That's why when she's on screen, nobody ever gets bored. Doesn't matter — you can just keep the camera on her face for ten minutes, waiting for something to happen there, and behind her eyes there's *always* something going on. It's very interesting when people see that in a movie. That's what I look for.

How do you feel about the augmented tit syndrome? I noticed that on the box for *Fresh Meat* you state all the women in the film have 100 percent real tits.
I didn't realise that until after I shot the movie, so I just put that as a selling point on the box. Consequently, someone who may not be interested in the box may see that little quote, and they may purchase it or rent it. It wasn't intentional at the beginning. I don't look for that. I *prefer* that, but I look for somebody whom I really want, and I'll deal with their body problems after that.

I loved the scene in *Dog Walker* between Lana Sands, Maeva and Joey Silvera. Even though Lana's got the strap-on and never sticks it in Maeva, it's still an incredibly sexy scene —

On the set of *Dog Walker*. Leslie directing, with Krysti Lynn on horseback.
Courtesy: John Leslie Productions/Evil Angel Video

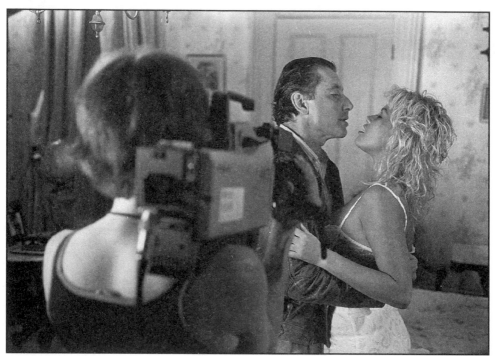

Rare behind-the-scenes shot of Leslie with Gail Force from a lost film by Chris Chase.
Photo: Dave Patrick

with the tease factor and the fondling between the two women.

Well, see, I used that. Maeva didn't want to go down on Lana or get penetrated by the strap-on. What? — I take that as a negative or a positive? I take it as a positive. My feeling is: "Let's use that. Let's scare her a little bit." You should've heard me in the outakes. I was telling Maeva, "Talk, talk, talk." And I had this French woman behind me who was one of our PA's, and she's constantly translating what I'm saying, constantly talking to Maeva in French. And I didn't care if Maeva recited the alphabet. (Laughs) "Count from one to ten, I don't give a fuck, just *talk*." (Laughs)

Looking back at all your films, what would you consider the hottest scene you've shot so far?

Hottest?

Yeah. I suppose that's a pretty ambiguous term, isn't it?

Hot. I don't know what that means.

Okay. What's the most intense scene you've shot thus far?... something you consider top-notch whacking material?

For me personally?

For John Leslie.

That I've shot?

Yeah.

Out of all the stuff I've shot?

All of it.

I don't know... I'd have to go back to when I was with VCA. Let me see... one of the sexiest things that turned me on, that *absolutely* turned me on was the alley scene with Jamie [Gillis], Ashley Nicole, Rocco [Siffredi] and Raven [St. James] in *Curse of the Catwoman*. The whole build-up to that thing was so personal to me. To me, it's one of the sexiest things I've ever seen. And I'm in awe of it not because I directed it or anything... it just worked my instinct... my... Actually, you know how that scene came about? Well, first I have to tell you that I hate sequels. So when I do sequels, I take a whole different approach. And I'm really glad I had the experience of doing a sequel to *The Catwoman*, because my first reaction when Russell [Hampshire] at VCA said, "Can we do a sequel to this?" was, "I don't like sequels, man. It's already done." But he said, "Go ahead and be creative about it." So I thought about it, and what I decided to do was use the same concept but not connect the two pictures at all — as if I'd never done the original. Then it becomes an advantage to me because the things I missed in the first film, or the things I thought of later, I try to do in the second one. So it's more fun for me.

So how did the alley scene in Curse

of the Catwoman come about?

From a female model I'd known in Europe. *Beautiful* woman. Just drove me crazy. And she liked gettin' fucked in alleys. Anyhow, one time we were walkin' down 66th Street or some place, and she dragged me down into this stairway that led to a metal door that was closed. So she dragged me down there, backed herself against the wall, and lifted up her skirt. And when I took out my dick, she looked at me and said, "It's not big enough." And I *loved* it. I mean... it just grew another inch. It was such a turn-on, because it's always sexy to me to know about somebody that fucked somebody you're fucking *better* than you fucked 'em. It's like, "You must have been with somebody that could give you something I could never give you." So I used that in the scene in *Curse of the Catwoman* — "It's not big enough" — when Ashley was fuckin' Jamie and talkin' about his dick not being big enough. It's as sexy as anything... I mean, I'll show that motherfucker to anybody in the world, to the Academy of Arts and Sciences, it don't matter. *That is it.* That whole feature really is very much a landmark movie. Jesus, I wish I'd have shot that on film. That would have *really* blown everybody away. But even as a video, it's just incredible.

Comparing the Golden Age of Porn with the present, do you think video has made us lose touch with the whole porn-theatre experience?

Well, if going to theatres is something you really like doing, if it puts you in the mood... again, it goes back to *The Voyeur*. When someone says, "Here's a video of my wife fucking somebody," that's nice. But if you come upon that drama from looking through a window, it's much more exciting because there's danger there. The more elements of human drama you enter into it, the more exciting the situation. That's the key to me in all film — you have to start dealing in abstract images, not all literal, to explain what your story is. Let the imagination draw its own conclusions. Very complex. But it demands your attention. I've always thought of doing a movie with no words. If you do that, you can't present the images in a literal, descriptive sense. You must give your audience an overall impression which might be completely confusing in a literal sense.

No words. That would be a helluva thing to do.

Very difficult. But that's what I think about. And you'll see as I go along in movies, I'll bring more of that in. I can't just jump into it because I wouldn't know what to do. But these are the things I'm looking for. And, to me, I'm at the forefront of movies — everywhere, because I'm looking at concepts. Whether I'm technically capable of pulling it off, I don't know. But my concept and ideas... I think Oliver Stone deals with the same things. I haven't talked with him, but I feel he thinks in those terms just from looking at his work. *Natural Born Killers* was a big influence on *Fresh Meat*. But, see, *Fresh Meat* was already written and ready to go when I saw *Natural Born Killers*, and I thought, "*That's* what I want to do! I want to give those images." And maybe seeing Oliver Stone do it, gave me the okay, brought it to my mind, loaned it to me. It's like an artist going to another artist's studio. Like George Rockwell going to Picasso's studio and discovering cubism. Rockwell never did cubist work. But all of a sudden it inspired him to do something in his own particular style.

Do you get some of your ideas from the Tenderloin area here in San Francisco?

I would love to shoot in the Tenderloin, but it's very dangerous for me to shoot there because I don't have the money to film under those circumstances... you know, for protection.

Actually I was speaking more along the lines of your painting.

Well, there's human drama everywhere... it doesn't really... um...

Limit itself to one location.

Right. It's just something that you get interested in at a period of time and you sort of explore it. Could be gamblers one day, the homeless another day. It could be... I don't know... anything that strikes your interest.

What's the style of your painting? Realistic? Surrealistic? Impressionistic? Expressionistic?

I deal with the figure.

Oils?

Water colour. It's realistic, but in the sense that Degas was realistic. Degas was realistic, but there are other things going on there. See, paintings are not pictures. They're just statements of how someone feels about something and deals with it in the visual elements. I mean, painting's not the visual medium now; it used to be one hundred years ago and for centuries before that. But not now. So today painting takes on a whole... private kind of a thing. Video and film are the current visual mediums, whereas painting is... I don't know *where* it fits in now. Literature, on the other hand, is different. Literature can never be improved upon — *ever*! It's the closest link to the brain you can have besides music, which is a little more abstract. But literature is it. I wish I could write. That's the most direct, complex, simple... all these elements at once are in words. Words completely free the mind up to create images. It's the greatest. But, then again, I'm not saying film and video *shouldn't* be the visual medium. Don't get me wrong. Painting is much deeper than a video because it's one picture that allows a mind to go off, whereas videos give you a number of pictures which,

just in their characteristics, limit your imagination to those same visual images because they're constantly changing. Man is always trying to make things simple. And the mistake he repeatedly makes when trying to simplify things is show something in a very literal way. As a result, in video you're limiting the whole experience to the person who's *showing* it to you *when* he decides to show it to you.

Whereas in literature, one uses his or her own imagination far more. Even though the writer may be describing something, the reader can imagine it in his own individual way.
Right. It's your perception of their description. And in a film or video your perception is not as complete as it is in literature or painting. See, any time we can close our eyes and let our imaginations wander... I mean, your imagination is better than *any* movie. In movies you allow people to take you through these series of events that give you an impression, an experience. But in a sense, when you think about it, it's very limited — until you become completely abstract.

Eva Flowers (*Voyeur 2*) exemplifies the exceptional porn look Leslie aims for in his films...

What about violence in porn? Why is it that these days in porn we can see a woman hit a man, but we can't see a man hit a woman?
Only because if you do that, certain distributors won't take your movie... because they've already made deals with the district attorney. You have to remember that we're doing something that must return money so we can live and do another movie. So in that sense there are certain restrictions you have to abide by. When I'm doing my paintings, that's a different story. I do whatever I want. But in video you have to be sensitive as to what's good for you, 'cause I'm trying to make a living. I'm not trying to make a stand, make my life all about going to court. On the other hand, it's not my responsibility. People have to make these decisions themselves. I mean, if they're trying to make sure everything's right and fair, that ain't how life goes. Let the chips fall where they may. I should be able to do any movie I

want, show anything I want. Obviously that perception of freedom is different for other people.

What about the peeing scene in *Fresh Meat*? Did that create any problems for you?
Certain distributors didn't take it because of that scene, yeah. And the funny thing is, I didn't show anything there. I didn't show a *thing*. I showed her face, and then I showed the floor beneath her, and I kept cutting back between the two. So, take a scenario where you're in a court room and for some reason it's against the law. "Peeing here," the prosecution might say.
 "Well, no, there's no peeing there," I'd say.
 "Well, yes, we saw it there."
 "Will you show it? Did you see any?"
 "Well it's obviously..."

"No, no, no. Did you *see* any?"

"No."

"Then it's in your mind what you're seeing."

But let's say you show *another* movie in that court room — a film showing somebody getting his head blown off with a sawed-off shotgun. That same person who feels the 'peeing' in *Fresh Meat* is wrong might say, "That's against the law — a person murdering someone like that."

And I'd say, "Well, why don't you prosecute the people who made *that* film?"

"Well, it's not *really* real."

"What do you mean 'it's not really real'? We both saw his head being blow up."

"Oh, no. It's prosthetics and all that stuff."

"Well, wait a minute, you're saying that you see this head being blown off, it looks real enough, but it's not really real. But in this other movie, you *don't* see peeing, but you say it's really happening."

How do people draw those kind of conclusions? (Laughs) Help me out here. Put me in a court room, man. I mean, I could say to them, "No, no, no. She's not really peeing. I never had any intention of her peeing. I had a guy pouring some water behind her. I'm just showing water dripping. It was a pipe up there or something. Nothing was said, nothing was inferred, nothing was shown."

But, again, the person who's watching it says she's peeing even though they didn't *see* her peeing? See? It's full of holes. (Laughs) I mean it's like (pretends to fire machine gun) 'Brrrrrrrrrrrrrrt!'(Laughs) It's just amazing how blithering people get when they get so wrapped up in subjective issues that have *nothing* to do with anybody's mind but their own. And the point is, they can let themselves rest easy. If they're watching the movie, and they're enjoying it, and all of a sudden they perceive that she pees and it turns them off, it's their decision to be turned off. It's their decision to say, "I don't like this." It has nothing to do with me. Leave it alone if it bothers you. Why must you convince the *world* that it's fucked up? (Laughs, rolls his eyes) The world *must* know! (Laughs) You see, the problem with this day and age is that people's noses are so big that they stick 'em into other people's affairs. It's none of their business. Leave it alone. People berating others due to social differences in power or wealth… that has *nothing* to do with the universe and the harmony of things. Nothing! It's a dissonant note which stops the plant from growing.

Some people will see a man fucking a woman as being violent… just in itself… a hard dick 'raping' a woman. They perceive this male, no matter what the situation, as *forcing* a woman to do this act. But those are their own prejudices getting involved. And that's bullshit, man. I mean, why should you concern *your* morality with anybody else? It's just applicable to your own life. When someone spouts a point of view, most of the time it's just to test, to validate that same point of view in their own mind. I don't think I even *sound*

…and Kirsty Waay (*Fresh Meat: A Ghost Story*) typifies his girl-on-bar-stool fantasy. Both courtesy: John Leslie Productions/Evil Angel Video

like I have a point of view because, if I do, it's going to change tomorrow. Something may enter my mind that I wasn't aware of. My points of views are always subject to change. While this works for me today, tomorrow it may not. It can't *be* any other way, otherwise you refuse to learn anything. You merely see things in black and white terms.

What about your impressions of other directors?

I think I like Gregory Dark's approach. I don't think his approach is as sexual as I like it. He's very subliminal in his things. I mean, I think his ideas and his approach are wonderful. Wonderful. It's just not a thing I want to jerk off to because it's too… (thinking)…

Clinical.

Clinical. Cynical. But I *love* that part of it. Don't get me wrong. There's a casualness about it in a… how can I put it into words?… there's a word I'm thinking of…

Parody.

There's a parody there, a goof on what we are as people.

Combining people with animals — like

seals and fish. Or combining people with inanimate objects such as lampshades.
Yeah. And I'm not going to jerk off to that. But I like his explanation of it. And I think the way he chooses to show you it to you is very artistic. His dirty movies, however, are much more creative than his regular movies. Man, he's done all *kinds* of things. But he's much more creative in our genre. But at the same time, I don't find his movies horny. And I don't think *he* finds them horny. I think he's making a statement in a very amusing, clever, creative way.
Early on, I think the Dark Bros.' films *were* horny. But then they got into... I don't know if it's been overdone...

The sex is still there, it's just a bit more psychological.
Yeah. I like that. I like that. See, I'll tell you something, I got news for people: you don't have to get a sex movie to jerk off to it. You can see them for a lot of other reasons — certain ones, that is. I mean, some of these directors are making statements. And two hundred years from now, these films *will* be looked at in that way.

What about Bruce Seven? Do you think this is the decade of the lesbian? — of girl-girl films?
Well, Bruce told me when he started doing girl-girl features years ago that he was doing it to avoid the police and getting arrested. So that's cool. And what happened is, he discovered something by that, because he also wanted to do S/M stuff. And in the process of doing that, he discovered *other* things that become a whole new market. So, in a sense, he created a market.

How about Patrick Collins? What do you think of his films?
Very inspiring. Patrick has a wonderful sexual mind that is bizarre. The thing I like about Patrick's stuff is that he explores those things better... except... no... how do I say this?... he explores his sides, the things that turn him on. His approach is a little more dangerous. It's a little more on the dark side. It's uneasy. But it's still very sexual. Danger and sex are very, very connected. And he's allowing himself to be personally exposed in some of his shows. He finds these things sexually exciting. So he produces these shows that aren't really fancy but they're effective for what they are... sort of on *The Voyeur* range... the same vignette kind of a thing.

Director Anthony Spinelli presenting John Leslie with Best Actor Award for the latter's performance in *Talk Dirty To Me*. AFAA Awards, Los Angeles 1981. In background (on left) is *Talk Dirty* co-star Jessie St. James, and (on right) New York porn star Bobby Astyr. Photo: Dave Patrick

Short stories.
Short stories! Great. I've said this for 20 years, that the vignette or short story approach to porno is wonderful, because a lot of the time people don't have *time* to watch two hours of a movie. For me, it's a fun approach because it's a different approach than when I do the features. Everything is contained in one segment. And, again, you use them as sketches; I get ideas from these things that I apply to my Fresh Meats and stuff. They develop there. Believe me, *The Voyeur* is very loose. I come in and I say, "Okay, I want you to do this, that, this, just think about this..." It's very, very loose. I *want* it to be loose. And then as things happen, I look at the tape and I see things that happened while we were shooting them, and I think, "That was very good. I'm going to elaborate on that in my next feature." And for sketches it's wonderful.

You mentioned in an interview for *Hustler Erotic Video Guide* that *Sexophrenia* — one of the later films you did for VCA — was somewhat connected to your paintings of the homeless.
There you go! That is one of my *favourite* movies I've ever done. I wish that was my movie. It really speaks for itself. But you're right. *Sexophrenia* did come from a painting of the homeless and transients living in hotels. It stimulated this idea of the way we repress things in society and don't want to look at them; and the sexual thing in which people are so involved in this society, so wrapped up in. Everything is sexual. On television the other day these guys were dancing to win the title of Blue Collar Hunk on one of these talk

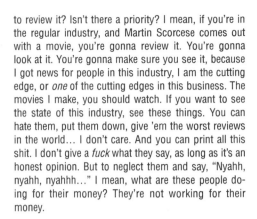

shows, and they had like 10 contestants dancing. And everybody was absorbed in this sexual thing, but at the same time they were trying to deny it. So that's the sort of thing which gave me the idea for *Sexophrenia*. These people have this disease called sexophrenia and they can't stop fucking. But they're listed as people with an affliction whom the government gives a check to every month (laughs) 'cause they can't work, 'cause when they come into work, they can't control themselves — they have to fuck. And nobody else in the world fucks but these sexophreniacs. In other words, I was creating an odd world where everybody wonders, "Why do they do this?" The interviewers don't know why, but they get involved a couple of times because they're sort of sneaking it in, you know… they want to see what it's like. In 1985, you recall, Reagan removed the mentally ill from hospitals and basically cast them into the streets. So I brought that in. It's all the same, whether they let them out for mental disorders or they're trying to suppress their sexual feelings. It's the same kind of repression and sickness when someone else tries to tell you what you're supposed to feel morally.

But, to me, *Sexophrenia* really says so much. I'll put that up in a film festival. I think it's a statement. I don't care whether it's a sex movie or not. That has nothing to do with it. But, listen, did you ever find out about *Dog Walker*? Was it ever reviewed?

Quite honestly, I think I've only read one review of it so far.

Amazing to me. *Dog Walker's* been out since April 20th [of 1994]. It's obviously one of the big movies of the year… of the genre, to me. What makes them not want to review it? Isn't there a priority? I mean, if you're in the regular industry, and Martin Scorcese comes out with a movie, you're gonna review it. You're gonna look at it. You're gonna make sure you see it, because I got news for people in this industry, I am the cutting edge, or *one* of the cutting edges in this business. The movies I make, you should watch. If you want to see the state of this industry, see these things. You can hate them, put them down, give 'em the worst reviews in the world… I don't care. And you can print all this shit. I don't give a *fuck* what they say, as long as it's an honest opinion. But to neglect them and say, "Nyahh, nyahh, nyahhh…" I mean, what are these people doing for their money? They're not working for their money.

Probably just an editor on an ego trip… reviewing the films he personally wants to see and not taking his readers' tastes into account.

That's ridiculous. They don't create this industry. Those editors, and those fucking reviewers, and those writers — including yourself — are only doing this because the industry exists from people like me and Jon Dough and Joey Silvera and Jamie Gillis. If those people weren't around, this wouldn't exist for anybody. Again, I don't give a fuck whether they like it or not. It doesn't matter. The fact that they *don't* like it is just as valid and interesting to me as the fact that they do like it. It's another point of view. But they should at least be reviewing it. It's *ridiculous*.

What would you really like to do in a movie which you haven't done yet?

Well, see, that's the discovery process. I have a couple different shows in my head and they're developing as we talk. It's part of… I mean, while I'm washing dishes, the thing's in my head. It's constantly happening. It's always there to be entertained. And as I do the project, I discover things about it. I don't know what I want to say. It's just… I feel like I'm a baby. I really do. I don't feel like I'm 50 years old, man. So what I'm trying to say about the process is… I have *no fuckin' idea*

John Leslie with Ron Jeremy at the 1981 AFAA Awards, Los Angeles.
Photo: Dave Patrick

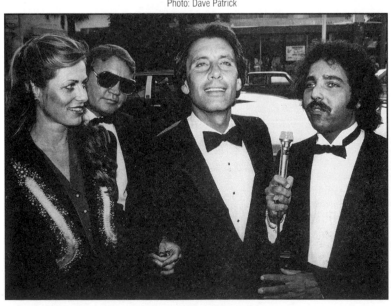

what I'm trying to say. Never did. It just happens at the moment... just my emotions and feelings at the time. This life we're having here is just a long, fun-filled discovery process. And it's not that I like coming around here to talk about myself. I mean, I talk to my wife every night. I'm frequently giving her these philosophical dissertations. (Laughs) But with the major media, I'll tell you something, I always ask them, "What are you trying to do? Are you trying to put this business down or something?"

Like a Born-Again Christian channel or something?

Hey, I would take an interview from the 700 Club. I would. But I'd want to know if it's going to be a fair interview? Because I got news for them — *I'm* a Christian. And... (laughs)... come on... gimme a break. All it is is feeling good. This is a nice glass of wine (hold up wine), and I enjoy it. But if I drink five gallons of that every day, I'm really not enjoying that wine; I'm abusing it, hurting myself, mentally, physically, and spiritually because this is becoming my God. That's the difference. Everything on this earth is to be enjoyed in its right perspective, in its right amount. And that's up to you.

Looking back again at the Golden Age of Porn, what would you say were some of the pluses and minuses of that era?

Well, the advantage of that era was that it was new. People had never seen this before in that environment. All of a sudden they were seeing it on screen — people doing it. That in itself was exciting. The films themselves, looking at them today, leave a lot to be desired. They can call it the Golden Age all they want, but those films are not as good as what we're currently used to. We're used to better films now in the sense of the knowledge we've learned to put these images together. I'm not saying the films are any better or not. The films of the Golden Era are refined for that time period. But if you played them now, they wouldn't hold up. The *best* movies from that period leave a lot to be desired. Of course, a lot of movies done in the *regular* industry during that time had a different pace than the mainstream films we're used to today. But, still, it doesn't *have* to be professional-looking. It can be crude. You know what I mean?

Right. That crudeness can create an atmosphere all by itself. Like John Waters' movies in the Seventies.

Yeah. I mean, they still work. You have to look at them relative to that time. When you look at them now, a lot of them will be boring or too long. The pace in the Seventies was a whole different thing. Look at *O, Lucky Man!*... I mean, movies like that seem really long compared to what we're used to now.

What a great film... Lindsay Anderson...

Isn't that a great film? (Laughs boisterously) "Would you... um... put this in your pocket?" (Laughs) But to compare the two generations is unfair. The people making porn in those days were essentially students, learning their trade. They were babies. And if you look at their movies, you'll see they did things they hadn't discovered yet, things they know much more about now. But, again, you don't have to be proficient in moviemaking to do a good film. You don't. Take a 10 year old who's very expressive in his drawing. It's not the best drawing in the world, but it transcends that. The more tools you have as an artist, the better you should be in the executing what it is you're trying to say. ∎

John Leslie Filmography

VCA Productions:
Night Shift Nurses (1987)
The Catwoman (1988)
Goin' Down Slow (1988)
Hot Scalding (1989)
Second Skin (1989)
Mad Love (1989)
The Chameleon (1989)
Oh, What A Night! (1990)
Bad (1990)
Strange Curves (1990)
Slick Honey (1990)
Playin' Dirty (1990)
Curse of the Catwoman (1991)
Hate To See You Go (1991)
Anything That Moves (1992)
Chameleons: Not The Sequel (1992)
The Rehearsal (1993)
Sexophrenia (1993)
Nurse Tails (1994)
Bad Habits (1994)

John Leslie Productions (An Eye For An Eye, in association with Evil Angel Video):
Dog Walker (1994)
The Voyeur (1994)
Voyeur 2 (1994)
Fresh Meat: A Ghost Story (1995)
Voyeur 3 (1995)
Voyeur 4 (1995)
Voyeur 5 (1995)
Dirty Tricks (1995)
Fresh Meat: The Series (1995)
Fresh Meat 2: The Series (1995)
Voyeur 6 (1996)
Fresh Meat 3: The Series (1996)
Dirty Tricks 2 (1996)
Voyeur 7: Live In Europe (1996)
Voyeur 8: Live In Europe Part 2 (1997)
Drop Sex (1997)

Danielle

Crossover Cooze

Danielle was one of the few starlets to successfully breach the gap between the Golden Age of Porn in the Seventies and the video explosion (or should we go ahead and call it the Silver Age?) of the Eighties. A soft-haired blonde — with perky tits, adolescent cunt, tight little ass (ranked right up there with Nina Hartley's better halves), and a decadent, Presley-like upper lip — Danielle entered porn at the tender age of 18. Her first major film, *The Blonde Next Door*, almost immediately made her a marketable name in 1980. That decade would see Danielle come and go (due to a string of possessive boyfriends...who also came and went), making her a staple of Eighties sex.

The key words to describe Danielle, of course, were 'young' and 'attractive' — a rare combination, indeed, for women of the Golden Age. Granted, starlets like Seka, Annette Haven, and Veronica Hart were blindingly attractive — but hardly fresh meat. Danielle, on the other hand, was such a hardcore teenager, she still had the mark of her graduation cap distinctly lingering in her shimmering blonde locks. And she used that edge to her advantage, starring in a wide variety of films — bisexual, bondage, anal (without ever being ass-fucked!), and fetish — right up until 1990 (*The Lust Squad* marking her final appearance). Yet, though Danielle hasn't appeared in skin flicks for many a moon, you can still catch her at the corner liquor store. No, she isn't turnin' tricks. She isn't even publicising an official porn comeback (not yet, at least). But check out the back sections of some of the X-rated film zines sold in your finer liquor mart...you know, the publications wherein you find those wonderfully sleazy ads for horny Chinese girls, peter pumps, 900 numbers, and woman-sucking-horse-cock movies. Danielle's in there, too, in full bloom, right alongside such dead-but-not-forgotten ad girls as Megan Leigh, Savannah, and Shauna Grant. C'mon, did you expect any less in as free-wheelin' a racket as porn? To quote professional slimebucket Don King, "Where else but in America?"

Strictly by chance, I ran into Danielle dancing at SF's New Century Theatre in late '93. She was a housegirl. A housegirl?! I couldn't believe it. "Here's a classic porn starlet," I thought, "coming up to me and asking if I want 'company'." I asked *her* for an interview instead. Sure enough, a week later, in her cosy Nob Hill apartment — with the din of cable cars and wisps of fog drifting up from the busy streets below — Danielle opened up about past, present, and future. Gregarious, warm, yet streetwise, she talked about (among other topics) growing up a (privileged) youth in Sacramento, her sexual exploits in the Golden and Video Ages, the ups and downs of a stripper, battling an addiction to crack cocaine and her vocation to the adult industry in general.

Unfortunately (or, fortunately, depending on your perspective) more and more adult films are glutting video stores these days, making it increasingly difficult to find titles dating back only a few years. As a result, many of Danielle's features — some dating back well over *fifteen* years — are all but impossible to locate.

Let's start at the beginning. What was it like growing up in Sacramento?
I had the best of everything, and I took every lesson in the book, from horseback riding, to gymnastics, ballet, acting...everything. My parents took real good care of me. Then when I was 15 they got divorced. We had a vacation home in Mexico which my mother and I received in the divorce settlement. So we split to Mexico

The Blonde Next Door, videobox artwork for Danielle's first major porn film.
Courtesy: Collector's Video

and lived down there for a year. I *loved* it. My mom was really hip. She let me live with my first boyfriend, who was 22. I was just 15 at the time. Then my mom's boyfriend and my boyfriend — both of whom were best friends — ended up getting killed. After that, my mother and I moved to Tucson, Arizona. I went back to high school and was a year behind everyone else in my class. And after graduation, I went to LA to become a star. And I *was* damnit! (Laughs) I didn't say what *kind* I'd become. (Laughs)

What about your first sexual experience?

That was when I was 15, in Mexico. I met this babe driving by our house on a boat and my girlfriend and I went (waving arm) "Hell-lo-ooooh!" You know, waving in our bikinis. And he picked us up on his boat. His dad, whom my mom knew, was a real high-powered guy in town, owned a couple restaurants, an airplane, this and that. And I was like "Wow!" (Laughs)

What part of Mexico was this?

It was in San Carlos, which is about 250 miles south of the Nogales border.

So this guy just bowled you over, hmm?

Yeah. You know, I fell in love with him. He didn't believe I was a virgin. I guess in Mexico their idea of an American girl is like… 'They been around.' (Laughs) You know, 'you're-an-American-woman-so-you-done-it-all' kind of attitude. But I *was* a virgin. And I *think* he finally believed it. (Laughs)

Where did this deflowering take place?

At his house. He lived with his parents, had an outside house on their land. The family stayed tight, you know. It was in his bedroom… I remember… (smiling) It was the first opportunity I ever had to fuck. All the popular girls in school were talkin' about screwing. But I was kind of dorky in high school. So no one even *wanted* to screw me. (Laughs) I'm serious. So the first guy that came to me and *said* he wanted to screw, I was like (nodding head vigorously, smiling)… I was scared, of course, but I said to myself, "Okay, I'm gonna do it…" But before I got laid, my mom was uptight about any guy over 18 touching me. She was like, "If he touches you… *statutory rape*!"

Very protective.

Very. I think it was menopause. She was about 37 and started flip-flopping. My first boyfriend and I had an exotic romance, though. On our second date he flew us to Mazatlan. In Mexico you can buy alcohol, and it doesn't matter if you're 15. Of course, I thought I was *very* mature. (Laughs) And when I returned to the States, I had a real hard time assimilating into the whole high school scene. Actually, I had a hard time dealing

"Now, students, I want you to look up my dress . . ."

DANIELLE ⊗ K.C. VALENTINE

Also starring KAY PARKER • MARIA TORTUGA • BECKY SAVAGE • JESSIE BLU
PAUL THOMAS • RICHARD BULIK • GEOFF CONRAD • BRUCE KIRK
JERRY RAM • and WILLIAM MARGOLD as the chauffeur

COLLECTOR'S VIDEO

Danielle; *Intimate Lessons* videobox art.
Courtesy: Collector's Video

with the teachers. They talked to me in a condescending way, as if I was a child. I mean, up until that time, I'd hung out with adults… with my mom who was 37, her boyfriend who was 30, and my boyfriend who was 22. And I hung out with my mom's friends, too… all adults.

Would you consider yourself a product of the Seventies?

Hmmm… yeah, I suppose I'm a product of the… I guess I grew up during the seventies, yeah. It was that 'suburbia' thing for me. I was curfewed, would go roller skating, went to my first concert — The Who — in '76. The Who and the Grateful Dead. I fell asleep during the Dead! (Laughs) I thought they were boring. But I saw that movie *Tommy* and fell in love with The Who.

So how did you get involved in porn?

Well, when I was 18 years old, I left Arizona for LA. I slept on Malibu Beach for a couple weeks near the lifeguard's station. Eventually I got a job at a sporting goods store in this little mall right across the street. And I met this girl who was 16, a runaway. She got a job, too. We slept together on the beach. Her grandma finally felt sorry for us, so she bought us a mobile home right across the street from the ocean. And then

my girlfriend kicked me out. That's when I got a full-time job hostessing at a restaurant. I was only making like $400 a month. Actually, when I first got to LA, I'd gone into Jim South's office, and I was appalled at the fact... I mean, I was like, "I will *never*, *ever* do that, 'cause I'm gonna be like Marilyn Monroe. I'm not gonna have that *slapping* me in the face later," okay? (Laughs) That was my attitude. And then six months later, after my girlfriend and I had completely broken up, I ended up going back to South's office. At that point, I was living with a guy, working full-time, making 400 lousy dollars a month after taxes and everything, and had to come up with half the rent. But I didn't have it.

So I went back to Jim and he set me up with a job... for *Velvet* magazine, I think. A photo shoot. And I got a hundred bucks for the whole shoot — eight hours, one hundred dollars. I was like "Hmm... five days a week... that's $500." So the next day I called Jim up, and I'm all I-Spy secretive because I didn't want my boyfriend to find out. And I find out *Hustler* wanted me to do a shoot for 'em. At that time they paid like $1,500 for *three* days work. I was like "Whoooo! That is a *lotta* money!" So after that, I modelled for practically every magazine. Then one day I was leaving Jim's office and that girl Monique-something... you know, with the big boobs... kind of an old-timer, too... been around for a long time... I was with her in her car and she was gonna give me a ride home, and she said "Oh, I'm gonna go try out for this porno movie. You wanna come along?" And it was at Ted Paramour's place. Ted had these big budgets back then. We were like "Whoooo!" So we went to Ted's house, and all that Monique did was read lines 'n' show off her body. I was just surprised at how *easy* the whole thing came off. At first I was thinking maybe she'd have to fuck all these old guys to get the job. And see, when I was in LA originally, I *did* get a scholarship to attend this acting school. And this old man who said he could get me in the mainstream movies took me to a producer's house saying, "Now he's gonna put you in a movie, so you better be nice to him." And (laughs) this guy was 80, I was just 18, and I'm like "Naaaaaaahh" (Laughs) "No way. I'm not gonna fuck *this* guy." So then, in terms of the porno thing, I just said "Fuck it... might as well try it... " But, see, at least in porn, you don't have to fuck to get the job. In straight acting, you *have* to fuck to get a job. I mean, I *truly* believe this. Anyone who is a star in mainstream has *fucked* their way to the top. Believe me, they've *slutted-out* to the utmost.

It's the reverse in porn, though.
Right. In porn you don't have to fuck to get the job. You fuck *on* the job. (Laughs).

Was *The Blonde Next Door* your first film?
That was my first major role. I did *Night Dreams* before that... just a small part, in one scene. Pretty big film, though. The same folks also did *Café Flesh*. They're very creative guys.

You had a crying scene in *The Blonde Next Door* which, for such an early feature in your career, really showed your scope as an actress.
Yeah. I think I did pretty well in that crying scene. Remember in that scene where everyone's talking on top of each other? Well, everyone on the set was telling me (talks excitedly) "Are you gonna remember?" "Are you gonna be able to read?" "Can ya do it!?" "Can ya do it!?" And I hadn't memorised the lines yet, so I just said, "Leave me alone." There was just too much stress on me. So I went into the bathroom and studied the script. Usually what I do is read the first line, memorise it, then I read the next line, and keep going back and forth, adding another line each time. And by the time I get to the end... (Laughs) Anyhow, that's how I memorise the script.

Danielle; *Intimate Lessons*.
Courtesy: Collector's Video

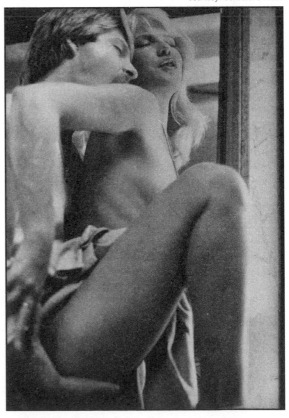

What about the come, urine, or whatever it was coming out of your pussy in that movie?

We rigged that up. We took an enema bag, hid it, angled it, cheated so the camera couldn't see it, and it would just... squirt out. I went to Japan to promote the film. That was first time I'd ever been on the road, too. It was crazy because the Japanese really *believed* that movie! They believed I squirted out my orgasms like that. They even brought a doctor in to take a specimen of my come. (Laughs) We had a big press conference with everyone taking pictures and asking me questions like (pretends she's holding a microphone) "'Scuse me blah-blah-blah." (Laughs) And I was at a big banquet table answering questions, people taking pictures. It was really exciting. Even Japanese *People* interviewed me — that's the *People* magazine of Japan. The month before me they had interviewed Victoria Principal, and two months before that they interviewed Brooke Shields.

Do you remember how you felt after making your first porno?

Didn't have a problem with it. When I grew up, my parents always walked around the house naked. I mean, I could walk into the bathroom and my dad would be standing there shaving in the nude. I didn't think anything of it. They raised us to believe there's nothing wrong with the human body, and you shouldn't be ashamed of your body. They were always very open.

So your parents were fairly progressive.

Well, no. When I was 11 or 12 years old I was growing pot plants in my closet, and my mom didn't dig *that*. (Laughs) It's funny because she started smoking pot later. I busted her, too. (Laughs) Yeah, we've done role reversals. I'm the mother and now she's the child. But my parents were open about the skin thing. My stepfather — he was really like my dad most of my life — he's a very wealthy lawyer. If I felt shy to be seen naked, that was okay, too. They obviously respected my feelings.

How did they feel about you getting into porn?

Well (laughs), that's a whole *'nother* story. I tell ya, I need to write a book. When I left home at 18, I kind of ran away. And I didn't speak to my mother for *years* . Then I happened to run into her at a Chicago CES convention years later. I hadn't spoken to her in three years. And by a fluke she was there with her boyfriend. And she told him, "Well, if you really want to see a girl that looks like my daughter, that girl right over there, she looks *just* like my daughter." And she got a little closer and went, "Bill?... Bill, that *is* my daughter!" So she runs up, calling me by first name. "Danielle! Danielle!" But there were so many guys packed around our booth that she had to like *bust* through 'em... this little tiny woman with her arms waving all around. She was all

Danielle; *Expose Me Now* videobox art.
Courtesy: Cal Vista

happy with me. And I'm like, "Mom, I don't *believe* it..." It was just a trip... fate that we were supposed to meet again. When I left home, though, I was so mad at her. You know how they throw that 'I-could-charge-you-rent' thing at you when you're 18. I was just like "Well, hmmmm... if *that's* the case..." (Laughs)

Is your mom still alive?

Yeah. Would you like to see a picture of her? She's very cute. (Goes over to bookshelf to get picture.)

That's your *mom*? She looks very young.

Um-hm. That was taken recently. She's on a boat and her hair's blowing in that picture, though.

Does she live in Northern California?

In Grass Valley. Here's a picture of my little brother. He was just de-virginised at 23. (Laughs) Talk about total opposites. Isn't it ironic what life does to you, huh? He had a porn star sister. (Laughs)

Did he talk to you about his first time?

Yeah. We talked about it *before* it happened! (Laughs)

I told him how to get laid. "You gotta take 'em out," I told him, 'cause, you see, he didn't drink any beers or anything. And I said, 'You gotta have at least *one* beer." I was like (snaps fingers) "Go to a meat market, (snaps fingers) have one beer, (snaps fingers) buy her as many drinks as she wants, and you'll do fine."

Was that here in the Bay Area?
He lives in Sacramento.

Back in the Eighties, when you were full-steam into porn, how did you feel about that particular kind of lifestyle?
I *loved* it. But I only worked in increments, in spurts. I would have a boyfriend and I'd quit about two years because I'd usually have my boyfriends for about that long. And after I got back into porn, I'd eventually quit again, 'cause boyfriends don't like you making porno. Now it's different. Nowadays they don't mind pimping their wives out. (Laughs) The guys are getting married to these ladies and they don't care. But, still, you know how guys don't want anybody fucking their girlfriend. But I believe the reason I was so popular — because I certainly didn't have any boobs — was the fact that… Well, I'm getting a bit ahead of myself here…

Okay, there was the Sixties, right? And during that time there were basically ugly, ugly girls in the scene. Then in the Seventies there were ugly, *ugly* fucking girls in these weird, seedy hotels. Really tacky. Then they came along with *The Devil In Miss Jones* and *Deep Throat* and Seka. And I believe Seka was one of the first *pretty* blonde girls willing to fuck in front of the whole wide world. Then I came along, right? I only had the singular name 'Danielle' because Bobby Hollander wanted to fashion me after Seka. She was kind of spacing out by that time, living in Chicago with some hairdresser or whatever, and just… not working that much anymore. So Bobby was like to me, "Oh! The next Seka! I can *see* it!" And that's why I just go by 'Danielle'. Bobby thought it was more dramatic, catchy… like the name Seka. And he was trying to market me as the next Seka… trying to make me a star. (Laughs) He had a talent for it, though. Shauna Grant and Amber [Lynn], they were his discoveries. So he was really good at pullin' 'em out of his sleeve.

But, getting back to why I made it so big. See, then I was like an 18-year old blonde. And it was like, "Shit, who *cares* if she ain't got tits? She's *eighteen*!" (Laughs) And, again, back then they didn't have that many pretty girls willing to fuck on film. And I really believe I was a pioneer in that sense. Taking it a bit further, I think other girls watching my films with their boyfriends got to thinking, 'Gee, *that* pretty girl did it. *I* could do that.' Maybe my films made them more willing to do porno. It's like in an audience — if one person claps (claps), everyone else starts clapping. We do the same thing at the Century.

Who were some of your female peers when you began porn?
Serena, Lisa DeLeuww… Ronnie [Jeremy] and I had to fuck each other a lot in the beginning. There were a lot of movies I made out in Mill Valley. (Winces, grabs her knee) Oh my knee…

What's wrong?
Oh, shit. I just crunched it again. I pulled it. Oh it hurts like hell. Shit. See, last week our feature star was Shauna McCullough, who had a laser light show. But to make the lasers show up, you have to put smoke in the air, right? And the machine that blows the smoke was spewing out fine oil, which got onto the stage. And when I was doing my act, I was doing a turn, slipped on the oil, fell, and cracked my knee. Pulled it right there.

No workman's compensation, huh?
No way! We sign a contract every day when we walk in. But I could sue Shanna. (Laughs)

So did you hang out with porn stars like Serena and Lisa DeLeuww after you finished doing a film?
No, not that much. I mean, maybe we'd go have a drink or something during the movie shoot. But when the movie was over, I went to LA and lived in my own world. Back then I lived in LA most of the time. I moved to Manhattan for a couple of years, too. Remember when the business relocated to New York after all those busts, when they had like a narco task force in California that had jurisdiction over the whole United States? They even busted people from LA making porn in upstate New York. But any big city is a little more liberal about that shit. So we started filming in New York and started working for the guys that owned the Pussycat theatres. I know one of 'em was like a mobster guy, but he was *really* good to us, always very nice. In fact, they *owned* the Pussycats, so they made movies to show in their own theatres. You know, you make it, distribute it, show it, you make all the money. And we used to always film in Plato's Retreat.

You also appeared on a number of talk shows on American TV in the Eighties, didn't you?
Well, that's what I did when I'd go on the road dancing. And I started dancing a little here, a little there. It was a little different back then; there was just a dance circuit for strippers. And I was one of the first *porno* woman to break in. But me, I was like, "I don't even know *how* to be a dancer." (Laughs) That was around '82. But, really, I don't like being on the road.

Because the lifestyle's so rough?
Well, I travel alone. I mean, I'm not gonna *pay* somebody to baby-sit me. (Laughs) And if you travel alone, you have to watch out for yourself, because they try to take advantage of you. But if you have a boyfriend with you, they usually pay up and act normal.

The club owners?

Um-hm. But if you're alone... I don't know, I been fucked over too many times. It's lonely. You also end up spending a lot of money on the road because you end up buying stuff all the time.

How long have you been at the Century?

For a year now. But I used to feature there a while back. One of the owners hangs out at Market Street Cinema. Anyway, when I was low on money or whatever, he'd give me work right away at The Market Street if I called him up out of the blue.

Is dancing a very lucrative job? — with tips and all?

Yeah. It doesn't hurt to be here in San Francisco, either. I get recognised quite a bit.

Lap dancing with a porn star... fans must get quite a kick outta that.

They really trip on it. "Oh my God," they say. "Oh my God. I can't believe it." Some guys tell me they grew up to me. (Laughs) It makes me feel *so* young. "I grew up to you..." (Laughs) But, yeah, I'm making good money. I just don't like being in a hotel. So I have my little apartment here. And I just bought a house in Sacramento. It's my first house, just a starter in the city. I'll have it paid off in three years or so. It's a good deal.

How do you like living in San Francisco?

I *love* San Francisco, except it's so fucking expensive.

Do you enjoy dancing? Or is it just another job?

Yeah. I like it. I hang around with all the 19-year-old girls who are coming into the business.

I'm sure some of them want to get into porn. Do you give them advice about the business?

I try to but, then again, no one can ever learn except from experience. You can talk 'til you're blue in the face, trying to tell people not to make the mistakes you did. But they're not gonna learn 'til they fall. I plan on being here dancing for the next... put it like this, I'm gonna drag it out to the bitter end, honey. When I was eighteen and I first started dancing, I thought I was gonna go in, take one day's work, and stop. Never in my *life* did I think it would become a career. But when I was twenty-eight, I turned around and said, "This *is* like a career now." It'd gone that far. The skin business, stripping, Nevada, whatever it is, it's gonna be what I'm gonna do because it's what I *know* how to do best. I quit before and tried to work for boyfriends as secretaries and (laughs)... oh God, I sent out Christmas cards at Thanksgiving... things like that. I didn't know. I was just trying to be helpful. (Laughs) But I'm gonna keep dancing, and in a couple of years when I start getting a little older... I mean, I'm not opposed to plastic surgery. I'm gonna get my boobs done again. I've already had 'em done once.

When was that?

After I quit the business for a while I had 'em done... just before coming back to make *The Lust Squad*. And that was my big 'fuck you' to the industry. I was like, "I got tits and you can't have 'em now. Fuck you," you know? (Laughs) I got 'em done for myself, and I think it's the best thing I ever fucking did. I was gonna get 'em done again this April, but guys always rave over my body. I mean, they're all happy with it. But if I was gonna get my boobs done bigger, I'd go to a doctor who did 'em right. They'd have to look natural. I wouldn't want them to be *so* big that I'm a freak. But I'd like to maybe go to a 'D', just because it helps prolong your youth. I want to extend my career. I don't want to progressively go downhill. I think if I play my cards right, in another five years, maybe four, I'll get my boobs done. The technology for boob jobs is getting better all the time. That's *really* the deciding factor. So why not just wait and get the better ones? Besides, I'm not doing so bad right now. I'm buying a house, and have basically got my priorities in other directions at the moment.

Do you do any other work besides dancing?

Um... right now? Just working on my yard at my new house. I also like to sew... make costumes and stuff.

The ones you wear in your shows?

Um-hmm. And when I retire I'm probably gonna end up doing that... being one of those ladies who brings in a rack of clothes at a strip club and sells costumes. (Laughs) I'm also learning how to use my computer. I'd like to learn how to play my guitar... someone gave me a guitar recently. Those are some of the things I want to do, but it takes time to set it all up.

Have you ever worked behind the camera? — directing? — producing?

Never. I really wish I did. Maybe I'll take some classes just for the heck of it because I really do enjoy the creative level of filmmaking. And I understand the other side of it... that you can't be an actress forever. It's short-lived. There's always another pretty face out there. And that's what they're into, especially in porno... you know, it's a man fantasy. Men are always looking for another pussy to conquer. (Laughs) Even if they've got one at home, they still have to go and see if they've *still got it*, if they can conquer it. And afterwards, they're like "Okay, I'll go back to my good one now."

I have to agree with you. What is it about us? What makes us feel the urge to fuck a score of women?

Danielle at Vomitus Maximus Art Gallery, San Francisco, circa 1993.
Photo: Anthony Petkovich

I don't know… fragile egos or something. It's the nature of the beast.

Do you think there's a vital difference between video and film?

There is. I don't like video. I think it's ugly. If you're gonna make a porn movie and make a quality movie, shoot it on film and then transfer it to video. I didn't do Dark Bros. films, and I'm sure I limited myself quite a bit by not doing them. But that was my choice. Then again, I went to Germany and France once to do an all-anal movie called *The Backdoor Club* — and I don't even do anal. (Laughs) I was getting (snaps fingers) $850 a day, (snaps fingers) eight days in Munich, (snaps fingers) two days in Paris. And in the movie I just watched other couples doing anal. And at the end of the movie, I insinuated that my husband and I were gonna go home and try it.

So you weren't really that much into DP's and anal?

No. I don't do that. I'm saving my asshole. I mean, you have to have *one* virgin hole. (Laughs) If I ever get married, my husband can have my asshole. But, no, I'm really not into that. It hurts. I have a lot of doctor friends and the bottom line from them is: if you do a lot of anal sex, you'll become incontinent when you're older. And I certainly don't want to walk around with shit in my pants. (Laughs)

Were you ever married?

I was married once — for four and a half months. I'm trying to get a divorce right now.

Speaking of marriage, how do you feel about bondage?

(Laughs) I want to get into some fetish films, yeah. I've heard that there's quite a bit of that going on in San Francisco.

Spanking films…?

Yeah. Yeah. I would *love* to get into some of that. I did some enema fetish films a while back, too.

But your last film to date was *The Lust Squad*, right?

Right. I made that film when I was 27 years old… giving away my age. (Laughs) About five years ago. I'll be 32, actually, in April. Anyways, that's when the money started going down. It was *legal* then to make porno movies at that time. They had a sound stage in LA, and this and that. But the money had gone down for sex scenes. I put in three sex scenes the day I filmed *The Lust Squad* and made $1,000. But back in the old days when you got $1,000, you'd agree to do one guy-girl, one girl-girl, and maybe an orgy. But you wouldn't *always* have to do that. Maybe some days you'd just do one guy-girl in the morning, some dialogue later on, and you'd be gone. And you'd *still* get $1,000. Now they're, "Nuh-uh." (Laughs) They got hip to that. Now they're like, "Unless you're fucking, you don't get any money."

So what happened was, after I quit the business around '88, I got addicted to crack cocaine in LA and I really had a lot of problems. I'd already pushed making movies three years past the point when AIDS came out in the media. I just kept going. But when John Holmes died of AIDS, I left the business. When it got *that* close into the business, forget it.

Which male co-stars did you prefer working with?

I liked working with John Leslie. And Joey Silvera, he's a nice guy. Actually I heard that John lives around here, out in Marin or something. He's a real nice, level-headed guy. Quite handsome, too. Oh, I loved his eyes. (Laughs) And he loved my ass. He was just like (pretends she's ramming someone), "Doggie, baby… NYAHHHHHH-HHHHH!" (Laughs) I've heard he paints, too. He's quite a creative guy.

You and Amber starred in a number of films, one of which was *Miami Spice*.

And we actually filmed that in Florida, too. (Laughs) We had fun, fun, fuuuuuuun… Amber and I. Oh God, we were having *too* much fun. She won some X-rated video awards when we were in Florida. And you know that nice boat in that movie?

Um-hmm.

(Whispers) That was Barbara Mandrell's boat. (Back to regular voice) I don't care if that's on the record. Fuck it. (Laughs) That was Barbara Mandrell's boat! (Laughs) I don't think she lived there, though. She just had someone in charge of renting it.

What about some of the directors you liked working with?

Henri Pachard was one. I met him in New York. He's from that mob thing over there… still kicking it, too. He's like one of the only ones. But, you know, I really didn't pay that much attention to the directors. I think I worked for the Mitchell Brothers once. (Laughs) But I don't remember.

Just a job, hmm?

Right. I was just talent. I was just into like (snaps fingers) "Oooooh… I'll fuck everyone." (Laughs)

Have you been in many features on the slightly more mainstream level?

I did some cable work. I was mostly in R-rated videos like Electric Blue, The Girls of Penthouse, the Playboy Channel.

What do you miss about the porn scene?

The travel probably. If you go travelling with a group of people making a movie together, you have someone to hang with when you're in that town. You know what I mean? But when you go dancing on the road, you're alone. You might have to fuckin' hang out in the bar to meet someone, and they're always out for pussy or whatever.

As far as a return to X, what are your plans?

I don't know. I guess I'd have to start all over again and break out a newspaper. I understand they're being quite safe now. Most of the stars have one doctor apparently whom everyone has to go to. The stars go in every three months for an AIDS test. And if you *don't* have your paperwork updated every three months, you're not working. Period. I have no problem with that because I also worked in a brothel. Did it for a couple years — from late '89 to '91 or so… up in Nevada. We had doctors… used to get our AIDS test once a month, including gonorrhoea and syphilis once a week. And we used rubbers. So you can see why I was a little stand-offish with the porn industry. Not only that, once they test you in Nevada, they lock you up; you go into the whorehouse, and you can't leave. You're a prisoner, because they can't be responsible if you go out and fuck someone. You could contract a disease, pass it on to a customer, and the brothel could get sued for not being on top of the situation. But, no, I wouldn't mind making a few more movies just for the hell of it. Fuck it.

Would you expect your male co-stars to wear rubbers?

No. I'd just probably use the Today Sponge or something. But, you see, my theory is that AIDS is going to better itself eventually to Nonoxynol [a birth control pill]. Just like gonorrhoea is penicillin-resistant.

Almost forgot to ask: what's your favourite position?

I like being on the bottom, baby, (laughs) 'cause I like being comfortable. I don't like my muscles achin'. Besides, you guys have a better rhythm in that position. Doggie's okay, too. But I like missionary best 'cause I like to look at their arms… they're over me and I'm all "Ooooooohh take me, baby." (Laughs)

How do feel about girl-girl scenes?

I love 'em. Yeah.

When did you learn you were bisexual?

After we came back from Mexico, when I was going to high school in Arizona. I was hanging out in bars and stuff… had fake ID. 'cause I was like, "Fuck, now I'm in the United States and I can't even go to a disco or a bar?" Anyhow, I fucked some bar owner and his girlfriend. They were into high-heel shoes, had this Jacuzzi — it was hot. But I like pretty girls. This girl wasn't that pretty. But I was… curious, you know.

How about oral sex? You really give a mean blowjob.

Actually, I prefer *getting* head than giving it… ∎

**DANIELLE
SELECTED FILMOGRAPHY**

Sex Spa USA, The End of Innocence, The Sex Detective, Miami Spice, Miami Spice 2, Aggressive Women, The Backdoor Club, Switch-hitters, Nicki, Sex F/X, Hostage Girls, Leather & Lace, The Life and Loves of Nikki Charm, My Sinful Life, The Oddest Couple, Summer Beach House, The Thrill of It, Oriental Hawaii, Raw Talent, Pumping Flesh, Scented Secrets, Sex Pistol, Behind the Scenes of an Adult Film, Memphis Cathouse Blues, End Zone, Forbidden Worlds, Vanessa…Maid in Manhattan, Working It Out, Hot Stuff, Hottest Ticket, Karate Girls, The Lingerie Shop, My Sinful Life, Inspiration, Stray Cats, Expose Me Now, Stage Girls, Amber Lynn's Personal Best, Flasher, Bondage Boot Camp, Black 'n' White in Color, White Women, Sweet Dominance, The Therapist, Pink and Pretty, Rambone: The First Time, Women At Play, Moments of Love.

Cumisha Amado

A Fistful of Amado

For decades porn audiences have craved more Oriental poontang. So why the shortage? I've never really understood. Over the years, Asian girls like Mai Lin, Saki, Anisa, Satomi, Mimi Miyagi, and Liquid Slater have consistently given inspired moments of deep passion and lurid love to their sex scenes. You'd think that (merely in the name of decadence) their vast accomplishments would have *easily* paved the Burma road for more Asian ass. Not so.

Yet in the case of Cumisha Amado, the unsuspecting porn public got more than it bargained for.

An exotic mix of Filipino, Japanese, and Spanish, Cumisha (much like Saki) was a late bloomer in porn — but a maniacally *filthy* Far Eastern vixen excelling in the arts of anal, DP, and gang bang. Simply put, Cumisha loved dick, *any* which way she could get it. For instance, how often do we find a slut (let alone an Asian slut) who'll consume two throbbing cocks in her butthole? Cumisha did it without a second thought. *Très* nasty. She was also extremely fan-friendly. When I saw her performing in San Francisco at the Market Street Cinema in 1994 (with co-star Lana Sands), she was jumping up on chairs, wiggling her tush in fans' faces like a randy bunny rabbit, sticking a double dong up her cunt and asshole, and — oh yeah, almost forgot — shoving her whole hand, all five digits, an entire *fucking fist* straight up her shitter. Now *that* was a showstopper! With her hot, little, brown ass to the audience, her wrist slowly disappearing into her anus, I was half expecting Cumisha to turn around and display a set of fingers wriggling gleefully from her open mouth. (And, yes, Baby Wipes were on hand to mop up any excess Hamburger Helper.)

I'd love to know the breakdown of your nationality.
Well, I'm Spanish, Japanese, and Filipino. On my mother's side, my grandmother's from Spain and my grandfather's from the Philippines. And on my father's side, my grandmother's from Japan and my grandmother's from the Philippines. I also understand four dialects in Filipino.

You really worked your ass off on that stage tonight.
Yeah. And they also go, "You're so little. How can you stick your whole hand in there?" (Laughs)

I definitely want to get into that a little later. But let's backtrack a bit. Would you mind talking a bit about your first sexual experience?
Let's see... my first sexual experience... the first time I had sex? That was when I was 16. I was a late cummer. And that was with my baby-sitter. (Laughs)

Male or female?
Male. He was 10 years older than me. And he said, "Well, now that you're a grown woman, let me teach you a few things." (Laughs)

I bet he didn't ask for any baby-sitting money from your parents after that.

Cumisha Amado at the 1994 FOXE Awards, Los Angeles. Photo: Arno Keks

Cumisha Amado; *Blow Job Boulevard.*
Courtesy: Sin City

It was easy, too — he was just down the street and around the corner. (Laughs).

Did you have an orgasm the first time 'round?
Yeah. He had a big dick. A *really* big dick. And then my pussy was so... it wasn't... you know... (low voice) well, it was hard for his dick to get into my pussy, you know, it was the first time. But I got used to it after a while. (Laughs)

How long have you been in the business?
A year and a half.

Any new films you'd like to talk about? Any which stand out?
The ones that stands out... (thinking)... God I've done so many... oh, well *Bachelor Party* is a new one... um... *Junkyard Dykes, Smooth As Silk.* Bionca and Debi Diamond are in the *Bachelor Party* tape. Watch that one... a lotta high energy and downright dirty sex. (Laughs) Debi Diamond is really wild. She jumps off the table and just *stomps* on T.T. Boy. (Laughs) A lot of action and energy in that one.

On the Road With Sean Michaels —
you were in one of those weren't you?
That was fun! We did a Chinatown scene over here in San Francisco. We were in a restaurant that had these booths in it, and they were filming inside the booths.

Did you rent out the restaurant?
No. No. This is real stuff. We had lunch, closed the curtains... it was right here in San Francisco, up in Chinatown... (whispers) don't put the name of the restaurant in the piece, though. But this restaurant has booths with curtains you can close, and you can press this buzzer, this little bell to have the waiter come and bring your food when you're ready. When the food

came, I was on top of the table and we were shooting in the booth. We were worried the whole time that the waiter might pop in. But (giggles) we had a lot of fun in there. And afterwards we went to one of those import stores in Chinatown. We went all the way down to the basement where they had the furniture and everything. There was hardly anybody there, so I could lift up my skirt and show my pussy throughout the whole store. There were just a few customers. We were very discrete when we were filming. Sean was carrying around the camera... it was so funny... (whispers) and there were people watching.

What about your first X-rated film?
Anal Annie's All-Girl Escort Service. (Laughs) That was my *very* first movie. It was for Rex Borsky and starred Nina Hartley.

What was it like working with Nina?
Oh, she's a wonderful person. She's also a personal friend of mine. She's the one that actually got me started in the business.

Where did you first meet her?
At a swing party. It was at a mansion here in San Francisco above St. Francis Woods. A private club. They have parties there every third Saturday of the month. The house is still there, but the owners are gone. They sold the house. But I met Nina there. I didn't do a movie until eight years later, though. I was working as a nurse during that time.

Are you from the Bay Area?
I'm from Marin County. I was born in San Rafael. Then I moved over to Vallejo — military town — went to school at San Francisco State, graduated, and was a nurse for six years at Alta Bates Hospital in Berkeley.

Do you still live in Marin County?
No. I live more towards Marina Del Rey now. I was living in Hollywood for a while… didn't like Hollywood. I wanted some fresh air instead of the smog… (fluttering her eyelashes, smiling coyly) Do you want to know what my speciality is?

Please.
(Laughing) Double anal. (Giggles) Two guys… in the butthole. Actually there's a movie called *Double Butts* produced by Sigma Cum Laude. (Laughs) It's a different kind of movie because it's with a post-op transsexual. And she had a real pussy. And you could actually put your dick in her pussy and fuck her. (Laughs) They took away the dick, you know. (Laughs) It's just a piece of skin that hangs down like a flap.

Thank goodness for the fast forward button. So in what movies have you done double anal?
There was a double anal in *Bachelor Party*. There's also a double anal in *Double Butts*.

What about your first anal experience? How old were you?
My first anal experience was… oh God, when I was like 24 years old. I was a late cummer in that, too. I remember it hurt sooooo bad. It was a bad experience. And then someone told me to just practice and stretch out my muscles with my fingers, 'cause a lot of people aren't introduced to anal sex properly. They see it on the screen but they're not educated about it. You need to prepare your butt for anal sex. You just don't put the dick *right in* there for the first time because you could rip some muscles. All you have to do is gradually put a finger in and stretch it over to the side. And then keep adding fingers in and stretch it over to the side. Then, if you want to get into the fisting, you gotta keep practising 'til all your fingers are in there, and then… twist it, you know… just relax your muscles, and then just push your whole hand in when you relax… gradually… and it'll go in.

And you've been practising this for a while.
A year. It takes a year. And then you're ready for the double anal. That's when you get two dildos up the butt, or two dicks, and one in the pussy. I can come from a double anal. I enjoy it.

Is it difficult to come when you're working with a large crew on a film?
No! That's even *better* because I'm an exhibitionist. Oh yeah. I really get into it.

When you got the hang of fisting your ass, what happened? Did you see angels?
No, when I got the hang of it… actually, it was Dick

Nasty who taught me how to do that. He has his own company now, too. His hand's a little bit bigger than mine. It's illegal to do fisting on video here.

How many films do you average per month? Per week for that matter?
It depends on how much work there is. I can do, three, four movies a week. You can do maybe five movies a month. It just depends. You could go up to ten movies a month if you really want to swing it.

You obviously like DP's.
Those are great, too. I've done 'em with *so* many guys. God, there was Ron Jeremy, Peter North, T.T. Boy, Marc Wallice… those are some of the major ones.

And gang bangs.
A *lotta* gang bangs. For John T. Bone, Harry Horndog…

Boiler-plate question: what's your favourite position?
I like doggie. I like pile driver, that's when you lay down and your legs are over your head. It goes in deeper, there's more of a thrust. Like when a girl puts her legs over your shoulders and your dick goes in deeper. You want to know what the craziest thing that I've done is?

Sure.
I was at a bachelor party for Zane where they had two Doberman Pinschers. The Dobies were on these stairs watching everything. And so, right in the middle of my whipped cream act, one of the doggies came down and approached me. And I said to the owner, "Now, this dog isn't gonna come near me, is he?" And he goes, "I'll give you a couple hundred bucks if you let it lick your pussy." And I go, "Are you sure?" "Oh, he *loves* whipped cream," he says. So the Dobie came up when my legs were spread apart and just *went* for it. And afterwards they asked, "Well, how does it feel with a Dobie licking your pussy?" "Well," I told them, " it's not like a cat because it's not like sandpaper. But still it was a little bit coarse. But… it did feel good." (Laughs)

The dog wasn't complaining either I'm sure.
Oh! I gotta tell you what happened after that. The dog that licked my pussy went upstairs where the other Dobie was and started humping the other dog.

Did they get the Dobie licking your pussy on film?
Yeah. They were filming it. (Laughs) They took the video cam and shot it.

What would be dependent on your staying in the business?
Right now I'm doing a little bit of both — in front of the camera and production. I've produced three movies. *Casting Call* — I think VCA put that out — *Joy's Lucky*

Club, and *Miss Fix It*.

When you produce a film, what exactly is involved?

A lot of work. You've got to get the talents together, juggle around the budget, figure out how much you're going to pay talent, how much you're going to pay the crew. You've got to make sure there are back-ups when talent don't show up on set. You have to get the PA's. It's basically a lot of technical things.

What's the best and the worst part about producing?

It's a lot of work… calling people up. You've got to keep calling everybody to make sure they make it there on time. First you've got to read the script so you can match the talent for that particular character. You've got to analyse the script. You've got to figure out how much you're going to pay the talent, how much your overhead is going to be. It's a lot of work. But the best part is the end product, the result of all the editing.

Do you feel scripts are necessary in porn?

Let me tell you what happens. There's a basic script and everyone goes through it. There's always a change in dialogue and that's a pain in the butt. A lot of times it's better for the talent to read the scripts and for you to ask them, "Well, do you feel comfortable with this?" We want them to be themselves. That's another thing — if it's a big production, they have to pick up the script about a day or two beforehand. There's a lot of time involved in it. And time is money, especially if you're shooting on a location. You don't want to have

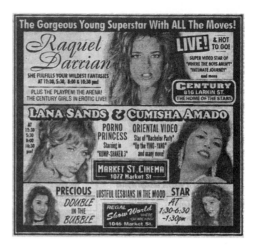

talent waste a lot of time coming late and not knowing what their lines are.

Do you see yourself going more in that direction than performing in front of the camera?

Yes. I'm doing a lot more of that. I co-produced, directed, and starred in all three of my movies. That took a *lotta* work. It was like around the clock.

Have you done much location shooting?

For *Miss Fix It* we used a Malibu ranch… and, of course, you have to rent the ranch. And that's money right there. You're talking about anywhere from $100 an hour to a $1,000 a day. There's a lot of laundry costs involved. And generators. We're talking about big generators to run the lights. When you're on location, there are certain spots that are pitch dark and you've got to have generators… especially in the mountains. And then Malibu gets foggy at certain times. You're working with Mother Nature so it's harder to shoot on location than in a studio. In the middle of the day you get that strong brightness.

Do you have your own company?

No. I work for other companies now. Eventually I'd like to have my own company. It depends. It takes time and money. Time and money.

One of your favourite films so far?

Of allllllllll my films?… well, my parents know that I'm doing this. (Laughs)

How do they feel about it?

They were pretty open about it. I was shocked. Actually my cousin took home a tape to my mom and said, "You gotta watch this movie." She didn't tell my mom it starred me, though. She just told my mom, "We're gonna watch a movie." So she puts in this video tape and it was *me*. I don't know, it was probably one of my

Cumisha; *On The Road With Sean Michaels 3*. Courtesy: Video Team

gang bang tapes, right? And so my mom calls me up on my pager, and when I call her back, she starts talking in her own language — Tagalog. And then I'm going, "Oh God I'm so embarrassed." She wasn't mad, though. She actually wanted to see *more* of my movies! (Laughs)

Anything you'd like to add?
Um… I love to cook… play the piano. I do concerts for Julliard… I used to teach piano. And I *love* to give great *back* massages.

I'm sure you gave a lot of those as a nurse. For six years you said…
OB/GYN's my speciality [Obstetrics/Gynaecology]. And my mom's also a doctor.

Hospitals are really erotic places. Did you ever…?
Have I ever done anything in a hospital?

Yeah.
In the physical therapy room, in the Jacuzzi, of course. (Laughs)

Doctors? Patients?
Doctors. (Laughs) You know, doctor-nurse types of things. Or the doctor's lounge… during the after hours.

Never in the OR?
In the operating room? No, but I did it in the morgue down below. (Laughs) But not with the patients down there. (Laughs) No. I don't want no formaldehyde. I remember those days in anatomy class in college. One time when we had a break, we took out brown bag lunches from the refrigerator and found a frozen dick in there. (Laughs)

Lana Sands: What did you do with it, Cumisha? Did you suck it? (Laughs)

Cumisha: No way! Threw it out. Who wants a dicksicle? Another Bobbitt case. (Laughs) ∎

**CUMISHA AMADO
SELECTED FILMOGRAPHY**

Superstar Sex Challenge 1 and 2, Bachelor Party, Hollywood 'Ho House, Hollywood In Your Face, Rodney Moore's Dirty Dating Service, Junkyard Dykes, Joy's Luck Club, Miss Fix It, Casting Call, Double Butts, Escape To the Party, Asian Beauties, Dirt Bags, Up the Ying Yang, Erotic Dripping Orientals, Blow Job Boulevard, Frathouse Sexcapades, Fortune Nookie, Rising Bun, On the Road With Sean Michaels 3, Deep Inside Rachel's Rear, Smooth As Silk, Everybody Wants Some, Beyond Reality 2.

Lana Sands

Flesh on Flesh

I love Lana Sands. Fuck it. I *love* the woman. In the mid-Nineties, not only did she have the hardest body in porn — and a mouth-watering bubble butt, to boot — but her personality sparkled like marina fireworks. When I saw her dancing with Cumisha Amado at San Francisco's Market Street Cinema in 1994, I was bowled over. During the show's climax, Cumisha strapped on a dildo and fucked Lana from behind. In turn, while the house DJ fucked up — fumbling with the pre-recorded music in between songs — Lana and Cumisha were still at it, slamming away. All the sleazoids in the club were unnaturally silent. Chests heaving. Jaws clenched. Brows sweating. Eyeballs extended. Hardons a-waggin'. Christ, you could hear your asshole twitch. Then, just as Cumisha sunk that plastic, juice-glittering dong deep into her co-performer's sweet pussy for the thirtieth time, Lana let out a groan. A deep, passionate groan — as if taking a hefty dump in the nearby girls' room. And that's when the house went wild. After the show, patrons awkwardly stumbled out of the joint with their chins on their chests, nervously covering their nether regions on account of ripping themselves new zippers and soaking themselves through. What can I say? I love the woman. I love her!

And aside from having one of the most luscious bodies in porn, Lana was also extremely approachable. Right up there with Cumisha, Missy, and Stephanie Swift. No bitchy airs. No cunty attitude. An easy going girl you could comfortably share a beer with over a quiet game of pool. And ethnicity-wise? Well, you really couldn't pin her down. As Lana herself admitted, she fit all categories: Latin, Black, Asian, or any of the above combos. (She's actually half-Thai, half-Irish.) And all those firm, taut muscles gave her irresistible bronze body more ripples than a Ruffles potato chip. Finding a bit of fat on her was like trying to pinch a concrete wall. Yes, indeed. Lana is proof positive that porn *forever* needs more minorities.

You starred in one of John Wayne Bobbitt's first pornos, which I confess I haven't seen yet. What's his dick look like? — part black, part white, part Zebra?
It's like… um… you've seen Frankenstein with all the

stitches and everything sewn on? It looked like Frankenstein's penis. (Laughs) When it's limp, it's normal looking. It looks like a… limp dick. But when it gets big, it's like a… (shudders, speechless; but soon snaps out of it)… well, you know, just looking at it you could tell it used to be a really nice cock. It could have been something really beautiful. (Laughs) But half of it looks like air bubbles now. The part that's sewn on is pretty much useless. He only gets feeling at the bottom of the shaft, two inches… an inch and half… (laughs)… maybe an inch at the bottom. So if you're giving him head, you've got to deep throat it so you can touch that part.

So was Bobbitt trying to prove that his tool still works?

Um… you know, actually I think he needed some bail money. (Laughs) No. But he's saying, "Yeah," he did the film to prove himself to the public. But if that was the case, he didn't do a very good job on *my* scene. (Laughs) There was me and another blonde girl with him… They haven't figured out a title yet. They're thinking about a take-off from Howard Stern's book… *Uncut Parts** or something.

Lana Sands in *The Voyeur 2.*
Courtesy: John Leslie Productions/Evil Angel Video

So what are your impressions of San Francisco?

Well, I've been to Haight Street. Shopping there is fun, but I haven't really gotten out of this dressing room at all. I have two down days, so Cumisha and I are gonna travel a little bit. But San Francisco seems nice. The people are different than LA. Los Angeles is very 'in style'. I don't like that attitude, that wall. Here, I notice a lot of girls don't really dress to impress at the clubs, which is nice. Most of the people who have nice cars in LA are getting them repoed. They have no money. I went out with a guy who had a Porsche, and he asked me if I would give him 10 bucks for dinner and a pack of cigarettes. It's like, come *on*…

Your scene in *Dog Walker* with Joey Silvera and that French wench Maeva was a real scorcher.

Oh yeah. She didn't speak any English, either. She didn't speak *any*. She had to have a translator. And the only thing she could say to me was "Oui." (Laughs) So everyone was saying to me, "Tell her you're gonna stick

your fist up her ass" (laughs) because she would probably say "Oui." (Laughs) I was so excited to work with her. I picked her out myself, you know. I thought she was really, really pretty. Early on she said she liked girls, so I said, "Perfect. We're going to have a great time. Joey's going to probably end up watching us because we're going to have so much fun." And then when we did the scene, I put on the strap-on, was ready to fuck her, was *really* excited about fucking her. (Aside) I'm a dominant. But, come to find out, she'll let you lick on her pussy, but she won't do anything to another girl. And she won't get fucked by a girl. That's why I didn't… I didn't know what to do with the strapon. I had a dick, and it was all up and ready to go, but she wasn't on. And Joey (laughs), Joey didn't want it. (Laughs) I asked him. I had to fuck somebody, but nobody wanted to fuck me. I've seen Dick Nasty take it. I've seen Tommy Byron do it. Actually, I did the lighting for Tommy and Sarah-Jane Hamilton in a film. I asked to fuck him but she beat me to him. But I held the lights for them so I could just be there, right over them, watching.

* *John Wayne Bobbitt Uncut.*

What was your first sexual experience?

I was raped when I was 15 by my lifeguard. I was really, really innocent, and I'd never had any alcohol before. He invited me over to a party. I brought my girlfriend with me, and there was another guy there. I drank and I was feelin' really good. So I kept drinking. And he really took advantage of me.

Did any good sexual experiences follow shortly after that one?

(Thinking)... Um... good experience... well, after that, it made me start thinking sex didn't mean anything — that it was very impersonal. And it was easy for me to... I guess I became a slut. You know, I just had sex just to do it — not to enjoy it, just to do it. And I never had any feeling behind it for a long time. Never. I hated guys for a long time. And I hated myself for a long time for letting it happen. I guess I did anything to hurt myself, to punish myself even more.

Do you feel that has a lot to do with

the fact that you're a dominant now?

Yes. And a big fetish of mine is fucking guys with a strap-on dildo. I enjoy that. But I think in the back of my mind it might be to have full control, so nothing like that will ever happen again. *I* have the control and I won't let go of it.

So it's... therapeutic for you.

Yeah. And, you know, sometimes it's very difficult for me to come. I'm really the only one who can make me come because I'm scared to let go. I can't let go and really enjoy it. It's very difficult for me to trust somebody else.

What did you do after graduating from high school?

I went to Golden West College in Huntington Beach for two years. I was going to major in math but really wasn't sure. I'd been tutoring math ever since sixth grade.

Obviously you're good with numbers.

Yeah. My dad's a mathematician.

Cumisha Amado: She's great at playing pool, too! She knows the angles.

Lana: (Laughs)

Cumisha: She's a *shark*! Oh God. She embarrassed those preppy guys at the club we were at the other night. They were betting for money and she won.

Lana: I won 200 bucks one time because... you see, the first game you play with someone, you have to kind of win, but you just *barely* win, you know. You don't make really fantastic shots. And that first game you bet for like $20, $30... just enough to get by, to make it look lucky. And then, when they bet a lot of money, you blow 'em out of the water. (Laughs) You kinda gotta bait them so they think, "Aw, she was just a lucky bitch. She ain't gonna win this time."

Cumisha: She sunk the last four balls into the pockets.

Lana: (Laughs)

What about some of your hobbies?

I scuba dive. I was certified. I've

Lana Exposed; videobox art.
Courtesy: Video Team

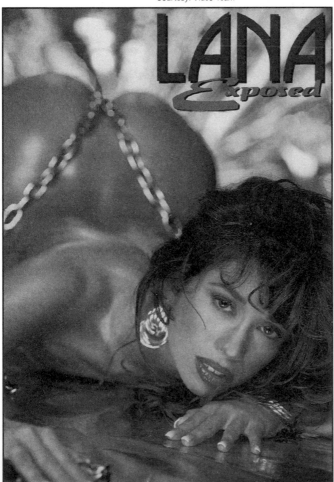

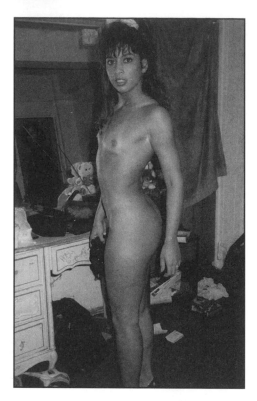

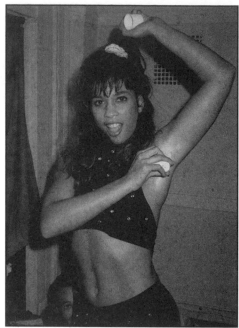

Lana in the dressing room of San Francisco's Market St. Cinema.
Photos: Anthony Petkovich

been doing that for quite a while. I love to swim, love water sports. I jet ski. Um… I also sing.

What type of music?
Stuff like Sarah Brightman, who was Christine in *The Phantom of the Opera*. She's got a beautiful voice. I also like singing stuff like The Cranberries. Is that alternative rock? Alternative rock, yeah.

Are you thinking about maybe pursuing that?
God, you know, I have stage fright. In the bathroom or at home, I sing great. Or I could sing to you now and sing great. But put me on stage…

I'd love to hear you.
(Laughs, embarrassed)

But I don't want to put you on the spot. You don't have to.
(Laughs)

Hey, let's get back to sex. What about singing into mikes? How do you feel about oral sex?
I'm into really safe sex. And, you know, just having that… I mean, I love giving head, but usually I have to put a condom on it, and then I don't enjoy it. But, God, one night I gave this guy head for three hours — at *least*! And I could !

You must have come close to killing the guy.
I almost did. (Laughs) He kept pushing me away. I climbed on top of him, and he kept pushing me off of him. Then I pinned him down and kept fucking and fucking and fucking. He came twice in my body. It was so undulating. And it was so… I needed *more*. He told me to go sleep and I was staring at him all night because he went to sleep on me. And he was an ugly guy, too. Whoo! Cumisha had two good-looking guys with her, and I wanted one of them, and I went home with the real ugly guy. I swear to God, he looked good. But in the middle of the night when I was staring at him, I was going, "Oh my God, he's fuckin' ugly. But I gotta fuck him again." (Giggles) And I was just watching him, and I was *so* horny, and I just started blowing him in the middle of the night, and he came again. Then I tried to climb on top of him, but he pushed me off. It was like (disappointed)… man… he kind of ruined my trip.

What about condoms? Do you use them in many of your films.
In the movies, you can't. I take my chances in the movies. But I stay with the same guys. I'm really selective on the guys.

Cumisha: Everybody's tested every three months, Lana.

Lana: But, you know, that's not foolproof. We all take

chances. Nobody talks about it but, you know, it's scary just thinking about it. I mean, with the AIDS test... it's not 100 percent.

There's such a large grey area.
Yeah.

Cumisha: They don't use condoms in regular porn. But if you do a bi movie or a gay movie, they *always* wear condoms. *All* the time. That's what Jim South and Reb don't understand because they're always degrading girls that do bi movies and gay movies. They think we're going to catch AIDS. I've done bi movies and gay movies. They always use condoms. But in regular porn movies they don't use condoms.

Quite honestly, I don't like seeing condoms in movies. It just ruins the nastiness.
Lana: Yeah. That's why they don't use condoms in the movies. You know, I *love* watching flesh on flesh. I don't really get into the condom thing, either. I don't have a lot of sex in my private life just because it doesn't do anything for me to see a condom on a dick. So I would rather masturbate, *thinking* about fucking someone without a condom. That's my safe sex. (Laughs) That's about as safe as it gets.

So how do you feel about anal sex?
I like anal sex. I enjoy it.

What about girl-girl?
In my private life I do like women. I like girls that are non-whites... a... something mix. I've come in contact with a lot of girls in this business who say they like it but really don't. It's very difficult for me to have sex with someone who doesn't like it, who's only thinking about the money, you know? I can't really work with those kind of people. That's why I don't do a lot of girl-girl in the movies... I save it for my private life.

What guys do you like working with?
Marc Wallice is great. Tommy Byron is great. Alex Sanders, too.

The one who slaps his dick?
Yeah. And Joey Silvera. I *love* Joey.

He's a fairly good comic.
I love Joey. I like doing dialogue with Ron Jeremy.

He's incredibly spontaneous, isn't he? Constantly ad-libbing.
Yeah. He's great.

Looking at your figure, it's obvious that you really work out.
Yeah. I weight-lift. (Stands up, displaying her body.)

Look at that. My God. You can't pinch anything there.
I just did my shoulders today. I work out a lot. After I get off the porn set, I'm right at the gym. So, I don't really have time for anything. But I have time to call Cumisha. (Giggles)

How many hours a day do you work out?
Oh, I work out twice a day. In the morning I do cardio, and at night I hit the weights and do cardio again. I only work out about an hour to an hour and a half. You don't need that much of a workout with weights. People who stay at the gym for two or three hours are just wasting their time. They don't know what they're doing. I mean, if you know what you're doing, you super set and get the hell outta there. Of course, a big part of it is diet. Definitely. And if I eat something really bad — which doesn't normally happen — but if I do, I bust my ass. I eat very little sugar. I eat no fried foods. I stay away from saturated fats, anything with a lot of sugar in it. Like on my period, I eat a lot of sugar. You know, I can't help that... I just need the chocolate. But I work out *hard* to get rid of that. I mean, right after I eat it, I can *feel* the fat just... coming on, right after it goes down my throat.

Do you get a lot of compliments about your ass?
Oh, all the time. That's how they recognise me. You know, I can be at the gym without makeup and they'll recognise me just for my butt.

Does that bother you?
No. It's very flattering. I like that. I love my butt. I think I have a great ass. I could tone down the sides... but, no, I think I have a *really* nice ass.

No argument. By the way, whatever you do, please don't let any surgeons go near your tits. They look great. I'm sure you get a lot of compliments about those, too.
Yes. Thank you. I've gone up and down with the thought. It's like, in one way I see changing your body as a sign of insecurity. And I *have* thought about it many times. I've been thinking about it for three years. But, you know, I love my body. In my eyes, I think it's perfect. But this business really distorts your way of thinking. Then you're the one who feels like a black sheep because you don't have them. And then it makes you start thinking, "Well, maybe I should have them. I'll get on more boxcovers, get more money, more magazine layouts." But then, when you step back and look at it, porno is such a small part of life. And I'm moving on. I'm not going to be doing this forever. But if I get a boob job, I'll have them forever. So, I'm thinking about the rest of my life. There's some girls like Isis Nile who have really, really nice tits. But I don't think mine will

turn out good. My skin's just too tight. Bionca Trump's got some nice titties, too.

Debi Diamond's still got a natural pair. They look good.

She looks great. I prefer natural women. I'm not really into hair extensions. I'm not really into fake. I'm into a girl that's… I'm more into the attitude. If someone feels confident, they tend to be different than the girls with the silicone and the cheek implants and the new chins.

How did you originally get involved in X?

I was stripping for a bachelor company here in California for quite a while. And at the time I was also going to school full time, and cleaning boats early in the morning — as an underwater hull cleaner. I did the striptease stuff because being in a wet suit for eight hours made me feel really ugly. You know, I was just

Lana (centre) flanked by Jasmine (left) and Tabitha (right) in ad art for My Baby Got Back! 7. Courtesy: Video Team

another guy. The bachelor parties were my way of being a woman, of being sexy. And I started getting into escort. But the men I dated were really old, and I started feeling really old and unattractive. During that same time, my relationship was going downhill and… well, I was just feeling really ugly. Anyhow, I was watching a lot of porno 'cause I love sex. I really do love sex. And it was like, "Wow! I could have sex with really good-looking guys and get paid for it. And I could have sex with beautiful girls… it would like being in heaven. That would be the ultimate." And around that time, I'd met Dominique Simone on Hermosa Beach and — I'm really into dark-skinned girls — I thought she was *beautiful*. Then I found out she did pornos. And I was really shy. I never had sex with my escorts. Never. I was really young, inexperienced. I didn't do a lot.

Well you're still very young, but obviously much more experienced.

I know my shit now. (Laughs) Actually, I came into the business to find her.

Dominique?

Um-hmm. And, you know, I thought maybe we could go out and be pals. She was just so pretty. And then when I got into the business, it was really rough, because I was too nice and too innocent. I got taken advantage of a *lot*.

And you've been in the business for…?

A year and a half.

In what ways were you taken advantage of?

In Pro-Amateur films, which I did for *very* little money because the girls didn't talk about how much they made, since everyone has their own price. They just said, "Charge whatever you want to charge." And I was like, "Well, I've never charged for sex." And I didn't know what the range was. And, you know, the Pro-Ams said, "We'll pay you $150 for sex and $250 for anal sex." And they were hyping it up like that was a lot of money. So I go, "Maybe that… *is* a lot of money… I don't know." And then I realised, "My God, they were just ripping me off." See, the lower you price yourself, the more you work. And if you price yourself high, you may get the money you're asking for, but you won't get work as often. I'm not as worried about the money as I am about having fun, because I enjoy it. I don't price myself too low, and I don't price myself too high because I like the work. I like to be

booked.

Do you act as your own agent, your own manager?

Well, you know, I'm with Jim South's agency, but with him doing his own producing, it's kind of like a conflict of interest because he's also an agent. As a producer, he tries to get talent for as cheap as he can, and he's starting to make a lot of movies. And he's got a lot of friends that work for him and, you know, they help him out. So he tries to get girls for as cheap as he can for his friends, okay. Well, that's not an agent's job. An agent's job is to work for the girl and get her the most money. So, you see, he really doesn't do that. What he can do, if you lower your price, is get you a lot of work for his friends. I don't know. In a way, I'm happy because I'm getting a lot of work. But in a way I'm upset because I'm worth a lot more, and he doesn't see it, and that makes me real angry. And it's because I don't have the plasticness, you know. I don't have the 'star look' with the blonde, puffed-out hair, or the big titties. So I don't think he pushes me as much as he can. And a lot of people tell me, "Yeah, we look for dark-skinned girls, but Jim never says anything about you." So, I don't know.

How do you feel about the position of minorities in porn?

There are a lot of clubs in the Midwest that I can't get booked at because they don't like to see interracial sex. The companies worry about where they can sell their stuff. Canada doesn't take interracial or black movies. They don't like to take chances. Me, I'm in a lot of movies. If you watch the movies, you'll see me in a lot of them because I'm not black and they put me in the interracial because I'm a crossover and I can slide by. I play a black role and they know I'm not black. But it gets by.

What's the hottest film you've done so far?

I like *Dog Walker* a lot. I shot something for Ron Sullivan... I believe it was for Cabellero. I don't even know the name of it. But he shot something with a lot of... passion. The movie was really powerful. I'm into a good script; not actually the words, but more of the feeling. It was a really *sexual* movie.

What, if anything, would make you get out of the business?

You know, I think about HIV all the time. I live in West Hollywood.

Cumisha: They call it Boystown.

Lana: So I live a gay lifestyle. And I'm surrounded by... I mean, it's real. People in porno who live in Canoga Park, or who live down South Hollywood... a lot of them don't *see* gayness. And they don't see people

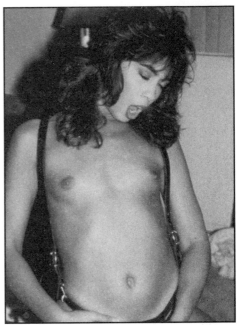

Lana in *Dog Walker*.
Courtesy: John Leslie Productions/Evil Angel Video

with HIV. I see people with HIV every day, and it can happen. And I think about it every *day*. And every time I do a movie I'm going, "Great! I'm gonna get fucked!" but I also think, "God, another *chance* I'm takin'. I mean, what the fuck am I doin'?" And I'm not a dancer. I mean, I *can* dance, but I don't really enjoy being on stage. I'm more of a... I'm a people person. I like bachelor parties and I like escorting. I like to be there with them, talking to them. I don't like them watching me like I'm some kind of... side show. I just like to be there with them. I'll probably do bachelor parties and escorting for a long, long time... eventually go back to school... I just, you know, got a little side-tracked. I just needed a break from college. I was really stressed out. I wanted to get into the environment. I don't like computers and I don't like being in an office. I don't think I could ever do a 9-to-5 job. So, I'll probably do field work when I get older. ∎

**LANA SANDS
SELECTED FILMOGRAPHY**

The Tempest, Bump-n-Grind, Sparkling Champagne, Rump Shaker 3, The Blues 2, The Reel World, Anal Vision Vol 7, Black Buttman, Sex Fugitives, My Baby Got Back! 4, The Dragon Lady 5 and 6, The Sweet Sweet Back's Big Bone, Randy West's Up and Cummers 3, Smooth As Silk, The Anal Diary of Misty Rain, Dog Walker.

The Evil Eye

An Interview with Cameraman Michael Cates

Close. How close? Dangerously close. Close enough to smell the fishiness of a torrential cunt. Close enough to get your camera lens steamed up from the rising pussy heat. Close enough to get squirted in the eyeball with a wad of sperm gone awry. *Aieeeee!!!* That's the thrill (and spill) of it all. That's job of Michael Cates, porn cameraman.

Cates has been the evil eye for Bruce Seven for the past two decades, as well as cinematographer for such respected directors as Patrick Collins, Paul Thomas, and Bionca. (No, Cates never *really* got popped in the kisser with a wad o' lovin'. But he has been popped a few time by the illustrious LAPD during several 'nationally relevant' raids. But more about that later...)

Born and raised in Glendale, California, our Vittorio Storaro of porn was an avid photographer from the get-go. "I always wanted to do still photography," recalled Cates during a 1996 interview in the Republic of Van Nuys. "As a teenager during the late-Sixties, I'd go off many days and shoot things with a camera, trying all kinds of different apertures and speeds, and just had a great time doing it."

Cates got his degree in broadcasting in the late-Seventies, shortly thereafter landing a job as disc jockey ("in a small market here in LA"), and then as set builder for Burbank Studios. The ambitious young Cates swiftly moved up from set design to props and special effects. "Anytime you'd see a spaceship in a film and lights flashing, those are the things we'd film. But it wasn't as if we'd blow up something every time we went out. We certainly did that on a number of shows... it just wasn't our mainstay"

While in special effects at Burbank, Cates met soon-to-be godfather of porn Bruce Seven. "Bruce was doing explosions. But a lot of his main efforts were in miniatures... building little robot jobs. And Bruce had this special knack where he could walk into a general area as a prop maker, turn around, and five minutes later be wearing a tape measure and pointing fingers. I, on the other hand, would still be putting on my toolbelt. (Laughs) Bruce was just one of those guys who'd be able to walk onto a set and take control."

By chance, Cates stumbled upon co-worker (and neighbour) Seven making a clandestine home porn film one fine day. Cates was game. The two instantly hooked up, shooting bondage and girl-girl features in 1981; Seven directed, photographed and edited, while Cates acted as second cameraman and co-editor. Soon it was "Farewell, Burbank Studios" and "Hello, Fuck City!"

In the mid-Eighties Cates and Seven took the porn world

Michael Cates in the editing room at Evil Angel headquarters. Photo: Dave Patrick

by storm with a string of *Loose Ends* and Ginger Lynn films. The incredible popularity of these shows (now considered classics in the genre) caused Seven to start doing less camerawork and more direction, allowing Cates to come into his own as first cameraman.

Then in the late-Eighties, with the creation of Evil Angel Video, Seven went into a porn partnership with EA founder John Stagliano, in turn, making Cates' camerawork all the more prolific and stylised. "See, around 1991 Bruce talked to both John and Patrick [Collins] and just said, 'Look at all these great reviews we're getting for these films — and Michael shootin' *all* of 'em! Why don't we just take him in? Each of us can put in so much money, sign him under contract, and have him for ourselves and nobody else.' And that's pretty much how it started with Evil Angel."

Cates now divides his time between projects for Seven and Collins, with an occasional Bionca fuck fest thrown in for good measure. "When you see a Patrick Collins' movie," director Collins stated in issue #1 of his Elegant Angel newsletter, "you're seeing a Patrick Collins/Michael Cates movie." Indeed, unlike the glut of videographers out there, Cates gets *into* the action, has a special instinct for knowing exactly what the viewer wants. As a result, he picks up what the majority of porn cameramen miss, i.e., the centre of things… close up and nasty! Examples of Cates' all-out evil eye include the rewind-worthy orgy (laden with gorgeous, wall-to-wall Hungarian twat) in *Sluts 'n' Angels In Budapest*; Tiffany Mynx and Kitty Yung's classic 'soapy', lesbo-whore sequence in *Sodomania 5: Euro-American Style*; and Cates' amazingly graphic double-anal, black-dick attack of Cumisha Amado (not for the weak-stomached) in *Beyond Reality 2: Anal Expedition. Scandalous* shit!

In his first interview ever, the ace cameraman related many fun porn anecdotes to photographer Dave Patrick and me, and even passed along a few helpful tips for start-up videographers.

You worked with Amber Lynn a great deal in the Eighties, didn't you?

Actually, I was more Ginger Lynn's cameraman. But since Amber and Ginger were friends, we'd do a crossover with Amber whenever I'd work with Ginger. So, no, I wasn't doing any full-length features with Amber… but I did film her in quite a number of scenes.

What are your memories of Amber?

(Smiles) Amber was really very good. She did have a little bit of a… I don't know if you want to call it attitude but… well, I guess you really could call it an attitude. But as far as any of those young girls go, after they've been tossed around from here to there enough times, they'd eventually come onto a set and tell you exactly what *they* wanted. And, of course, Amber knew who she was at the time — which made it so much easier for her to get her way.

And Ginger?

Ginger was the same way — but sweeter about it. Bruce would actually get her pissed off because he knew he could pull out the finest performances from her when she was hot and bothered. (Laughs) Seriously.

So what's the full story on how you and Bruce broke into porn?

Bruce really broke in before I did. Early on, he'd pick up a videocam at work and you'd see him walking through the shop with this little portable thing, which was humongous at that time… (laughs)… but he'd walk through the shop, photographing various things.

And about six months later, I was on this special effects baseball team — you know, where one company plays another company over a game of baseball — and I injured myself. I was catcher and caught a ball which put my finger out of commission… put me out of work for about, oh, two or three weeks. Well, since Bruce lived close by at that time, I went to his house to visit one day while I was recuperating. So I knocked on his door — knowing someone was home — but nobody answered. And I kept knocking, knocking, knocking… Finally he comes to the door, opens it about two inches, and says in a low voice, "Yeah… what-what's goin' on?"

"That's what I wanted to ask you," I said. "What's going on?"

"I'll call you back later, okay?" he said. "I'm doin' something."

But he wouldn't tell me what. So the next day he gives me a call and tells me he was shooting his first bondage movie. It was with Danica Rhae, a blonde girl from way back. When he finished filming the whole thing, he called me up, and we went to pick up some editing equipment. After that, we started cutting the movie. And that's pretty much that point that I came on board.

When did you actually start working the camera?

Well, I was going to try to get into the cinema-photographer's union at Burbank Studios. Unfortunately, it wouldn't have been a lateral move. It would have meant me starting at the bottom of the totem pole, after I'd already made it to the top of my field. If I didn't have a family, it probably would have been fun. The fact is, my responsibilities lay elsewhere. But you also have to understand that the mainstream film world is a very egotistical and family-oriented type of business. Of course, there's a lot of things to say about being single. (Laughs) I mean, if you make a decision, it's only you who lives or dies. But when somebody else is involved, you can screw up their whole lives.

But when I started working with Bruce, initially he was always the cameraman. We started off doing the bondage movies for $1,500, $2,000 a piece. And I was second cameraman. Bruce would shoot for a while, then I would pick up and start to do it, pretty much

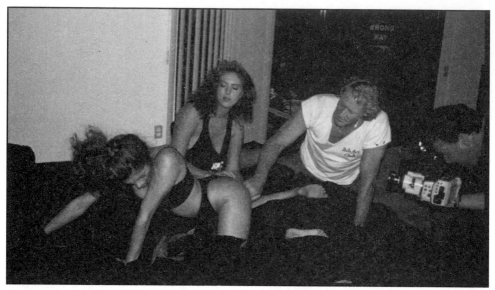

Cates (far right of frame) lines up a shot with (from left) Francesca Le, Cheri Lynn, and Randy West in *Sodomania 1: Tales Of Perversity*. Courtesy: Elegant Angel

learning from him. But I had no formal cinematography background... neither did Bruce. He taught himself. And I came in, learned from him, and taught myself a lot of the basics, as well. Of course, the first thing the film industry was saying to us at that time was that we didn't know our ass from a hole in the wall (laughs)... because we were crossing lines with our films, doing everything that was totally wrong. But we were also shooting what *we* wanted to shoot.

Anyhow, for the next few years, Bruce started doing less camera work while I did more. Finally, I was the main cameraman shooting all Bruce's material — all the bondage, girl-girl, Ginger movies. I also did some directing and writing... like *Ginger On the Rocks*... that was one of the films I wrote and directed... that and a few others.

What other directors have you worked with?

I pretty much started working for other directors during Bruce's thinner years in the late-Eighties. His health was down and he wasn't able to do what he wanted to. But trying to get money as a director was pretty much going down the tubes for *everyone* at that point. So I started shooting for Vivid. I was PT's (Paul Thomas') first cameraman when he began directing. I did a lot of work for him, like the original *Beauty and the Beast*. And I did all the editing for him, too. I also did quite a few of the different Brat series. We filmed the shows with Jamie Summers, then after Jamie left we shot Julianne James and Nikki Randall. And I was bouncing around from set to set so much that somebody might ask me, "Who'd you shoot today?" And I'd just say, "I don't know... I can't remember... I can't place that particular girl on this particular set..." because I was just doing so much work back then. And during that time in the Eighties there was also the promise that no

matter what you did, you were going to make a lot of money. So like everybody else, my credit card indebtedness went up.

Well soon enough, everything started crashing... the work wasn't there anymore. And when the work *was* available, the money you previously saw wasn't there. I mean, this business is built on economic pressures just like any other business. So if a company's not making any money, they're not puttin' any money *into* that same business. Consequently, they make cheaper products. But I was pretty much a set-price person, making $300, $400 a day as a cameraman. And since they needed to get underneath that type of thing, I wasn't getting as much work as I wanted. But I never lost a lot in this industry, either.

Why's that?

Because I've always had the philosophy of 'If you fuck me once, you won't fuck me again.'

These days, though, you're pretty much doing all of Patrick Collins camera work, aren't you?

Right. But in the mid-Eighties I was doing a lot more for Bruce... the *Loose Ends* stuff, way before *Buttslammers*. And in the late-Eighties, Patrick — in his infinite wisdom — said, "Look, I can't see paying half of your salary when you're working one-eighth of the time for me and seven-eighths of the time for Bruce." What he didn't realise, though, is that very soon that'd turn around, and I'd be working for him more than Bruce. Since then, that's really the way it's stood: I'm basically on Patrick's payroll, and whatever time I work

Box cover art courtesy: Video Team

Box cover art courtesy: Rocco Siffredi Productions/Evil Angel Video

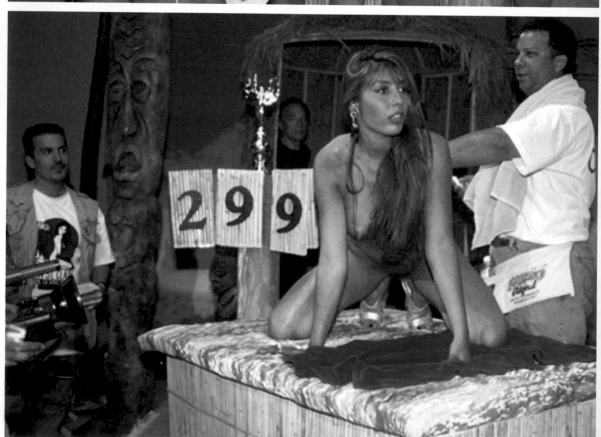

On the set of *The World's Biggest Gang Bang 2*. Photos: Anthony Petkovich

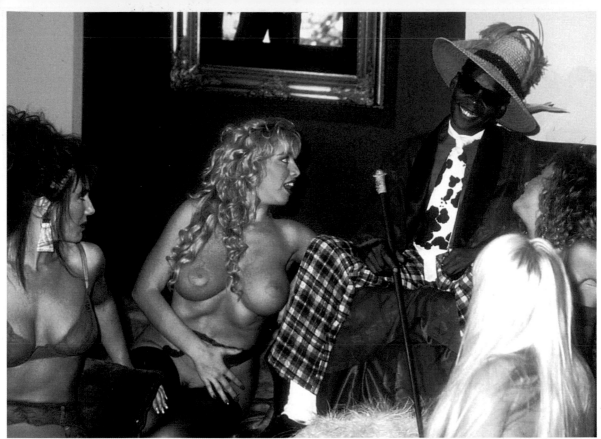

Jack Baker in *New Wave Hookers 2*. Courtesy: VCA Pictures

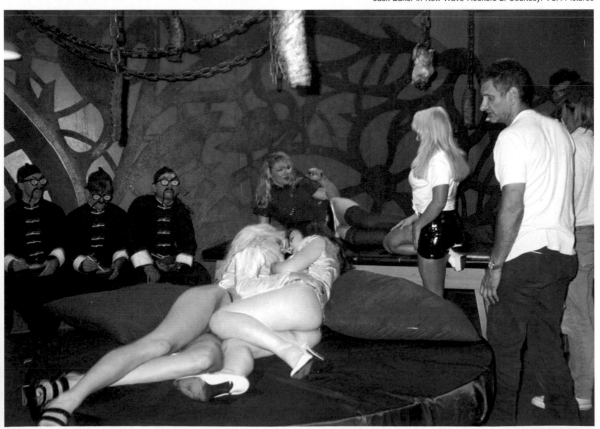

On the set of *Gregory Dark's Sex Freaks*. Photo: Anthony Petkovich

PATRICK COLLINS
Presents...

SODOMANIA

SWEDISH SLUT

HUNGARIAN HARLOT

FRENCH WHORE

C..T LICKIN', C.M DRINKIN'

BITCHES

Written, Produced and Directed by PATRICK COLLINS Camera by MICHAEL CATES

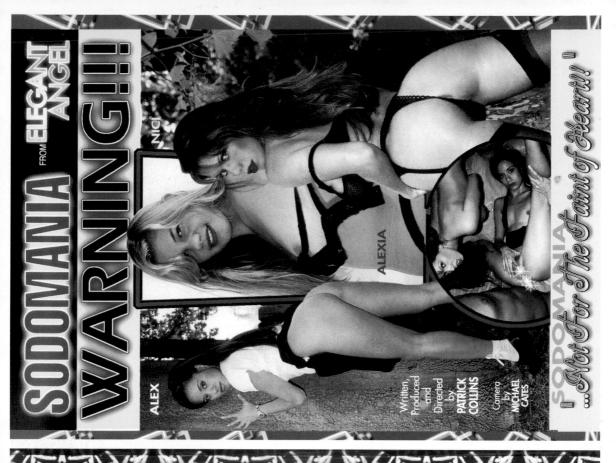

SODOMANIA FROM ELEGANT ANGEL

WARNING!!!

NICI

ALEXIA

ALEX

Written, Produced and Directed by PATRICK COLLINS

Camera by MICHAEL CATES

"SODOMANIA ...Not For The Faint of Heart!!"

Sometimes it's fun being a dirty old man!!!

Elegant Angel Presents...

FAZANO'S STUDENT BODIES

Roxanne Hall

Alona

Szilvia

Rachel Love

Melisa Monet

Kirstie Waay

Lulu

Monika

Ursula

Written, Produced and Directed by PATRICK COLLINS

ELEGANT ANGEL VIDEO

Box cover art courtesy: Bruce Seven Productions

Isis Nile in her dressing room at SF's New Century Theatre. Photo: Anthony Petkovich

for Bruce, he more or less pays Patrick for my time.

Any resentment there on Bruce's behalf?

Well, Bruce is making films more regularly. But Patrick has a real aggressive approach, which I like, because I'm always trying to keep track of where I'll be in five years. And to me, Patrick had more of an insight. Whether we're talking about ideas for movies or what have you, we always seem to click. On the morning of our shoots, Patrick and I make it to the set, sit down, and, while people are putting on their makeup, we ask each other, "Well, what are we going to do today?" Both of us kind of like the psychological thing. I realise a lot of the *Sodomania* stuff has kind of gotten away from that. But it's really hard to come up with… I mean, the series was much more dark originally. And I still like that dark angle.

Actually, it was you who were originally scheduled to direct the *Sodomania* series, weren't you?

Right. I was supposed to direct a movie for Elegant Angel called *Sodomania* before the series ever came out. And the deal was, whatever I wanted to come up with, I could shoot. So I sat down and just thought to myself, "Hmm… now what should I do here? Well, why don't I try something different? Why don't I shoot a film where a guy can come home, sit down, watch some of a movie, take a break, get some peanuts, come back in the room, watch more of the movie, put it down, and watch it the next day without having to get caught up in the way he might have watched it the night before?"

Like the difference between the short story and the novel.

Exactly. And I said, "Well, let's put it up to where we're doing three different features, three separate stories for the full-length." And I threw that passed Patrick and he liked it. So we sat down, started coming up with ideas, and the first scenes we shot were in Vegas.

So how did Patrick come to direct the film?

What happened is Patrick said, "Look, I've been thinking about this, because I really like your idea. But I'd really like to be able to direct this thing." And I've never been a showstopper. In fact, this is the first interview I've ever done. I just don't do 'em. It doesn't matter to me. I could care less if somebody says, "Look, we gotta put our name on the credits instead of yours." Fine. On most of our boxcovers I'm down there as cameraman and co-producer. Patrick comes up with as many ideas, maybe moreso now, as me. But it never really bothered me before. It still doesn't. Hell, maybe I can help somebody out. (Laughs)

But you did get credit for directing

Tianna in *Sodomania 7*.

Right. Well, one of Patrick's big fetishes has always been the foot thing. And I've kind of gotten into it, too. But both Joey (Silvera) and Tianna are great people. Tianna… what a sweet girl. And it just so happened that Patrick was ill at the time, and we needed to get another scene done for *Sodo 7*. I had a little bits and pieces of scenes that I wanted to do, little ideas that I'd written down and thrown on the side. And I wound up doing a thing called "The Cobby", about this little shoe repairman and the women and the shoes that turn him on. Joey was just perfect for it.

So we shot Tianna walking down a street in Hollywood trying to get to a bus, going up a street, and all of a sudden falling down when one of her high heels unexpectedly collapses. So, totally frustrated, she picks up the broken shoe and hobbles away. Then we cut to Joey. But before I actually show Joey, I wanted to show what he was all about. So I had this slow pan of all these different women's shoes in his shop just sitting there, ready for repair. And then we see Joey, and he's got this pump with his dick in it. (Laughs) And that pretty much was his character. A fun scene to do.

What other scenes have you directed for Elegant Angel?

I did a scene in *Sleeping Booty* with a German girl. Part of the *Sleeping Booty* thing was always my fantasy… this girl passed out with a guy sort of taking advantage of her… (laughs)… it's one of those ideas I really like. Anyhow, Patrick started doing it with the Fazano character, first with Rachel Love. But, see, the one perspective I find works best is when the viewer thinks he's there. And the only way the viewer is going to think he's there is if you're actually shooting the scene yourself. But Patrick was getting burnt out with the Fazano thing because it was really too much work for him — he was shooting and starring in it himself. And I told him, "You know, filming this stuff works better if you don't put your whole… *body* in there…" (Laughs) "Just shoot the camera. That's fine. Get your dick sucked, do it, fuck from that position. But once you set the camera down and start to go in… well, that's a different perspective and it's not for the benefit of the viewer." And that's how we shot many of the scenes in *Sleeping Booty,* with that perspective where the viewer really feels as if he's there.

How did your directorial sequence in *Sleeping Booty* evolve?

Well first off, Patrick was out of town. And you have to remember, I'm not a performer. I'm not going to stick my dick in front of the camera. It's just not me. I'm much more comfortable doing what I'm doing. So I had this girl talk to me, talk to camera as if I was going to do a scene with her and her boyfriend. And she's giving me wine in one scene, and the next thing I know, I wake up from being passed out. I look over and see that she's still passed out. So I get up to leave, turn

around, see her lying there all passed out, and start thinking "Goddamn, look at that ass." So I oil her butt up, take a dildo, and put it in and out of her. And all of a sudden — Oh! — it's her boyfriend looking down at me. And she's still got this dildo hanging out of her ass. Then the scene became me convincing him to do what I was originally going to do; in other words, for him to take over. "Why don't you fuck her?" I tell him. And, all in all, I think that scene worked pretty well. But, again, it was shot from the perspective which I think works best — where you're just working the camera yourself. John Leslie does the same thing as *The Voyeur*. Hey, it's a big thing being a voyeur. It's a club. We should all have cards… (laughs)… and get free discounts. (Laughs)

So why did you and Patrick decide to film in Hungary?
I think it had to do with one of the guys that distributes our movies over there. He had an interpreter named Charles, and we went over there the first year and became friends with this interpreter, who also happened to be an historian of Hungary. And Charles basically showed us everything, made all of our arrangements. I mean, for a box of candy, he got us an entire streetcar — which, of course, we used a scene from *Buttwoman Does Budapest*. We only had three hours to shoot it. The streetcar was on one route. It would go up one particular path, stop, come back the other way, then stop and go back again. So every time we'd get to the end of a line, I'd switch my position with the camera. In other words, we'd take the next car to make it look as if we were always going in the same direction. And I basically cut the scene showing two different perspectives. At times I'd go into Tianna's carriage and shoot her masturbating in the foreground with this Hungarian couple fucking in the connecting carriage in the background. Then when I wanted to shoot the Hungarian couple in foreground, we'd stop the train, I'd get out, get in their carriage, and shoot them fucking, this time with Tianna masturbating in background. It was difficult to edit, but it was fun. Actually, I think we were the first Americans to make our mark in Hungary. Beautiful, *beautiful* women over there, walking up and down the streets of Budapest… bra-less a lot of them and just… *very* comfortable with their own sexuality.

In this business you're definitely one of the most sought-after videographers —
I just get along with everybody. I mean, I can work with the worst possible person in the world and get along with 'em. Of course, I'm also a sarcastic son of a bitch in a funny sort of way. I love to pull things off on people. Back in the later Eighties I shot maybe six or seven gay films — not my forte, by the way. (Laughs) And the guy who got me through it was my still photographer — a good friend of mine. What happened is, as I filmed those gay shows, I'd look over at him and

blow kisses and wink. (Laughs) You gotta have fun doing what you're doing. If you're not, get out of it. That's just the way it is. I enjoy doing the camera. I enjoy the editing. The stress, the pressure… I live through it. I mean, in many ways it helps me: I work better under that kind of pressure than I do when I've got a lot of time on my hands.

What about DP's? Do you find them difficult to film?
DP's? No. Double anals? I've found those pretty tough. In a DP, you've got two different holes and some skin in between them. But with a DP anal… well hell, you got two dicks trying to go into one little thing, and it's hard to show that one hole no matter what you do.

Did the Brucie doll in *Beyond Reality* pose any technical problems for you?
No. It was remotely operated from off stage. His eyes and mouth would work, and that's pretty much it. His head wouldn't turn, so you pretty much had to prop him in certain positions that would look okay. Bruce probably used slow motion in the post production end of it. When you see the doll masturbating in his prison cell at the beginning, I shot it with Bionca holding the arm in the back and moving it up and down with the dildo. I mean, in special effects everything is Mickey Mouse. It's not as if somebody gives you a Ford truck and says, "Here. Make one of these." You don't have a

Buttwoman Does Budapest; videobox art.
Courtesy: Elegant Angel Video

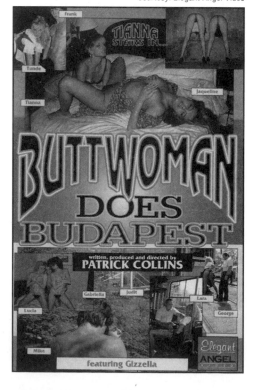

prototype to go by. They just come to me and say, "This is what we want to see happen"... just like when I was working at Burbank Studios. And I have to make something up.

What camera are you using these days?

Right now we've got the new digital video camera. We shoot on digital video, and I transfer to beta and edit from beta. We'd been shooting high eight with a VX3 camera for quite a while, but this digital video camera has so much more. The clarity is incredible. Even when you're shooting, the light level is better than the VX3, especially under low lighting conditions. And if you're going from a very bright area to a real dark area, it doesn't give you that real fast kind of black image. It's a nice camera. Actually, it's a dream for any consumer who wants to do his own particular projects because the thing does all kinds of effects. If you want to insert a piece of video from one spot to another, you can do it with this camera. You've also got a photo dial which allows you to take stills. And if you want to do video prints, it gives you the best quality picture. You can actually do boxcovers photos with this camera. Very user-friendly. But right now our video is there. Boom! It's stark, it's there. (Laughs)

Let's talk a bit about editing. How does it typically fit into your schedule?

I pretty much edit all Patrick's films. I used to do all of Bruce's, but I haven't had the time to keep up with all the Elegant Angel and Bruce Seven releases. Bionca, of course, is doing her *Beyond Reality* series for Exquisite Pleasures, and Bruce still has his features and the bondage stuff to shoot. Patrick's putting out 12 releases a year, and he wants to up that number. So (laughs) I'm pretty much at the capacity level, doing just what I can do. Sure, you can pull me apart as many times as you want, but I can only do so much.

As any editor will tell you, however, it's a mental fatigue... a mental mind fuck. But when I shoot, I shoot to edit. I know what I need, and it comes naturally now. If somebody hits the camera when I'm moving, or if somebody off-camera is talking to one of the girls, I immediately know to pull out, pick up another shot, and zoom in on that. And when I sit down and edit... it's there. I don't have to go back and try to pick up shots here, or go forward to pick up something, or use one particular shot over and over again, which is what a lot of people do. Hell, they'll shoot a DP for ten seconds and just loop it and loop it and loop it. I mean, it's just the same thing. And I'm totally against that. That's one thing you won't see in our features. I don't shoot or edit that way. One quarter of whatever I shoot is normally editing time. I'm pretty damn close to it every time, too. I mean, if I shoot an hour, it boils down to a 15-minute scene. And if I shoot an hour and a half, it boils down to a 20-minute scene.

How about danger? What's one of the most hair-raising moments you've experienced as a cameraman?

Nothing's really scared me. I mean, I've gone through three different busts — one here in LA, one in San Diego, and one in Oakland. The first bust was really the most intimidating, though.

What happened?

I was in the Hollywood Hills shooting a scene in a room with just me, the sound guy, and two people on a bed. And I heard this little commotion outside the room. Next thing I know the door's being kicked in — literally! They could've used the damn doorknob, but, no, they've got to *kick in* the door. And then in Oakland I was with Paul Thomas shooting a movie in some bar around the Jack London Square area and (laughs) LA Vice came in again. Every bust I've experienced, LA Vice has been there. And I think that's the point at which I just said, "Fuck you people!" Seriously. "You're spending all the taxpayers' money to run up here for this? And you come in with guns like we're gonna blow your brains out. You guys ought to be out on the streets trying to get the drug pushers." And the only reason they were after us was because we were easy prey.

After filming so many sex scenes, do you find it's somehow lost its charm? — that you've become somewhat callous about the whole thing?

I think that pretty much happens to anybody. I can go out and shoot a scene one day and the next day at eight o'clock in the morning I'm in here editing it. There was a book written years ago by a gynaecologist, and his statement was that it's just like peeling potatoes. And it pretty much is; once you've seen one pussy, you've pretty much seen 'em all. The personalities are what it's really all about... the people. When I pick up a magazine — whether it be *Hustler* or *Adam* or any of them — I go right to the reviews. I don't sit there to see a girl's picture with her clothes off. Hell, I see that day in, day out. I want to see what people think about our product. And that's pretty much where I'm at. But, I mean, we've probably gotten a little more decadent as we've been drawn into it, simply because we've see so much that we want to see more. So it's like, let's push the limit, let's see something new.

Any words of advice for those folks interested in professionally filming porn?

I recommend that people just get the experience — grab a camera and start doin' it. If you're lousy, you're gonna find out right away. And if you're good, you'll keep improving on yourself. You'll always get better. No matter how bad you are when you start off, you'll always get better. ∎

LennX

Mad as hell

She's angry. She's pissed. She's *not* gonna take it anymore. At least, not where the sun don't shine. She's Lennox. And she doan suck no stinkin' cock, meester. Well, not anymore. When I met Lady Lennox on the set of Gregory Dark's *Sex Freaks*, she was… hmmm… how shall I put it?… a bit… bitchy? No, the lady wasn't anal retentive. Matter of fact, she just got fucked in the ass by two of Dark's hired hoses the previous day. So why the attitude? According to our disgruntled 24-year-old starlet, it was all due to the long hours, the lousy money, and the limp talent prominent in X. In fact, by late 1995 (after less than a year in X), Lennox became so fed up with the cheese-whiz biz, that she'd come around 180 degrees and only craved cunt. *Lots* of it, too! But, hey, that's okay. You earned your cans o' tuna, Lennox. Besides, it's always healthy to hear someone really rag on the industry. Therefore, consider the following tirade Lennox' way of shoving the dildo way, way, *way* up Fucktown's crud centre. Let 'er rip, Lenny baby.

Lennox, before we get into your disenchantment with LA, how about a rundown of some of your films?
Sure. I've been in *Tricky Business*, *Call Of the Wild*, *Big Bust Babes Volume 32*, *Ass Freaks*, *Hollywood On Ice*, *Temple of Poon*, *Double-D Dykes No. 18*, *Pussyman Auditions*, *Black and White Fantasies*, *Black Knockers Volume 15*, and *Sex Freaks*.

What's your role in *Sex Freaks*?
To play a really bitchy girl named Lucy Juicy. I did four guys dressed as devils in my scene yesterday. I didn't do 'em all at the same time, though. There was another girl in that scene, too… Paisley I think her name is. The scene basically involved the four guys, Paisley and me, and double anal on me. But by double anal I don't mean I took two dicks in my ass at the same time. They were two different anal sequences. Actually, this whole movie's pretty weird. Greg makes some really eccentric stuff.

How did you like working with Dark?
Greg's really cool. Very understanding. I like his style. He's got a really unique way of doing things, which is very different from the realm of porno folk I've been used to working with. And had I been introduced to him a while back, I probably would have enjoyed working in this industry a bit more; I would've had more tolerance in terms of the time and hours involved in making porn.

Is that why you seemed somewhat… stressed on the set today?
Yeah. I guess I was primarily burnt out because of all the… ASSHOLES (laughs) in this business.

Which specific assholes are you referring to?
Well, I really never had a bad experience with any particular company. I guess I've got a problem with the way the pay scale's arranged. I mean, they'll pay you $400 to do a deed — which is *work*, by the way — and they pay you this ridiculously low rate while crying the financial blues. In the meantime, these movies are bringing in profits of at least $80,000. C'mon, there's no *way* they're not banking on porn. No way. Yet they try to pay the talent as little as possible. And that's why I call 'em "assholes."

And why the shift to strictly girl-girl?
Partially because of the disease thing. I've *no* way of knowing what these people do in their personal lives. No way of knowing if they're bisexual, doing [intravenous] drugs, whatever. Even if they meet a girl in a bar, c'mon, no girl in a bar's going to be carrying an AIDS test.

Have you done a lot of anal in porn?
Oh *yeah*! That's primarily how I got a lot of work. (Laughs) When I first started doing the movies, I wasn't doing anal at all. Then I switched over to it… worked a *lot* for Mitchell Spinelli doing anal. I love Mitch. He and his family have always been very good to me.

What's the most molten scene you've done thus far? — the one with the highest energy level?
I think folks should check out my bathroom scene with Shannon Rush in *Call of the Wild*. They should also check out my work for Stuart Canterbury and the anal stuff I did for Mitch Spinelli.

Can you fill us in on how you got involved in porn to begin with?

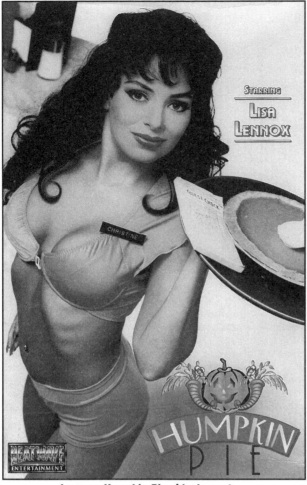

STARRING
LISA
LENNOX

HUMPKIN PIE

Lennox; *Humpkin Pie* videobox art.
Courtesy: Heatwave Entertainment

Well, on the East Coast I was doing magazines, some feature dancing. And then (laughs) I don't know why… I was always told *not* to do porn by a lot of people. And I didn't, because there wasn't the moral support of a significant other in my life. Then I met my fiancé, we moved to California, and we decided to do porn together. I did my first shoot with him. It's funny because the first time I fucked a stranger on camera, it was no shock. It didn't mesmerise… it didn't have *any* impact on me. Not until the long term. To tell you the truth, I don't even remember the first movie I was in. (Laughs) But I suppose officially I started March 4, 1995. Originally it was kind of a fantasy thing for me and my fiancé. But afterwards I saw how real fantasies are for you and you alone, not for everyone else to witness. Still, it's cool to look at a video tape of us having sex, knowing that millions of people are watching it, because they'll never know who we are (laughs)… unless they recognise us in the street. In hindsight,

though, I also realised that I got into porn for the wrong reasons. I mean, there's just no longevity in this business, no retirement plan. Let's face it, anyone can fuck.

So why did Lennox start fucking on film?

Oh, curiosity was definitely a big part of it. But having sex with other guys just doesn't fly with me anymore. I'm bisexual, so I don't mind having sex with girls at all. And as far as doing a girl-girl on video, for the money they pay, it's a *lot* less tedious in terms of the hours. All I have to do is sit there for about an hour with another girl, as opposed to four hours with a guy who can't get it up and is complaining about my sponge at the same time.

Complaining about your sponge?

Yeah. That was always a problem. A lot of guys couldn't get it up with me and they'd blame… this is going to get me *so* much flak (laughs)… but they'd blame it on the fact that I was wearing a c*-sponge, saying it would make them numb. And that's *bullshit*! Believe me, I've worn a sponge so many times while my man's fucked me, and he's *never* felt it. Sometimes I even feel like I'm choking on his dick when he fucks me. (Laughs) Not literally, but, I mean, it's very possible. And half these guys can't even *get* hard-ons. Yet they're blaming it on my sponge, which I specifically stick way up inside me. Initially, see, I was very 'laxed, very easy-going with a guy who couldn't get it up. But then, when they started pointing fingers at me, well, at that point I just couldn't refrain from being a bitch. And it's not going to make the scene flow if I turn into a bitch. Believe me, then he's *really* not going to get a hard-on. Some of these guys even expect you to be a counsellor when they go limp. They want help, they want fluffing. Hey, I'm sorry but I *don't* get off on getting a guy ready to go.

Where are you from originally?
New York City. Raised there.

And you've been in California —?
About a year.

Your impressions of California so far?
At first I was enthralled with it. But now I'm beginning

* Contraceptive.

to see what the people are about; and they're all full of shit. Everybody here is out for themselves. I mean, if you get shot in California, it's usually a random shooting. But if you get shot in New York, there's a *reason* for it.

That's certainly good to know.
And the people out here... I just don't think they have... let me find a way of putting this... First off, I'm basically talking about LA, because I love it up north. It's so beautiful up there.

Lennox publicity shot from *Sex Freaks*.
Courtesy: Dark Works/Evil Angel

But obviously I can't live in a place like San Francisco because of the geographical nature of this business. But when I first moved out to LA, I was at such war with New York. I was fed up with it. Then I went back to visit in October, and I'll tell you something, I really miss my state. I really do. The people there are real.

Whereas in California they're surreal.
No, not that. But in New York they'll tell you like it is. You can exchange phone numbers with someone in New York and *hear* from them. You can actually make an appointment to do lunch — and do it! Here, it's all talk. It's like, "If you don't have something for me, then, huh! see ya." It's more ruthless. I believe in karma. What goes around, comes around. The more effort people put in trying to mind fuck you out here, the less energy they have to take care of their own business. Somehow people always end up backstabbing you out here. I mean, I'm not crying the blues. It happens to everyone, not just me.

Have you made many friends in X?
Yes, I made one very good friend — Heather Lee. She and I clicked in the beginning of my... 'career'. We're friends to this very day. She helped me out in more ways than one, and I'm very grateful, very thankful for her friendship.

So is Lennox finished reaming Pornville yet?
No. I've more to say. Some new girls in X work at extremely low rates, maybe even throw in a free boxcover now and then. And I'd just like to say that those newcomers are really making it hard for starlets who've been in the business longer... making it tough for really nice girls like Nicole London and Nikki Sinn. Some girls even come into the business and do anal for $300, which is *sick.* (Laughs)

So what kind of sex pays best in X?
Anal, DP, double vaginal, those pay the most. But the producers are still ruthless. After speaking with veterans in the business, I've learned that producers used to pay by the amount of time you were on a set. These days, let's say you have a call time at 11 am. Okay, that's when you show up on the set. But you may be there until midnight. And basically you have a choice of sticking around until midnight when the film *may* be wrapped up, or walking out and not getting paid. Personally, I think they should pay you an extra hundred dollars or so for being on the set longer than originally planned.

Anything else?
Yes. Since I've been making porn films, there's been maybe two or three batches of new girls. All young, very naïve, haven't got a clue in the world. I don't think they even know anything about getting turned on and heated up. There's no way you can do it, anyway.

In the business you mean?
What do you mean?

You said you don't think newcomers can get turned on in front of the camera at such a young age?
No. I think they can. But personally I don't condone them getting into this business at such a young age. Some are 18-year-old girls. I mean, I'm no angel myself. I started doing bikini modelling and lingerie stuff at the age of 15. But I never *fucked* for money.

Until now.
Right.

You're 24, though. You don't think that's fairly young?

But, see, when I was 18, I was mentally 23. A lot of the girls who are up and coming now, they still need to have their hands held. Let's face it, we can't deny it, this business mentally rips up females. That's why there's suicide. Look at Savannah. She didn't kill herself because she was screwed up on drugs: it was because she did drugs to get through her scenes because the money was so damn good. See, it's love of money. I really believe money is the root of all evil. If people would stop thinking about their pockets, think more about what they can obtain by just being themselves, then they'd probably be more content. But it's not going to happen. Some girls I've spoken to, I mean, they've even worked without AIDS tests! They don't have a clue.

I'm surprised they allow them to work without AIDS tests.

Well, that's *another* story, another reason why I don't fuck porn guys anymore. You can't even be *sure* with an AIDS test. I knew someone that died of AIDS in 1986, okay? 1986. We're talking *years* ago. The doctors told us he could've had it for 10 years, but he never showed a sign of it. They tested him while he was in the hospital with pneumonia, and he came up negative. It wasn't until he had full-blown AIDS that they said, "Excuse me, Mister So-and-So, did you ever have any gay or bisexual relationships?" And he said, "Yes, years ago. But I'm no longer active. I'm celibate." And he hadn't been with a man in ten years. This is what I'm saying — for one scene, for $700, you can *die*!... in two years! What good is $700 gonna do for you if you're dead?

Let's go back to New York. What was it like growing up there?

Well, before I went to live with my relatives, my dad wasn't very well-to-do. We lived from pay-cheque to pay-cheque in a very tiny apartment. We barely made it. But my dad made sure I had everything in the world. Even if I wanted a piece of gum and it was his last ten cents, he would have gotten it for me. He was the best man in the world. He passed away when I was 14. Then I moved in with my aunt and uncle, and that was also around the time I first experienced sex. I was 13... very memorable. It was a romantic thing to me. See, I was the kind of girl who was... I never slutted around, always had a steady guy. Actually, it was the *guys* who always slutted around on me. But I like a steady guy. I like security.

So what happened after you graduated from high school?

I started dancing for Club MTV. That was around 1989. Dancing on that show was a lot like *Soul Train* — you know, sexy dancing without the nudity. And around that time, I really wanted to move out and be on my

own. I felt I wasn't getting the gratification, the appreciation I deserved. See, I'd come a long way as a child... went through a really hard time. But I didn't end up being fucked up or falling into drugs. I partied, sure. But I didn't end up a waste case on the street. And I didn't get any credit from my aunt and uncle for that. So I kind of felt mistreated, like I didn't get the pat on the back I deserved. From what I understand, they *talked* about how good a child I was but never actually told me. And I suppose that's what I really needed from my aunt and uncle. I mean, I really love them and all. Actually, it's my aunt who caused most of these family problems, not my uncle. I just don't feel she ever understood me. So we had highly conflicting interests. Of course, to this day she'd beg to differ.

So what happened after the Club MTV stint?

I basically ran away from home, moved in with somebody I'd been with for a long time. And for a while he was able to support me. Then his business just died, and I had to drop out of college and start working.

What were you studying in college?

Philosophy, at a community college. Then when I dropped out I was holding four different jobs at one point.

What kind of jobs were these?

I worked in two gyms, danced for EMJ Entertainment, and did catering. For EMJ we did corporate parties, Christmas parties, bar mitzvahs, 90th birthdays. We had this big entertainment crew that would come into your house and just tear the place up. Yeah, I had four jobs, but the money each week basically amounted to shit. I had a passion for everything I did, though — except the catering, because I was more or less a slave. But I also have a passion for cooking, so I learnt a lot from that job. Then Howard Stern came out with his show.

The original show on Saturday nights?

Right.

Great show.

It was. And I was one of Howard's first Snapple girls. After that show, I continued working with him on his radio program as a guest. I worked a *lot* with Howard before breaking into professional erotic dancing.

And how did you break into that?

Through a man I met on Howard's set. He asked me, "Do you dance?" And I said, "Sure I dance." And he said, "No. Do you dance." And I said, "Yes! I dance!" See, I had *no* clue what he was talking about. Then he said, "No, I'm talking about strip dancing. Do you know how much money you could make doing that?" And I said, "Yeah? To dance and what else?", because after I

heard how much money I could make, I really thought there was a blow job or something else involved. But being the little having-to-go-try-everything type of person I am, I eventually called him up and started dancing. I danced in clubs all over New York.

Going back to porn now, while you're somewhat beguiled by the whole smut galaxy, what *goal* did you primarily hope to achieve through sex films?
I was hoping to do feature dancing through it. That's why I've stuck with it. Slowly but surely, however, there's no goal. I mean, I'm not working at all. It's only a backdrop. If someone calls me to do a girl-girl, I'll do it. But, you know, it's for the money. That's what I need right now.

I can't help but notice that your boobs have been enhanced. How do you feel about breast implants? Good thing? Bad thing?
Totally a good thing.

And these new titties make Lennox feel better about herself?
Totally! That's one of the reasons why I started dancing, so that I could afford breasts.

Were your tits fairly small to begin with?
Oh-ho, God yes. (Laughs)

Are you happy with your current size?
Well, I wanna go one size bigger. Just one. (Laughs)

Finally I'm sure folks are dying to know the nationality of the very exotic-looking Lennox.
Thank you. But I really don't know — I was adopted. I'm sure I have some Middle Eastern in me, though. I know I have some Italian in me. I mean, I just *look* Italian. I also think I've got some Latin blood because of my temper. (Laughs) I can definitely have a hot temper. But I've *really* been trying hard to control it lately. Can you tell? ∎

Art: Maxon Crumb

Nyrobi Knights

Bring on the Sex... Hold the Fried Chicken and Watermelon, please

So Nyrobi Knights is squealing on the other end of the phone shortly after returning my page. "Oh shit! What time is it? Is it noon already? We've got an interview, don't we? I've been watching the clock since nine this morning. I'm at the laundromat." (There's an unmistakable hollow drone in the background.) "But I'll meet you at my place in 15 minutes. Is that okay?"

"Well don't rush yourself," I say, trying my best to relax her. "Why don't we meet in about an hour?"

"Yeah. That'd be great. See you then."

A porn starlet doing her own laundry? — in a laundromat? I love it! Kinda makes these adult film 'artistes' seem all the more human, doesn't it? Renting rundown technology, for the hour, by the quarter, in sleazy laundromats, where unattended, snot-dribbling, potato-chip-littering brats run screeching up and down the aisles, while their braindead, hungover parents gawk at reruns of Flipper or Mexican wrestling matches on blasting, out-of-focus television sets bolted to the ceiling. I'd call that down-to-earth, yeah.

But aside from being fascinated with Nyrobi's dirty laundry, I wanted to interview her for several reasons:

1) Her hard-on inducing features — mainly that slurp-worthy, mocha skin of hers (she's actually German and black); along with her cutesy girlish overbite; thick cock-sucking lips; big sleepy (yet fuck-hungry) eyes; and one positively jee-*yoo*-say bootay.

2) Her voice. Yep, you heard me right — her voice. That nasally, Valley Girlish whine of "Ooooh, fuck mee-*yeeeee*!" simply made me go lovely all over. And —

3) Her slut integrity, i.e., sloppy, loog-laden blowjobs; a passion for asshole plunging, DP drillings, mouth-to-cunt suctioning... AND (big plus here, folks) no possessive, balding, ex-Marine, fuckin' *loser* boyfriend micromanaging her fine pussy.

Quite simply, I felt Nyrobi was the best-looking black in porn. And a *nasty* little tart, too.

My personal recommendations for a memorable Nyrobi night include seeing Lana Sands grease up our lady's bubblicious black forest for some African-American orgy action in Video Team's *My Baby Got Back! 8*; a strangely tender, public lesbo makeout with Stephanie Swift in Gregory Dark's *Sex Freaks*; and a kaleidoscopic overdose of Nyrobi's DP's, ass-fucks, blow jobs, and facials in Rosebud's ferociously filthy *Gang Bang Face Bath 4: DP's Galore*.

Despite Nyrobi's trials and tribulations at the laundromat, we did eventually get together for a comfortable chat at her LA home on a warm, pleasantly breezy April afternoon in 1996.

The name 'Nyrobi Knights' — did you come up with that yourself?
Yeah, I did. (Laughs) I started out with the name Nikki Darling. Then when I was doing my third movie for Rosebud, they picked me up in a limo. And since there was another girl in the limo, we just started talking about this, that, our cats, blah-blah-blah. And she said, "My cat's name is Nyrubi." And I'm like, "Wow! That's a beautiful name." And that's where I basically got the name Nyrobi from.

And 'Knights'?
I think the guy from the Free Speech Coalition thought it up. What's his name?

Bill Margold.
Yeah. Bill Margold. I think he suggested 'Knights'.

How many films do you average in a week?
I've been doing a lot — twice a week, three times a week. Kinda slowing down right now. I've been in the business for nine months and I've got, I don't know, maybe 60 films to my name. I've done a *lotta* work for Rex Borsky at Rosebud Productions.

What's Rex like to work with?
Really strict. He doesn't like you playing around too much. Just wants you to get in there and give him a good film. But when the camera's not rolling, he's a real sweetie pie.

Thus far, what kind of weird sexual fantasies have you fulfilled in porn?
It was a turn-on getting fucked by a clown in *Sex Freaks*. That was a little fantasy thing of mine. But I thought it was hilarious, too. And having sex in a bar! That was really great. I did that in *Sex In Public Places*. I don't know which volume, though... but it was for Leisure Time. I also did a weird film called *The Chicken Boy 2*. In that one, I'm driving up a mountain, and I look and see this chicken boy with webbed feet and a beak sitting on a rock. Well, actually I don't see him until after

I get out of the car and am ready to go to the bathroom in the middle of nowhere. Then I hear this "pawk!-pawk!-pawk!", look up, and it's... a chicken boy! (Laughs) So I chase him around and eventually get him in the car and have sex with him. But during the scene I'm having a hard time fucking him, because he keeps moving around and going "pawk!-pawk!-pawk!" So I feed him bird seed. Then, like 10 minutes later, a farmer comes by and goes, "What are you doing fucking my chicken?" And he starts slamming raw eggs over my head, on my body, squishing them inside me, throwing bird seed at me. Then he fucks me really hard for fucking his chicken. Dave Hardman plays the farmer. He's really good. I did another film with him where he plays this Vietnam vet who kidnaps me from a store and goes, "Yeah! We're gonna get bombed!" Really nuts. Anyhow, he and his friend kidnap me and *fuck* me really good. They DP me, too.

Do you like DP's?
Um-hmm. I've always had a fantasy about being DP'd. See, when I first started, I didn't like anal, didn't like DP's. They were really hard for me... very painful... because I actually had my first anal activity on film.

I'm sure you remember the title of that film.
Yeah — it was *Fire and Ice: Caught In the Act*, with Jill Kelly and P.J. Sparxx. I came out dancing like a stripper. Then this guy shows up, seduces me, and fucks me in the ass. Everyone on the set knew if was my first anal ever, and they were all really supportive. My male co-star was talking to me while he was doing it, too... being really gentle with me.

Nyrobi Knights (centre) in publicity shot with Tabitha; *My Baby Got Back! 8.*
Courtesy: Video Team

I've noticed that some girls — like Tabitha, for instance — do DP's in the sitting position. Others like being bent over. Do you have a preference?
Sometimes while doing just regular anal, I like sitting on a guy. But with the DP's, I like to be reversed, where my back is towards one guy and I'm face-to-face with the other. I started working with Video Team a month ago and shot a movie called *Two Pac...* which I'm on the boxcover of, by the way. (Laughs) In that one I do a DP with Sean Michaels and Julian St. Jox. I love working with Sean Michaels. He's really good for anal... has a nice, smoooooth cock. But the best guys that I've ever worked with on DP's are Rick Masters and Dave Hardman. They're really good.

Where are you from originally?
Born in Germany... adopted. I'm an army brat. We moved from Germany to St. Louis, Missouri, and then to Northern California, where I was raised.

Whereabout in Northern California?
In Madera, just past Fresno.

What was life like in Madera?
Really quiet. My mom lived in the country section where all the grapevines are. We were the only house on the road and lived next door to a slaughterhouse. It was really horrible, but I guess you kind of get used to the stink.

You said you were adopted...
Right. My mom was in the service. I don't know... it's a really hard story. My life's very complicated. I don't recall too much about being born in Germany. I do know I was adopted by my stepfather, who was black. My real dad is German and I actually know who he is — but I won't say anything. From what I understand, however, he's pretty well-known. I know who my mom is, too.

What were you like as a teenager?
In high school I was... um... weird. Very quiet. A disturbed child. Always curious about who my real dad was. I lived with 13 brothers and sisters who were all black and, since I was the only mixed child, the only mulatto, they always picked on me. It was really hard growing up. That's also why my mom spoiled me out of everyone. Spoiled me badly. But I just wasn't happy. My brothers and sisters were always doing stuff like pulling my hair and calling me "oreo." It was really hard growing up in that

family.

What happened after high school?
Well, while I was growing up, I'd always came to LA to stay with my brother. He's the only member of my family I really got along with… the only one I really love. And whenever I got upset with my family, I'd come see him and stay for a while. Then I just figured, well, I might as well go to school in LA since I'm always down here. First I went to a small medical college called Northwest; then after that I went to Waterson College — they're both in Pasadena. I studied phlebotomy [vein surgery] and worked towards my RN license. At first I was a medical assistant, then I became a Registered Nurse working at Madera Community Hospital.

Generally speaking, what are your feelings about LA?
I don't know. I kinda like it. It's kinda fast… really *wild* out here. I've been here for about a year and seven months now.

Since you've been in LA, how much racial tension have you observed or experienced?
Well, actually I get it from both sides. Ever since I was a kid I've gotten it from the blacks and the whites. I get it from the blacks because I have white in me. And sometimes I get it from the whites because I have black in me. It's like, "Oh she's just a half-and-half little bitch." Sometimes it's good because it works out in my favour. I mean, because of my looks, I can get a job anytime I want to. People adore me. Some people are just really amazed at my nationality. I mean, I am black — and German. I just don't speak the German language. I'm half and half. But, generally speaking, I guess I would be considered black.

What about racism against blacks in porn? Have you picked up much of that since enlisting in the ranks?
That's a good question. When I first started I was only doing white films. Everyone adored me. And while I've never actually gotten any racial slurs from anyone, I have noticed blacks get treated a lot differently than whites — like the food on some film sets. All the sets I've been on have had great food. And I don't know if this is racist or not, but I've noticed the food isn't as good on the sets of black films. I've done three black films so far, and, I mean, on the set of one movie they actually cooked fried chicken and served watermelon. I swear to God.

You think that was intentional?
I don't know. But some people do have these little prejudices where they think, 'Oh, black people like to eat fried chicken and watermelon, blah-blah-blah.' But, to tell you the truth, I've never really had a problem with any one producer. Everyone's been really sweet to me.

Gang Bang Facebath 4: DP's Galore!; videobox art.
Courtesy: Rosebud Pictures

I've only been a little upset because I missed out on some magazine work. I mean, one well-known porn photographer took a Polaroid of me and my girlfriend Kitty Monroe, whom I got into the business about four months ago. We *both* took a Polaroid, but he called her back the same week and didn't even bother calling me. So one day I was working for Vivid, and the same guy comes on the set, takes one look at me, and goes, "Wow!" And I said, "I'm Nyrobi Knights." And he said, "It's a pleasure to meet you." And I'm like, "Well, it's *not* a pleasure to meet you. You took a picture of me and didn't even look at it. I guess you just assumed that since I'm black, I'm a hideous-looking, ugly woman. You make me sick. You disgust me. Just… don't say anything to me."

You sure put him in his place. Did he get pissed?
No, he didn't get pissed. I just told him how I felt: "Don't look at me *now* and say, 'wow!'," I really caught him off guard. But Kitty really is pretty. We did a film together called *Tight Asses 14*.

When I watched Kitty getting butt-fucked in Gregory Dark's *Flesh*, it looked like it really hurt her. Very intense stuff.
Yeah. She did her first anal on film, too — just like me. Now it's no problem. I love it. It's wonderful.

Any other evidence of racism against blacks in porn?
Well, Vivid was like the main company I wanted to work for. And I thought I was going to have problems with them because someone told me they were really racist. So when I went to one of their talent calls, I walked up to a female talent scout and just said, "I've heard you guys don't work with blacks." And she goes, "Who told you that?" And I said, "I just heard rumours not to come into this room because you guys wouldn't give a black girl the time of day." And she said, "Are you kidding? You're *beautiful*." And as it turns out, she called me at home that same day and wanted to know

directed by REX BORSKY

directed by REX BORSKY

Nyrobi Knights; Videobox for Rex Borsky's *Booty Bitch*, the back of which (left) features the 'unauthorised' KKK figure on Nyrobi's waist chain. Courtesy: Rosebud Pictures

if I'd do a film and a boxcover for them. I was like, "Sure! I'd love to!"

What made you decide to get into porn in the first place?

It's always been a fantasy of mine. I've watched porn since I was 14 years old. My brothers had videos and I was *really* curious. I think I grew up a little fast… started feeling funny at the age of 13. I mean, my body was like… I don't know, I guess I started getting horny early on. I wasn't a bad girl, wasn't wild or anything. I was into modelling, gymnastics, ice-skating… typical things for a child.

But you thought about sex a lot.

Oh my God, I *did*.

Did you masturbate a lot?

I tried. I was really curious. I even came to LA when I was 16 years old and went to *Hustler*. And you know what? — I just shot for *Hustler*. I meant to ask if they remembered me or if they still had a file on me. I was

just 16 years old when I went into their offices and filled out an application. But I told them I was 18. Anyhow, they took a Polaroid of me and I never spoke to them since.

You mean they didn't call you back to follow up on the Polaroid?

Oh they couldn't. I didn't have a phone. It was just a fantasy. I wanted to do it just because I was curious.

So once you were of age, did you go directly into porn or start off dancing like most girls?

I came out here 11 months ago and started dancing. P.J. Sparxx was dancing at the club I was working at. She wasn't featuring, though… just one of the housegirls. Anyhow, we became really good friends, and I asked her, "Well, what do you do?" because I wasn't really into porn that much, you know, to the point where I knew who the stars were. And she said, "Adult films, blah-blah-blah." And I started watching some of her films, hanging out with her, and one day she took me to one of her shoots. And, well, I just got into the shoot and loved it.

What's a real plus in porn for you?

You get to have sex a lot. (Giggles)

And a negative?
Sometimes it's really scary because you don't know if you're going to contract something. So far I've been really lucky; I've been tested negative, and all my other tests have been pretty good. I don't know... I've been kind of swinging lately and notice a lot of people who just don't care. They just fuck everyone, like on a fuck farm. On the one hand it's cool, because you know everyone from the business has been tested. But some people come into these parties who you *don't* know — and they're fucking everyone! When I swing, though, I only do girls. It's much safer that way. But I only swing with girls I'm really attracted to. Like Missy. She's one of the best girls in the business. I really adore her. We did a layout together that's appeared in *AVN*.

How does your husband or boyfriend feel about your work?
I don't have a husband. Still dating at the moment. (Laughs)

I couldn't help but notice that your eyes look different in a number of features.
Coloured lenses. When I started — like around the time of *Sex Freaks* — I was wearing gray lenses. Then I started wearing amber because they highlight my eyes. But my eyes are actually light brown.

Do you have a fan club?
Yeah. It's my 'exclusive,' 'official' fan club. (Laughs) You send $25 and you get all these... goodies.

What kind of goodies?
Videos, posters, vibrators, accessories that I've used on film. A guy can call in and say, "I'd like Nyrobi to snick a film, saying my name while she's using a vibrator. And I want her to send me the same vibrator — not even cleaned." And it'll be sent to him. If the guy's name is Tom, for example, I'll be masturbating on the film while saying, "Ohhhh, Tom." Then I'll sign the boxcover, send him the video, and... all just for Tom.

What about gang bangs? Have you done many of those?
Um... I did... let me think... how many guys did I do in that one?... in *Face Bath 4: DP's Galore*... I did Tom Byron, Tim Whitfield, Marc Wallice... and... some other guy. I did a gang bang with all of them and just tore 'em apart. I mean, I *loved* it. And at the end of the film I'm like, "More! More!" And they taped me saying that. I didn't know it, either. (Laughs) I just couldn't get enough.

Generally speaking, how do you feel about breast augmentation?
Actually, I had a breast reduction.

Reduction?
Yeah. My boobs were kind of big so I got a reduction. Then after I got the reduction, they kind of sagged a little. So I'm like, "Oh, fuck!" That's when I got a lift.

They must have been pretty big to begin with.
No. They weren't like huge. I mean, had I known I was getting into porn, I wouldn't have even touched them.

Let's take a video like *Booty Bitch*. Does that sort of title bother you?
No. 'Bitch' doesn't bother me at all. But now that you mentioned it, I did have a problem with that particular boxcover. And I acknowledged it to Rosebud the other day. If you look on the backside of the video, you'll see someone has painted a KKK guy on my belly chain. It's this drawing of a guy wearing a white sheet over his head, with these little eyes and teeth peeking out, and holding a torch. I was very upset by it. The thing just disgusted me. And the folks at Rosebud claim they don't know who put it there. But like, I mean, *fuck*, why would somebody do that in the first place?

Hmm... very strange. Well, is there anything you'd like to discuss which we haven't covered? Something you'd really like to get off your chest?
Yes. I was in Cabo San Lucas, Mexico about a month ago, filming for Coast To Coast Video with Bruce something... not Bruce Seven... I can't remember his name... but his first name was Bruce. He's in the same building as Snatch Productions. Anyhow, I had a problem with him down there. He was talking to me like I was a piece of shit. So I just gave him my favourite line in the business: "Kiss my *ass*!" I mean, when I'm pissed, I'm pissed. So I walked off the set. Funny thing is, I gave him a *great* scene. But he just wouldn't treat me like a human being. So I was really shitty back to him. And you know what he did? — he actually called just about *every* production company in the Valley and told them, "Do *not* hire Nyrobi Knights," which is very low, ignorant, and stupid of him. He was trying to make people think I'm difficult to work with. But everyone knows I'm wonderful to work with. They love me. I even had people calling me saying, "Oh yeah. Bruce is calling people saying that they shouldn't hire you. But we all know that you're great, blah-blah-blah." And I actually got *more* work after he did that. He's just a fucking drug addict asshole who should learn to respect people.

Since you mentioned kissing your ass, would you say that's one of your best features?
Yeah. Everyone loves my ass. My face, too. Sometimes I get upset because a lot of people want to use me only for my face. Sometimes that's good. I really don't mind. But, yes, everyone really adores my ass. ∎

Saki

Fuck and Suck for Cash and Prizes

Saki; ad art for *Saki's Private Party*.
Courtesy: Totally Tasteless Video

The fact that she's an older woman — like the unforgettable Georgina Spelvin — adds that much more mystique to fuck star Saki. And just like Spelvin during those Golden Age days of porn, Saki currently lends that cherished dosage of pure, raw passion to her sex scenes in the Nineties. She's particularly great (along with her marshmallowy, made-in-Japan butt) in VCA's *The Makeup Room 1*. In this particular slut selection, Saki is righteously doggied on a casting couch by some unknown, forgotten, yet effective stud. Although this wannabe baron of beef looks every bit a man's man, he mercilessly bangs Saki till she squeals like Miss Piggy being cannibalised (the over-heated hussy literally sinks — and eventually scrapes — her whorish snap-on fingernails straight across a frosted glass end-table… sca-*reeech!*)

An even more classic Saki scene is her low-down 'n' dirty double penetration in *Caught From Behind 16: The Reunion*. Even though this particular DP initially sets the viewer's cactus up for a fall, it does not disappoint. Of course, when you've got a splendid, outgoing sex maniac like Saki in a room with two veteran scum buckets like Ron "the Hedgehog" Jeremy and Joey Silvera, well, even a genius like Sly Stallone can predict the outcome. That's right: DP-aroony. But, still, you can't help but think the obvious: 'Yeah, yeah, yeah. Jeremy's gonna fuck her in the cunt cause he's got such a huge redwood.' Nuh-uh. Think twice, friends. Jeremy *jams* his log straight into Saki's gorgeously pigmented poo parlour, holding his vein-laced torture tool by the base as King Kong would a ripped out tree trunk. Saki, as usual, is fabulous. Her well-seasoned Asian looks, great set of full-bodied, real tits, and incredibly fleshy, quivering ass make for one dynamite vision of unbridled sleaze. And despite Silvera's bizarre groans to Jeremy of "I-I can't move, Doc… I-I can't move," this is a primo example of rape rock, with Saki throwing in all the necessary backing moans. Her two assailants make her look like a human wishbone. Ka-*rack!*

I interviewed Saki during her visit to San Francisco's New Century Theatre in the summer of '95. At a nearby Tenderloin apartment complex (where the Century generally houses its talent), we sat by the pool and chatted until I ran out of recording tape. That's when we decided to get a bite to eat… and, of course, buy more tape. We took a taxi to Original Joe's on Taylor Street, where Saki enjoyed a plate of meaty spaghetti (while I gnawed on the pot roast). And between us — with the tape recorder rolling; Italian-American, white trash patrons swillin' dago red; paunch-flaunting cops sucking down gooey cheeseburgers; and bungling Slavic waiters fucking up as usual — we split a bowl of steaming Saki between us.

After your show today, you said you typically don't do interviews. Why's that?
They scare me. The thing is, I enjoy both my privacy and my career. But I realise you have to separate the two. I mean, the only thing that's kept me going, that's kept my feet on the ground is learning to separate myself from the business. Besides, I like you. I like your approach. You're not over-pushy, or "Can I please, please, please…" I get the sincere impression that you like my films.

Right on the money.
But it does scare me that if I do too many interviews, and the fans know this or that about me, someday I may be out shopping in a grocery store, and someone might approach me with all these questions. And I just might not feel like dealing with it.

Do you get recognised quite a bit in public?
Sometimes. And when I do, it surprises me because I really try to dress down. (Laughs) I do.

When they recognise you, is it usually a positive experience?
Yes. It's always positive. But I really don't want to be famous. I suppose it's good getting your face and name out there, but I need my own space. (Laughs) I know that's so clichéd, but it's true. I've actually made a lot of sacrifices to maintain my privacy. What's really hard is that sometimes, because I *don't* do something, it comes back to bite me in the ass. You know what I mean? It's like, because I don't say, "Oh, I want to be Miss Fame and Fortune," or because I don't say, "I'll do this boxcover for free," it'll come back to haunt me.

You've gone under the names Satina, Saki, and Saki St. Germaine. Are Satina and Saki —?
Oh, they're totally different people. (Laughs) Totally different. Satina is always inside me and loves dancing more than anything else on earth. And I think she's an exhibitionist. But *all* my characters are exhibitionists. (Laughs) At the same time, however, I think Satina can't deal with the video business as well as Saki, who tends to be a little bit harder, a little more... what?... a little more stern, bitchy. Her tolerance for bullshit is somewhere between zero and two seconds. Satina, on the other hand, will go along, absorb a situation, and make a decision. Unfortunately Satina doesn't get to come out as much as she'd like to. It's unfortunate for the world I think. (Laughs)

Well, Saki's good enough for the time being. So why did you originally get into this business?
When I first got into it I was Satina. But um... how do I say this and still be kind to some people?... okay, the clubs where I used to dance were ones which I felt had a lot to give the performer, as well as the clientele, and the art of dancing itself — like the Mile-High Saloon in Denver. And when I got to LA, I expected the same calibre of clubs. And whether it was culture shock or whatever, it kind of took me by surprise, because the LA clubs were totally different from the clubs I was used to. That's when I figured, "Oh my goodness, I'll have to figure out something else to do." Then a friend of a friend of a friend... (laughs)... a certain British director... John T. Bone... decided that he wanted to make me "a *star*"... you know, the whole 'baby I can make you a star' thing. My very first movie was well before that, though. It was for Titus Moody and Eye Shadow Productions... a girl lingerie fantasy with me and Charisma. After I did a couple of those lingerie fantasy things, this friend of a friend (smiles) said, "Maybe you should be a porn star." I was one of the few girls that was literally discovered, who didn't walk into an agent's office and say, "I want to fuck and suck for cash and prizes." (Laughs) And I started doing it because I enjoyed it, thought it was fun... and, of course, it paid very well. But I also enjoy being in front of the camera. You can do stuff in front of the camera that you can't do in real life. It's great. That's also why I like horror films — you can view things in a horror story which you normally don't see in everyday life while walking down the street. I love it. But I think it's also sad that we can't do the same stuff here that they do in Europe.

Like fisting?
Yeah! Not only that, but you can't be tied up and have sex in American porn films.

Do you like being tied up and fucked?
Yes! Oh, *hell* yeah. Who wouldn't? People are just as perverted here as anywhere else. But you can't come out and *say* it without being chastised or judged. It's really sad that our government does that. Oh! Let me tell you what happened to me last time I was in the city. These people came to see my show, right? And they wanted autographs and the whole nine yards. And after the show, they were like, 'Well, would you mind if we walked you part of the way to wherever you're going?' And I turned to my bodyguard with this look of, 'Well? What do you think.' And he said, 'Yeah, it's cool.' So there were three guys, right?... three fans. And they were dressed in really nice suits, and as we walked along, one of the guys had this little notebook out and he started asking me all kinds of different questions. (Aside) I'm sure he remembers everything I'm saying if he's reading this. So he's walking down the street, talking to me, and writing stuff down in the notebook, and I'm going, 'Wow! How do you walk and write at the same time?' (Laughs) And I'm honestly thinking in all innocence, 'Oh, wow, that's really a cute trick. I wish I could learn how to do that.' So I ask him, 'Are you a reporter or somebody?' And he slowly shakes his head. 'F-B-I,' he says in all seriousness. But to this day, I think he was just a fan who happened to work for the FBI. I mean, I haven't heard anything since that episode... knock on wood. (Laughs) They're probably reading this right now. But, anyhow, that's my big experience with the law. I try to behave myself.

What about co-performers? Whom in the business do you like working with?
Sharon Kane, Nina Hartley... You know what? I have to clarify this by saying, 'I hate to name names,' because there are so many beautiful people out there that you leave out when you answer that sort of question. But the people I'm naming are close to me, personally as well as professionally.

What about male stars? I suppose that's a fairly tricky question, too?

Yes it is. (Laughs) I love them all. As long as they can stay hard and perform, I love 'em all. (Laughs)

You know, I include you in my list of top-ten DP's and...
Oh! Thank you! Yeah!

You're welcome. But let me step back a bit. What's *your* favourite DP so far? I know you've done a number of them.
Yes. But, you know what, my very favourite one was my first one. And the reason why it's so special to me is *because* it was my first. It was with Peter North and Sean Michaels. Sean's very gentle. He knows what he's doing. And if you have special request about what you like and don't like, he knows, he remembers. I don't recall the title of the movie, but it was my very first DP... very special to me.

So were double penetrations a new experience to you?
Well... on film they were. (Laughs)

What about your first DP in real life?
(Laughs) No, no.

What? We can't talk about that? Oh, I see — Satina's coming out now, right?
(Laughs) Very good.

Well the Saki DP I really enjoyed was the one with Ron Jeremy —
Oooh!

— and Joey Silvera —
Mmmm...

It was in a *Caught From Behind* film.
Oh, my God yes! *The Reunion* movie. That was a while ago. Oh, I love Joey. It was fun, yes. *Very* stimulating.

Do you think anal sex is more stimulating than vaginal sex?
(Smirks) They can both make me come if done... properly. I like 'em both. But sometimes I like one over the other. It depends on my mood.

You've been in the business for at least six years now and, thankfully, have kept your breasts far away from the cosmetician's scalpel. What's

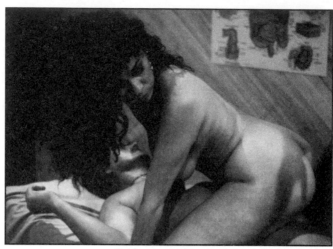

Saki gets double-stuck by Joey Silvera and (out of frame) Ron Jeremy in *Caught From Behind 16: The Reunion.*
Courtesy: Hollywood Video

your reasoning?
Well, I've been exercising to keep them at least... firm... (laughs)... or at least half-way there. Now and then I feel like I'm under pressure to get them fixed, like (into microphone) *when people don't call me for work!* (Laughs) And no offence to any girls, but the reason I haven't gotten my tits fixed is because I'm chicken, I'm just afraid of what they'll look like after they're done. I've seen some really, really beautiful ones but... I mean, the chance I'd have to take compared with what I've got, with what I'm happy with now... to me, it's not... I just like them. I like them! They've been good to me — and a lot of other people. (Laughs)

Have you ever thought about doing your own line of sex videos?
Oh hell no. You have to think too much... too much of a headache. I don't want to think that much. But I can still sit and watch an old John Leslie movie. The one which comes to mind is this film with a girl coming down the stairs and a whole voyeuristic thing going down. I can just watch that, and watch that, and it gets me... ohhhhh... my God, it gets me going. (Laughs) I'm not sure what film it is, but Leslie directed it in the Eighties. I love those older porn movies since I really can't watch the new ones. I mean, I know all the actors and actresses in the new ones. But I still look at those older films fairly critically and say things like, "Oh, look at that lighting," or "Oh, look at her... they could have done this or that with her."

Listen, I'm curious. I once saw you in a film with Marc Wallice where you kept slapping him in the face — not really hard, but very methodically. What was that all about?

Oh, Marc Wallice! (Laughs)

What was going on there? Was he nodding off or something?
(Laughs) No. Let me tell you... I had PMS that day, okay? And we all know what that's about, right? So Marc just started hittin' himself while we were doing this scene. So I'm going, "Let *meeee* do that!" See, he needs to slap himself because it helps keep him from like... coming. It keeps him stable, on an even keel. So he's sitting there doing that to himself and I'm going, "Oh, dude, you ain't even doin' that right. Let me help you out there." (Laughs) SMACK! SMACK! SMACK! (Laughs) And the producers kept it in the film. I was really whacking away, too. But, again, I had PMS, so once you get me started, I'm *goin'*, thank you very much. (Laughs) I have to go pee, how much tape time do we have?

We've got a little left.
Okay, I'll be back. (Goes off to pee; comes back 10

minutes later.)

At this point, we leave Saki's borrowed apartment to buy more tape at a nearby convenience store; afterwards taking a cab to Original Joe's on Taylor Street, wherein the remainder of the interview takes place.

So, Saki, what's your definition of the word 'slut'?
First off, I think it's a great word. But it can have two meanings. One would be if you're trying to degrade someone, put 'em down by calling 'em that, saying they're bad because they go around and are promiscuous. That's the definition used by someone who thinks sex is wrong, who thinks it's bad stuff, who thinks it's evil... which is actually their own problem.

The other meaning is much more positive. A slut in that sense is somebody who can feel good about themselves, who can go around and be who they want to be, do who they want to do, be happy about it. And even though the outside world may look at them with the first viewpoint, this use of the term isn't offensive. I think it's goooood. (Laughs) I mean, there are dresses with 'Slut, Slut, Slut' written all over them. So if you saw a girl with that dress on, you'd say, "Okay, she's confident about herself, and comfortable with what she is, with what she does." But no, hell no, I don't mind you asking me that. But, still, most guys will tell you a slut is just a woman who can suck a mean dick. (Laughs)

Since we're on the subject of sluts, have you ever worked with Casi Nova?
Um-hm.

What was she like?
Great. She was wonderful. Nicest person. *Nicest* person. Very sincere, very down-to-earth, very wild. (Laughs) I worked with her and Viper at the same time. We did a three-way girl scene. I'm not sure of the title. You know, I feel like there's so much I want to say in this interview, but I don't know how to say it. (Laughs)

Don't think about it too much. You're doing fine.
(Laughs) Okay.

Are there any Saki fantasies which remain unfulfilled

Saki's Bedtime Stories.
Courtesy: Hollywood Video

outside of the movies, as well as in them? Or have you — ?

Covered it? (Laughs)

Well, you still have a very positive, fresh attitude.

Thank you! You know, I think you have to. I think that's the only way you can stay in the business. You have to be happy about it. As I said before, there are times when you really get down on yourself, the business, and everything. HOWEVER... (laughs)... however, if you're not happy with your work, what's the point? Why do it... just to do it? You have to like what you're doing. You have to be happy about it.

What about girl-girl? Does that make you happy?

Oh I love that. I didn't always. But, yeah, I love it. Love it.

Were you introduced to it through the business?

Oh no. My girlfriend introduced me to it right before I got into the business. It's very popular now, too. I think every guy really likes it. And as far as interracial sex, *anything* I do is interracial. (Laughs)

Bungling Slavic waiter arrives.

Slavic waiter: Do you vaunt meelk in yor cuff-ee?"

Saki: No thank you. I like it black. (Starts laughing uncontrollably as idiot Slavic waiter waddles off.) Black.

Do you ever have a hard time finding work because of your ethnicity?

I don't have a hard time because I don't look Asian *per se*. I'm not your stereotypical Asian. And people look at me and go, "Well, we're not exactly sure... *what* she is." But it's really hard enough when you're totally Asian because you're constantly being stereotyped. Producers don't know where to put you. (Laughs) "Where does she *fit*?"

But when you do these 'geisha' scenes, do you resent having to turn up the volume on your ethnicity?

No, because it's always a part of me. I can speak conversational Japanese and understand it completely. But as far as Japanese business talk, I probably couldn't get by. I'd probably have to take classes.

Any recommendations for girls wanting to get into the business?

I think it's good for a girl to know what the pitfalls of this industry are, to be forewarned of them, to have it in the back of her head all the time. However, people have told me from day one, "You can't do this forever." It still hasn't sunk in. But I still remember that line.

And I *am* still working. But let me say this: you can tell a girl, "You'll be really hot for maybe two years... then expect this, this, and the other thing to happen." Well, excuse me, but if a girl is up here (puts palm horizontally above her head) for two years, do you know how hard emotionally and physically it is for here to go from here to here (quickly lowers hand to her lap) in two days? It is *not* an easy thing to do. They feel like they're on top of the world, then all of a sudden someone new comes into the business and they're replaced. All of a sudden, they go from here to here in their own mind. And you can't change that. There's nothing you can do or say to them to prevent that from happening. They're going to have to experience it themselves.

But when that moment of reckoning *does* come, it's good to have somebody nearby who they can trust. Somebody who isn't going to exploit them, who isn't going to take advantage of them, who is there to actually help them as both the porn person and the real person. And if somebody isn't there to do that for them... well, we've seen what can happen. I have some good friends who have helped me with that. That's why I'm still alive, because I've been through it: from here to here, and back up again... and still climbing.

I hate to be this depressing (laughs)... but somebody needs to say this. I think we've lost too many people in this business because of the ups and downs. I've lost people who are really, really important to me, and it just hurts. We're dealing with body and soul here. When somebody says, "We can't use you in a film," they need to give you the *reason* why they can't use you. They shouldn't say or even give the impression of, "Oh, we've used you. Now we don't want you anymore." Do you know what that does? It makes you go, "Ohhh! My God! What's wrong with me?" It makes you look in the mirror and go, "Oh well, maybe it's because my eyebrow is out of place, or maybe it's because this is wrong, or that is wrong." It's really fucked. It is. Because sometimes a body is all some people have.

This is the first time I've ever said this, and that's why I don't do interviews, because I think this kind of subject is too deep. But I feel very strongly about it. When I think back on it, there really were times when I would be dead right now if it wasn't for my having a support system. Having those people around me has helped me stay alive, happy, and excited about the business. They've also helped me remain invigorated about life in general, too.

So what are some of the other positive things you've experienced from porn?

I've learned to do my makeup a lot better. How's that for shallow? (Laughs) ∎

Roscoe Bowltree Speaks!

An Interview With Porn Auteur Patrick Collins

Nasty. That's probably the most singular term you can use to describe a Patrick Collins video. Fetching starlets slurping up jizz like sperm-hungry vampires, then — ever so stoically displaying the maxim "share and share alike" — spitting the still-steaming slime juice into one another's mouths (Tiffany Mynx and Nikki Shane sharing Nick East's liquid offering in *The Bottom Dweller*); filthy homemakers literally sitting on (and readily squashing) black forest cakes with their luscious, perfectly sculptured flesh muffins, whilst their boyfriends lick the smashed debris of grotesque, brown, excrement-like pastry from

their quivering assholes before jamming the proverbial ladle into the bubbling vat of chocolate (intoxicatingly sultry Chelsea Ann playing the galloping whormet while the truly hideous, pug-faced Jack Mann shows how to raise more than your cholesterol level with the proper diet in *Sodomania 4: Further On Down the Road*); outrageous hussies gulping gamete cocktails as the thick nectar is slowly poured out of dirty high heels like molasses in January (the phenomenally intrepid Tiffany Mynx in *Sodomania 3: Foreign Objects*); totally unknown, scrumptious European tarts getting their assholes pumped full of knockwurst in public streetcars (Hungarian pepper pot Laura putting the goo into goulash in *Buttwoman Does Budapest*). Those are just a sampling of the many classic sleaze concoctions Collins has whipped up over the past several years for the palate of the truly discriminating pornoholic.

Not surprising, Collins' one-time partner in porn was none other than John "Buttman" Stagliano himself. During the late-Eighties, because of his vicissitudinous global gash-gallivanting in Cannes, Amsterdam, London, and Rio — to name but(t) a few picturesque locales — Stagliano needed someone with the necessary savvy to keep his Evil Angel Productions afloat. Collins fit the picture. Originally an investor from Burlingame, California, Collins took the reins of Evil Angel in July of 1989, overseeing the advertising, sales, and distribution of all productions and, consequently, turning Stagliano's erotic cockbusters into financial blockbusters. While managing Evil Angel, Collins also extended his talents in front of the camera, starring as the wily (now cult) character "Roscoe Bowltree" in a

Patrick Collins draws attention to his billboard in downtown LA, 1996, advertising the new Elegant Angel. Photo: Anthony Petkovich

number of Bruce Seven kink videos, including *Dark Interludes*, *The Challenge*, *The Power of Summer* and the classic *Face of Fear*. He further succeeded in erecting Elegant Angel Video (an off-shoot of Evil Angel), some of the early titles for which included *Buttman Versus Buttwoman* and *Buttman's Revenge*, with Collins at the helm as producer.

Then in the early Nineties, Collins figured it was time for Buttman to make way for the 'Bowltree' international, cunt-and-crack-hunting camcorder. As a result, Collins' first full-length feature, *Buttwoman Does Budapest* — the premiere American porn film with an entirely Hungarian cast — is highlighted by an unforgettable line of Magyar mutton, capable of making the most chauvinistic Hungarian give up paprika for life to get merely a whiff of such delectable Euro-uterus.

By 1993, Collins and Stagliano had became the perfect business pair. Both were directing films and running Evil Angel at full steam. Stagliano was the softer, happy-go-lucky personality, while Collins was the firm hand of business. Together, they expanded E.A. Productions to new sexual heights, bringing on board such greats as Bruce Seven, John Leslie, and Gregory Dark, as well as stars-turned-directors Bionca and Rocco Siffredi. But the heaven-sent tag-team of Collins-Stagliano was soon to change.

While Dave Patrick and I interviewed and photographed Nicole Lace at Collins' LA mansion in February 1996, Collins took us into his confidence. His plan? To break away from Stagliano and go it alone. Less than a month later, Collins did just that. In an almost Hatfields-and-McCoy fashion, he relocated Elegant Angel directly across the street from Stagliano's Evil Angel, potentially leaving room for tensions to flare. Collins, however, revealed to the press that he harboured no hard feelings about the split.

"What basically prompted me to do it," said Collins, "was that over a seven-year period, John continually said he was paying me too much money — and I kept taking less money. It eventually got to the point where it didn't make sense for me to stay. I felt a loyalty, an obligation to him because he'd given me a chance. But, you know, that ends at some point. And it probably should have ended sooner. But, to me, this change was evolutionary not revolutionary. And the freedom is great. I'm shooting some of the best stuff I've ever done."

Almost starting at zero with his new Elegant Angel, Collins made his company a sort of testing ground for up-and-coming directors. Some of the fresh talent to arise from the reincarnated Elegant Angel included Tom Byron (with his Cumback Pussy line), Van Damage (with Filthy First Timers), and Robert Black (with *Shooting Gallery, Cellar Dwellers,* and *Sexual Atrocities*).

A sort of Orson Welles of X, Collins is still involved in every aspect of his movies. Not only is he producer, director, and still photographer, he also does everything from scripting the film to screwing the actresses (hey, there's something Welles didn't do! — on screen,

at least). And the results are far from limp. Collins' movies allow serious purveyors of hardcore filth the pleasure of seeing such scintillating screen strumpets as Tiffany Mynx, Vanessa Chase, Lovette, and Tami Ann getting brilliantly cornholed by the greasiest of studs. Indeed, the videos are typically wallowing in a swamp of bodily fluids. You name the ooze — hey, it's in there. Heaping, intemperate tablespoonfuls of the stuff(ings) that murky dreams are made of.

The following interview was conducted at R.S. Connett's "Vomitus Maximus Art Gallery" in San Francisco on May 22, 1993. During this period, Collins was still in business with Stagliano, married to porn super slut Tianna, and just making headway with his *Sodomania* series.

So who's Roscoe Bowltree?

(Laughs) It's the name of a guy who used to collect money. I picked it up years ago because I always thought it was kind of a cool name... you know, (shifts eyes over-dramatically) "Roscoe *Bowl*-tree..." (Laughs) But, still, I'm proud of what I do, so I always use my real name on the production end of it. My name as a star in the movies themselves is Roscoe Bowltree. I've always done cameos in a lot of the Evil Angel productions just because I have fun doing it. But the funny thing is, I meet people and they go, "Aren't you... Roscoe Bowltree?" And we start talking and they find out that I'm Patrick Collins and they never even knew that. People in the business know my identity, but the fans don't.

You've done a lot of filming in Hungary, what with *Buttwoman Does Budapest, Tianna's Hungarian Connection, Buttwoman Back in Budapest* and now *Depravity on the Danube*. Aside from the gorgeous females over there, what's the attraction to such a relatively distant locale?

This is getting a little ahead of the story, but the truth is, after my association with John and Bruce Seven, I knew I was going to be compared to them in my directorial style. So I went to Budapest to shoot my first movie. And I did it because I didn't want anyone saying, "Oh, well, Bruce must've been on the set" or "John was on the set." I didn't want any of that. And so far so good. But as far as shooting videos in Europe, I don't want to do it again. It's so difficult. Oh God, it costs me three times as much money. I make the same amount of money here. Of course, I don't add to the price of the video because I really do care about the consumer. That's why I got into the business.

How did you meet your wife Tianna?

I met her at a social function in Palm Springs in 1988. I rode my bike up there with a bunch of my friends and

was exhausted. It'd been real hot all day. It was during the summer in Palm Springs. *Hot*. And it was at night at a dance. I don't like to dance, but I was looking for some… company, you know. So I went into this dance hall, and there was no place to sit down, so I had to sit on the floor. And I was tired. Then I was pissed. And she came up and asked me if I wanted to dance and I said "No!" I

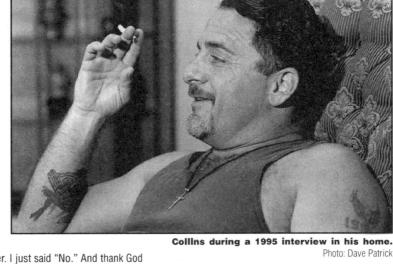

Colllns during a 1995 interview in his home.
Photo: Dave Patrick

didn't even look at her. I just said "No." And thank God my friend was sitting next to me on the floor, because he *hits* me like this with his elbow and goes, "What's *wrong* with you, man. *Look* at her." And I looked up and I'll never forget it. She was wearing this suede thing, with little strips of suede all over her, and this light was coming through, and I looked at her. (Laughs) I got up real quick, went over to her and said, "Well, we don't have to dance. But let's talk." And we started talking, and I liked her. She's actually my fishing buddy, you know. She loves to fish. Actually, on one of my first dates with her we went fishing. It's one of the things we love to do.

And the truth of the matter is, early on I said to her, "I don't date girls that aren't bisexual." And she said, "Well, I had a girlfriend for a year. Is that good enough?" She came back with that one so quick I just said, "Absolutely." I was kind of blown away.

What do you think of the scene in *Between the Cheeks 2* with Tianna and Heather Lere fucking in the trash bin?

I only heard about it. Never saw it, though. But I can guarantee if it was with Heather Lere and Tianna, it was probably pretty good. And besides, Greg Dark does some really nasty stuff. He's my kind of guy. But I don't know him that well personally.

Do Tianna and you work together regularly?

We try not to. First off, she's my wife, she's my friend, right? And when I'm directing and producing a movie, it's very important to me that everything goes right. So if there's a problem, I have a tendency to be harder on her than I'd be on other people. And it's unfair to her. This time when she was in Budapest she was only there for like eight days. I was there for three weeks.

She made the one movie and she left. That was our agreement before we left. It's very stressful for her.

She does the dance circuits, too, doesn't she?

No.

No more?

No. She never really did. She *is* a dancer, and she really loves to dance. But we've got three dogs, two cats, and she really hasn't had the inclination to dance anymore. What she really likes are the fantasy booths. She likes those because there's an interaction with the guys, and she can see the immediate reactions. She likes seeing the guy get a hard-on because she's very much an exhibitionist. But, I mean, she likes dancing, too. She's danced at the Market St. (Cinema) and at the Century (Theatre) here in the city. Just locally, though. She's never been out on the road. She's thinking more about it now because I made a deal with her just the other day. I told her if she wants me to get this new house, she has to dance at least once every three months. (Laughs) And she said she would. She's got a big name, and there's a big demand for her out there, so she might as well capitalise on it.

Does Tianna just star in girl-girl movies now?

Not really, no. I was just in Hungary and I shot *Buttwoman Back In Budapest*, and she does guys in that. In fact, she does her first anal scene. It won't be out 'til July ['93]. That's the sequel to *Buttwoman In Budapest*. I just came back from there.

So how did you and Tianna get

connected with the porn scene?

I think it was January of '89 when we got into the business. And we basically got into it because my wife and I like always liked fooling around with other girls.

Swinging?

To a degree. But not really in the textbook sense. Because a lot of these swinger parties are full of older people in their 70s who are kinda out of shape and unattractive, you know. And a girlfriend of ours, Raven Richards, who used to be in the business, we were over her place one night, and my wife, who, again, is very much of an exhibitionist, said "Do you think I could do this?" And we thought it would be a way to add some vitality to our sex life. And Raven said, "Honey, if I ever met anyone who would be great at this, you're the one." And that's really how we got into it. She shot her first movie for Scotty Fox. A couple weeks later I met Bruce Seven, who is one of my heroes. Then a couple months later I met John, and my wife Tianna worked for him. John had started Evil Angel in January of '89, and he was having some problems with the company. Not in the productions but with the running of the company. And so he and I talked around July of '89, and we shared a lot of the same principles. And I said, "Hey, I'm interested." I was in the investment business and had no idea that I was going to get into this business. So we started this company. And I did everything. I did the sales, shipping, distributing ends of it... everything in this little tiny office.

Then I started to produce. And what happened is John and I started Elegant Angel as 50/50 partners, with Bruce directing the all-girl movies for us. And we paid Bruce a fee for doing that. Then Bruce decided to get into his own bondage film company, Bruce Seven Productions. Now I own all of Elegant Angel. John still has Evil Angel, and he still owns half of the productions we did as a team. I'm still pretty much involved in every aspect of our business, even the design of the boxcover and shooting still pictures for it. I learned that from John. As far as the editing, I don't do the mechanical end because my cameraman Michael Cates is also my editor. As far as the camera is concerned, I consider him the best in the business. We hired him full-time about a year and a half ago.

So what was your first Elegant Angel feature under this new business set-up?

I think I started with *Sodomania 3*. I shot so many movies over the past three months, I can't tell you who stars in which. I shot just three over the last three weeks in Hungary. And what happens when you're doing that much is you get a bit confused, because you're actually shooting three different movies at the same time. So one day I can shoot a scene for one movie, but the next day I'm shooting a scene for another. I had twenty-seven hours worth of tape on *Buttwoman Does Budapest*.

Why do you shoot in that manner? Is it cheaper to keep the cameras rolling constantly?

It's not that. I just want what I want. When I did *Buttwoman Does Budapest* it took me three days to figure out how to get that streetcar scene done. Let me tell ya, the movie was just released three weeks ago in Budapest, and there's a big political thing going on there right now because of that scene. When we shot that scene, we literally were going through town filming on the streetcar, with people waiting and watching at the stops. Tianna was playing with her pussy, these people in the adjoining car were fucking, and these citizens were waiting for the streetcar to stop and were looking right into the streetcar window.

How come it didn't stop?

Because I owned it. (Laughs) I bought it. We bribed the conductor with boxes of candy and that kind of stuff. I did it through an interpreter. It took days to figure out.

It's a terrific scene, what with all the various angles and the entire notion of filming it on a moving, public streetcar.

Well, it's something I don't think that's ever been done before.

Can you guess why Tiffany Mynx is one of Patrick Collins' favourite actresses?

Courtesy: Elegant Angel Video

A hot anal scene, too. That Laura's absolutely gorgeous.

She's in my latest one, too. Laura. Yeah, yeah. With those big lips. That's her boyfriend who fucked her in the streetcar. He's a very nice guy. I like him. He worked for me again while I was there. In fact, he did the anal scene with Tianna in *Buttwoman Back In Budapest* along with this other guy Frank whom I used in the wine cellar scene in the first Budapest film… you know, the foot-washing scene in the wine cellar with the maid…

Right. That's got another pair of fantastic women in it. Since we're on the subject, this whole foot thing in your videos, do you want to elaborate on that?

(Smiling) I love feet. I *love* them. And in almost all my movies you'll see something about feet, toe sucking — but only pretty feet.

So who's your favourite actresses?

Tiffany Mynx. Nasty as hell, man. Girl loves to fuck. In *Sodomania 3* she gets fucked in the ass. There's a lot of build up and tease. But the final thing is this guy fucking her feet. She's laying down on her stomach, he's holding her feet here (leans forward towards coffee table with hands clasped together above head to illustrate) and they're all lubed up and her old man's in front of her and she's sucking his dick. And then, the high-heeled shoes that she'd taken off earlier, at the end of the scene one guy comes in one shoe, the other guy comes into the other one, and she drinks the come *out* of the high heels. That was her idea! That was her idea! She's great. I love it. Better than champagne. (Laughs) I don't know. I love her, though. She's great. But the bitch didn't show up in Budapest and I'm pissed off at her for that, and she knows it. You can put *that* in print. She was supposed to show up in Budapest, but she got on the plane, freaked out, and never came over. It's a long story. At any rate, she had some emotional problems, apparently to the point where the plane had left the gate, she freaked out, and they had to call the airport police to unload her luggage. You know, she's 21 years old and has a kid. Maybe she was worried about leaving the kid behind. I dunno. But we haven't spoken since I got back.

What do you think of Francesca Le?

Oh. I love her. She's wonderful.

That snarl of hers, is that for real?

Oh yeah. She's nasty as hell.

She kind of reminds me of a younger Elle Rio. Remember her?

Yeah! She's incredible. Incredible. Francesca's not in the business anymore, though. She actually married some girl, from what I understand. Lately, though, I've heard she's not together with her. She's really special.

I don't ever use girls that don't make my dick hard. There's just some types that don't, and it just doesn't matter how great looking they are. Like Christie Brinkley. Christie Brinkley's a great looking girl but (laughs) forget it, you know, I'd rather jack off than fuck her.

So how long does it take you to film a 90-minute feature?

I don't do 90-minute features. Most of mine are two hours and 20 minutes.

Why's that?

Because it's the most quality, high-graded backed tape you can put on one cassette. Two hours and 20 minutes. I'll shoot say five scenes, usually end up with about 12 and a half hours of raw footage, and then edit it down to two hours and 20 minutes.

That seems to be the same length Stagliano aims for, too. The tapes are long. I was at a video store the other day and rented a Buttman video and the guy behind the counter mentioned how long they are, how he loves 'em because he gets the most for his money. Of course, he doesn't have to rent the films since he works there.

Did you see *Face Dance*? It's four hours and 40 minutes on two cassettes. I charged for each cassette and added 20 percent to the entire package, and most of the distributors said, "You're outta your fucking mind. We won't pay that price. We won't buy it." And I said, "That's alright. Don't buy it." But they bought it.

How much does it typically cost to make a video? Or are the figures constantly fluctuating?

It's hard to say because I own the company, my cameraman's on salary, and everything else. So, to break it down… actually my brother's working on the computer to break this whole thing down per production. But I can tell you this, it costs me between $80,000 and $100,000 to go to Europe for three weeks. And that doesn't include boxcovers. That's just to shoot the movie. It's really expensive.

What's one of your favourite scenes in your latest movie?

The one I shot in Hungary? That'll be *Depravity on the Danube*. I shot it at the Club Maximal in Budapest. There's a girl who does a dance with three lit candles. She does this dance with these candles in it. It's so sexy. She just drags the candles along her arms and around her breasts. She's really sexy, too, with these incredible blue eyes. Some people have a way with the camera, they're very intimate with it. And that's how she is. She ends up with wax all over her — I mean this is *hot* wax. There's black marks under her breasts from

the candle and stuff. It's just a real seductive thing. I'll tell you something, too. I gave her a hundred dollar bonus just for that dance. And that was *before* she even did her sex scene. That's how incredible I thought her dance was.

Getting back to Tianna, she really orchestrates her girl-girl scenes well. And putting the Buttwoman moniker aside for a moment, she really does seem to love women's asses.
And the thing is, she *is* into it. She always knows where the camera is. Yet the Buttwoman films are entirely different than John's series. Actually it was John's idea to create Buttwoman and have Tianna do it.

There are a lot of articles and X-rated news clips which state that Tianna directed *Buttman versus Buttwoman*. Any truth to those rumours?
No. Not at all. Bruce Seven [and John Stagliano] directed it.

PATRICK COLLINS
Presents...

SODOMANIA

SWEDISH SLUT

HUNGARIAN HARLOT

FRENCH WHORE

STARRING
CHARLOTTE
STEPHANIE SARTORI
MARY
SHELBY STEVENS
GAYA
PENELOPE
EVA
ELISABETH KING
BERNADETTE

C..T LICKIN', C..M DRINKIN'
BITCHES

Written, Produced and Directed by PATRICK COLLINS Camera by MICHAEL CATES

Sodomania: Cunt-Lickin', Cum-Drinkin'
BITCHES. Courtesy: Elegant Angel Video

Is Bruce still married to Bionca?
Well, they're still married. They don't live together, but they're married, yeah. I'll tell you a story that kind of summarises what Bruce is all about. When I first met Bruce — we talked on the phone actually, we hadn't even met — I told him what Tianna's rate was. And it was higher than most of the girls at that time. He said, "No. I can't pay that." And I said, "Well, okay, I understand." And Bruce said, "I have to pay one hundred dollars more." He taught me a very valuable lesson: if a girl asks me for x number of dollars and I can give her more, I'll always give her more. Because what you're really talking about is people. You're talking about bartering over their body and their looks and their personality. And it's a very difficult thing on them emotionally. It can be. I know this from my own personal experience with myself and my wife. And as a result, if they ask me for so much money for a scene, I almost always give them more. It's like the girl that danced for me in Hungary. I mean, I was gonna pay what I was gonna pay. But when she did the dance thing, I loved it so much I gave her another hundred dollars. Because you're talking about how people feel about themselves.

And I'm saying, "You're worth more." I believe these girls are in a difficult situation. They need to make a living. They need to pay the rent and everything else, and sometimes they gotta deal with assholes who are going to take advantage of them, who are going to pay them a lot less, or make them work a lot longer and a lot harder, or trick them into doing another scene and paying them only for one — which happens in the business.

What about the whole censorship thing going on in the States? As a director and producer in this industry, you're obviously very conscious of it.
Censorship keeps us in business. I'll give you an example. In Eastern Europe you walk down a street and you see bookstore after bookstore after bookstore. Never before have I seen so many bookstores anywhere in the world. And I asked this guy there, "Man, what's with all these bookstores?" "For years under the Communist regime," he said, "we couldn't read a

Sodomania: Warning! Not For The Faint Of Heart! Courtesy: Elegant Angel Video

lot of these books. And that's why people really treasure them." If you want to make anything big, make it either illegal — like alcohol during the Twenties, or pornography and nude dancing during the Nineties. It doesn't matter. If you want to make it big, then censorship is necessary. (Laughs) Pretty sick, huh? What made the Mafia? It's an amazing thing, you know.

Still, I hate censorship, though. To think of the audacity of some son of a bitch tellin' me what the fuck I can do in my own house, with whoever I want... I mean, it's an amazing thing. I can't even imagine people would want to do that. Especially in light of the fact that it doesn't work. (Laughs) It has just the opposite effects the censors intend it to have.

The same applies to prostitution.
You know, if you make prostitution legal, it's not that big a deal. You go to any country where it's legal and the locals probably use them very rarely.

So how do you chose the actresses in your features?
I like girls who like to fuck.

Bisexual girls?
No, they don't have to be bisexual. Some girls like anal, some girls like to suck dick. I wanna know what they like, what turns 'em on.

And then you focus in on that.
Yeah. If I get the impression that they're doing it just as an act... I never use Savannah.

'Cause she's phoney.
Well, yeah. Great lookin' girl but it's like, she's gettin' fucked and it's like (imitating uninterested dingbat) "Duh... where's my laundry? Do I have to pick it up at five?" I don't wanna watch that. So I only use girls who are... um...

Sincere.
Yeah. Ones who I believe are really doing this because they *like* doing it. The money has to be secondary. Because if you're doing it just for the money, you're gonna feel like a whore. What happens is, a girl might do it just for the money, and then say, "Well, I'm not gonna do anal." And then some fuckin' prick like John T. Bone — and you can put that in there... I think he goes by the name of John T. Bone.

Right, he's married to —
Whatever; some fuckin' bitch who slaps him around all the fuckin' time 'cause he ain't nothin' but a punk and a fraud. But, at any rate, he's the kind of guy that'll go to a girl and say, "You know what, you don't wanna do anal, but I really need an anal scene." Or he'll hire her and *know* he's going to do an anal scene with her, and he'll just offer her a little more money or whatever he has to do to get her to do it, and she'll end up feelin' like a whore afterwards. So he's one of the low-life punks in this business that, when *Inside Edition* or *48 Hours* or *20/20* or any of these shows do a story, you know they always want to focus on the assholes like Bone and some of these other pricks that are misogynous and have absolutely... (getting upset) they could give a *shit* about any of the people in this business. They only care about themselves.

So your rehearsals are basically just talking to the girls and finding out what their sexual interests are rather than coach their acting.
Right. Absolutely. In fact, in *Sodomania 4* [*Further On Down The Road*] you'll see a scene that recreates that entire thing, with this girl coming into my office and me, playing myself, interviewing her. And I'm asking her, "What would you really like?", which is what I really asked her in the actual interview. So we recreated the whole thing. And she says, "Well, you know, I'd really like to fuck Tony Tedeschi." And I say, "Well, you know, maybe that could be arranged. If you did star in a video with Tony, what would you do?" And she started telling me this whole fantasy of her dancing for him. So it's intercut in with the actual fantasy of her dancing for Tony Tedeschi, 'cause she really is a feature dancer.

You did the same thing with Randy West in the first story in *Sodo I*, with him more or less delving into the fantasies of Cheri Lynn.
Let me tell ya' something, what you saw there was

absolute reality. It was that girl's first movie and she was so easily excited... she came so easily. I mean, she came like 13 times. I was shooting Francesca Le in the other room, I had a whole other idea for this scene. And then I walk out on the patio, and Randy West is on his knees eating Cheri's pussy, and she's got that T-shirt on and her tits are just... great. And I get Mike Cates out there and I say, "Shoot this stuff." Now *Hustler* complained about that because they thought it took so long. But, you know what, oh, man, I *love* that because it was *real*. It's real! She wasn't screaming and coming, but if you watched her, boy you could *see* every time she got off. And between that scene on the patio, and her scene in the bedroom scene with Francesca Le and Randy West, Cheri came about 13 times.

What do you think about boob jobs? They seem to be quite a trend now.
I hate 'em. I like real tits.

Tianna's got real tits. She obviously doesn't need enlargements.
No, she doesn't. And she never will. It's because a lot of these girls work under the assumption that they're going to make more money on the road, which is encouraged by a lot of the guys who own clubs. And the truth of the matter is, if you sit in a room full of guys and you ask 'em, "What would you rather see: some girl with big fucking tits which stick straight out when she lays on her back, or a girl with small, *real* breasts?" And they'll tell you, "I'd rather see a girl with small breasts that are real. It's much sexier." But, I mean, you can get into all the psychological aspects of it, too. You know, maybe they got a problem inside and they're trying to fix it on the outside. I dunno. That's none of my business. It's just a theory.

Worried about getting old, ageing.
Yeah. Nothing's ever good enough.

What about someone like Wendy Whoppers?
(Laughs) Wendy Whoppers. Check this out — she weighed 93 pounds before she had her tits done and 107 afterwards. They're like (eyes bulging, extends cupped hands one foot away from his chest). I said, "My *GOD*!" And she said, "Oh, tiny girl." I couldn't believe it. You could work out with 'em. Seriously. It's an aberration.

What about Axinia? Those are' real tits.
Yeah. She's from Germany. She was married to a guy in the Marines. I filmed that particular scene from *Foreign Objects* in my house. Berlin is another girl from Germany. They were girlfriends there. Axinia was living here, married to a guy in the Marines or something like that, got tired of this guy mistreating her, and decided

she wanted to make some money and go back to Germany. Her girlfriend told her I was doing a scene, and that I might be interested in using her. So she came in, and I did a whole scene about her, her husband, and Berlin bringing her to me, and me trying to turn things around. Basically, we tried to keep it grounded in reality. It's real nasty. It's got foot worship and tit fucking. Great tits on both of those girls. Great, natural tits, man. Big, big tits on that Axinia, you know. And she's like really thin, but she's got those... oh, man...

What are some of the reasons why you think women leave the business?... Traci Lords probably being one of the worst offenders.*
Oh, well, you know, Traci Lords burned the business and then still tries to make money out of it. I read an interesting article in LA where they were interviewing this girl who was a stripper, and she said, "You know, I told my parents that I was a junkie for seven years, but I never told them that I was a stripper." I think psychologically they have their ups and downs. Even if they really like it, when they have to do it for the money, they start feeling like a piece of meat, and I think that probably contributes to them dropping out. I think that any girl that gets in the business should only do it for the fun of it and never do it so much that she gets tired of it. And if she does get tired of it, she should stop. It's gotta be fun. Because really you're dealing with your soul, man. It's an emotional thing. Some girls start compromising their principles and values because they need money for rent or something like that. And once that integrity starts to go, and they're not feeling good about themselves, well, then they don't want to have to face that kind of thing every day. And I think that's the point at which many girls should choose to leave the business.

John Leslie's says he's been working with film for the last two years. How do you feel about film versus video?
Well, they both have their finer points. Film has a much softer look. It depends on what you're lookin' for. Per-

* Nora Louise Kuzma, aka Traci Lords, was edited from all fuck films in which she appeared during her brief stint between 1984 and 1986 after the authorities 'discovered' the actress was barely 16 when she'd enlisted in the ranks. Ironically, Kuzma was celebrating her 18th birthday (in May '86) when close to 100 Lords titles were yanked from video outlets and adult bookstores nation-wide. It's still a mystery who tipped off the cops. Some insiders staunchly contend Kuzma herself (along with her manager) anonymously blew the whistle in order to establish a monopoly on the "Traci Lords estate" (TLC, Kuzma's newly-formed company at the time, had released *Traci Does Tokyo* shortly before her age was 'revealed').

Sometimes it's fun being a dirty old man!!!

Elegant Angel Presents...

FAZANO'S STUDENT BODIES

Rachel Love

Fazano's Student Bodies.
Courtesy: Elegant Angel Video

Written, Produced and Directed by PATRICK COLLINS

sonally, if it's something for me to look at to get off on, I prefer video. But I honestly can't tell you.

There's more of an intimacy with video.
Yeah. It's more real. But film also has its real special qualities. Who was it that did *Café Flesh*?

Rinse Dream.
Right. He also did *Dr. Caligari* and the original *Night Dreams*— films which are more mainstream, very erotic, very strange, with great lighting. The problem with film is you lose the spontaneity. With film, lighting and everything has to be so perfect that you've gotta set a girl or guy in a situation and say, "Okay, you can go to this spot, but you can only do these things in this spot." So you're limiting the spontaneity of it. It's very hard to get real passion because sometimes you gotta just do it over and over again. What I try to do in video is find out what the girl likes, what guy she likes to work with, what girl she likes to work with, what kind of personality type she is, and then write the scene around her. And I always say to them, "If you could direct your own scene, if it could be the most exciting thing in the world to you, what would you do? Who would you work with? What kind of situation would you like to be in?" Then I build around that. It's just a

lot easier to do that because while they're fucking, I don't stop. If I need another angle, I'll wait. That's why I shoot so much tape. I'd rather wait. One of my wife's biggest complaints was that every time she'd get real horny and get close to coming, the directors would say, "No. Change. We're going to do something else."

It breaks up the passion.
Yes! It does. Time, of course, is another factor. I shoot one scene in a day. They shoot one whole *movie* in a day. So there's a trade-off. If a guy's only getting $7,000 from a manufacturer to make a video, and he's gotta pay himself and his cameraman and his makeup artist and the still photographer and the location rental and the talent, he's not making that much money. So he has to make some compromises. I don't denigrate these people for that. They're in a position where… that's their living. What I'm disappointed about, and somewhat disillusioned by, is that we've shown with Elegant Angel and Evil Angel that you can put out something that costs more money, and, if you're willing to do the work, your numbers are far superior to any other manufacturer. I mean, we sell more tapes than *anyone*. There is no company that sells more tapes for full price than we do. And they all lower their price almost immediately — certainly within 90 days. And you can't get a lot of titles from other companies. Any of my titles, you can get. I stock 'em. They don't understand the business. Maybe it's a genre that they don't even particularly like, but they got into it for the business. *I* got into it and I *am* into it because I like it.

Do you have any mainstream directors that you respect?
Francis Coppola.

Did you ever see *Dementia 13*, one of his earlier efforts?
I didn't see it. I don't go to a lot of movies. But *Apocalypse Now* and *Hearts of Darkness: A Filmmaker's Apocalypse* are what really sold me on him as an individual. And it's funny because just lately I was talking to my wife about *Dracula*.

Visually, it's pretty impressive.
That's exactly what she said. She said the visual part of it was wonderful but the story was lacking. And I said, "You know why? Because now Coppola has to go to an executive producer and get the money from him. And Coppola probably went to him with a great story, but the executive producer said, 'Well, people can't follow a story like that. Make it visually right.' 'Cause they think the consumer's an idiot. And so he's forced

to do that. So, in a way, Coppola has to whore himself out now. He put a lot of his own money into *Apocalypse Now*, and that's still a movie that you can watch today and tell the difference. He did what he believed in. So if you're going to use someone else's money, you have to give up that creative control. And, as a result, what you end up seeing now is a lot of gratuitous sex and a lot of gratuitous violence because it sells. But there's no moral behind it. It means nothing. Our objective over the next year, John and I, is to do an R-rated film and it's gonna have those things in it. But it's also gonna have… I mean, if some guy cuts some other guy's throat, you're going to know why, how he came to that point, and how he felt after he did it.

More psychological.

Well, it's more *real* fer crissakes. That's how it happens. People don't walk up and slice some fuckin' guy's throat. Sure, there are sociopaths and psychopaths out there. But the truth of the matter is, there's a lot of passion and emotion behind people's deeds. There's a lot of things that lead up to those deeds. My life, the parallels of what I believe in, and what a Fundamentalist Christian who opposes me believes, they're all very similar. And my partner John Stagliano is a devout atheist. I'm not. John lives by Christian principles that I aspire to. Believe me, he's a wonderful example. These are the kinds of things I want to show on film.

One of reasons I do what I do is because the people who star in these films don't have a lot of experience as actors or actresses. So I don't want a submissive girl playing the role of a dominant because it's going to be uncomfortable for her. And I never write dialogue.

So it's all spontaneous?

Well, I have it in my head and then (snaps fingers) I tell 'em how I want 'em to say it, and until they say it the right way… but usually I have a feeling for their personality and it comes out pretty quickly. I don't ask them to go beyond who they really are. In that scene in *Sodomania 1*, for example, with the transition of a girl (Brittany O'Connell) being sweet and innocent-looking and then turning into this… well, basically raping this other girl… well, when I told her to slap Lacy's ass when we started the scene, she went like this (gently pats his knee with limp wrist). And I said, "No, no. I *really* want you to slap her ass." And she went like this (repeats harmless pat). And I said, "Understand what I want you to do, alright? I want you to slap her fucking ass. I want you to take control of her, alright." And there was something that went off in her and, man, she fucking laid into that ass. She took control of her and basically raped her. But she totally got off on it. So did Lacy. And there was such intensity in that scene, you know. And so I take chances like that if I believe that's part of a person's personality. Maybe I'm wrong. And I have been. (Laughs) Sometimes it backfires. But

it worked that time.

You definitely have more plot in your films.

Yes, absolutely, because people just don't walk in a room and fuck. There's nothing really sexy about that. So it has to be something else. You see, in that instalment of *Sodo* with Brittany, she's a very innocent girl, right? She's peaches and cream. She also happened to be new to the business. And to me it's a challenge to get somebody to portray what I believe is inside them but they've never unleashed before. And the one thing she said to me during our interview which gave me an indication about how naughty she might be was that she really liked being called all kinds of dirty names when she got fucked. So I ended up putting her in this scene where you look at her, you think she's real innocent, yet she's conspiring the whole time. At the same time, you've got this dominant/submissive thing between the husband (Rick Masters) and his wife (Lacy Rose) going on which turns around completely, where *he* becomes the dominant and she's the submissive.

Leslie says the atmosphere on his sets is "horny and serious." What's it like on your sets?

I don't see how you can have both of those emotions together. They're kind of conflicting. Maybe that's the atmosphere on his sets, but mine are small, intimate, nasty, and thorough. Very rarely do I use make-up artists. I like girls doing their own makeup. I don't have the restrictions of having a big crew. When you're on one of *my* sets, you've got me directing and also taking the stills, you've got my cameraman Michael Cates, my assistant Parker Schurman, and that's it. There's no one else.

I really miss Leslie starring in the films. He had such a distinct presence.

Yeah. He's intense, man. I remember a scene he did with Bill Margold's ex-girlfriend, who never turned me on until I saw her in that scene with him.

What was her name?

The one who had the snake that went all around her torso…

Oh, Viper.

Viper! Right. John Leslie did a scene with her… man, it was so fucking nasty. On the couch, you remember?

Oh, the double penetration (in *Loose Ends 4*).

Yeah. On the couch. Right. With Jon Dough? Wasn't Jon Dough in the background?

Right.

What a great scene.

While we're on that subject, what do you think of DP's?
They're too hard to shoot. There's no real spontaneity in them. You know, DP actually means a double penetration in *one hole* — not just the pussy and the ass. And the problem is there's lot of guys who obviously can't work under those constraints.

Constraints is right.
But there was a girl in Hungary who I was supposed to do a double anal on. Actually Tianna and I did her in a scene, and she was great, really adorable. But her agent tried to run a game on me, and I'm probably known in this business for a lot of things (laughs), but I don't have a long fuse when it comes to somebody trying to rip me off. And I kinda felt like he was trying to rip me off, so I got a little angry with him and didn't use her... but only because she was with him.

There's a lot of pirating going on in the video business, particularly porn.
I have a big problem with that on the East Coast. But it's not a problem with the other manufacturers to any great degree because they put out such shit that nobody wants to dupe it. And not only are our videos being duped, but they're also colour scanning our boxes. Again, they're choosing to do this to our videos because it just wouldn't be profitable for them to go to the trouble and expense of colour scanning the boxes of any other manufacturer's merchandise, since they don't sell as well or for as long. But I'm working on

the pirating issue now. I've been to New York twice and have done whatever I possibly could within legal means.

Why particularly the East Coast?
You know Times Square. It's a whole different world. Some of these guys just don't care. They work without business licenses. A lot of 'em are Sri-Lankans and Israelis who feel they can make what they can, turn around, and leave the country. But I'm spending actually a great deal of money now on a legal front and we'll see what happens. I had one guy who was a snitch who backed out of the deal, and I'm trying to rework the deal now, 'cause I need another witness.

What about pornography in Europe? How would you compare it to America?
It depends on what area you're talking about. As far as sex, they're much more advanced than we are. But you go into Budapest, Paris, any of those countries, and you ask a girl, "Do you like to eat pussy?", and the girl will say, "Well, I will because it's a job." And what you learn after a while — and I didn't learn about this until my second year in Europe — is you gotta look at the girl and see whether or not she blushes and looks away. Because they'll never tell you that they like doing it, even if they do. *That's* different here.

What about Kiss, the original hostess for *Sodomania*? What happened to her?
Kiss? It was a bad idea. Now Brockton O'Toole does it. I have the same format, but I have a guy doing it. It's

Left: Ad art for Sodomania 12: Raw Filth!
Right: A confident young lady from Patrick Collins' Sluts 'n' Angels In Budapest.
Both courtesy: Elegant Angel Video

Patrick Collins at Vomitus Maximus Art Gallery, San Francisco, circa 1993. Artwork by R.S. Connett. Photo: Anthony Petkovich

our business. First off, the guys don't come in the girls, they come *on* them. Visually it just looks better. To get AIDS the tissue has to be traumatised. So it's certainly more likely to happen with anal sex than vaginal. Orally it's almost impossible to catch. And I think that if somebody's worried about it, they should either get out of the business or use a condom. And if they wanna use a condom, they won't work for me. Fuck it, man, I don't wanna see some guy fucking with a rubber on his dick. It just doesn't do anything for me.

much better. Ya gotta see the next three. Brockton O'Toole's a professional actor, a retired lawyer for the IRS and a good friend of ours for a long time. I write the dialogue for him, and he gets it down rather quickly. We set him up with this big book in front of him and it's kind of dark, you know, with this spotlight on him and a library behind him.

Like *Tales From the Crypt*?

Yeah, something along those lines. But not as sinister because he comes off like (puts hand to chest, imitating Boris Karloff), "Oh my *Gawd*!" (Laughs) It's pretty interesting. I think what I didn't like about *Sodo 1* was Kiss' performance. She's a pretty nasty girl, though. But she's also involved with a guy and, you know, her relationship changes from day to day. I don't want anyone doing anything they don't want to do. And I never work with a girl who, after I've hired her, doesn't show up for a shoot or is late and doesn't call me. When she finally shows up, I just send her on her way. The bottom line is: this is a business. I always keep my word with 'em, and I expect them to do the same with me.

How do you feel about the AIDS issue in porn?

First off, I think it's over blown as hell. Rock Hudson fucked his boyfriend in the ass for years, and the boyfriend never got AIDS, did he? The truth is, AIDS is really hard to catch. Sure it's deadly when you get it. But in our business, if it was a problem, you can bet your ass every right-wing Christian organisation, and guys like Mike Wallace, and every other motherfucker in the world who wants us out of business would be making a big deal out of it. And it's *not* a big deal in

What's Tom Byron like to work with?

(Rolls his eyes) He's a trip, man. He's like a throwback from the Sixties… a 'rock 'n' roll' kind of a guy. But I'll tell ya what, he's a great performer. He's never had a problem gettin' his dick hard.

What about Rocco Siffredi?

He's unbelievable. Really unbelievable. Very articulate and intelligent, too. Rocco's the kind of guy who can charm a man or woman. I mean, here he is, 6' 3", Italian, blonde hair, blue eyes, he's got this incredible body, and he loves to fuck. He once told me, "You know, Patrick, when I was a kid I used to look at these pictures and I'd think, 'God, guys get *paid* to do this.'" And then he had a chance to do it. And when he gets into a scene, he's into it. Rocco also has a way of getting girls to do things they'd *never* do otherwise — because they really like him.

What about Ron Jeremy?

Well, that's kind of a complex issue. A lot of people put him down. The truth is, I like about Ron the same things I like about Ed Powers. And I dislike about Ron the same things I dislike about Ed Powers. What I like about them is their neediness. They're not ashamed at all to… they *need* you as a friend. They kind of wear their feelings on their sleeves. They're very sensitive individuals. I think both are very talented. But I think both manipulate women because they're addicted to sex. And no matter what it takes, they'll do it to get pussy. You know what I mean? So I don't agree with that. But I do like 'em both.

What do you think of the women in

Rio?

I love 'em. Love 'em! They're great. They're a lot more open about sex, a lot sweeter. They're not like hardcore prostitutes. They're really loving, passionate, sweet individuals.

What about Asian women?

I don't particularly like Oriental women. I like the way they look, but they're not passionate enough for me. They're too subdued. I always get the feeling when I'm watching them in a sex scene that they're not doing it necessarily 'cause they like it. They're just doing because it's something to do.

What about gang bangs? What do you think of them?

Well, it depends. If the girl really likes to be gang banged, I love 'em.

Trixy Tyler?

Oh Trixy's nasty.

Do you think you'll ever use her in one of your films?

I already have. She's in the original *Adventures of Buttwoman* which we made in 1990. I produced it, Bruce Seven directed it. That was an all-girl movie.

How do you keep up with the new videos out there?

I really live in a kind of secluded world. I basically watch what I film and don't watch other people's stuff. I did see *Hidden Obsessions* — you know, the Andrew Blake film with Janine Lundmueller in it and all these beautiful girls. And to me it's a fuckin' joke. They've got great shit in it, man — the cinematography's incredible, the ice-dildo thing, I love it all. But it's like, "Wait a minute, am I watching this thing to see pretty girls fucking for two seconds and then going on to something else with no fucking storyline and dubbed in dialogue?" *Any* motherfucker that knows how to run a camera and light a scene could shoot a movie like that. It's like looking at a *Penthouse* magazine. I'm in the fuck business. I'm in the sex business. That's what I do. Blake's not in the same fuckin' business. And it seems like the industry wants to do something like that to raise themselves above the business. I'm not saying that doesn't appeal to some people. Facial cum shots appeal to some people, too. But *they're* saying this is one of the best things ever done. I don't see it. Believe me, I'd tell you in a minute if I could beat off to it. I'd tell you I loved it. There were a *lot* of things I could have beat off to in that film — but I didn't get to see 'em long enough.

But I really don't watch a lot of porn. What I'll do is I'll go into a peep show, and try and get an idea of what's going on, what's out there. I put my quarters in and check 'em out. Most of it is absolute shit because most of these manufacturers — and I believe there's about 46 of 'em — don't give a fuck about the consumer, never have from the beginning, think of themselves in a lot of ways as better than the consumer, try and distance themselves in some ways from our industry, and don't seem too proud of what they do. And, as a result, it shows in their product. Their theory is: if you wanna to sell more tapes, lower your cost and lower your price. My theory is: if you wanna sell more tapes, work harder and give people what they seem to really want — which is what I can jack off to. I want to watch something that makes my dick hard, that I can jack off to. That's what I want to watch, and that's what I try to shoot. ∎

**PATRICK COLLINS
SELECTED FILMOGRAPHY**

Where the Girls Sweat (*producer*), Where the Girls Sweat 2 (*producer*), Buttwoman Does Budapest, Sodomania 1: Tales of Perversity, Sodomania 2: More Tails, Bruce Seven's Favorite Endings (*producer*), Buttwoman Back In Budapest, The Bottom Dweller, Buttwoman's Favorite Endings (*co-director*), Face Dance 1 and 2 (*executive producer*), Buttman Versus Buttwoman (*producer*), Buttman's Revenge (*producer*), Sodo 3: With Foreign Objects, Buttman Goes To Rio 4 (*co-director*), Sodo 4: Further On Down the Road, Depravity On the Danube, Tianna's Hungarian Connection, The Anal Diary of Misty Rain, Sodo 5: Euro-American Style, Sodomania 6: Gangs and Bangs and Other Thangs, Sodomania 7: Deep Down Inside, The Best of Sodomania: The Baddest of the Best...And Then Some!, The Bottom Dweller: Part Deux, The Theory of Relativity, Sodomania 8: The London Sessions, Everything Is Not Relative, Sodomania 9: Doin' Time; Sodomania...And Then Some!! (A Compendium), Sodomania 10: Euro/American Again, Sodomania 11: In Your Face!, Sodomania 12: Raw Filth!, Fazano's Student Bodies, Sodomania 13: Your Lucky Number!, Erika Bella Eur(a)slut, Sodomania 14: Cunt-Lickin', Cum-Drinkin' BITCHES!, Sodomania: Warning! Not For The Faint Of Heart, Sodomania 16: Sexxy Pistols, Al Terego's Double Anal Alternatives, Sodomania 17: S.M.U.T. (Simply Makes U Tingle), Sodomania 18: Shame Based, Sodomania 19: Sweet Cream, The Coming of Nikita, Where The Girls Sweat: Not the Sequel, Freshness Counts (*co-director*), The Bottom Dweller...331/3, Big Babies of Budapest, The Bottom Dweller 4: The Final Voyage, Sodomania: Smokin' Sextions, Thermonuclear Sex, Sodomania: For Members Only, Sluts 'n' Angels In Budapest, Sleeping Booty.

Star Chandler

Porn's First Glam Girl

Star Chandler does her thing for Alice Cooper in Gregory Dark's *Shocking Truth 2*.
Courtesy: Dark Works/Evil Angel

Alice Cooper. You remember that old geezer, right? "School's Out," *Billion Dollar Babies*, forefather of America's glam rock scene, one-time sidekick of horror kingpin Vincent Price...

Well, it's time for Alice to roll over and make way for Star Chandler, porn's female counterpart to the "Coop" and all his killer snakes, baby chickens, and severed dolls' heads.

Freaky in her own unique 'LA' way, Star likes to dress up in shimmering, glitzy devil garb in some films. In other movies, she's known to paint every inch of her luscious body red, topping it off with flame-orange hair, black lips, and deadly spiked heels. And in still other smut sagas, she drags dog men about on chained leashes, spits homogenised milk into the mouths of pretty young bimbos, supervises gang bangs with the ferocious, foul-mouthed appetite much more typical of a filth-minded male, and even participates in a Bruce Seven cuntfest now and again. And on top of all this great shit, Chandler manages to direct bondage tapes, too! Quite a raunchy, mondo-based agenda, eh?

A native of southern California's San Gabriel Valley, Chandler majored in English literature with a minor in photography at U.C. Irvine in the mid-Eighties. After attaining her bachelor's degree, she enrolled in graduate school but soon dropped out, opting instead for a career in evil. Star fiercely pursued roles in bondage films and, by the late-Eighties, became a well-recognised submissive. After her involvement in a number of Bruce Seven films, however, she fully realised the power of the dominant — and the creative possibilities *behind* the camera.

In turn, Chandler hooked up with Harmony Video in 1990 to produce and occasionally direct episodes in its Consensual Erotica series. During this transitional period, she not only became a formidable on-screen mistress, but also published monthly bondage 'photoplay' zines, the bizarre 'n' sexy likes of which included *Fetishette*, *Bondage Fantasies*, and *Love Bondage Gallery*, among others.

By 1996, Star's adult film career had truly come to fruition. Via lesbian alter-ego Ruby Richards, she reconnected with Bruce Seven in *Buttslammers 11 (Asshole to Asshole)* and *Buttslammers 12 (Anal Mad-*

ness). And as Mistress Star Chandler, she appeared in Gregory Dark's *Shocking Truth 1* and *2,* playing an intense — at times self-parodying — Satan-like character doing Dark's sinister and sleazy bidding. Aside from looking great, and pulling out some great sex from Dark's hired ho's, Star also utters some fantastic dialogue in these Shocking features. Actually, she delivers *the* most memorably abrasive speech in *Shocking Truth 1*.

"You're a slut. You're a whore. You're a piece of shit," she snarls at Chloe, while the latter slavishly sucks 'n' fucks the seemingly ubiquitous dicks of dogmen, skeletons, and (is this a pattern or what?) devils.

And, finally in '96 Star also forcefully lent new meaning to the glitter phrase "Wham, bam, thank you mam" by developing Bondage Obsession, her own line of bondage features in association with Exquisite Pleasures.

In the Fall of '96, photographer Dave Patrick and I were invited to the set of Chandler's first Bondage Obsession film *Alexis Goes To Hell* for an exclusive interview with the Star. Knowing enough about the bondage genre to get by in conversation, Dave and I were expecting the usual — phoney dungeons, stocks and bonds, and the prerequisite animal cages. We were in for a surprise.

On the day of our arrival, Star was shooting the *European* version of her film. European? Oh ho, you know what that meant, right? You got it — heavy bond-

age with nasty sex. Yes! Dave and I showed up just as China Tymicks was delightedly munching on the juicy-steak twat of Sofia Ferrari (hold the A-1 sauce, please), while veteran porn star Eric Edwards video taped the slattern sequence under Gregory Dark's direction.

Greg Dark? Wait a minute. What about Star Chandler? Unfortunately Star wasn't around for this decidedly hot scene. As we later learned, the poor girl was suffering from food poisoning. Still, Dave and I made the most of the situation, witnessing some choice cunt sucking between China and Ferrari, the latter moaning as if she'd just been impaled.

Luckily, I hooked up with Star the following weekend at the offices of Exquisite Pleasures. *Alexis Goes To Hell* was in post production, and Star — enthusiastic, pleasant, sexy as ever — was cured of all traces of botulism. Gotta watch them chilli dogs, girl.

How far back does your interest in bondage extend?

The earliest, *earliest* recollection I have was when I was five or six years old. I remember getting ready to take a bath and thinking, "If I turn the hot water on full, it'll eventually turn cold." Somehow the extremes were confused in my head. I thought they would somehow meld together. And, of course, I put my foot in the water, got scalded, and cried.

Then as I got older I was very into the heavy metal music scene, which had so many of the trappings of S/M. I was wearing chains, studs, and spikes and a lot of the songs were about S/M. Judas Priest especially. (Laughs) They were my favourite. But while the idea was in my head, I was afraid to experiment.

Then I was having sex with this guy one night, and he held my hands above my head. He didn't tie them — he just held them there. And I loved that feeling of being out of control, of knowing that he was manipulating my body.

And this was when?

In the early Eighties, when I was pretty much experimenting with it in my personal life. Then in the late-Eighties I started modelling and starring in fetish movies. And I found myself in a very safe, protective environment, with the best people in the business, people who really helped me acknowledge that I was into bondage — and helped remove much of my fear of it.

During my first years in the bondage films, I always played the submissive, and eventually got to be a very heavy one. I was like, "Hurt me more! Do more!

Star Chandler publicity shot.
Photo: From the personal collection of Star Chandler

Do more!" Some dominants wouldn't do it, though. That's when I saw the power and the influence they could exert over everyone else. They were the stars — and *I* wanted to be one! (Laughs) It was really a turning point in my career. And I took a long time honing my craft, like beating up furniture to make sure my aim was on. Furniture's the best way to learn, because you want to make sure you don't miss your targeted area. Like if you hit the kidneys — which are right above the butt, your normal target — you can obviously bruise them. Or if you go around the side of the butt with a whip — what we call a "wrap," when the tails of the whip wrap around the submissive — the pain is two or three times more intense than usual. It's *not* a good feeling. Very *un*-sensual. So you really have to know the human body, know the person you're working with fairly well, and know what they can take.

So how would you classify your films?

They're considered "speciality" films. I use the word "bondage" in sort of a general way, inclusive of S/M and fetish. You can really get into all sorts of definitions, but bondage is basically the catch-phrase.

And your ultimate objective in directing such a feature?

The subject has to intrigue me and the performers really have to be there. That's who I cast my films around — the performers, not the script. For years I've been working with a lot of the same people off and on, so I pretty much know what they can do. But I'm always meeting new people. And I make a point of first talking with them to get an idea about where they're at... like if they're just doing this for the money, or if they've been abused — I try to stay away from that — or if they're too young. I also make sure the girls see exactly what I do. I talk to them a lot, tell them about *eight times* what they're gonna do, 'til they're like, "Okay. Shut up!" (Laughs) I really build up this sense of trust with them. Then they'll come back and work for me again. And they might *not* work for other people simply because they *don't* trust them.

Did you know Sofia Ferrari very well before she starred in *Alexis Goes To Hell*?

Even though she'd never done bondage before, I felt safe hiring her because I'd seen her work with Gregory in *Shocking Truth*. I knew if she could take the sexual aggression in one of his movies, then she could do a hard scene. Of course, when it comes time to tie up a model, I always make sure they feel safe and comfortable, because it's a scary experience if you've never done it before. When you *are* tied up, suddenly you're out of control, you're helpless, you're at the mercy of everyone else there. Even if you get an itch on your nose, you can't scratch it. It's a very odd feeling.

Gags and masks always struck me as fairly spooky.

They are. They're very spooky. They represent total sensory deprivation. And a lot of models get into that. Your whole body becomes a *giant* nerve. You don't know where the next sensation will come from, so your whole body just tenses up, waits, and thinks, "Are they gonna hit my chest? Are they gonna hit my ass? Are they gonna hit my legs? Where is it gonna come from now?"

Where do you feel the deepest drama in bondage lies?

Well, there are basically two different schools. The first is the non-consensual or "damsel in distress" school harking back to the *Perils Of Pauline*... you know, the girl tied up on the railroad tracks trying to escape, and the valiant hero saving her. That school involves a lot of rope bondage and, again, vignettes of girls being tied up and trying to get away. The other school involves consensual bondage, where someone is being tied up for their own pleasure and a dominant is working on them to make that person feel good.

And which school do you prefer?

I prefer the consensual side because it's more real. But I also enjoy exploring the non-consensual arena because it's dramatic and fun; and for a video you can overact, play around, and go into a real fantasy space. When I was at Harmony I did a movie starring Summer Knight and Alexis Payne called *Desire and Submission* about two lovers and how they play in bondage. That was one of my personal favourites. Harmony is fairly prudish company, so I had to push my l'mits at the time. On the other end, one of my favourite non-consensual features is *Sadistic Sisters*. In that one, Laura Palmer and I play two evil, wicked, rich girls who kidnap this sweet little innocent girl named Valentine. And we tease her, torment her, beat her up. We did some wrestling in that, too. And by the film's conclusion, Laura and I eventually turn on each other.

Of course, part of the pure darkness of these films is seeing people getting the shit beat out of 'em.

Oh yeah, totally. And the films can be violent. I mean, you can really get scarred. The second scene in *Alexis Goes To Hell* is with Alexis and a girl by the name of China Tymicks who doesn't do any hardcore, only bondage. But she's the heaviest submissive I know. I mean, Alexis caned her in that film to the point where welts instantly appeared on her body. And China loved it!

Star Chandler's *Suffering Artists*; videobox art. Courtesy: Bondage Obsession/ Exquisite Pleasures

That's why she does it. She definitely has the highest pain threshold of anyone I know.

Do you prefer the physical aspects of bondage or the mind-fuck aspects?
When I first got into it, I liked the physical aspects. I liked the idea of being restrained because then I was released from all responsibility. I didn't have to worry about pleasing my mate because I couldn't *do* anything. He would tell me what he wanted, and that took a load off my mind. It's like, "Okay, I know I'm making him happy, and I don't have to worry about, 'Should I be doing this?, or 'Should I be doing that?'"

Is this in films or your personal life?
Both. In films it's very easy to be a submissive because, again, you just react, you experience what the dominant does to you.

But there's a lot less creativity.
Yeah. Well, there's not nearly as much. The creativity in that particular capacity comes from the way the submissive might challenge the dominant.

Which can be fairly dangerous, right?
Right. You have to have a good working relationship with one another. I have some scenes with Ivy English, a very… 'challenging' submissive (laughs) in one of a series of movies I did for Harold Lime about eight months ago. Anyhow, in one scene I was wearing spiked leather gloves and slapping Ivy's pussy with them, really hitting on her. And at one point she just leaned up and bit me in the butt. (Laughs) I was like, "Okay? You're gonna mess with me? Then you're gonna get it!" So I grabbed her by the neck, took some candle wax, pinned her down, and went to town with her.

You've also worked with Bruce Seven on a number of occasions.
Right. Most recently in *Buttslammers 11* and *12*. But the first time I ever worked with Bruce was six years ago on a film called *Dances with Payne*. I was fairly new to the business and scared to death. And when I showed up for this shoot and saw this guy named Bruce Seven, I was thinking, "Okaaaay… can I get away if I have to? Let's see, with the way I'm tied up, if he does anything bad, I can reach over, unhook myself, and run." (Laughs) But actually he was so talented and skilled with the crop, I was like, "Okay. I can stay and do this."

It seems like all the good stuff shot in America is instantly exported to Europe, for their eyes only.
Right. Currently in America we can't show any form of penetration with bondage. I hate it! I really wish we could distribute it here because everything I do is very consensual and sexual in nature. I basically consider bondage and S/M as foreplay to sex, not necessarily

an end. Some people, of course, see it as an end in itself; their orgasmic release is in the actual S/M. And since I see it as foreplay to better sex, it's frustrating in a video not to be able to get to that point.

How far do you typically go with the European stuff? For instance, do you have any fisting?
I don't have fisting yet just because Alexis and I have such large hands. We just haven't found the right girl yet. (Laughs) But in the future there'll be fisting in the European versions.

What about golden showers?
Personally that doesn't intrigue me very much. Lately a lot of people have made it pretty trendy to do water sports or golden shower kind of things. I don't know anybody that does that sort of thing in their private life… only those who do it for artistic reasons.

From what I've seen in your credits, you've worked with Alexis Payne quite a bit.
For about six years. She was the dominant in the first bondage video I was ever in. I've always been fascinated by her beauty, intelligence, and skill. She never does submissive work, either. But in the first scene in *Alexis Goes To Hell*, she's actually tied up. That was a great honour for me because I'm the only person she'll let tie her up. We kind of compete, too. I mean, I'll try tying her up and she'll literally try to get out.

Why do you think girl-girl has been on the rise for the last decade?
In general, I think girl-girl actresses are much stronger performers. I know a lot of the hardcore girls don't like doing girl-girl because you have to work too hard. It's kind of like being a dominant — you have to constantly act instead of react. You also have to be very aggressive and masculine in a girl-girl scene.

What would you say is your major aim with your new line at Exquisite Pleasures?
My first and foremost goal is to make artistic images. I'm *not* shooting in dungeons. I've been in so many bad dungeon studios with dim lighting and fake stone walls, and I hate that. I really hate it. I like a lot of natural light because I want people to see what's going on. And I want my performers to have a real sexual chemistry and play between them. Lately I've been using a lot of coloured rope for my bondage films. About a year back I worked with a Japanese bondage master on a photo shoot. We shot in some beautiful locations and he was using a lot of different coloured rope, doing some incredible stuff I've never seen before. So right now I'm trying to emulate his style. I really want the viewer to get a sense of bondage because most S/M stuff these days doesn't *have* bondage in it.

In the future, though, I might work with surrealistic sets like Gregory [Dark] does. But right now I'm just concentrating on the natural and the real. I'm not an expert on lighting like Gregory, but I am trying to pick up on it and learn as much as I can on his sets. The Melvins shoot was amazing. It was so much fun. These images were so strange. And then the final footage is just glamorously beautiful.

Were you there when the worms came out?
No. I left right before that. (Laughs)

What happened? You don't like worms or were you just tired?
By then I was tired. I think it was something like 3 am, and I'd been running around for hours. I'd already tied up the lead singer's face… the scene that got banned from MTV.

Why was it banned?
MTV thought it was too violent, too ugly or something.

So what do you feel is the hardest part of directing?
Just making sure everything happens. Once the scene has started, then I'm relaxed. But when everyone's not there, when a girl is unsure, when someone is hungry… See, I'm really like the den mother to bondage models. (Laughs) I'm just worried about them. Also, if they don't tell me they're hurting, they may be damaging themselves. So there's this clock inside my head — which I call the bondage clock — and it tells me exactly how long a girl can be in bondage. For example, if a girl's hands have been over her head for too long, I know she's going to faint within ten minutes if we don't get her down.

Bondage seems like a genre where you really can't have a lot of editorial cuts due to the sheer physicality of the action.
Yeah. You just can't do it. It's too physically challenging on the body. I've worked on some films where I've fainted and other models have fainted. It happens very quickly. My films typically run about an hour, and I try to shoot the scene in real time; I don't like stopping the action because I want to see real chemistry between the performers.

You mentioned that when you were growing up, Hollywood was only minutes away from where you lived. Of course, by that time, Hollywood had already established itself as a den of seediness.
Oh definitely — that's why my friends and I would go there. (Laughs) From the time I was fourteen on, I was running out to rock clubs just to look for trouble.

How about an anecdote from that period in your life?
Sure. One time a band we really liked was playing the clubs, and my girlfriends and I arrived early to the show… a friend of ours gave us a ride because most of us didn't have cars yet. So while we were in the bar, we watched the band do their sound check, and got to meet the bass player for a band touring at the time. And, you know, I was fairly attracted to him, knew he was pretty famous, and just started talking to him. Next thing I know, he'd literally ripped the shirt off my back (laughs) and threw it to the guitar player on stage. So I'm running around in this club, topless, trying to get my shirt back, calling to one of my girlfriends to help me. And she's like, "I'm not going to help you. They might steal *my* shirt." (Laughs) And the next thing I know, my shirt's hanging from the marquee of the club, and I have no way of getting it. So the bass player who'd originally stolen it said, "Alright, I'll give your shirt back if you follow me." "Follow you where?" I said. "Outside. Just follow me and I'll give your sweat shirt back." So I'm like, "Okay." And we went across the street, into a park, into an alley, and had sex right there.

How old were you?
Under 18. (Laughs)

Were you standing while you got fucked in the alley?
Actually it was doggie. My knees got scraped up. (Laughs)

So did you like that aspect of danger, of getting fucked in a public place?
I *loved* the aspect of danger, that we might get caught, that I was doing something that was very *bad*, sinful, something which I shouldn't be doing — and doing it with a virtual stranger.

Where was this in Hollywood? On Hollywood Boulevard? Sunset?
It was really more on the border of Beverly Hills.

Oh. *Very* dangerous.
Uh-huh. Million dollar houses close by. (Laughs)

Would you say you had a fairly normal childhood?
It was very normal. I was very shy, got good grades in school, never ditched class, read a lot of books, listened to albums in my room. I didn't necessarily like school or the structured aspects of it, but I always was fascinated with learning. One of my favourite writers at the time was Charles Bukowski because you never know what to expect in his books. He rambles on and on, and you're going, "Okay, he's talking about getting drunk, throwing up, eating an egg," and then suddenly, out of nowhere, he'll come up with a phrase that just…

defines life. I really find beauty in that. Most of his writing regards the common man. There's nothing lofty in his style. On the opposite end of the spectrum, I'm a huge fan of D.H. Lawrence. I just love his approach to sexuality, and the dominance and submission involved in sexuality… like in *Women In Love*, which I consider his best work. I also enjoyed a short story of his called "The Horse Dealer's Daughter". It's all so sexual, religious, and symbolic in nature. And the way he mixes all those facets together so beautifully has always intrigued me about Lawrence.

You mentioned you were working on a master's degree in English. Is that still in the works?
It was. Then I started producing films.

What was the focus of your graduate studies?
I was working on the correlation between Seventies rock music and romantic literature.

Which of the Romantic poets do you like most? Shelley, Coleridge, Keats, Byron, Wordsworth?
Coleridge and Wordsworth especially. My theory is that Wordsworth had a great influence on Led Zeppelin. In Wordsworth's poems there's this whole thing about nature, and the Industrial Revolution, and how people reacted to both at the time. And I believe there was also a similar movement captured in Seventies music.

Star with a bent-over Gigi in *Suffering Artists.* Courtesy: Bondage Obsession/Exquisite Pleasures

The amount of cultural power Led Zeppelin had back in the Seventies was pretty amazing.
They did have power. And their manager Peter Grant was totally amazing. He was an illiterate but one of the smartest managers in the business. He was also one of the most feared men in the business. But as far as their music goes, I think part of what they were saying was true, whereas other elements of their songs are just a big joke. They became these 'gods' who laughed at themselves. The music was technically incredible and the lyrics were fairly literary, but they'd drop things into their songs to throw people off. For instance, Plant would say, "When I wrote 'Stairway To Heaven,' I felt my pen being *pushed*." Well, no. He was actually reading a poem by Wordsworth and copying it. So I saw their approach to rock 'n' roll as very tongue-in-cheek.

Any favourite Zep albums?
I've gone through all the phases with all them. Lately I've been listening to *Presence* a lot.

Definitely one of their loudest efforts.
Right. It also shows all of the evil and dark things that happened to them around that time: Robert Plant's car crash, his son's death, all the problems they were having with Jimmy Page living in Aleister Crowley's house. They'd gone through some really bad periods around the release of that album. And a lot of the anger in that album definitely influenced me in some of my films.

Has there ever been a bondage situation which you felt was going over the top, getting out of hand?

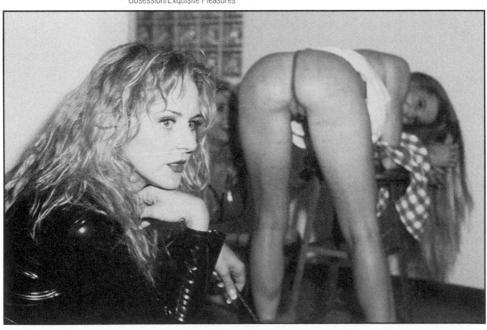

Yes. In one film I was topping China Tymicks and was fairly inexperienced as a dominant… I think I'd only done like four or five scenes by then. Anyhow, I was flogging her and she wasn't reacting — and, I mean, I was hitting her as hard as I felt was safely possible. And she *still* wasn't reacting. So after a point it just got past my normal logical thinking, and I became really angry at her. And the anger took over. That's when I hit her harder than I'd ever hit anyone in my life. I was *violently* mad because she was making me look bad on camera. She was just haunting me, laughing at me, and going, "Is that the *best* you can do?" China, you have to understand, does have a tendency to reverse the roles. And not understanding that, I went off on her and flogged her as hard as I possibly could, just put my entire *body* into it. Finally, *finally* she screamed and pulled away. I broke her. Afterwards I was just shaking and trembling. And she came up and said in this sunny voice, "Thank you! That was great!" (Laughs)

So how long did it take to break her?
The scene went on for about thirty minutes. (Laughs) She was black and blue. I saw her about five days later, though, and she was fine. She heals very quickly. I think she's accustomed to it.

What are your impressions of the LA bondage scene?
Well, there are two very different scenes going on. There's the trendy, kind of Melrose, hip, let's-dress-in-some-real-expensive-clothes-and-go-out-and-dance-to-some-industrial-music scene. And then there's kind of the older, extremely un-hip, real players kind of scene. They don't go to nightclubs. Instead, they have their own social clubs. It's more underground. I used to be involved in it somewhat, but it really wasn't for me. I still get invited to those parties, but it's like, "No, I don't want to see your overweight wife get tied up and, no, I don't want to beat you up."

What about novices? Why should a newcomer in bondage rent one of your tapes?
First off, the bondage is the best in the country right now. I focus on bondage, while other people focus more on whipping. The definition of bondage is being restrained with rope, cellophane, whatever. And the people involved in my films are really doing it. S/M involves more whipping, pinching, spiked gloves, clothes pins. I like S/M, but I want to make sure the bondage is there first.

And why should bondage aficionados rent your tapes?
The action is hard. It's on the level of a Bruce Seven tape. In other words, it's really happening. We're not using fake whips. We're not pretending to hit. I mean, sometimes in a scene you'll just start giggling. But there's an intensity there that can't be denied.

Any particular girls you prefer working with?
Missy. (Laughs) I did a scene in *Buttslammers* with her, and before we started we were saying, "Okay, what can we do? And what *can't* we do?" She said, "Well, you can pretty much do anything to me — spit on me, strangle me, pull my hair." And I'm like, "My hero!!" (Laughs) I really like the way she gives out this guttural *growl* when she enjoys something. I also liked her nerve to fight back. In one part of the scene — I think Bruce edited it out — I grabbed her by the neck, and she looked at me, and spit right in my face. So, of course, I threw her head to the ground and went at her with twice as much force. I like that resistance, the fact that we're both struggling and you don't quite know who's going to win… there's really a fight going on. I also think she's one of the true, genuine performers out there. She's not faking her scenes. She's growling. She's there.

Is there a specific area of the bondage genre which you like to focus on?… Girl-girl?… Boy-girl?
Definitely girl-girl. I occasionally like working with men, but there are very few effective male dominants. But when they are good, it's a great experience. Right now I'm just sticking with girl-girl. And in future shoots I'm going to hire some of my favourite softcore actresses so they'll be exposed to a different market. 'Softcore' meaning Playboy video girls and magazine girls who don't typically perform in sex videos. But also girls whom I have crushes on… ones I'm trying to talk into doing girl-girl. Of course, that's really just part of my own personal perversion. (Laughs) ∎

Art: Maxon Crumb

Brittany O'Connell

Cookies and Ice-Cream

Brittany displays her natural breasts in Sodomania 1: Tales of Perversity.
Courtesy: Elegant Angel

When I first met Brittany O'Connell at the 1994 FOXE Awards, I was half expecting her to proposition me... with girl scout cookies. Her youthful, innocent looks really catch you off guard. She'd just finished filming *Face Dance 1* and *2*, *Between the Cheeks 3*, *New Wave Hookers 3*, was still 21 years old, and looked it! With a delicate, petite frame; smooth, creamy white Italian-Irish skin; subtle tits dramatically embellished by big, puffy nipples (did I hear someone gasp "Traci Lords"?); fragrant, shoulder-length red hair; jiggly butt cheeks just pleading for an indiscreet pinching on St. Patrick's Day, Brittany succeeded in leaving me breathless. Her sweet, maiden-like voice could even melt the righteous thunderbolts of Zeus himself. Other-worldly, indeed.

Raised in Phoenix, Arizona, Brittany wasted no time after high school. Nude dancing came at age 18, followed by the skin flicks at 19. And after only a month in the business, her gash made quite a splash with *New Wave Hookers 3*, wherein she delivers a passionately horny DP with Marc Wallice and Jon Dough. Watching a cutie like Brittany shiver with unbridled lust, her eyes rolling into the back of her skull, as two slimy, surging eels plug her electrical sockets way past the overload level... well, it was proof positive that Ms. O'Connell had the 'Power'. And (believe it or not) her overall acting didn't prove too shabby, either. For example, her erotic, eerie portrayal of the twisted 'Nutwhacker' in Patrick Collins' *Sodomania 1* and *Sodomania 4* could raise the hairs on your average schlep's sphincter, while her 'method'. performance in John Stagliano's *Face Dance 1* and *2* succeeded in making heavyweights the likes of Brando give up ice cream for life.

I interviewed Brittany in February 1994. Coming from a fairly conservative background — which included a "normal" childhood — Brittany seemed rather shy. Questions like, "Were you a very sexual person in high school?", were answered with pauses, hesitations... then, "No. I wasn't. I'd have to say I was kind of a protected child." Vague. Such ambiguousness, however, only fuelled my interest in uncovering the real Brittany O'Connell. I don't know if I was successful, though. Probably not. But during our conversation, Brittany did reveal some provocative truths about porn.

Could you describe your first adult film experience?

I was extremely nervous. Everybody was taking bets on when I was going to throw up. It was *Constant Cravings* for Caballero. Jay Shanahan was the director. *American Garter* was only the third or fourth movie I'd ever made. Gosh, that was quite a while back. Actually, I didn't have that big of a role in *American Garter*. Originally I was supposed to be an extra in it, but I went from being an extra to having a sex scene with Seka and Nick East. Seka seemed nice, really easy-going. I was very new to the business so I hadn't worked with that many people. *American Garter* was such a big budget movie, there were so many people in it, I just thought it was fantastic. It really kind of overwhelmed me.

To date, what's your favourite Brittany O'Connell performance?

Let's see here... (laughs)... the ones I recommend very much to fans are my performances in *Sodomania 1* and *Sodomania 4*, as well as *New Wave Hookers 3*. Um.., I'd have to say there isn't one in particular that's my favourite. I enjoyed the *Sodomania* series because it's such a stretch from my personality. I'm not at all a... I came across as a very dominant person and very

manipulative in that, but actually I'm not that way in real life. I'm more of a sweet, easy-going person. So it was a stretch from my personality. I liked *New Wave Hookers 3* because it was made fairly early in my career — I'd only been in the business maybe a month or so. First time, of course, ever meeting Greg Dark. I had a great time working him. I also did *Between the Cheeks 3* with him. It's kind of an interesting storyline… um… basically all life originates from the female butthole. (Laughs) The power of the universe is *all* centred around it. Tony Tedeschi plays a swami in it, and he goes into these dream-like stages in which he teaches couples about discovering the female butthole, and how it just adds everything to sex. (Laughs) It's a *very* usual Dark Bros.' film. (Laughs)

Meaning it's *un*usual.

Yeah. (Laughs) It's *very* kinky.

What's your scene like?

It's an excellent scene. I do a DP with Marc Wallice and Steve Drake. I don't do that many DP's, actually. I enjoy doing them, though. I have no problems with them at all. Anything you ever see in my movies is definitely something I enjoy doing. I never do anything I don't like to do. Actually, *New Wave Hookers 3* was the first time I'd ever done a DP in my life… right after I got into the business, too. Basically for films, I enjoy the doggie position because I can really enjoy myself and not worry so much about placing myself for camera angles. It makes it a little bit easier when it comes to shooting. I enjoy laying on my back as well. I'm really very open about the whole thing.

For the benefit of our readers, would you mind explaining the process an X actress or actor must go through for AIDS testing?

Everybody is AIDS tested every three months. We all ask for it; it's something we require. You do it every three months and basically carry a photocopy of your AIDS test with you on the set. If you're with Jim [South], he keeps your original at his office and then you carry a photocopy with you on the set. I don't know how Reb works it, whether or not he hangs onto the original, but everybody carries their AIDS test with them on the set. A lot of times, just the actors and actresses ask to see your AIDS test, and you show it to them. Some production companies keep a copy on file with them, so you don't necessarily have to ask each person you work with to show you their AIDS test; you know they've got an updated AIDS test because the company's taken care of it.

And if your card isn't current, you obviously can't work.

Right. If you're past the three-month limit, you get a phone call stating that you need to have your papers updated.

How did you get involved in X?

Well, where I danced in Arizona they showed adult films in the waiting rooms. I did private room dancing, but when there were no customers, we'd watch the adult films. And, actually, I thought it looked fun.

What was Phoenix like?

Oh, I had pretty much of a normal childhood. Overall it was fine growing up there. I love Arizona. It's a real beautiful state.

How about some directors you've work with? Going by the law of association, why don't you just state the first thing that pops into your mind regarding these guys?

Um-hm.

Wesley Emerson (*Buzz*)?

Real funny guy… laid back, easy to work for.

John Leslie (*Sexophrenia*)?

I definitely enjoyed working for him. I suppose you'd call him a perfectionist. I'm not sure if he wrote the script for *Sexophrenia*… there were no rewrites by the time that I saw it. However, he usually has a rehearsal before it comes time to shoot the movie; that helps out a lot.

John Stagliano?

Face Dance had a very big budget… another movie I did fairly early on in my career. John's very artistic… another perfectionist. I have a lot of respect for directors like Stagliano and Leslie because they care about what their movies look like; they take a very professional attitude toward making them. When I'm in one of their projects, I know it's going to look good. I don't have to worry about whether or not the project is going to be a flop.

Patrick Collins?

How to describe him… um… he gets into his work… really has no script… just ideas basically. There's a lot of improv. He has an idea about what he wants to see, encourages talent to come up with ideas, and everybody just kind of works together to make the scene.

Is that what happened in *The Nutwhacker Suite*?

Yes. But, actually, that was completely unexpected. When I made *Sodomania 1*, I had no idea, no idea. Originally, you see, it was supposed to be the other way around, where they [Lacy Rose and Rick Masters] took advantage of me. But (laughs) there was a complete turnaround, where I dominate *them*. I was a little unsure of myself, because it was a change of my own personality. So, I just threw myself into the role.

How many features do you typically

make in, let's say, a month?

Well, when I first got started in the business, I worked a lot for the first three months or so — at least a film a week. I kinda threw myself in head first. I've been in the business a little over a year now, and no longer work at that prolific level. I enjoy making the movies and all, but I'm pacing myself a lot more now.

What about mainstream films? Any intention of getting into that area?

If the opportunity comes along, yes. I've been asked a few times to do some R-rated work, but things just haven't come together because of other projects I've been involved with. I'd definitely enjoy broadening my acting ability. I have to say, though, that I'm proud of what I do, and I'd never discredit the adult film industry whatsoever. There's no need for that.

Do you feel X-rated stars get the respect they deserve?

I think they're strongly misunderstood by society. Very, very misunderstood. Especially the girls. Fan-wise, the girls get the respect, the understanding they deserve. I love meeting fans. It's really a boost because you realise your work's being noticed. You feel very appreciated, and you're kind of put on this pedestal. You don't feel at all ashamed about what you do.

Where do you feel the conflict comes in then?

With censorship. They always say the only reason girls are in this industry is because they have problems, that they don't like what they do, that they don't have any intelligence. They can't be in this industry because they enjoy making the movies. They only like it because of the money, or because it's the only thing they can do, or because they have low self-esteem. It's not

true. I graduated from high school at the age of 17. I've been through two years of college already. My major was astrophysics. And I enjoy *very* much what I do. Again, I don't do anything I *don't* like to do. And I've handle myself in a very business-like, professional way. Also, they're constantly saying that the X industry is degrading to woman, that it's dehumanising. And what they don't realise — or don't *want* to realise — is that the girls in this industry decide what they want to do and who they work with. It's not forced upon you. We do have the option of choice.

When you mention "they," you're referring to the media at large?

The press, the media, right-wing organisations, right-wing religious organisations… I don't want to put down women for obvious reasons (laughs) but some feminist groups really… I'm a strong woman, but I'm not a hardcore feminist. I love men, and I don't think men are the scum of the earth or anything. And a lot of the feelings you get from some of these groups is that porn is dehumanising and demoralising, that women are degraded, that men are the cause of it, that women can't be sexual, too, that only men are aggressive. But I always like to say, "Why can't women enjoy sex just as much as men? Why is it that women can't be *just* as aggressive about sex?"

If you weren't in the adult industry, what sort of career would you pursue?

I'd probably go back to college and study marine biology.

Left: Cover to *Carnal Comics: Brittany O'Connell #1*. Courtesy: Re-Visionary Press. Right: Brittany (on knees) and Lacy Rose in *Sodomania 1: Tales Of Perversity*.
Courtesy: Elegant Angel Video

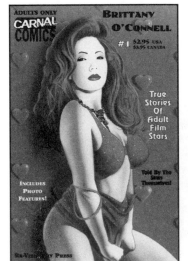

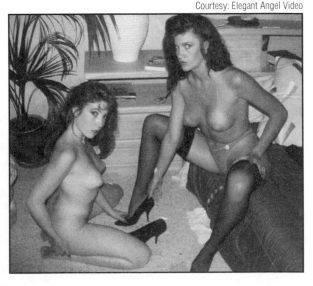

I've read that ice skating is one of your long-time interests.
Yes. I used to be an ice skater.

Do you still skate?
I would like to actually, but I haven't been able to find an ice skating rink in California. (Laughs) No, actually I really haven't had a chance to look. I used to ice skate when I was younger in high school and never really went anywhere with it. But I enjoy it very much.

So how do you keep in shape?
I go to the gym and do the step Rebok program... aerobics... and, of course, when you're on the road dancing, it keeps you in shape.

What male stars do you like working with?
Marc Wallice is one. He's very easy to get along with, he gets involved in the scene. There is no attitude to speak of. Randy Spears, Sean Michaels, quite a few men that I like to work with. Let's see... who else is there?... umm... Joey Silvera. (Laughs) He's a real character. In *Constant Cravings* he was actually the first person I'd ever worked with, and I had no idea what to expect. At the time, he'd just gotten back from Europe so he didn't say a whole lot other than "Hello." And I was extremely nervous. But he was very easy-going and relaxed. I have to say that all the guys I've mentioned, they really enjoy what they do. They put the girls at ease. I work with certain guys usually because there's more of a chemistry *per se*. I'm not the type to solely judge on whether someone's buffed or not. No. There's more of a chemistry involved.

What about female co-stars?
Oh, umm, I'm trying to think... is it Keisha? She has long, dark brown hair, big-breasted...

Spanish-looking?
Yeah. Keisha. I worked with her on a movie just last year which hasn't been released yet. It was for VCA, a Jim Holliday shoot. She's very enjoyable to work with, very sensuous. Most of the girls I enjoy working with are very sensuous: they enjoy doing the girl-girl scenes. Nikki Sinn's also fun to work with.

A pretty wild woman from what I hear and read.
I think a lot of it depends on what's called for her to do. I enjoy working with girls, with men who *like* to make movies. They get into the scenes, it's not just a job to them. Ashlyn Gere, too. I enjoy working with her. She's a pretty wild woman. She really gets into her scenes and brings that same wildness out of me, too.

How do you feel about gang bangs?
I've done a gang bang. Actually, I've done two. The first one that's already been released was for Rosebud.

It's called *Gang Bang Comers*. That was definitely a first — and I loved it. I've also done a bondage movie, and I have to say I'm not into bondage. I'm not into B&D at all. I kind of take the attitude, 'You can't talk about something unless you've tried it at least once.' That's why I tried it, just to see what it was all about. I enjoy what you might call very light bondage, but I'm not into the pain side of it.

How does your husband feel about your career?
He's very supportive, no problems with it whatsoever. And he enjoys watching it. He'll be on the set and watch my scenes being made. And, of course, he watches the finished product, as well. He has no problems with it at all.

Have you heard from any fans that you bear a slight resemblance to Traci Lords?
Yes. (Laughs) I've heard it from a few fans. More from directors. I've tried to figure out the similarities, and I have to say, it's kind of strange. Of course, I try to distinguish myself from anybody in the business. In a sense, I don't mind the physical comparison, but, of course, there's no similarities in the way we look at things. You know, I don't agree with what she did to the industry, how she went about it and all. I don't agree with that at all.

What would make you leave the industry?
Umm... the politics are actually the biggest thing. I know there's politics in everything, and either you let them bother you or you just brush it off and you stay out of it. You don't allow what other people say about you to influence how you think of yourself. And that includes making deals with companies, as well as the gossip that constantly goes around... the petty gossip. It gets pretty old after a while. You know, it's not just gossip among the talent... it's everybody. I guess it's normal. But it makes you wonder sometimes. The backstabbing, the politics, the gossip... that's the biggest discouragement for most people. But I plan on sticking around. I'm not going to let it bother me. ∎

**BRITTANY O'CONNELL
SELECTED FILMOGRAPHY**

Sexophrenia, The Rehearsal, Stars and Starlets Vol. 1, The Hustler, Gang Bang Comers, Battlestar Orgasmica, Butt Bongo Babes, Slave To Love, American Garter, Midnight Madness, Nikki's Last Stand, Mind Shadows 2, Girls Will Be Boys 5, 7 Good Women, What's Up, Tiger Pussy?, Deep Inside Brittany O'Connell, Between the Cheeks 3, New Wave Hookers 3.

Sarah-Jane Hamilton

Has Risen From the Sleaze

M y 'original' introduction to this interview first appeared in the January 6, 1995 issue of *Spectator* maga-zine. And it got me into a wee bit of trouble with the management. The publisher — an erudite, slightly squeamish female — was on vacation when I turned my story in. Consequently, my editor — an erudite, somewhat ribald male — took it upon himself to print the article in its raw, original state. (Hear, hear.) On the publisher's return, however, she read the printed piece, shit a brick, and proceeded to thoroughly bust my editor's balls. Naturally, since shit flows downhill, my editor gave me his *own* rendition of the Nutcracker Suite.

So why the big deal?

Apparently the intro was too scatalogical, *way* too misogynistic for the zine's more refined, 'politically correct' readers. As a matter of fact, one female freelancer actually quit after reading it (yeah, right — as if a freelancer's ever *hired* in the first place). Along with her 'resignation', she left the following message on my editor's answering machine: "I'd tell you what I thought of the Sarah-Jane Hamilton piece, only I'm too drained from puking my guts out in the bathroom. I *quit*!" (From what my editor tells me, the bitch was a lousy writer, anyhow).

So why the big deal?

I'm sure when you read the friggin' intro, you'll realise how overblown all this yapping is. To be perfectly honest, I wrote the opening (even the title) as a sort of half-baked homage to my childhood heroes and heroines from the great Hammer horror films. Christopher Lee. Peter Cushing. Roy Castle. Veronica Carlson. Michael Gough. Yvonne Romaine. Yutte Stensgaard. Ingrid Pitt. Jimmy Sangster. Freddie Francis. Don Sharp. All those crazy cats. At least… that's what I was thinking. The result was a hodgepodge of images I fuzzily recall (or totally made up) from Terrence Fischer's 1961 classic, *Curse of the Werewolf*. Have a read:

Sarah-Jane Hamilton is a wench straight out of a Hammer horror film. The kind of tavern slut just itching for a smelly, drunken brute like Oliver Reed to yank her by her the hair, chuck her into a muddy ditch, and violate her with the savagery of a sex-crazed werewolf — with lots of bad breath, foamy spittle, and rancid body odour thrown in free of charge. Think I'm bullshitting? Check out a thoroughly degraded, lustfully intoxicated Ms. Hamilton in Bionca's latest circus of filth, *Takin' It To the Limit 2*. Dressed as a maid in Bruce Seven's home, Sarah-Jane services three well-dressed perverts chomping on cigars, guzzling wine, flinging the same vino in Ms. Hamilton's face, and ultimately dining, quite jadedly, on a nice bit of crumpet *à la* Sarah-Jane. Warning: this one's not for the faint of heart. For Sarah-Jane eventually conducts none other than an 'anal train' with her three mannerless rogues. That's right. While one stud fucks her loose caboose, she busies herself sucking off the other two hired glands. Then, the pud shovelling coal *out* of her turd bin moves around to her mouth, so she can lick her own poop (yikes!) off the fat, long, grotesque, shit-streaked dip stick, dangling like an unearthed centipede before her smacking lips. Great stuff! Then, while Sarah-Jane chows down on

Sarah-Jane Hamilton; *Takin' It To the Limit 2.*
Courtesy: Bruce Seven Productions

this freshly crap-soaked salami, another stud pummels her shitter, while the third bulldog is off to the side yanking his gummy worm, impatiently waiting to turn over some soil himself. And around and around we go! Aside from Bionca's outstanding direction, what's great about this one is Sarah-Jane's distinctly visible love of domination, replete with a devout hunger for being roughed up, slapped around, and fucked silly. What a trooper!

While dancing recently at San Francisco's New Century Theatre, Sarah-Jane kindly took some time off to speak with me. In the private noise of a bar across from 'Needle Park' — over a good cup of bad American coffee — we discussed life in her native England, her new life in the US, her current studies in fashion design, the success of her recent adult comic book line , and, of course, her blazing career in 'fuck'.

As you'll soon learn, Sarah-Jane is not only loaded to the gills with lust, she's also over-flowing with opinions. Proud to be vegetarian, Sarah-Jane's anti-gun, pro-choice, pro-universal health coverage, anti-war, pro-animal rights... ahem... did I hear someone say, "Get on with the fucking interview"?

I never found out what Sarah-Jane thought of the piece. Naturally, I'm a bit curious. But, all in all, I could give a shit. Judging from her general feelings about porn writers (as you'll soon learn), I'm sure she found it loathsome. Yet if you ever *do* see *Takin' It To the Limit 2*, you'll agree me on one major point: I've merely reported the truth. And if Ms. Hamilton can't handle *that*, perhaps she should be serving up rancid bacon in a greasy spoon instead of fucking like a porker on film. Cheers, Mammy Hami!

As a porn starlet, it must be difficult reading some of the things written about you. For instance, some actresses have told me they absolutely refuse to read reviews of their films.
Bullshit. You look at it, read it, can't help it. And other porn stars say to you, people say to you, you say to yourself, "Ignore it. It's just b.s." But every time you get a review which, instead of talking about the quality of the movie or the script, talks about the way *you* look, the way *you* dress, the way *you* talk, how much they liked *your* ass, or how much they *didn't* like your ass... (getting upset)... it just takes that much more out of you... one chunk, another chunk, another, until they've totally ripped away your self-respect and any confidence you have. I think the reviewers in this industry tend to forget that porn is full of very delicate egos, very delicate personalities. Okay, we fuck for a living. But *why* do we fuck for a living? Because we need appraisal, we need a pat on the back, we need somebody to say, "You know what? — you're *gorgeous*." So when I go out on the road like I am now at the Century, and I get my fans coming up to me, buy-

ing me flowers and Teddy Bears, coming up with photographs that are five years old from some English magazine... that little chunk which those reviewers out there, those self-appointed demigods have decided to rip away from me... the fans put it right back. I just wish the media would realise that the problems within this industry have *nothing* to do with sex. It all has to do with the political shit that goes on.

Which you feel is partly perpetuated by the media.
Right. The fans are great. The girls are great. The guys are great. Even the producers and directors are great. But when you do a really hot scene like I did in *Takin' It To the Limit 2*, where I took three guys in my pussy, up my ass, in an anal train... I mean, I took three big dicks — Sean Michaels, Blake Palmer and Jake Williams — was wearing leather... it was a totally wild scene. But all these 'critics' can do is mention your name and not even describe you in the movie. I have just one thing to say to the people out there who give me those reviews: if you really lack self-esteem, if you really are such an incompetent writer that you can't stand up and critically analyse a film for what it's worth, but instead critically analyse the poor girls that are in these movies, then you're just a bunch of assholes. And that's *on* the record. If you don't like the movie 'cause it's a bad script, then say it. Don't talk about somebody's breasts being too flabby. Don't talk about somebody having cellulite. Don't talk about somebody's clothes. Don't put somebody down because you don't like the colour of their skin or you don't like the way they walk. That's none of your business. It's *none* of your business! Nail the people who make the movies, who had control of the movie. If I, as an actress, gave a low-energy scene, then say, "Sarah gave a low-energy scene" — which I might add, I've *never* given. I'm totally hot, totally wild, totally love it. I give 110 percent of everything I have.

So what would make you leave the

industry?... push you to the point where you just say, "That's it. I'm outta here"?

I wouldn't just storm out. But, you know, everybody has to eventually wean themselves [off the industry]. There's only a certain amount of time you can be in this industry and do well. You can't hold onto it for dear life, hoping they'll be more work around the corner. When the timing's right, you have to make your departure. Right now, my time is okay. I don't need to leave. Things are going well. Some reviewers love me, some reviewers hate me. But I'm doing okay. I have a lot of fans, I'm making money... perhaps in three of four years, maybe then I'll gracefully leave.

Any Sarah-Jane Hamilton films other than *Takin' It To the Limit 2* you'd care to discuss?

Let me think... I was in a movie called *Unplugged* where I play a radio talk show host. It's *really* good because I get to use my accent. They totally took advantage of the way I speak, which is great because normally it's, "Hello, Pizza boy, come in." I did three amazing sex scenes in that one. I also did another movie called *Sex Lives Of Clowns* for VCA, again playing a TV newscaster who speaks with an English accent.

So you like roles which allow Sarah-Jane to be herself.

Oh, I like to act. You don't have to be an *amazing* actress to be in this business. You just have to be comfortable in front of the camera. But whenever a role comes along that's a little challenging, it's always a pleasure to do it.

What about *Starbangers 3*? You probably get a lot of questions about that one.

Oh God, it's a *wild* movie. I've talked about it a million times. One of my best movies I've done. I get gangbanged by eight guys in it. A *totally* intense movie. Really hot to shoot, too. Actually, most people know me through my *Starbanger* or *(Sarah Jane's) Love Bunny* films, that's the little girl-girl Pro-Am series I did.

What about your comic book line? How's that coming along?

Really good! It's not big money but it's quite an accomplishment — to actually start something, go with it, achieve success, and finish it. I sell them on the road now... make some money from it. I truly believe this sort of comic book has never been done before. I think there was Traci Lords and the 'oh-poor-sad-me' thing, you know, that kind of comic book. But I wanted to do more of a positive, uplifting, truthful comic book about my life in the industry, how I got into the business, a little bit of my childhood background, to give you some kind impression of why I started.

That way the readers can identify with your character?

Yeah, so they won't think I'm some nympho sex maniac. Instead the reader might say, "Okay. She went to school, had a boyfriend, owns three cats... " You see me as a real person and not just some rigid sex goddess, which, of course, I don't mind being seen as. But I also hope people realise I'm a human being. I just wanted to be honest. Anything I didn't want to reveal or felt was too private, I just left it out, as opposed to lying about it.

From what I hear, you're also an avid comic book reader. What are some of your favourites?

I like *Cry for Dawn*. The main character's a redhead with big breasts and these beautiful little tears coming down her cheek. She reminds me of me. I also like Big Rita of the Sexual Erotica Comic Books from Italy, France, and Germany.

Going back to *Takin' It To the Limit 2*, what was it like working with Bionca?

Well, Bionca is such a woman. She's so sexual, so beautiful... a lovely, good-hearted person. Working with her is always such a great pleasure because she's so professional — and yet so nasty.

With her huge porn status, people wouldn't expect it of her, but she's really quite gracious.

She is gracious. Just lovely. And I've worked with her on a number of things — *Rainwoman 7*, *Steam*... I'm trying to think what else... that's all I can remember right now. I suppose those are the most memorable titles.

In *TITTL 2*, it looked like that glass of wine splashed into your eyeballs really stung.

Well, I felt the wine in the face was *rude*. I wanted those three guys to really slap me, pull my hair, fuck me hard. But they were really intimidated. They didn't want to do that.

They didn't know how to react to your intensity?

Exactly, because they're conditioned not to hit a woman. And they *refused* to do it. But, you know, it's all part of my masochistic nature. I *love* to be really fucked hard, held down, scratched, and bitten. I really enjoy doing it like animals. Like two cats. You ever seen two cats fuck?

Oh yeah. The sounds they make and everything...

Yeah. I love that feeling of two cats *fucking*. And that's what I wanted to capture. But that kind of attitude scares

off some guys. So instead of doing that, they threw wine in my face, which I thought was *totally* rude. But that's my only complaint. The video went really well. *AVN* reviewed it and acknowledged my appearance in it, but the editor Gene Ross said *absolutely* nothing nice about me. And I want *that* on the record.

How about writing and directing porn films? Any interest there?
I'm not the slightest bit interested. I'm going to college.

What are you studying?
I'm studying for a degree in management, manufacturing, and fashion. All my life I've had an idea for swimwear. I know what I want. I just don't know how to do it. So now I'm going to college to learn how to do it and invest in a business with the capital I've made in porn.

Good for you. Are you going to stay in the States to follow this dream?
Oh yeah. I love America.

What do you think of LA?
LA is like no other place. Like a different planet. But as soon as you go out of LA — like to San Diego — you see the difference immediately. Yes, Los Angeles is a totally different place, to say the least.

What about England? You mentioned in an interview for *Adam* magazine that it's fairly bleak, somewhat miserable over there these days.
It's very sad, very pathetic over there right now. I can't make money. I can't do anything. There isn't a fashion industry, a porn industry, no industry of any kind. Just a bunch of miserable people. And it's really sad, because England is such a beautiful country.

What was high school like for you?
Horrible. I was ugly, unsociable, quiet, shy. I liked to read and draw. I was very artistic. But I was very quiet and always bullied.

And in what part of England was this?
London. Yeah, I was horrible. One thing after another happened. Then things changed for me, and I hardened up. I sort of became a little more streetwise, but I became more feminine at the same time. I just grew up. And now nobody bullies me. (Smiles) Nobody *daaare* bully me, not if they know what's good for them. (Laughs) But, yes, England's rough and tough and hard. It's miserable and grim. Yet it's a very beautiful, mature, intelligent country. America, on the other hand, is young, immature, a little dated, somewhat… backwards in many ways. It's very vengeful, very aggressive. People want to carry weapons, are anti-abortion, anti-this, anti-that, pro-prop 187*. The thing is, in Europe we've ex-

Cover to *Carnal Comics: Sarah-Jane Hamilton, Part 3 of 3.* Courtesy: Re-Visionary Press

perienced fascism. We've experienced Hitler, Mussolini, Franco. We've experienced these dictators and we don't want *no more*. America hasn't experienced that yet. They don't know what they're getting into with prop 187 and carrying automatic weapons. I mean, it's just a bunch of shit. And pro-Capitalism… it's all just shit. What you have to do is educate, have a good health plan, stop worrying about killing people when they do wrong. That's not how you sort out problems. That's not how you run a country. It not all about revenge and anger. The big difference between America and England is that America is angry and England is not.

So why do you think we're so angry?
Hard to say. It's a younger country. It hasn't learned yet. It's like a brat — still young, still teething, still doing bad things. I have loads of opinions about everything. That's one thing I don't run out of. (Smiles)

What about girl-girl? What's your opinion of that?
Oh, I love girl-girl. I'm actively bisexual in my private life. I'm not one of these girls who just goes around

* Proposition 187 is an immigration control initiative that seeks to deny such services as health and education to illegal aliens in California.

hooting and hollering (in ditzy voice) "Oh, yes! I'm a lesbian!" No. I'm the real thing. I'm the real McCoy. I don't care what other people think.

And some of the women you like working with?

Melanie Moore, Bionca, Tyffany Million, she's my girlfriend. She's such a pro. Tyffany's so good. I haven't really worked with her, but I know I'd like to.

Tyffany *Million*? Really?

Um-hm. Tiffany Mynx, too. I've never worked with her but I'd love to. She's such a wild thing.

Now Tiffany Mynx... I agree with you there. Listen, since you've got to get back on stage pretty soon, why don't we talk about something, anything which really interests you?

(Thinking) Let's see... fashion, touring... I love my cats. I love my kitties. I lived at John T. Bone's house for a while and found these tiny kittens underneath his house with their mum. The poor things were dying so I thought, 'Well, just let nature do its thing.' And I let nature do its thing. Then one kitten got really sick and I couldn't bear it, so I took it to the vet and got it cleaned up. Then the another kitten got sick, so I took *him* in. Then I just couldn't bear it any longer and took them all in. I wound up giving one kitty to the receptionist at the vet's and kept three for myself. Unfortunately, last April [1994] my little girl was knocked over in the road. So now I have two boys — Tiddles and Fatty. I'm a big animal lover. I'm also anti-vivisection and anti-cruelty. I've been that way since I was 13 years old.

So while you've grown to be tough, you also consider yourself a fairly sensitive person.

To be an animal lover or somebody who protects the vulnerable, the victims of our society, you have to be tough. But you have to have a heart. I find that the weakest people *have* no heart. People who are like sheep and follow the way they're told to, they have no idea where they're going. They're lost souls. I don't think I'm mean, though. I'm just determined.

Are there any fantasies Sarah-Jane Hamilton has yet to fulfil?

Oh no. There isn't much I haven't done by way of fantasies. My only fantasy now is a dark room with a guy on top.

No cameras rolling?

No cameras rolling. Sex is really different when there's no camera up your ass. And, of course, me and my fiancé have a very... healthy sadomasochistic sex life. (Smiles)

How did you two meet?

Through movies. He was a director who put me in an S/M movie and we just fell in lust. He offered me the world of sadomasochistic play and I couldn't resist. We play a lot of sex games, do a lot of weird and wild stuff in the bedroom. So I definitely get that side of my life fulfilled. But as far as film roles, I'd really love a good deal with another company, like the nine-month contract I had with John T. Bone. But I've been in this business too long to get any more contracts like that. Once you've been in all the movies, been around, been used, people don't want you under contract. They only want girls under contract who haven't been used before. I've done over 60 movies now. To me, it's like dog years in this business: one year is equal to seven. At least, that's how I feel. Not that it makes you old or anything. But it makes you grow up real fast, hardens you, makes you more focused. It totally destroys some people, but that's because of the persons *they* are, not what porn has done to them. If you're weak inside, then you're going to be battered by whatever you do in life.

So your advice to other women interested in following a career in porn is: if you're fairly insecure, don't bother.

(Smiles) No. Get out. Stay out. Don't do it! Don't do it! I'm telling you. They'll kill you! They'll *destroy* you! (Laughs) ■

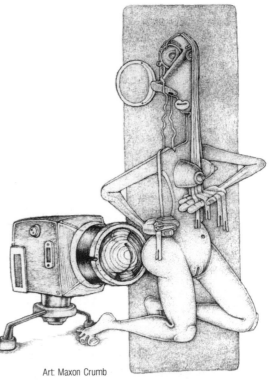

Art: Maxon Crumb

Bruce Seven's Pain of Love

An Interview with the Godfather of Porn

"I don't give a fuck!" That's Bruce Seven for ya'. He could give a fuck about… well, just about everything. Seven, of course, has been *called* just about everything under the sun, too. Curmudgeon, misanthrope, dirty old man, sick mother fucker, asthmatic ass master… You name it, Seven's been called it. And Mr. Seven's blunter-than-blunt response to his critics? You got it. "I don't give a fuck!"

Yet the one thing Seven *does* give a fuck about is porn. More specifically, the quality of adult cinema. During the latter Twentieth Century, Seven, in fact, can easily be credited for embellishing nearly every genre within the porn industry. Boy-girl, girl-girl, fetish, bondage, kink… what the fuck *hasn't* Seven reinvented? Attempting an answer would leave you tongue-tied, which is probably the one thing Seven hasn't tied up in his kink videos (though there's enough tongue-to-twat binding his girl-girl videos to generously fill that loophole).

Born in Torrington, Connecticut, Seven moved to California in 1945, and has since spent most of his life in the Golden State. For a number of years he worked as a special effects guru at Burbank Studios (alongside future cameraman Michael Cates) before the bondage bug mercilessly bit him in the early Eighties. Seven swiftly made the porn plunge, almost immediately beginning to make videos at a non-stop pace. His efforts eventually came to a creative boil in 1984 with *Loose Ends*, the monumental film which succeeded in open-

Brucie doll with prostrate Nicole London in *Beyond Reality*. Courtesy: Bruce Seven Productions

ing up the conventional world of porn to a wonderfully decadent potpourri of perversion. A tour-de-force in the annals of filth, *Loose Ends* contains graphic scenes of bondage, girl-girl (*good-looking* lesbians for once — a previously unheard-of achievement in the hardcore universe), boy-girl, anal, and (ah, yes!) double penetration, all photographed in the relatively revolutionary medium of crystal-clear videotape; Seven, of course, being a pioneer of video during the early Eighties. *Loose Ends* also prooved enormously successful in putting the true romance of the female asshole on the map.

As result of the all-around praise *Loose Ends* garnered from porndogs nation-wide, Seven systematically set out to go one better. He directed six Loose Ends features in all, succeeding beyond the wildest, sleaziest dreams of whackers coast-to-coast. Who can forget the infamous John Leslie/Viper tag team in *Loose Ends 4*? Leslie devilishly taunts the whorish Viper on a sofa, pounds her jaw with his stiff dick, punches her ass with a hard-knuckled fist, and eventually gets serious by double schtupping her with Jon Dough. Leslie and Dough make the tattooed circus slut look like human pin cushion! Such rowdy raunch is, of course, a great prelude to Laurel Canyon's gooey, awe-inspiring DP at the film's climactic orgy. And let's not forget *Loose Ends 6: The Dark Side* — undoubtedly one of Seven's best-looking features — in which Megan Leigh gets double corked upon a pile of still-steaming trash. Pure poetry.

Every film in the *Loose End* series also placed Seven's born-for-porn, infinitely-filthy wife Bionca one notch higher on the Superslut-of-the-Century list, ultimately making her *the* Van Nuys vixen around whom no 18-year-old nubile was safe.

Unfortunately, *Loose Ends 6* also marked Seven's last good-bye to boy-girl features.

Disenchanted with the sweatshop nature of porn in the late-Eighties, Seven returned to his first passion in X — bondage. His honest, back-to-basics approach to the belt-on-booty business helped Seven produce clas-

sics like of *The Face of Fear*, *The Power of Summer*, and *The Challenge*, to name a few.

Then in the early Nineties, Seven became part of the Unholy Trinity of Porn, going into partnership with John "Buttman" Stagliano and Patrick Collins. Reinvigorated after a healthy hiatus, Seven reinvaded hardcore with a vengeance. His weapon? The all-vile, all-girl *Buttslammers* line. In this powerful, trend-setting series, Seven (literally and figuratively) sticks 10 to 11 slices of prime female flesh on the screen, fiendishly pitting them against one another. All the way up until *Buttslammers the 13th*, the master chef of girl-girl has fed us the tasty taco salads of Felecia, Suzie Mathews, Lia Baren, Kitty Yung, Alicia Rio, Kaitlyn Ashley, Victoria Hall, Sahara Sands, Tiffany Mynx, VixXxen, Tammi Ann, Ruby Richards, Tianna, Bionca, and… *whew!* Time to come up for air.

In the end, Bruce Seven has always given a shit. About quality, viewer satisfaction… about raw sex. Hey, they don't call him the godfather of porn for nothin', Bubba.

What was your first X feature?
(Laughs) *Bound For Desire*… for Bizarre Video. And previous to making those early bondage videos, I never saw a video camera before in my life. I just didn't like the boring format everyone else was shooting. And I knew I could do it better. But I also knew nothing about cameras, video tape, or editing at the time. I sure went through the hard knocks of learning, though.

I notice you edit most of your films.
Either I do or Michael Cates does.

You work with Michael Cates quite a bit.
Michael is better than anybody in the business. And what really pisses me off is he's never won an award for his work. *We've* won all the awards. Why the fuck do you think Patrick and I win awards?

Well, partly because of Cates' camera work.
Fuckin' right. He worked for me at Burbank Studios. Then he came over to my place one day, and pretty soon he started working the camera. I did all my early camera work myself, so I was showing Michael what to do. And I think I'm the best cameraman that ever lived. I did all the camerawork for *Loose Ends 1* and *2* myself. So Michael started just learning at that time, and I told him what to do, what shots to get, and exactly what we needed to make the best fuckin' movies. And it worked.

The *Loose Ends* series was quite a watershed series.
Well, the first *Loose Ends* film has bondage with hardcore penetration. Janey Robbins was tied up, gettin'

Bruce Seven and Bionca on the set of *Buttslammers 6: Over The Edge!*
Photo: Anthony Petkovich

fucked in the ass, fucked in the mouth. Still sellin' that tape, though. *Loose Ends 1* and *2* both got busted, but the films won all the cases against 'em. It was all because of the bondage scenes. Bionca was tied up by Erica Boyer, we had clothes pins, candle wax. It got busted in Arizona, too, but General Video got an acquittal on it. And it's still selling. I can't put that shit in 'em anymore, though. They just won't buy the tapes. They don't need any more lawsuits. And I tend to agree with 'em. I like to get real crazy.

Back in the early Eighties, were you very conscious of the fact that video was going to have such incredible potential in X?
No. I've never come from a point of making money in this business — or could give a fuck. I worked in special effects, blew things up, have been in bondage since I was four years old, and into kink all my life. I've always just wanted to make better movies. That's been my main point, and that's why most other people in this business fail. Patrick [Collins], John [Stagliano], and I want to make *good movies*. It doesn't matter about the price ticket. I mean, that comes *with* it if you do well. A couple months back, *Buttslammers 5* was the best-seller in the country. Now that's really weird considering it's a lesbian movie, don't you think?

I do. But girl-girl films seem to be bigger than ever, looking at the prolific amount you find on the video shelves these days.

Obviously they're on the rise. And when I started with Lipstick in 1982, I built their line up; I did the first six, maybe seven Lipstick lesbian movies. I went from bondage into lesbian movies. Then I moved into boy-girl movies with John. I met John in the early Eighties. He was a male stripper who'd worked in some of my bondage movies, and eventually we went into a business partnership with one another. But because both of us are so stubborn, we decided to drop the partnership before we killed each other.

You're pretty much sticking with girl-girl videos these days, aren't you?

Four years ago I quit doing boy-girl and went into bondage. I spend three year doing the bondage films because the fuckin' cheap motherfuckers out there wouldn't pay me enough to direct a movie. I mean, I directed five movies for Jim South at $700 a piece. That's when I knew I was whoring myself and I said, "Quit." There was no more money in the business. Every producer wanted to make movies for $3,000. I used to make *$100,000* directing one movie; like *Loose Ends* where I had a deal for $5 a tape. And at the end of three years I made $100,000 on one video at 5 bucks a tape. In the early part of this business, I had a percentage deal. Like when I did the Ginger [Lynn] movies with Vivid, I had a percentage of $2 a tape. And I was making money. That ran out, though, because they started doing the cheap fuckin' $5,000-a-day movies. And soon it became $4,000 a movie. Then there'd be *two* movies in one day. And I just said, "Shit!" I'd always wanted to do more bondage, anyway. That's how I came into this business — doing bondage for Bizarre. Then I worked with Lipstick on lesbian movies, and after that went into the boy-girl movies. I did 160 of

those, and they were *all* good. There's not *one* of them that's bad. I liked 'em, but I never really was comfortable with them. Then I decided to do it myself, and went back into the bondage movies. And now I have 47 bondage titles for Bruce Seven Productions.

But to get back to your question, I don't *wanna* do boy-girl videos. I got Bionca. She's gonna do boy-girl videos for me. I gotta keep the girl workin'.

How did you meet Bionca?

She was 20 when I met her at Jim South's office at World Modelling. She worked on one movie for Jerry Tenebaum of Western Visuals, then I got a hold of her. I just liked her and married her. We've been married nine years now. I taught her to work for the camera, how to get somebody to perform if their energy's down. I can get Bionca to pick up a performer's energy, get nasty, and dominate any fucking scene in the world. God, I've had her in 80 movies. Now she's 29 and a real slut. She's the best. Shit, the scene we're doing Wednesday [for *Buttslammers 6*; see page 159] with her, Debi [Diamond] and Krysti Lynn is going to be so fucking crazy, I'll probably go to jail for it.

Do you feel men aren't necessary in adult videos?

Absolutely not. I just want to do bondage and girl-girl. I have no *desire* to do a boy-girl movie. As long as I make over $1 million a year doing what I'm doing, why the fuck should I do something I don't wanna to do?

I notice in your latest videos there's no script credits. Is that due to

Left: Star Chandler (with crop) has Johnni Black just where she wants her, as Rebecca Bardoux looks on in *Caught & Punished.* Right: Ad art for *Takin' It To the Limit 3: Kickin' Ass!* Courtesy: Bruce Seven Productions

Videobox art for (left) *A World Of Hurt*
and (right) *The Face Of Fear*.
Courtesy: Bruce Seven Productions

complete improvisation?
That's absolutely right. Fuck your scripts. We don't use 'em. I decide what to shoot on the day I shoot. All I'm doing is giving the best raw lesbian sex I can come up with. I don't want to get involved with scripts and bullshit. It's just not an interest of mine anymore.

What traits do you look for in the women who appear in your videos?
Oh, simple — they have to get fucked in the ass and like it.

What's your goal with a Bruce Seven feature?
Nothing. I just get the nastiest girls I can, pay 'em the most I can, and, somehow, I get along with women very well. And usually I get more out of them than most people because I don't piss 'em off. I have food on the set, don't yell, and don't consider this a business. I consider it a very personal thing. I have a very good rapport with my women.

Any favourite parts of the female anatomy?
Ass and legs. And we shoot a lot of it.

Amen for that. So who are some of the girls you like working with?
Right now? Danyel Cheeks. I think she's the most *under*-rated of all of them. She's got that little cutsie Southern accent, and she's nasty as fuck.

What about some of the girls who aren't in the business anymore, ones you miss working with?
Traci Lords. (Laughs)

No argument there.
Ginger, Christy Canyon, Amber Lynn — I like 'em all. I mean, I got along with all of 'em. I had no trouble with any of 'em.

Until recently, why haven't we seen more black, Hispanic, and Asian women in porn?
They're just not good lookin' enough. I would give my left *eye* to do an all-black lesbian movie. Give me 12 black girls that look good. Because in my new lesbian movies, what I'm doing is putting 10 to 12 girls in every movie. But you can't come up with more than two black girls in this business that are good-looking. My preference runs to 5' 1", beach-bunny blondes wearing tennis shoes and short shorts.

Well you must love Tammi Ann, then.

She's one of my favourites.

And Debi Diamond obviously.
I really like Debi. She and Bionca could fire up an icecube.

So how did you fare in the most recent Southern California earthquake?
I lost all my dishes, some furniture got busted up. Other than that, I didn't give a fuck because it wasn't my house. We did *Buttslammers 5: Quake, Rattle and Roll* shortly after the earthquake. Of course, there's a lot of cute earthquake scenes in the film. We had a 5.2 and a 5.4 [on the Richter scale] while we were shooting. I think that freaked everybody out.

I notice you display some beautiful vintage cars in some of your videos — like the Ford hot rod in *The Awakening of Felicia*. Do you collect classic cars?
I wrecked that Ford last summer. Yeah, I collect 'em. One of my latest is a '73 Vega with a blown Chevy in it. But I also have a little race shop going with a couple guys.

I know this question is old hat to you, but how do you feel about censorship?
It pisses me off, but I'm not going to get upset or nervous about it. I know what I can't do in videos here. If I was in Europe I'd be fist-fucking, pissing... into everything you could possibly think of. But I'm not there, so I just stick to eight fingers, maybe 12, but always keep the thumbs out. I'm big on olive oil and latex gloves.

So what kind of lubricant do you recommend for slutfests? Olive oil or baby oil?
Olive oil. Nothing else. Baby oil is caustic. It's the worse thing anybody can use for an internal probing. Olive oil does not give yeast infections. Olive oil is thick. And I use latex gloves, which I'm sure people get sick of, but I don't care because of the fuckin' talons that these girls put on their fingers. If you stick four fingers in a girl's ass, the rubber gloves take the sharpness out of the fingernails. That's why I use 'em. That's the *only* reason why I use them. I can do more with a girl wearing rubber gloves than I can without.

Beyond Reality; ad art.
Courtesy: Bruce Seven Productions

Many of your films have a dark side to them.
You can shoot anything you want. But, sure, I have a dark side. I'm into bondage. I'm into beatin' up little 20-year-old girls. There is no doubt about that, and that's why *I'm* in my own fuckin' bondage movies. At 53, I've probably got the best job a man of 53 could have. Very self-indulgent, believe me.

More power to you. So when woman are blind-folded in your films, do you rehearse what's going to happen to them, or do you aim for that spark of spontaneity by keeping them in the dark?
You don't tell 'em what's going to happen. In the first place, I ask the girls, "What is your greatest fantasy?" And when they say, "I like to be blindfolded and not know what's goin' on," that's what I do. Did you like VixXxen with a gag in *Buttslammers 5*?

I loved VixXxen with a gag in *Buttslammers 5*. Of course, I love her without one. So she didn't know beforehand what was going down in the scene?
Which is *exactly* what she wanted.

You mentioned that you star in a lot of your films.
Yeah, I do. Like I said, I'm a self-indulgent old man who likes to take young girls and have my way with 'em — if they like it. And after a while I decided to get back into the girl-girl because I liked that, too. So I started my girl-girl line, and that's really when I started making money. They're probably outselling most boy-girl tapes. It kind of blows me away how a lesbian feature can be number one in the country.

And you get your statistics from...?
AVN and *Adam Film World*. *Buttslammers 1* won best girl-girl video of the year, and *Buttslammers 2* won best girl-girl scene of the year. Our company's doing really well. I've got my finger in all areas of X — except for gay. Don't think I'm not thinking about it, though, because it intrigues me to do every part of the spectrum.

Have you ever been influenced by any mainstream filmmakers?

No. Sex has nothing to do with filmmaking or making mainstream movies — and vice versa. That's where everybody makes a mistake.

You mean, X filmmakers make the mistake of comparing themselves with mainstream filmmakers and the story-telling techniques they use?
Compare or compete. It's not a two-day or one-day shoot. All these snivelling little scripts that don't mean a *fuckin'* thing to *anybody*. There are so many people in this business that are self-serving to think they're doing something "great." And they're *not* doing anything great. Porn is porn. I mean, shit, throw a little storyline in it. John and I did *Buttman's Revenge*. I did three scenes, he did three scenes, and we got a review which said, "Very well-scripted and paced." We both just fell over and laughed. We were making up the lines as we went. But we can do that — and pull it off.

How do you feel about the term "reality porn" when it's connected with your films?
I run everything in my movies like a soap opera. I *like* that. I don't have to think. The only characters I want are the people on the set — in their own character. Then you can draw upon their own fuckin' slutfest characters. They're all dirty girls. Just let 'em do with they want and you're going to get a dirty movie. The problem is that the Paul Thomases and all the rest of the idiots out there are trying to use scripts, trying to take a part which they build into a script, and *make* a person into that part on a one-day project. It's not only unrealistic, it's impossible. Reality sells better.

For someone who's never seen a Bruce Seven film, which films would you recommend as a perfect primer?
I don't know. It depends on what they're into — bondage, girl-girl, boy-girl. If it's boy-girl, then I'd say *Loose Ends 6*. I think that's the best movie that I ever did. That's *The Dark Side*, the one with the devil, and Megan Leigh getting double-penetrated in a junkyard. It's the best boy-girl film I ever did, and I don't want to do another one.

What do you see yourself doing five years from now?
Retired in Las Vegas with a dirty bookstore and a club where girls dance. Obviously, you *know* I like dancers.

Obviously. One last question: what do you think of Madonna?
I sent her management company six of our video tapes and never got a word back. Truthfully, I think the videos never got to her. My ultimate thing for a bondage movie, though, would be to have Madonna in it. I'd tie her up, blindfold her, gag her, and fuck her up something fierce. ∎

BRUCE SEVEN FILMOGRAPHY

Girl-Girl: Jaded, Kittens, Lips on Lips, Wet 'n' Working, Aerobics Girls Club, Where the Girls Sweat 1, Where the Girls Sweat 2, Bruce Seven's Favorite Endings, Snatched To the Future, Ghost Lusters, Buttslammers, Buttslammers 2: The Awakening of Felicia, Buttslammers 3: The Ultimate Dream, Buttslammers 4: Down and Dirty, Buttslammers 5: Quake, Rattle and Roll, Buttslammers 6: Over the Edge, Buttslammers 7: Innocent Decadence, Buttslammers 8: The Ultimate Invasion, Buttslammers 9: Fade To Anal, Buttslammers 10: Lust On the Internet, Buttslammers 11: Asshole To Asshole, Buttslammers 12: Anal Madness, Buttslammers the 13th.

Boy-Girl: Bionca On Fire, Buttman's Revenge (*John Stagliano, co-producer*), Buttwoman, Buttman versus Buttwoman, Shadows in the Dark, Mad Jack: Beyond Thunderbone, Ginger's Sex Asylum, Hollywood Starlets, Project Ginger, The World According to Ginger, Edge of Heat Volume 2 (*Loretta Sterling, co-director*), Corruption, Eye of the Tigress, Club Ginger, Conflict (*Henri Pachard, co-director*), Barbii Unleashed, Loose Ends, Loose Ends 2, Loose Ends 3, Loose Ends 4, Loose Ends 5, Loose Ends 6 (The Dark Side), Beyond Reality (*Bionca, co-director*).

Bondage: Painful Cheeks, Ecstasy of Payne, Overkill, A Touch of Leather, Punished Innocence, Obscssion, Forever Payne, Hang 'Em High, Shane's Ultimate Fantasy, The Face of Fear, The Power of Summer, Power of Summer 2, The Payne Connection, Attitude Adjustment, Crime Doesn't Pay, Painful Pleasures, The Submission of Felicia, Dangerous Assignment, The Challenge, Power Play, Dark Interludes, A World of Hurt, The Sting of Ecstasy, The Fear Zone, House of Dark Dreams, House of Dark Dreams 2, Web Of Darkness, Fit To Be Tied, Journey Into Darkness, Compendium 1, Forbidden Obsessions, Mystery of Payne, Autobiography of a Whip, Hot Rod To Hell 1, Hot Rod To Hell 2, Thrill Seekers, Dresden Diary, Dresden Diary 2, Dresden Diary 3, Depraved, Knight Shadows, Compendium 2, Blame It On Bambi, Painful Lessons, Strange Passions, You Bet Your Ass, Bound For Pleasure, Blind Innocence, Compendium 3, The Chains of Torment, Dark Destiny, The Distress Factor, Dances With Payne, Cruel Passions, Arsenal of Fear, A Twist Of Payne, Compendium 4, Passion For Bondage, Caught In The Act, Shane's Ultimate Fantasy, Felicia's Folly, Caught & Punished, Compendium 5: The Best Of Felicia, Sensuous Torture, Whacked!, Party of Payne, Controlled.

Missy

Inwardly mobile

U nbelievable. That's what I thought on first meeting Missy. I simply could *not* believe that the meek, soft-spoken blonde before me was the same outrageously filthy dominatrix-slut I'd seen in Bionca's *Takin' It To the Limit 6*. How nasty *was* Missy in *TITTL6*? Put it like this: after she makes porn stud Mickey (who's also her real-life hubby) put on a pair of woman's panties, she then fucks him in the butt with a strap-on dildo, dunks his head in a toilet bowl, and — once the guy squeezes an ample amount of man-made toothpaste onto the toilet seat — makes him lap up his own genetic droppings. Blechh! Luckily for Mickey there wasn't a turd floating in the bowl, otherwise the poor slob would've been bobbin' for a loaf — probably his own!

Missy; *Takin' It To the Limit 6.*
Courtesy: Bruce Seven Productions

At the spacious Granville Mansion in Altadena, during the filming of Bud Lee's *Southern Comfort*, Missy spoke with me about her budding career in Fuck; the two of us enjoying a private chat in front of a roaring, comfy fireplace. Just for the record, within minutes after our *tête-à-tête*, Missy got her soppy cunt nailed to the hardwood floor by Las Vegas succubus Anna Malle. Talk about yer rollercoaster lifestyles! Anna was actually drooling when she saw Missy in lingerie; the latter's garter belts digging into each juicy ass cheek, making the cushiness of those marvellous flesh scones all the more pronounced, all the more munchable. For do let the record also show that, aside from having an absolutely enchanting personality, uniquely combined with a ferocious appetite for sex (*Anabolic's Gang Bang Girl 17* being another primo example of that trait, during which, in a wonderfully lurid episode of reality-inspired fantasy, she gets her cum-uppance from eight sweaty orderlies in an emergency room), Missy similarly possesses one of porn's finest asses. A flesh bumper so round, so bubbly, so jello-y, so... fuckable, it's an ass to exalt on the highest altar of Booty Heaven, alongside such royal jelly icons as Nina Hartley, Lana Sands, and Tanya Foxx.

Was it your fantasy to degrade your husband in *Takin' It To the Limit 6*?
Not to degrade him. Just to switch places and be the dominant. I know how far I can take it with him and (laughs) I took it very far. A little further than he ex-

pected, actually. It was really fun working with Bionca. I've worked with Bruce a few times... did a bondage film and three girl-girl films with him. Mickey and I are also in VCA's *Mask* where I'm also the dominant one. I like living out that particular fantasy because I'm so shy and introverted. So when I get to play that part, I play it well. I'm really not a mean or aggressive person; but in this medium, I can be just that. It's a good outlet.

How did both you and your husband get involved in porn?
Well, we were both working in the emergency room together. We knew each other as friends for about a year before becoming boyfriend and girlfriend. We were just a *really* wild couple... watched porn a lot. And since I love women, I'd bring in a woman or he'd bring in another guy... usually just close friends, though. Anyhow, that's how it started. And when I first got involved in porn, it was just a fantasy of mine. That and the fact that my husband had a fantasy about seeing me in a layout or a movie.

I started around the summer of 1994, did it for about four months, then stopped because I wasn't ready.

Not ready psychologically, physically...?
Well, I'm a very sensitive, emotional person. I care a *lot* about people. And in this business... it's just very

Missy; videobox art for *Venom*.
Courtesy: Vidco

**Missy (right) giving Nici Sterling a kiss;
Sex Freaks.** Courtesy: Dark Works/Evil Angel

different from what I'm used to. See, I was a counsellor in the hospital, so it took me a little while to get adjusted. But since my husband started doing porn recently, that's helped quite a bit.

Then the two of you are usually together on the set?
Oh yeah. It's rare when we're not.

So being separated from your husband was a reason why you initially had such a hard time in porn?
Yeah. A lot of times he wasn't there because he was working, doing behind-the-scenes mainstream work. So I had to go to the porn sets alone. That was difficult. I can do it now, of course, but it's still totally different when he's not around.

How long have you been married?
Over a year now. But we've known each other for six years.

At this point in your career, what do you like best about porn? — or least about it?
What do I like least about it... that's a good one. (Laughs) Let's go with that first. What I like least about

this business is how people think they're better than others. I have a hard time coping with the egos of both men and women. I'm not going to mention any names because I know a lot of great people in this business, too. It's just hard for me to see a director or a producer treating a woman badly in front of others, or being disrespectful to her. And I usually speak out when that happens. I mean, I think there's a proper time and place to work out a problem. If something's going wrong in a scene, take the girl aside, take her into a backroom, discuss it with her. I'm sure she'll perform better if you do that. Besides, it'll spare her any humiliation in front of a bunch of people, which inevitably makes her performance all the *more* difficult. Being cruel is just too stressful on a person, especially if they're young and/ or new to the business.

Has a director ever done that to you?
Oh, no. I wouldn't let it happen to me. (Laughs).

So how long of a break did you take from porn?
About seven months. But I do mainstream work, too.

Really? What have you appeared in?
Beverly Hills 90210, *My So Called Life*, *The Watcher*... I was the devil's mistress in that. It's cancelled now. A *bad* show. (Laughs)

Whom did you play in *90210*?
I was an extra, the other woman who made Brian's girlfriend jealous. I didn't have lines, though. I just flirted.

So what sort of scenes do you prefer doing in porn?
I've only done a few DP's; two in my career so far. (Giggles) They're pretty rare... pretty hard for me, too. I don't mind *anything*, really. I do think the company's very important.

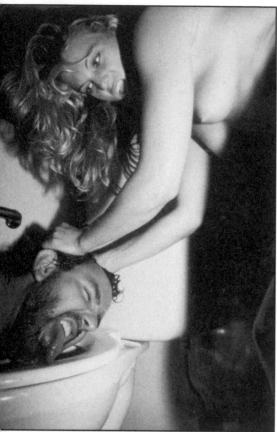

Missy making Mickey lick it good in *Takin' It To the Limit 6.*
Courtesy: Bruce Seven Productions

Would you mind explaining that?
Well, if I'm there with people who *want* to be there, people who love sex and just want to have a good time, it doesn't matter what I'm doing... I'll have a good time. I don't have a preference on the men or women — I love them both. What's important is where their minds are at. If they're in a positive place, then I'll have a wonderful time.

What about anal? Do you have a wonderful time doing that?
It was a problem at first simply because I'd never done it before, even in my private life. The first time I did it on camera was with a woman who had a strap-on. It was for Ed Powers' *Crème-de-la-Femme*, an all-girl feature. That was my very first movie, too. Ed's pretty relaxed, lets things flow. The first time I did anal privately was one wild night with my husband. He was the first guy I did it with on camera, too. Now I just do it with a few men.

Any Missy titles which you particularly liked making?

Venom. (laughs) That's a fun movie. Really hot. I'm with Jon Dough and Alex Sanders in that one. I thought it was neat because while we were shooting the video, we were also filming each other. Ron Sullivan [Henri Pachard] directed it.

Any directors you'd eventually like to work with?
Yes... Andrew Blake. I love his stuff because it looks so pretty. But I'd also like to be behind the camera. That's why I'm here, to learn all I can.

So is directing or producing what the future holds for Missy? You're obviously still very young.
Actually, I think I'm one of the older girls in the business.

How old are you?
I just turned 28.

You look much younger.
(Laughs) Thank you. That's because I'm happy — and don't do drugs.

What are some of Missy's goals?
I have so many goals, so many interests outside the business, it's hard to say. I live day-to-day. I know I'm going to be happy, though. That's all that matters.

What about filling us in on some of your interests, then?
Sure. Well, I play the harp... used to play piano when I was young. My father is both a violinist and a pianist. He used to play in the Philharmonic. My mother's also a concert pianist. I guess it runs in the family. I recently got into the harp, though, because I wanted to try something a little more difficult. I also like writing about philosophical things, subjects people usually don't discuss. Although I studied business for two years at a junior college, I also studied astrology on the side. I fantasise a lot about ancient times and enjoy reading about goddesses. I'm reading as much as I can on that subject because when I get behind the camera, my stories are going to be based on that kind of material. I've got so many wishes... But I figure, since everything I wish for comes true, I'm making *big* wishes. (Laughs) ∎

MISSY SELECTED FILMOGRAPHY

Voyeur 5, Crème-de-la-Femme, Sex Bandits, Mask, Sex Freaks, Pick-Up Lines: The Movie, Shameless, The Stranger, Prime Choice, Philmore Butts Meets the Palm Beach Nymphomaniac Kathy Willets, The Best of Sex Academy, Buttslammers 10: Lust On the Internet, Buttslammers 11: Asshole To Asshole, Venom, Shocking Truth 2.

Nic@le Lace

A Sweet 'n' Trampy Kinda Gal

Nicole Lace.
Photo: Dave Patrick

A round the time I spoke with Nicole Lace, Mariah Carey was the sex craze on TV. I can understand why. Carey had the tight body of a dancer, moved fairly sensually, and looked good enough to bang on New Year's Eve. But that's where the intrigue ended. For Carey's entire gig was (at least, to me) nothing save a tease, a joke, a bunch of goo-goo gah-gah ca-*rap*-ola. I would have much rather just *seen* Nicole Lace on MTV; merely a close-up of that tantalisingly cherubic face. That's all. No singing. No poncing. No pathetic overdoses of cutesiness (which the self-absorbed Ms. Carey succeeded in elevating to new mainstream heights on both MTV and VH1). For Nicole screamed innocence. But sincerely. She looked, spoke, (at times) acted every bit the giggly, sexually naïve Catholic schoolgirl. BUT… she was also filthy as fuck. Ah, *there* was indeed the rub, making it no wonder why she became an immediate hit in 1994. For it was during that eye-opening, slut-Laced year that Nicole — effectively meshing together naïveté and nastiness — appeared as "Cinda-ho" in the Dark Bros.' *New Wave Hookers 4*. While on the outside she appears pristine and chaste in this Nineties classic, little girl Lace winds up greedily slopping up Tammi Ann's love juice while getting unscrupulously ass reamed by knight-in-shiny-Vaseline Vince Voyeur — and loving <u>every</u> <u>greasy</u> <u>second</u> of it. She unleashed more of this seemingly untapped, violently gushing lust the following year in Dark's *DMJ5*, in which she portrays a faerie who gets gland slammed by a troop of sick muthah-fuckin' soldiers — and nearly passes out from rape rapture in the process. Of course, Nicole's killer body never exactly *hindered* her success. Scrumptious Spanish-Italian olive skin worthy of a thousand-and-one licks. Delicious, chocolaty pussy lips tightly packing moist, cherry sponge cake insides. And a dark, lovely butt which, when properly bent over, was divine enough to make even Nosferatu clutch his world-weary heart and submit to the death twitch.

Consequently, when Dave Patrick and I journeyed to Patrick Collins' Los Angeles home to speak with Nicole, we were grateful as jaded journalists to photograph and interview this classically beautiful 25 year old. Meeting and spending time with Nicole, however,

I quickly discovered a cultivated soul and complex creature behind those liquid eyes. She's also quite the "tramp" — as she so aptly calls herself — making Nicole simply ideal *X Factory* fodder…

That gang bang in *DMJ5*… how many guys did you do?
I think five. Before that I'd never had more than one guy in a scene. Then Gregory had a whole bunch of 'em in there for me. (Laughs) I got to chose 'em all, too, which was even *better*! You really can't mentally prepare for a scene like that. You just go in and do it. I really don't remember Gregory even *directing* me, because when I get into a scene, I may not even hear what someone is saying to me. In situations like that, I pretty much do what I want. Of course, you *do* go into the scene with an idea of how to play the character because part of it is acting. In *DMJ5* I played a faerie, and in *NWH4* I played a Cinderella type character. Gregory always has me playing these faerie princesses. He tries to keep it within that innocent personality.

Do you like being seen that way?
Yeah. That's how I usually am. In *Sodo 12* I played a

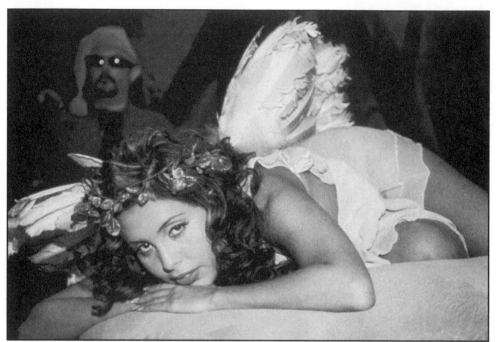

Nicole Lace as a seraph in Gregory Dark's
DMJ5: The Inferno. Courtesy: VCA Pictures

little girl in diapers. It was easy for me to fall into be-
cause that really suited my personality. Whereas in *A
Clockwork Orgy*, I had this one dominatrix scene where
I was really bitchy. I had to think of something that
would get me mad because I'm really not that way. I
don't really want to hurt anybody.

**Was the diaper scene your fantasy
or Patrick's?**
That was all Patrick's idea. In fact, that's where I met
Patrick. I don't think he knew what I was like. Normally
he'll meet the girl first and talk with her a little bit, find
out what she's like, learn something about her person-
ality. But I'd only spoken to him on the phone and we
met the day we filmed the scene.

Do you like anal sex?
(Giggles)

Oh, you do like it then?
I like it. I don't know why... I just do. Of course, I
didn't until I tried it. (Laughs) The first time I did it
was... different.

What was your first porn film?
I think it was Gregory's *New Wave Hookers 4*. No...
actually it wasn't because the first one I did was a girl-
girl scene. The first boy-girl was in *NWH4* because I
remembered being so excited. I like working with girls,
but I like it to be fun, you know? I don't like being with
a girl who doesn't really do scenes like that. I like it to
be *wild*. And sometimes I get mad. When I was watch-
ing *Where the Girls Sweat (Not the Sequel)*, I saw that

I was really mad. (Laughs) I don't know why. Some-
thing inside builds up and you just... actually a couple
nights ago was the first time I saw myself on video.
I'm really scared because when I watch it I get the
same feelings I had when I actually did the scene...
they come up... while you're watching.

**You said you get mad. Is that angry
mad or crazy mad?**
Crazy mad. You're releasing part of yourself. And when
I was watching it, I was laughing and I was like, "Wow!
I slapped her." (Giggles)

**In other words, Nicole Lace's alter
ego occasionally emerges on screen.**
Yeah! It does. It's definitely my alter ego because I
really don't like being angry at people. I really don't
know how to vent my frustrations out on people when
I'm angry. I just keep it in. So it was good for me to be
able to do that. I remember one film where I did a
scene with Vanessa Chase and Juli Ashton. Vanessa
and I were sort of double-teamed and... I don't know
what Juli said at the beginning, but it pissed us off. So
we decided we'd really pound her. And I have so much
respect for Juli because, I mean, I was *plunging* a dildo
in her ass, and Vanessa was like eating her cunt, and
we were hitting her and stuff and... it was great! I
miss Vanessa.

I notice you have a number of your

ROSEBUD · ALL ANAL · RP 185

ANAL Senorita

STARRING
NIKOLE LACE
EVELYN
KIM KUMMINGS
RACHEL St. MARIE
TOM BYRON
T.T. BOY
JULIAN St. JOX
MR. MARCUS

DIRECTED BY
REX BORSKY

Nicole Lace; Videobox art for *Anal Senorita*.
Courtesy: Rosebud

own paintings hanging in the house here. When did your interest in painting begin?

Well, when I was in kindergarten they had these state-wide competitions. And for my entry I came in first state-wide, third nation-wide. That was in kindergarten and my mom still has that painting. Sometimes during the holidays I used to make Christmas cards in a very Peter Max-like style. I used to make hand carvings, little cartoony things, little stories out of wood. It was such a *big* thing to do. The whole thing would take me months and months. Forever. I mean, I would start these Christmas cards in August. I always wanted to draw album covers, too. They don't make album covers like they used to, like the zipper on The Stones' *Sticky Fingers*. It's basically photography but it's such a unique design. Emerson, Lake, and Palmer have some interesting covers, too, like *Brain Salad Surgery*.

Where does some of your artistic inspiration stem from?

A lot of times I have these… visions. I don't know how you would describe them, but I see them while dreaming. I guess they're nightmares. Sometimes they're not nightmares. It's just… something that haunts me, keeps coming back to me. So I want to be able to paint them, that way they'll go away for a while… I'll have something different in my head. That's kind of where a lot of

my artistic inspiration comes from. A lot of the things I paint have nudes in them. A lot of the images I paint are of one girl's body, another girl's face… I remember one time I was in a grocery store, and there was this old, old woman. She had the most *beautiful* eyes. Her face was all wrinkled, but her eyes were so young. I'll never forget them. And I used them in a painting.

Do you ever express anger through painting?

I remember during one painting I had a migraine headache and I expressed my physical pain through the painting. It was this cowboy kind of face… very abstract, like triangles and squares. And in the background was the body of this guy holding two guns, pointing them at you. I remember doing that. I wasn't angry, though. Just had a really bad headache. (Laughs)

How did you get involved in porn?

Well I started off dancing at Bailey 20/20. I really don't know what made me start doing porn. I mean, it fell into me more than I fell into it. I just got bored with dancing. And to be quite honest, I was with somebody that kind of persuaded me to go further into the films. And I liked it.

Are you from LA originally?

Yeah. I grew up in San Marino. It's funny because I went to Catholic school and grew up in a really conservative family. And when I think back and compare *that* life to my current situation… Wow! It's just so different.

Rumour has it that you're in a wonderfully filthy European version of *Where the Girls Sweat: NTS*.

Well, in that version, we pissed in… we can talk about this, right?

Please do. Any fisting?

No. But I'd like to do that… I mean, I have a little fist (makes little fist) so it's perfect for that. I'm dying to put my fist in a girl's cunt. That would be kinda cool. Actually, I haven't even seen the final cut yet. I don't know if I put my fist in Kirsty's cunt. I'm sure I put my foot in her, though.

A whole foot?! Did you feel like you were getting sucked in?

(Laughs) I had fun with her. Caressa's really nasty. We were drinking *tons* of water and originally wanted to pee in a cup and all drink from it. Caressa ended up pissing on my face, then I pissed on her face. Kirsty didn't want to do any of it, but we made sure she got her body bathed in the piss. In the edited version you can see our hair's all wet — that's from the piss. We had a strap-on, and I'd never really fucked a girl with a strap on, but I loved doing it. Actually, I did — I fucked Jen Teal with a strap-on. But it's this great sensation of

having a *cock* there, right? I was like stroking it and controlling the girl and wanting to… get her to… *suck my cock!* That was cool.

Do you like being the dominant?

Not with guys all the time. It depends on the situation. But with a girl? —yeah, definitely, because that way I know what's going to happen. That'll keep the energy up. It shouldn't be just a sweet kind of fuck, you know? With a guy, I usually start off by sucking him. I love to suck. That really turns me on. I'm always in control of that. I remember working with Joey [Silvera]. I was sucking him, and at one point just wanted to jerk him off, have him come in my face. I just love that. It's just something inside me… gets me going to the point where I wanna grind on his leg… seize that cock, *hard*, on my face, suck it… just… (smiles, begins to actually blush!)

Nicole Lace during her interview in Patrick Collins' mansion. Photo: Dave Patrick

You're blushing.

(Laughs)

Hey, let's go back a bit. What kind of person were you in high school?

Fairly private… introverted… alone… kind of a loner.

And after high school? What happened then?

I went to college up north in San Luis Obispo. Studying business, actually. Not my forte. It was *so* boring… you know, a parental decision. I really wanted to go to art school at that time but was still such a kid. I didn't want to make decisions for myself. So I went up to San Luis Obispo for three years. I was seventeen at the time because I started school early. They have *great* beaches there. There's this one called Hazard which I really love. Avalon is the main beach. But to get to Hazard you have to go through this whole forest and then climb down the rocks. The waves there come and just *crash* on the people. It takes about 10 minutes to get there.

Sounds like fun.

It is. It's great.

So what area of business did you specialise in?

Accounting. It was so horrible. I really hated it. I came back and went to Cal Poly to study nutrition because, my God, I *love* to cook. That's one of my true passions, one of the things that's deep inside me. I like to cook healthy things… Italian food. I don't know where I learned to cook. Probably because my mom was such a horrible cook. (Laughs) My parents divorced when I was younger, so I used to cook for my dad.

Do you have a large family?

Just an older sister. She's *very* different from me.

How so?

Well, the first time she came to my old apartment she saw a dildo and

just *freaked* out. I used to work with *Playboy* and they have these really unique toys. And there was one dildo where you stick it inside you, and the other person has the controls. You don't even touch the darn thing. You don't even dilate it. The other person with the controls does everything. It has these heat sensors, and the person with the controls can *pound* you with it or make it really mellow. Anyway, I had one of these things sitting around the house, and my sister grabbed the contraption and went, "What the hell is this?!" (Almost whispering) And I was dying to shove it up her butt.

Did you —?
No. I didn't do it, though.

Darn. Well… let's see… have you done much travelling since you've been in porn?
I haven't had the opportunity. I've only been to New York. Patrick and I will be going to Cannes soon, though.

Do you find that exciting?
Yeah! — because I've never been to Europe. I was going to go to France and do some films there, but at that time I had… um… I don't know if you heard rumours about me or not, but I hadn't really worked… actually, I took a break in June '95.

Can we talk about it, or is it too personal?
It's a personal thing but, no, I'm not afraid to talk about it. It was more like… well… I kind of had a nervous breakdown. Not related to the business, though. In fact, the few times I was working were beneficial to me because it allowed me to get away. And when I was working, at least I was around my friends… I felt a little bit at peace. But I needed time off just to get myself together. I really didn't want to be 'broken', which is what you hear about a lot of people when they're emotionally distraught. It's a sad thing about this industry. I mean, there's this stipulation that everyone in this business is a nymphomaniac, or neurotic, or a drunk, or a drug addict, or whatever — which is not the case. It isn't that way at all. In fact, many of us happened to like what we do. And if we're comfortable with it, then that's great.

Was your painting therapeutic around the time of your breakdown?
No. I didn't work much on my painting then. I was really just trying to feel where I belong. You know, that's a lot of it… of what I feel about this business. I feel like I belong here. I'm around people who are like me. It's comfortable for me to be myself here. Whereas outside, I always felt like I'm having to hide a part of me… like I'm kind of… I just don't want to lie to myself, compromise myself or… like when someone asks me what I do. "Well," I tell them, "I'm an adult film

actress." And people say (eyes wide; whispering in shock), "Boy! You do *that*?" They're really judgmental about it. But we're all in this business together. We're so proud of what we do. It doesn't matter what you do or how successful you are. It has nothing to do with that in this group. We're just doing it because we *like* doing it. If success happens, it happens. If it doesn't, it doesn't. Who cares?

So any closing comments?
Only that I think porn is really getting more accepted. Another generation is coming in and we're changing a lot of ideas about it. I think people are more willing to accept it as a genuine business and not… mush like some people think. You still get the hardcore Christian people saying we're doing the wrong thing, but I like that. We're still the rebels. We wouldn't be having any fun without all these 'morals' to break. I like that aspect of danger.

Just for the hell of it, what's your sign?
Aries. My sister is the one who's really into astrology, and she tells me I'm not a very good Aries because I'm not true to my sign. You're supposed to be a leader, strong, able to tackle things. And, in a way, things have happened to me that I've been able to get through. But… I mean (smiling) I would have never *gotten* into those damn situations if I had been a real Aries.

I've heard you're thinking about changing your name to 'Ophelia Opening'? What's wrong with 'Nicole Lace'? That's a perfectly good name, isn't it?
Well, I wanted to change my name so I'd only be associated with Elegant Angel. Right now the only films I do are for Elegant Angel.

I've also heard that you like older men.
(Smiles coyly at Patrick Collins, who's sitting nearby) Yes.

Why is that?
'Cause I like fucking my daddy.

Yeeow! You caught me off guard with that one. Well since we're on a roll, let me ask you this: how do you feel about the term 'slut'?
I'd rather be a tramp. Some friends of mine and I used to go tramping. We'd go pick up on guys and fuck 'em. And I guess in some ways that could be considered being a slut. But a slut… I mean, a tramp at least has some class. ∎

Nina Cherry

Not in the eye

Media whores. Aren't you *deathly* sick of 'em? Everywhere you turn — television, newspapers, movie posters — they're peering out at you like rats in a wet lumberyard. You *know* the insufferable, ubiquitous fucks I'm referring to: John Travolta, Whoopi Goldberg, Robin Williams, Oliver Stone, Demi Moore, Bruce Willis, and, of course, that politically-fucking-correct dynamic duo who'll undoubtedly SAVE THE WORLD, Alec Baldwin and Kim Bassinger. *Enough!* Time to try something different. Time to be bold, daring, adventurous. Time to rent a Nina Cherry video. Why? How's this for starters: after just 10 brief months in the blasphemy business, this

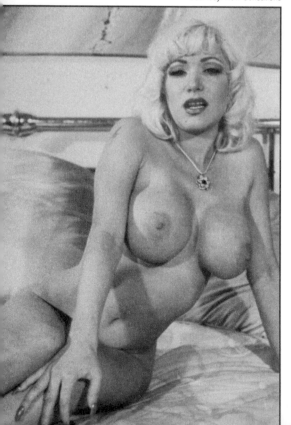

Nina Cherry publicity shot; *Anal Virgins 1.*
Courtesy: New Sensations

Texan-born hussy chalked up 50 (count 'em — 50!) double penetrations. Let's see… 50 DP's… multiplied by two penises per schtupping… that amounts to… um… yikes! — *one hundred dicks!* Somebody better put Nina's holes under citizen's arrest or she's gonna wear down the great divide between them thar orifices (and start letting out pussy farts which really *stink*). Needless to say, the girl's obviously smitten by (oink! oink!) pork sandwiches.

Interestingly enough, after I interviewed Nina on the set of Carl Danser's *A Shot In the Pink 2*, we met several days later at the 1996 Night of the Stars — and nearly made fu-fu right there on the carpeted floor! Emphasis on "nearly." For just when Nina and I started getting down to our birthday suits, a porn stud — infamous for both the size of his manroot, as well as his hog-like appetite — stomped by, a poorboy sandwich dangling from his mouth like a lettuce-munching iguana. Much to the shock of all present, this same human garbage disposal abruptly let out a horrifically sonorous, grotesquely wet fart. That's when all hell broke loose. The lights flickered dangerously; stars and starlets rocked back and forth as if on the Star Trek bridge; women, men, and mutants like Chi Chi LaRue shrieked madly; bodies careered into one another as if slam dancing. Then the lights went out, unconsciousness bellowed, and a horde of unrelated images floated past me like animated murals: *The gigantic head of Al Goldstein surgically connected to the tip of a Michelin blimp… Liz Taylor shooting up her latest over-priced perfume in a men's bathroom stall… Howard Stern pulling patches of hair from his suddenly balding scalp… Mariah Carey on all fours, getting heavily sodomised by Marlon Brando in the middle of a gigantic frying pan… Ronald McDonald forcing Willie Brown at gunpoint to dress in worn overalls and a backwards baseball cap… Jack Kevorkian putting Eddie Murphy's career out of its misery.*

Then the ink of darkness blotted everything out.

I eventually awoke in a moonlit, garbage-strewn alley (just outside the hotel's kitchen), the horrid sensation of sandpaper massaging my balls quickly triggering my consciousness. Upon closer examination, I observed my testes were in fact getting a rough scraping from none other than a pussy. No, not a vagina — but a bloody alley cat!

Needless to say, I didn't swap passion with Nina Cherry that fateful Los Angeles evening. But I did walk out of the alley with a sweet memory of an interview — and a pair of burning testicles requiring immediate medical attention.

So, Nina, what Cherry titles should we rush out and rent?
I did seven gang bangs for Zane… *Anal Jeopardy, Anal Connection, Anal Professor, Anal Rubbers 2, Anal Disciples 2…* can't remember all of them right now, but I had fun with the whole gang bang thing while it was

happening. It was a good time. A *lotta* work, though. At the time you don't think of it as work; but when you do that many sexual positions, that many anals, that many guys a couple times a month or whatever, it adds up and your body just tells you, "Gimme a break!" (Laughs) I usually did five or six guys for Zane — you know, the basic number. Zane shoots a lot of European stuff — double-triple blow jobs, double-triple anal scenes, double-triple vagina... and they shoot it with four or five guys, want two positions of each... (laughs)... whatever you can possibly muster, they're gonna get it.

How long does it take to recover from a gang bang like that?

Oh no, you're fine — unless you get an injury from something that you've done, which is why it's not always smart to go that route. I mean, you can do it a few times, show your loyalty to the business, then say, "Hey, it was fun, but now I've paid my dues."

So what's your role in this Carl Danser film?

I have kind of a lukewarm role in this one... my first time working for Carl. We pretty much stuck to directions in the script... stuff like, 'Acts like she's going to die,' lines along those... lines. (Laughs) Pretty minimal dialogue.

Why did you decide to get into porn?

Good money and good sex. (Laughs) I also thought it would be easier than dancing on the road, which I'd been doing for a while. Besides, I was kind of bored with life in Houston, and porn was more or less a fantasy of mine. I also wanted to get into mainstream films because through porn you can learn how to act a little, cheat your body towards the camera by angling it, learn about photography, meet people, and get a *little* taste of what real acting's all about. But a lot of times, even on porno sets, people don't read the script. Like on this shoot. At one point in the story, my character falls out of a closet, dead. And some of the crew members asked me, "You *die* in the script?" No one even *knew*. No one even read the script — the whole fucking crew! And I'm like, "Fuck. C'mon, you should *know* this." I just thought everybody on the crew would have been a *little* more informed.

So you obviously prefer working with scripts.

I think it helps the actress or the actor grow into the character they're portraying. They get a feel for the words, the story. Then, even if it's a small part, they get a chance to at least explore what's expected of them. I don't get that opportunity all the time. I mean, I've been here all day and all I've got to do is say, "Seeds and all," and rub my crotch. (Laughs)

"Seeds and all"? — what's that all

about? Sorry, I didn't read the script.

(Laughs) Seeds and all. It's about a watermelon and a lady's pussy. According to the script, this woman's pussy tasted so good to my character, she describes it as being similar to eating summer watermelon — seeds and all. (Laughs) It's not much of a role. I mean, I'm a dead person who comes back from the grave to say three words.

But you view porn as a sort of portal to mainstream films?

Yeah. I mean, Traci Lords did it and... who's that guy?... Tony Danzig or something?... you know, the guy from *Taxi*?

Tony Danza?

Yeah. Tony Danza

He made porn? Jeez, I have a hard enough time stomaching the guy's false modesty, let alone seeing the meathead's bare ass in a loop.

(Laughs)

Did he really star in skin flicks?

Yeah. I've heard these things through the grapevine. But keep in mind, porn has really changed. Everything is about anal these days. Me, I want more romantic films, more feature stuff. For instance, I did a boy-girl scene the other day for a feature film in which I had a *lot* of dialogue, and they didn't want all of the smut and the degradation of women. Instead, they wanted a couple coming together, caressing and enjoying one another That was nice; which is not to say I don't want to do the type of films which got me *into* the business in the first place. I'm not giving that up because I really like what I do. I mean, I didn't give up everything and move all the way out here from Texas for nothing. I even gave up a boyfriend (laughs)... told him, "See you later. Sorry." He was boring, anyway.

So what was it like growing up in Texas?

I was very wild, very sexual... dropped out of high school actually... (notices a naked girl come out of the bedroom shower and, still dripping, rush out of the room). *She* looked good... (sniffs)... smelled pretty good, too.

That's my aftershave.

(Laughs) Looks like there's another girl in there taking a bath...

Methinks the lady likes girl-girl.

(Laughs) Yeah. It's very nice... goes all the way back to pre-school. Today I'm doing a scene with Davia [Ardell]. She's a wild little thing, really hot. Both of us are petite, not extremely tall, so we're well-matched. It's just always a lotta fun working with Davia.

Nina Cherry on the set of _A Shot In The Pink 2_. Photo: Anthony Petkovich

Let's go back to high school. Can you give us some stories about your wild life as a teen?
Rent a movie, you'll see what I been doin' all these years. Basically I wasn't your average high school girl. I mean, I didn't have to seduce women or men. If it happened, that was fine. But it was usually effortless. They found me. (Smiles wolfishly)

What about facials? How does Nina Cherry find _them_?
Seems like it's mandatory these days — that and anals. Cum doesn't bother me. I just don't like it in my eye. It kinda hurts, kinda burns.

By the way, the spiky blonde hair looks very nice.
Thank you. When I first got into the business it was red. But I wore a blonde wig. Actually, I wore about 10 different wigs because this bad hairdresser fried my hair. (Laughs) But eventually I was ready to come out from underneath the wigs and do my own thing. I think my name's big enough now, and I've worked really hard since I got in the business 10 months ago.

What do you think is your body's best feature?
My ass — and the cleavage in my boobies. You wanna see?

Sure.

Unbuttons shirt, plops each breast out of her bra, presses them together, and leans forward.

Nice. Let me get a picture of that. (Flash! Flash!) Thank you. So what size are you?
Thirty-six, triple 'D'. They're saline.

What made you want new tits?
Peer pressure.

Seriously?
Oh, c'mon. All these girls with beautiful big breasts. They _all_ have 'em! I was a dancer when I was like 17 and I was just like totally... I liked my breasts. I have a nice body. And I didn't have to be all fake. But there's just too much peer pressure in this business.

You said you like the money and sex most in porn. What do you like least about it?
No hard-ons and waiting too long. (Laughs)

Christi Lake once told me that porn stars get paid to wait, not to fuck.
(Laughs) If you can walk off a set with your pay-cheque and a memory of some fairly good sex, you're a _great_ woman. This shoot's been 14 hours. I woke up at six in the morning and my scene is just starting now at around 8 pm. And all I have to say is that one line and rub my crotch. I prefer working for people who call you at the time they _need_ you and use you. Zane was pretty good; they don't waste a lot of time. I also like working with Mike Carpenter because he gets you in there and out. He shoots really good stuff, too — the storyline is good, the plot, the acting. But if you don't get it right the first time, he starts yelling. The first time he yelled at me, I was like, "Oh God... God..." (Laughs) But it was all right. That's just his nature. And I accept it because of the quality of the final product. Don't get me wrong... Carl's really good, too. As a matter of fact, I'll be working on four more films for him in the next two months. It's just that we're a bit hung up today because of some... I don't know... technical problems, I suppose.

According to your own record, you've done 50 DP's in 10 months. Did you do DP's before the business?
(Hesitates, smiling sluttishly) No. Actually... no.

Oh, you're not going to tell us.
(Laughs) No, I was thinking of something else I did.

Which was?
(Laughs) Gang bangs. I did gang bangs before the double penetrations, before getting into the business. It was kind of a fantasy. I did 'em in churches. (Laughs) No, I'm joking. Actually, I did them in hotel rooms.

Hmm... and how were these rendezvous' arranged?
Oh, that's a whole 'nother interview. (Laughs) ∎

Slut ests Foreve.!

On the Set of Bruce Seven's Buttslammers 6: Over the Edge!

B lasting down Highway 5 on that crisp, clear April morning, I felt somewhat like Joseph Conrad's Marlowe travelling down the untamed Congo, coming closer and closer to the mysterious, irreverent, darkly brilliant figure of Colonel Kurtz. Except it wasn't the Congo I was travelling. Just crappy old Interstate 5. And I wouldn't be meeting Kurtz, but eventually coming face to face with none other than Bruce Seven, a fair excuse for a madman if ever there was one. Considered ominous, twisted, and downright scary by many folks even within the industry, the lanky asthmatic (now in his mid-Fifties) had an intensely dark reputation which lay somewhere between the Marquis de Sade and a sick-fuck scumbucket from one of many Sam Peckinpah westerns. Seven had been called the King of Bondage, Prince of Pain, Archangel of Anal, the Guru of Girl-Girl. But he was best known as being simply the godfather of porn. And the thought of actually meeting this modern myth of decadence only sharpened my anticipation.

During a phone interview the week before, Seven suggested an on-the-set interview. Man, what an offer! Seven never invited people onto his sets. His films were strictly hush-hush — porn as it should be... underground... *deeply* underground. Now I'd finally meet the grand master of anal — in his own element! Four hundred miles lay between San Francisco (i.e., your most humble pornoholic) and the LA slutfest.

Giddy up!!

It's 12:30 pm (April 16, 1994) as I pull up to Seven's new home in Granada Hills. Cars and mini-trucks crowd the front of the unassuming home. Any neighbour would think a few friends were merely gathering for a barbecue. A feast is right. A flesh feast. Cornholed beef. Walking up to the front door, I can't hear a peep, not even the distant muffled sounds of female moans. I knock on the door. After a brief pause, a white bouncer in his twenties (or what appears to be a bouncer), all muscle and pug face, appears in the doorway.

"Hi," I tell him, smiling like a paper boy collecting money on his route. "I'm here to do a story on Bruce's shoot."

He slowly opens the door to reveal a long, dark hallway, at the end of which sits a wiry, older guy with slicked back gray hair and grizzled beard. Who else could it be?

"It's okay," Seven calls out. "Let him in."

I walk the long expanse of the murky hallway, eventually shaking hands with Seven who's sitting on a stool at the wet bar. The bar is located at the edge of the home's spacious living room where today's shoot — *Buttslammers 6* — will be filmed. Seven just moved into this place a few weeks ago. And this is the first feature ever shot in his new digs.

Most of the furniture's been moved from the voluminous living room, except for two black-velvet platforms. Glenn Baren — Seven's still photographer and musical composer — is busy taking snaps of the girls on one of the platforms for the new video's boxcover. Suzie Mathews, Kaitlyn Ashley, and (a beauty I've never seen before) Veronica Hall are lined up on the soap-

box, their gorgeous, bikini-clad butts aimed at the camera. This is almost as great as seeing the actual fucking! — ass, after ass, after ass, right in your face. I'm getting thirsty.

"We're running behind schedule," Seven matter-of-factly states. He's cordial, polite, but, as can be easily understood, economical with his words. The mash-faced "bouncer" quietly moves around the wet bar and pours himself a drink (I later learn the guy's not a bruiser but little Suzie Mathews' boyfriend... and a friendly lug, too).

"Okay," Seven calls out from his chair at the bar. "Glenn's gonna shoot two or three set-up shots, then we're gonna fuck each other to death."

Seven — next to Patrick Collins and John Stagliano — definitely has the most alluring, unpretentious video boxcovers on the market today. It's like buying a slab of steak, the freshness of which you can see through the plastic wrap. What you see on a Seven boxcover — a whole bevy of beautiful sluts fucking beautiful sluts— is exactly what you get.

"It's a stupid business we're in because it's a marketing business," Seven explains to me as Glenn gets his boxcover photos. "They spend $5,000 for a cover shot, and they're making the movie for $4,000 which they shoot in one day. If you can't jack off to it yourself, don't *shoot* it!"

Although Seven sits at the bar, it's not for swilling purposes. First off, the bar is ideally located at the central edge of the living room; here, Seven is at a perfect vantage point to view all the action (no more than 15 feet from him at any given time). Secondly,

there's a small television monitor on the bar's counter that allows Seven to view everything videographer Michael Cates shoots that day. And whether Seven watches the sex directly or televised live, he's still got the best seat in the whole house. And, shit, why not? It's his fucking house.

According to Seven, it typically takes him four to five days to shoot a complete film. Today's shoot will consist of three scenes: one with Suzie, Kaitlyn, and Veronica (slurp!); another with Bionca, Debi Diamond, and Krysti Lynn (gasp!). And, last but not least, Seven's mandatory olive-oil slutfest. I'm really getting thirsty, now.

"I like my girls to interact with each other," continues Seven, "so they *want* to fuck each other." The metallic click, the blinding flash of Baren's camera punctuate Seven's sentences. "You have to be very careful about who you put to work with whom. You just don't hire somebody because you think she's cute. Otherwise, you'll get one girl on the set that says, 'No, I don't want it in the ass.' Then you get the normal, average shit you couldn't even jack off to."

Once Baren is finished snapping, the girls hop off the platform.

The first scene — non-sexual, strictly dialogue — is at the bar, so the girls decide on a drink. Reasonable women. Suzie Mathews looks cuter each time I see her. Her golden, oven-roasted tan is magnificently highlighted by a shiny metallic waistband all of which further decorates that gorgeous bubble butt of hers. Suzie's partial to the Corona. Kaitlyn Ashley has a cranberry juice and vodka. She's got a great butt, too. Shit, they all have great asses. Kaitlyn's booty, however, is accentuated by a pair of white, knee-high leather boots. She's the quintessential blonde, looking as if she walked straight out of a Fifties exploitation film and — boom! — into the nasty Nineties. Veronica Hall's drinking light, just a soda.

"She's a manicurist," Seven says of the little-seen 'Vicky.' "Hasn't worked in one of my productions for six years. She only comes around once in awhile to work for me. I rehire the people I like most." I can see why. Vicky's a naturally dark-skinned Jewish girl, with long brown, slightly frosted hair, very suckable little tits, a rubber-band tight ass, and a semi-shaved pussy... her deep black bush is evenly contoured to form a sort of long rectangle. Umm-UMM! Think I'm in love.

Seven's busy giving a massage to "Casee" (better-known as porn slut Careena Collins). A regular star in many of Seven's bondage features, Careena currently goes under the name Casee (but we'll call her Careena, all the same). Rather than fucking some stud's brains out, Careena is merely on the sidelines today acting as a second assistant to Seven, whose first assistant is the ever-indispensable Lia Baren, photographer Glenn Baren's lovely young wife.

Seven rubs his palms deeply into Careena's shoulder blades. "You know what your problem is?" he tells her. "You haven't been whipped lately." Lucky Seven.

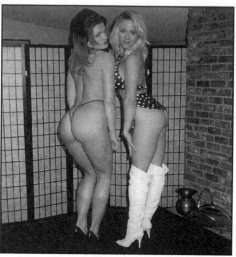

The girls do a slow grind for the cameras. Krysti Lynn (left) and Kaitlyn Ashley.
Photo: Anthony Petkovich

The mood in the Seven household is (at least for me) very much like that of a party. There's plenty of food, laid out buffet-style on the kitchen table, the refrigerator is well-stocked with chilled wine (white or red) and imported German beers, the wet bar contains every imaginable liquor known to man, and it's a help-yourself-to-whatever-you-like (and-how-*much*-of-whatever-you-like) policy. Just enough people, too. No more than fifteen people populate the place at any given time; these include actresses, assistants, cameraman, photographer, and visitors (like Suzie's boyfriend and me). Everyone's very casual, friendly, and respectful. The perfect party. The perfect porn set. It's actually hard to believe this is a real working day for many folks present.

Cates and Baren are having slight problems. Unfamiliar with the new home's interior lighting, they're running all over the room, trying to get it right. As lighting is one of the most important aspects of a fuck film (we wanna see all the action, right?), I ask Baren to briefly explain the problem.

"When you're shooting tungsten," he patiently reveals, "the daylight turns blue. And what happens is that blue hits the side of the face. Blue light, of course, is more unflattering than yellow or red light — it shows all the imperfections on the face. So you've gotta even it out. And you've got to even out the colour *temperature*, as well. You want to do that especially for women. Otherwise you get big shadows... and the girls *hate* ya'." Baren laughs.

But the momentary lighting conundrum soaks up way too much time for Seven, who constantly battles to stay on schedule. "We can't keep fuckin' with this," he complains. "We can't! It's like 2 o'clock and we haven't done the first scene." But Seven gets pissed at the situation, not the people.

Cates and Baren finally block out the daylight in

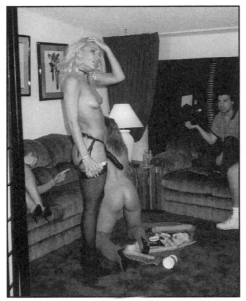

Debi Diamond and strap-on.
Photo: Anthony Petkovich

the dining room, plastering the patio windows with black tape. They've also stuck an artificial light in one corner to even out the remaining light.

"I've never worked so hard and done so little in my life," says videographer Cates, a bear of a man, as he wipes streaks of sweat off his brow.

Seven slowly nods. "Looks pretty good. It'll be fine."

Show time, folks.

First up: Suzie, Kaitlyn, and Vicky.

Seven throws his girls into the steam of things. "Just get in," he sedately tells them, "suck tits, make love for a few minutes, and then I'll start directing. Have fun for a little while. Then I'll make your life miserable. Do we have gloves?" Seven calls out to his right-hand person Lissa.

"We got gloves," she answers.

"Okay, let's get on and get off."

As usual, each girl gets fucked by the other two on a rotation basis. Kaitlyn gets the proper going-over first. Not, however, before she dances for her fellow slut queens. As if cherishing a dry gin martini before a lavish meal, Seven truly enjoys a slow, erotic bump and grind before getting to the nasty hump and slime. And Kaitlyn does it masterfully. She moves all those precious joints in rhythm to the funky music of Prince, which blasts on the boombox (an original GlennLyn soundtrack is later dubbed in during post-production). Looking directly into the camera, Kaitlyn's got this girlish, highschoolish face — and a nasty smirk to go with it. Eventually she's stripped down to her birthday suit... all that remains are those terrific white boots and a warm fuck feeling.

The girls are ready to eat — pussy and butthole,

that is.

"Vicky," Seven calls out from the bar, "get behind Kaitlyn and spread her legs *way* out... now sit on Kaitlyn's pussy, oil her down. I don't think the oil will hurt the boots. They're real leather, right?" Kaitlyn nods. "Then it's not gonna hurt the boots." Seven turns to me. "That's what I use to condition leather — olive oil. It works wonders, man. Softens it up so good... it's incredible. That's what they used to put on saddles." He then snaps back to the scene. "Let's go! Oil her up! Fuck her to death."

With Kaitlyn standing, Vicky licks the blonde's cunt from the back, while Suzie licks Kaitlyn's clit from the front. Vicky momentarily blocks the camera's view of heaven. "Vicky, get your head outta there," Seven announces. "C'mon, you can find it by Braille. " Vicky breaks up with the embarrassed laughter of an (almost) pure elementary schoolgirl.

Kaitlyn's laying on her back now, her legs spread from coast to coast, her mouth gaping wide. Vicki sits on the mouth. As Kaitlyn munches muff, she slaps Vicky's jiggly ass cheeks. In the meantime, Suzie's works diligently on both of Kaitlyn's orifices — with both hands! The girls soon have Kaitlyn in the doggie position, her luscious (now oiled and shiny) creamy white ass fills up the camera lens. While Suzie plunges a purple-and-white streaked love popsicle in and out of Kaitlyn's pussy, Vicky services the captive's clit with a mini-vibrator. Seven is *really* into it now.

"Suzie, pull the dildo out and stick it in her ass and let's get goin'. We'll shorten this scene *real* short. Keep goin'. Keep the energy. Just go for her asshole. Turn on the vibrator."

Kaitlyn is moaning now as the colourful (now buzzing) love stick sinks into her well-greased anus.

"You wanna turn it up higher?" Seven inquires with philanthropic smile. Kaitlyn issues an affirmative moan. "Turn it up. Get the turbo charge on that. It's got one."

Once Suzie and Vicky have thoroughly penetrated Kaitlyn's holes (and left her panting in the dust), Seven calls for a break. He's satisfied. "That looked great. Four fingers in your pussy, four fingers in your ass. We got a lot of that."

Kaitlyn is agog with sincere disbelief. "There were *four* fingers in my ass?!"

"So, I think a dildo ought to be easy," Seven adds, always (and quite admirably) going for the limit.

During the break, Kaitlyn sits on the platform diddling her clit with a mini vibrator. Seven shakes his head, almost chidingly. "There she is with the vibrator again." Kaitlyn giggles.

"She'd have it surgically attached if she could," Kaitlyn's husband Jay Ashley adds. Jay co-starred with, and co-fucked his wife in a gnarly gang bang in Patrick Collins' *Sodomania 6*. Sorry, but there ain't no place for him in today's all-slut agenda.

Seven goes over the upcoming rape scene with Vicky, his next victim of lust. "You can stand up (on the platform) and they're gonna tell you to hold your

The X Factory

Seven and his girls search for what they need in the box. Photo: Anthony Petkovich

ankles and stuff. Do it as long as you can. And they're gonna slap you, fuck you, do weird things, stick things in your ass, all that shit."

Vicky lasciviously grins. No need to twist her clit. She's ready. And for this smut scribe's money, Vicky's domination is undoubtedly the most intense of the three-way scenes today.

Cates runs around like a fiend with his camcorder, getting all that scenty, sensuous girlie action, with Seven intently, yet coolly, watching from the video monitor. Me? No way. I like to watch it first-hand.

"Stand up on the platform," Seven instructs Vicky. "Okay, that's a good way to start. Suzie... Kaitlyn... tell Vicky to put her hands over her head and keep 'em there. Start with her tits, oil her body, suck her tits. In fact, you can put the oil down now... suck her tits, and kiss her. Don't make my job tough, girls. Just get in there and get passionate. Please."

The girls obey. They start spanking Vicky's ass like a basketball — each girl dribbling a butt cheek... with zest... and pure aggression. *Smack! Smack! Smack!*

"Make her spread her legs," Seven dictates. "Suzie, don't do anymore spanking when her ass is away from the camera. We've missed every *shot*! Tell Vicky to turn around so her ass is to the camera."

The sex and spanking is working on Vicky like an opiate, making her groggy, dreamy.

"Grab her hair and pull it back," Seven reminds Kaitlyn and Suzie. Vicky begins to bend over. "You didn't tell her to bend over," Seven adds.

"Put your hands behind your head!" Kaitlyn shouts at Vicky. "Do you want more?"

"I want more," moans Vicky, a spoiled child nearly sobbing for cookies before supper.

"*Then keep your hands behind your head*!" Kaitlyn hollers.

Seven's happy now... but still insistent. "Spank her some more."

Vicky — her ass cheeks a tender pink now — is on the verge of coming. I count 40 slaps in a row on each cheek (that's a total of 80 for you math geniuses out there). Ouch. "Sounds like a standing ovation," I murmur to Glenn Baren. Seven chuckles. Vicky's an outstanding submissive. No small wonder Seven loves her. The girl truly digs it. No matter how vigorous Kaitlyn and Suzie smack her patty cakes, Vicky doesn't complain. At one point, they spank her so hard, oil splats onto the camera lens. Laughing, Cates stops filming.

Once the mess is wiped up, Seven continues to fuel his she-demons with fire. "Keep dominating... get in the mood. You haven't been in it. We gotta get in there... if we don't destroy the camera with oil."

Suzie examines Vicky's oil-drenched cunt like a gynaecologist (suppose she is, in a way) and winds up delivering one of the hottest lines in the scene, as well as the film: "Oooooh... look at that! — it's drippin' off her hair."

Seven then walks the girls through a chain of spontaneous dialogue. "Kaitlyn... Suzie... ask her, 'Honey, what do you like?' Then Vicky you say: 'I want something in my ass.' Then, girls, you tell Vicky, 'Well, you're gonna have to *beg* for it.'"

The girls follow his instructions to the letter — Kaitlyn and Suzie mercilessly teasing their writhing creature.

"C'mon. Beg. Whine," they command Vicky.

Vicky's begs, Vicky whines. "I want it up my ass. C'mon. Give me a dil-doooo... Plee-eeeeassse..." Kaitlyn and Suzie ignore her. Instead, they keep chipping away at her butt cheeks, with open-handed blows.

Seven soon senses Vicky's limitations. "She can't stand up there anymore," he announces. "Her legs are shakin'. Just turn around, Vicky. We don't have to transition. Just pull her legs back, girls. Use the dildo and the vibrator on her." Seven throws a big, black dildo at Suzie. "Turn the balls around on the bottom, please. Suzie, put some fingers in with the dildo. Make sure you oil that a lot."

The dildo goes straight in... as do the fingers... and the vibrator. Vicky acts like she just died and went to slut heaven. "Yeaaaaaah... hah... that feels soooo good."

Suzie's into it now. "OOOOOhh look at how hard it is... that big dick sliding in there..."

"Long, slow strokes, Kaitlyn," Seven calls out. "Push it farther, Kaitlyn, till she says 'no.'"

"Oh my God. Oh my God...," groans Vicky. But she doesn't say "No." In fact, she seems on the verge of tears. Joyous ones.

"Look at how sweaty she got," Suzie says, sincerely smacking her chops. "Look at that huge cock… Ummmm, that was goooood pussy."

"We're not through with her yet," Seven reminds them. "Turn her over on her side. Just roll her leg over. Scoot back, Vicky. Is that okay?" Vicki looks almost lovingly at Seven and nods. "Make sure it's good for the camera."

Vicky's on the her side now, the roundness of her beautiful dark ass perfectly displayed to all of us.

"Now we're gonna stick one of the dildos in her ass. Use the vibrator." Seven looks closely at the monitor. "We're very bad for camera right now. Mikey, scoot around. Is that vibrator okay for you, Vicky?"

"Um-hmm. Great," Vicky cozily answers as if floating in warm brandy.

"You can get that one at any drugstore," Seven suggests. He then runs through some more dialogue. "Kaitlyn, Suzie, just say, 'I think her asshole needs something else.' You can use a couple fingers on her. Spank her a couple times. Keep the energy going."

Vicky's sautéed cling peaches now look like strawberry pies. Her moans reach a crescendo. A bulb-headed dildo magically appears.

"Oil her all up," Seven says. "Down her legs and everything." Seven still thinks her wee wee hole isn't lubricated enough. "Stick the nozzle in her ass, give her a little bit of a squirt. No, no. Suzie, when you do something, *do it!* Stick it in and squirt. Punish her."

Slap. Slap. *Squiiiirt!*

"C'mon. C'mon," Vicky implores. "I need it. I want it reeeeel baaaad…"

"Beg for it, baby," the girls aggressively chime. They stick fingers in her holes like she's a piece of human Swiss cheese.

"Suzie, put a finger between 'em," Seven insists. But Suzie hesitates. "Don't stop! *Please.*" Suzie snaps to.

Vicky's pleas are child-like, now… a female Oliver Twist begging for more porridge. There's absolute silence on the set. You could hear a spider fart. On a bar stool next to her boss, Careena hypnotically watches the cunt heat rising. Rather than stuff her pretty face with buttered popcorn, she fingers her pussy lips through her a sexy pair of purple spandex shorts. When someone looks in her direction, she suddenly stops, slightly embarrassed, and smirks as if an innocent. A secret ritual unveiled. What a turn-on. Yet Seven doesn't notice; he's focused 100 percent on his starlets.

"Kaitlyn, keep your fingers in her ass so we get enough of this shit."

Vicky is melting in her invaders' latex-laced hands.

"Faces. Faces. Don't look at me," says Cates as he moves all around, getting the fire on film.

Once the girls have melted Vicki's wax, they're ready to light Suzie's wick. And the roller-coaster ride of raunch repeats itself.

When it's all over, the girls (quite literally) hit the showers. It's around 3 pm now. Casee runs around

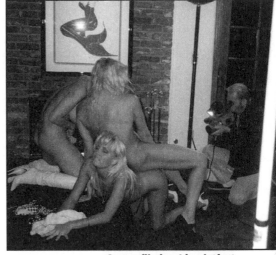

Seven filming his slutfest.
Photo: Anthony Petkovich

getting everyone's order for lunch. Twenty minutes later, Vicky comes out of the bathroom wearing nothing but a pink, silken kimono, her hair still fragrantly wet, squeakily stringy from the washing. Smiling, Seven holds his arms out. "C'mere," he says. She falls into his arms "You feel better now?"

"Yeah," she laughs like a doting schoolgirl.

Seven gives her a big kiss. "You're wonderful," he says.

"Thank you. So are you. He's the best," she tells me. "Lets me use his shower… I feel nice and fresh now."

Careena's still running around collecting everyone's lunch order. "What do you want, Bruce?"

"I'll have the turkey dinner. I'm not gonna eat it, but that's what I'll take."

Excited murmurs are circulating around the house: Bionca will soon be here. The last several days she's been shooting her own film; a boy-girl feature entitled *Takin' It To the Limit.* It'll undoubtedly propel her smut superstardom even further across this universe of sex and sleaze. In the meantime, though, Seven's got his own film to do.

Sure enough, before the sweat's been mopped up from the last scene, Bionca shows up. The woman is so casual, so unassuming in her clothing, she's almost unrecognisable. White tennis shoes, windbreaker, baseball cap, and — topping off that perfectly sculptured bottom — Beavis and Butthead shorts.

"Hey, Beavis!" Seven calls to her from his seat at the wet bar.

"No, *I'm* Butthead. *You're* Beavis!" Bionca answers with a warm smile.

The lunch arrives about an hour later. The crew and cast feed on spare ribs, roast turkey, spaghetti, meatballs, lasagna. The clock reads 4:30 pm now. Fairly

late in the afternoon, but Seven's feeling confident about the schedule now. In the meantime, Bionca, Debi, and Krysti get ready for the sequence everyone's been waiting for. "You won't see anything like this *ever* again," Seven promises me of the upcoming fuck episode. With a labia line-up like that, hey, I'm a believer.

As the crew wipe their chops, the girls show up in the living room. Bionca's wearing a bikini outfit and heels. As she adjusts her outfit, her tits tenderly peek out. The woman possesses a pair of the best nipples in the business — so pointy, firm, suckable. Debi's wearing a slinky black velvet dress, black garters and high heels. She's the quintessential, timeless Hollywood hussy: her tousled blonde hair a symbol of her own incorrigible sexuality. Krysti is decked in red. She's the best excuse for a mini cardinal I've ever seen. Red see-through blouse, red shorts, and lavish, ankle-high red boots. This is the real meal. Bruce steps off his bar stool to go over the scene with them.

"Hi, sweeties," he greets them.

"Hiiiiiii!" they answer in unison.

"Okay, Bionca," Seven says. "This is the sort of thing I want you to basically say to Krysti: 'Well hello, Krysti. It's nice to meet you. Bruce isn't here right now. But when he's not here, I'm the boss.'"

"Assistant manager," says Bionca, smiling.

"Assistant manager," Seven agrees. "'I don't know where Bruce is,'" he continues. "'This is a new house of his. You answered the ad in the fuckin' paper for a dancer? It's fine. Dance for us. I'll hire ya. It's no problem. Bruce'll love ya.'"

"Well, where the fuck do I come in?" Debi quips in. "Where's my motivation?"

"You just go 'Yeah,'" Bionca says with a smirk, nudging Debi. The two bust up like teenagers at a slumber party.

"You'll get your motivation later," Seven assures Debi. "First of all, Krysti, stand up. Bionca, Debi, you have her turn around, bend over, look at her ass, and say 'Oooh, God, that's fine shit.'"

"Okay, I know what to say now, Bruce," says Bionca.

Cates starts filming the dialogue between Bionca and Krysti. Seven closely watches from his monitor at the bar. The fun and camaraderie between the three girls are refreshing. No egos here — especially from Bionca. From her impressively prolific X career, you'd expect a super-bitch. Not so. Quite aside from her extraordinary looks, she's a sweet, modest woman.

Debi and Bionca can't stop cackling with laughter. They obviously enjoy working together. Seven enjoys the mirth, too — up to a point.

"Start that dialogue again," he directs. "Don't keep fucking interacting too much together."

Bionca: "Who?"

Seven: "You and Debi?"

Debi: "Well what the hell is my purpose here?"

Seven: "Your purpose is to get into this the way I *want* you to. C'mon, let's get with it." Seven picks no favourites.

After Bionca and Krysti run through their dialogue, Seven keeps his promise to Debi: "Okay, Debi, this is your line —"

"What do I say, Bruce?"

"I'll tell ya right now if ya shut up!"

Debi shuts up. She listens dutifully as Seven delivers the lines: "'Do you like bondage? Do you like to be tied up?'"

Debi indicates understanding with quick nods.

The filming recommences. "Do you like bondage? Do you like to be tied up?" Debi says with a lustful smirk. She then bites her lower lip in horny anticipation.

"Mikey, close-up on the actresses," Seven reminds his cameraman. "You gotta get in there close. I want to hear this. Pull back a little." He's very patient with Cates, whose work (for obvious reasons) Seven rates very highly.

A buzzing sound is suddenly heard from behind the wet bar. Seven frowns. "What's this? — the fucking dildos are going off all over the place?" Someone produces a pager from a backpack. "Pagers, dildos… they sound the same."

Krysti begins her dance for cooze critics Bionca and Debi. Bruce watches the erotica unfold on his mini-monitor. Krysti's a hot dancer, wriggling her torso so

Between takes. L to R: Porn starlet/ production assistant Lia Baren, Bionca and Debi Diamond. Photo: Anthony Petkovich

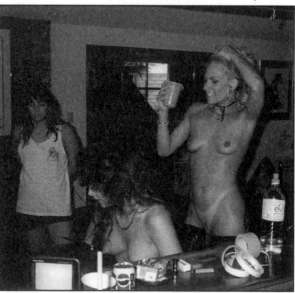

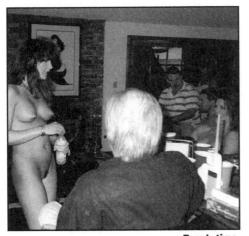

Break time.
Photo: Anthony Petkovich

smoothly, so naturally. I can't wait to see her headline a strip club. She's also great with the camera, making sure she gives that all-seeing lens a good nasty sneer. Bionca is in awe of Krysti's juicy, jiggly, succulent booty.

"You know how Bruce *loves* those plump asses," she tells Debi, revelling at the soft, round flesh muffins before her. Debi is one inch away from drooling. Seven wants to capture it.

"Close-up on Debi's face, Mikey."

But Debi can't hold back. The temptation's too great. Krysti's no sooner on her hands and knees, shaking her wobbly ass, when Debi lunges for it.

"Debi *sit back*!" Seven shouts, trying to protect his slut from this foaming blonde shark. "Let her dance!"

Bionca manages to wave Debi off, but still stands up for her porn pal. "Bruce, if that pussy was in your face, what would you do?"

Glenn Baren gets a kick out of the insatiable Diamond. "She's like a wild stallion trying to get out of her corral," he chuckles.

Seven's has a chore getting these strong-willed ladies in line. But once the talent *are* in form, the scene cuts loose with a mind all its own. And that's the Seven trademark: train the girls so that they spank, suck, and fuck on their own, without direction.

Once there's enough dancing captured on video, Seven gives in. "Alright, Debi, do what you want to her. Just leave enough for me tomorrow."

Debi descends like a vulture, spitting on Krysti's tight asshole. Bionca's not waiting for the leftovers, though. She wants some grub, too.

"Oh, God, your asshole tastes so sweet," Bionca whispers to Krysti. "You just pretend that I'm your doctor."

They really start to devour the woman in red. Yet Krysti, remembering how Suzie, Kaitlyn, and Vicky fingered each other to death, is a tad bit nervous: "Fingers up my ass are okay. Not four fingers, though."

"Don't make any laws on this," Seven bluntly states. "You just got the right to say 'Stop,' okay, Krysti?"

Bionca understands Krysti's anxiety. "Right," she assures her. "When you say 'Stop,' I'll pull back."

There are no platforms in this sequence; just a couple of big, fat, fluffy gray sofas to love on. And the girls dig in, generously spraying the olive oil on each other.

"There goes my couches," Seven mutters stoically.

Debi's sitting on top of the sofa now, her luscious legs spread for Krysti to chomp on her quim lips. In her uncontrollable heat, Debi slams her back against the window — and the window blinds — with a loud crunch.

"There go my blinds," says Seven. Glenn Baren and I laugh.

Debi's going mad, really smashing those blinds. And Krysti's getting her hot spot serviced by Bionca, who's making her see angels. "Oh God. Oh God," gasps Krysti. "Oh fuuuuuuck… Oh fuuuuuuuck!…" Krysti's hyperventilating now. In a few seconds, all three woman are growling. It's like seeing werewolves and vampires in a graveyard, clawing one another to a pulpy mess.

Bionca, by nature, takes charge. "Get that pussy open," she commands Krysti. "Get those legs out." Bionca then spanks the tender insides of the newcomer's thighs. Krysti's moaning like someone just cut off her right ear. On a Seven set, the smack of a palm on an ass has come to replace the director's clapboard. And with such professional spices of life as Bionca and Debi Diamond, the slapping is much more direct, more impactive, more like a punch, if anything. "Turn her ass over," an elated Seven tells Bionca.

But before Seven gets what he wants, Debi — still seated on the back board of the couch — sticks her leg out too far. Her extended limb hits a fat white lamp, which teeters threateningly, then disappears behind the sofa with a terminal *POP!*

"Shit!" Seven calls out.

Cates stops filming. Tired, somewhat irritable, he takes it personally, "Well, whaddya want me to do about it?"

"Nothin'… I'm just pissed, goddamnit!… Well, it had to happen sometime. We'll just go out and spend another $4,000 on furniture."

"Take it out of my cheque, Bruce," says Debi, almost blushing. Seven waves it off.

"I want a little extra for stunt pay…" Krysti jokes.

"Let me catch my breath for a minute, Bruce," says Debi, way too wound up from the sex.

"Okay. Stop. Two minutes."

"*Dos minutos*!" Debi ethnically echoes. She moves over to Seven. "I can't help it when I get turned on like this, Bruce," she confesses, crouching down beside his bar stool like she's going to pee. Instead, she insanely diddles her clit. Diamond eventually stands up and, twisting her already erect nipples, slinks over to a light boom. There, she slides her cunt (as best she can) up and down it the hot pole. The woman's a bot-

Left: Krysti shows photographer Glenn Baren some of her Polaroid prowess, while Suzie and Kaitlyn play. Right: Bruce calls the shots. Photos: Anthony Petkovich

tomless pit of lust!

Soon it's back to filming, though. It's Krysti's turn now to work over Debi. And Krysti taunts her to the limit. "You want something in your pussy?" she asks Debi. "You want something in your pussy, hmm?"

Seven: "How 'bout somethin' in 'er ass?"

It's all a bit dizzying, really. Bionca's got surgical gloves on. She's ready to "examine" Krysti. She sticks one, two, three rubbery, greased fingers in her insides. Seven isn't satisfied. "C'mon. All your fingers in her. Nobody does fists. Four fingers!"

Bionca plunks a thumb in Krysti's ass as she sticks four fingers in Krysti's clam trap. She's soon got *eight* fingers up Krysti's dripping cunt, moving them back and forth as if making a campfire by rubbing two sticks together. The set becomes as quiet as a mausoleum. Everyone's in awe. Even Seven. "This is really good-looking," he murmurs. Seven's very careful about keeping the thumb out of the fur pie. No fist-fucking allowed in these here United States.

Time for another break. That's when I ask Seven about the fist-fuck syndrome, knowing full well Stagliano and Collins make no-holes-barred films all over Europe. But I'm curious: has Seven ever dabbled with the idea of making films in, say, the more liberal state of Germany?

"You're wrong," he enlightens me. "You can have shitting, pissing, whatever there — but you can't have bondage anymore. They changed their rules. You have to go to some place like Sweden or Amsterdam, then you can get anything — shit, piss, fucking, pins, needles… but it's all done so badly in Europe. It's *bad*, man. They have no sense of camera. Those fuckin' people are just there to make a buck… get the girls in and fuck."

Krysti marches up to Seven like a spoiled child. "I want to lick some pussy," she pouts.

Seven reassures her. "Yeah, we're gonna do some lickin' pussy sooner or later."

Lia, Seven's assistant, is working up a storm throughout the day — buying food, setting it out, clean-ing up after people, writing checks… "Weird job, huh?" she laughs while cleaning cunt juice and lube off a big, black dildo. Afterwards she brings the dildo to Debi and Bionca, who now recline on the sofa. "Okay," laughs Lia. "It's clean up to here," she indicates, an index finger half-way up the love cylinder. The girls all laugh.

And our star sluts are soon back at it.

"Put your fingers in her ass, Krysti," Bruce orders. "Two!"

"What?" the three girls say in unison.

"Krysti, don't stop. Just…"

"Well," Debi says, "We can't hear you when we're yellin' to each other."

Seven cups his hands over his mouth. "KRYSTI, PUT TWO FINGERS IN DEBI'S ASS!"

The girls laugh.

"You need one of those megaphones, Bruce," Debi says.

Sure enough, Bruce pulls one out from his toy box full of dildos and vibrators. He puts the simple, trum-pet-like device to his lips. "CAN YOU HEAR THIS BET-TER?" His voice sounds like it's calling from the bot-tom of a well.

"Yeah," Bionca and Debi simultaneously answer, smiling.

"Good."

Back on the screen, Krysti sticks a taloned finger in Debi's hot asshole. It's a melange of groans, words, screams, slaps, and gasps. Brilliant.

Lissa is searching through Seven's toy box. A big, black, formidable strap-on dildo is produced. She hands it to Seven, who throws it into the milieu of tender twat. Debi grabs it and saddles up. Armed with this new love weapon, Debi lies back on the couch as Krysti sits longingly on the plastic black woody. In the mean-time, Bionca fucks Debi's house of Eden with four fin-gers. A big, big, BIG 18-inch dildo is produced from the infamous toy box. The… 'thing' looks like a cream-

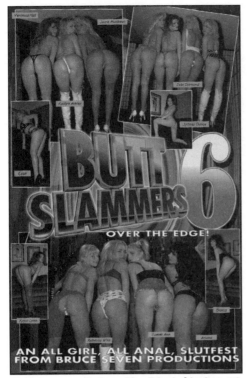

Buttslammers 6: Over The Edge! videobox art.
Courtesy: Bruce Seven Productions

coloured, vein-laced elephant gun. Earlier, they tried it in Krysti's pussy without success. Too wide. Seven wants to try it on Debi's niche for size. The crew seems a bit unsure about the inhumanely sized artificial manroot. Not Seven. He knows his women — and their limitations. "No. No. Let's just get goin'. It'll work. She's had the kitchen sink up there. No problem." As Krysti rides Debi's black strap-on, Bionca jams the rubber tree trunk in and out of Debi's love silo. Seven was right — as usual.

Time for Krysti to receive a backslam.

"Okay, Debi," Seven calls out. "Roll Krysti over and fuck her. Better yet, stick it in her ass, Debi."

Debi's on the floor now with Krysti squealing like a slut whore. Debi fucks the hades out of her with the strap-on — doggie style! Just what we've been waiting for, with Krysti's bountiful butt cheeks gyrating like electronically shaken cans of paint.

Before I know it, Debi's back on the couch and both Krysti and Bionca are shoving very thick, long, flesh-coloured candy sticks in the blonde's seemingly bottomless twat. Incredible! This is almanac material. The two bazookas (one guided by Bionca, the other by Krysti) are sliding up and down Debi's jam pot with the ease of two bread sticks in jelly. At the end of the scene, Seven is content — but not *totally* content. He just *always* want to top himself. "We never got anything in

Debi's ass. I'm really upset."

Now it's dark — well past 8:00 pm. And Seven's still got his prerequisite Buttslammer's full-blown orgy to film. Time's a-wasting. So he corrals his girls together. The participants are Suzie, Kaitlyn, Krysti, and Debi. Bionca unfortunately can't join the filth fest due to her commitments to *Takin' It To the Limit*. And Vicky had to suddenly leave due to a family matter. So it's wagons ho! Tuna meltdown time.

Seven — along with Cates and Baren — is seated on a couch shoved against the wall which they used earlier to shoot the Mathews-Ashley-Hall love triangle. Don't worry, the couch is clean. Seven's monitor is positioned on a glass coffee table before him. And a large black-velvet platform — where the oily orgy will actually be staged — is positioned directly in front of the coffee table. The entire set-up has all the trappings of the ideal bachelor party. Seven. What a *great* fucking job!

Around 9 pm it's ready, steady, go!

The girls dive in.

The whole thing's quite blinding, really. Arms, legs, pussies, buttholes mesh together in a hot pot of mad lust. Suzie's truly famished for cunt. Debi, too. Sorceress Diamond thoroughly sucks the juice out of Kaitlyn's jumbo-sized pussy lips, pulling at the flaps as she would the skin on a barbecued chicken. Yum!

Debi and Suzie are now fucking with the same dildo while a golden vibrator melts into Debi's sphincter like heated margarine. Yeeoww! And who should suddenly appear on the scene but Buttman himself! — John Stagliano. He seems somewhat bleary-eyed, as if having just awakened. He knuckles the sleep from his eyes. For kicks, Stagliano takes over the camera and films a good portion of the fish factory fracas. Seven takes a crack at the camera, too. This is great! An orgy of sluts, an orgy of directors.

Soon Krysti gets her chance to fuck Debi with a strap-on black cock. She mercilessly plows into Debi's shaved whisker biscuit. Debi's wonderfully tanned ass cheeks ripple with joyous abandon. God I love that woman!

Somehow during this maelstrom of munching and mounting of Venus mounds, an electronic ice dildo is produced. It finds its way into Kaitlyn's oily fudge pocket. The thing has a positive and negative charge. Then a vibrator appears, buzzing away at her clit, while the ice dildo happily hums in her unpuckered pooper. Kaitlyn's eyes roll into the back of her skull. No pain here. Wonder what the neighbours would think?... Nyahhh... *fuck* the neighbours!

As Seven wraps up the entire fish-wrap, a line of girlie dialogue uttered earlier in the film keeps buzzing through my head. "See?" one of the luscious sluts states, punctuating one of many heavy-metal fuck scenes tirelessly orchestrated by Seven. "We didn't need Bruce to break in his house."

Ahem. I beg to differ. ∎

Kaitlyn Ashley

Cranberry and Vodka

Kaitlyn Ashley; *Sodomania 6: Gangs And Bangs And Other Thangs.*
Courtesy: Elegant Angel Video

Spring 1994 was a good time for Kaitlyn Ashley. After premiering in the slit-and-dipstick trade just 12 months previously, Kaitlyn now found herself quite gracefully oscillating between two extremes of fuck film experience: not only was she still a juicy, steaming slab of fresh meat, but — after appearing in over 100 froth films that year alone — the sweet little Fort Lauderdale coquette had proven herself none other than a veteran rookie of smut. Indeed, Kaitlyn regularly brought a seasoned appetite for flesh to her pump sequences. One of her more classic interlewds is in Patrick Collins' *Sodomania 6*. Herein, under the invasion of four studs, Kaitlyn uses every bodily aperture to devour cock after cock after cock in a choad-blazing gang-bang/DP sequence that leaves her multi-sperm-drenched face looking like a dripping scoop of French vanilla ice cream. And in Bruce Seven's *Buttslammers 6* — on the set of which buddy Arno Keks and I met and interviewed Kaitlyn — she shows a tolerance for twat which most starlets approach with an aqualung. In the film, Kaitlyn literally *wrestles* her way to a sweaty puddle in an all-girl orgy that includes the bone-throbbing likes of Debi Diamond, Krysti Lynn, and Suzie Mathews. Gasp! Yet several years after our interview, Kaitlyn, marvellously illustrating the shimmering quintessence of beauty, still possessed those dick-swelling, nubile qualities which initially got her recruited into the sperm bank industry: that infectiously innocent smile, a tight round ass, and lusciously pouting pussy lips. Yes!

At Bruce Seven's home, Arno and I chatted with Kaitlyn in the luxury of a private bedroom (the sheets still warm from a gash-to-gash sequence shot earlier). In this intimate setting, some of the most delightful subtleties of her personality surfaced.

Kaitlyn, both you and your husband Jay are in the sex industry. Why?
It was a combination of things, really. The business side of it, and our desire to experiment outside our relationship.

Did the temptation to do it with other guys build up inside you before you got into the business?
Yeah. (Laughs) It built up a *lot*. My husband was in the marine corps and was overseas quite a bit, so there was a lot of temptation. But, no, I never strayed. I had my trusty vibrator with me. (Laughs)

That's where technology works.
Yeah, it does. It does!

How did you and your husband meet?
We were high school sweethearts, went to the senior prom together, stuff like that. But we never really hung out with any clique. We had our friends. I mean, we'd hang out with some of the guys from the football team, and we used to have parties almost every weekend at our house because I started living with him when I was 17. But basically we just hung out with ourselves.

Can you describe some of these parties for us?
A lot of beer. (laughs) No drugs, though. Just a few kegs.

What was your first X feature?
That would be *Beach Bum Amateurs*.

How many videos have you been in so far?
Um... it's been about a year since I've been in the business... I'd have to estimate around a hundred.

That's a year of hard work.
Yeah, especially the last couple of months.

Do you consider it work or fun?
It really all depends. If I can get in there, do my work, get out, then it's fun. On days like this it's still fun because, I mean, I've only known Bruce for a short time, but I can *talk* to him. If I don't want to do a scene, he'll say, "Okay, no problem," which makes it a lot of fun. I get to take a nap here, take a shower… it's like my second home. I like that. Bruce doesn't mind if I make myself at home here.

If someone who'd never seen one of your films wanted to rent a Kaitlyn Ashley video, which one would you recommend?
Probably *Sodomania 6*. Everybody's been raving about that one. I'm gang-banged in it, and do a DP with Jon Dough and Peter North.

Was that your first DP?
Actually, yeah.

What were your impressions?
Very exciting. It was intense.

Kind of short though, wasn't it?
Yeah. It was like, '*Take me there again*, rewind, loop it.' (Laughs) If I was in charge of editing it, I would have looped it.

Patrick Collins once stated that he basically steers away from DP's because they're not spontaneous.
But it was. This one *was* spontaneous.

You weren't expecting it?
Well, I was expecting it. We took a break for a couple of minutes, and Patrick came out and asked me, "Would you do an anal with Peter North?" I was a little sceptical at first because of Peter North's *size*, but I said, "Yeah, sure, I'll try anything once." So we got in there, and I was doing Jon on a cowgirl, and Peter just came up behind me, and we started doing a DP. It's pretty much the same here on Bruce's set — everything is spontaneous. Granted, we've got Bruce saying, "Say this, say that. Do this, do that." But we can basically do anything we want.

Are most directors like that, or are Collins and Seven exceptions to the rule?
I'd like to think they're exceptions to the rule. A lot of directors will say, "Okay, we need two positions, and then the pop shot." (Laughs) I know. Funny, isn't it? The *pop shot*.

When did you start doing girls?

Start doing girls?… um… It was about a couple weeks after my first scene.

You've never had sex with a girl prior to porn?
No. I always wanted to, but I was always scared. My husband and I… he… um…

He wanted a three-way with another girl?
No, actually he just wanted to see me with another girl because prior to this business, you know, we stuck with ourselves. And he got me very uninhibited. He really did. *Oh yes.*

He opened you up sexually?
Yes!

Was he your first sexual partner?
No. (Laughs) He wasn't my first, but he was the first one who introduced me to anal sex, oral sex, masturbation, using vibrators, everything else like that. He taught me.

And *his* performance?
(Whispers) Oh God, he's the best I've ever had.

He was in the *Sodo 6* gang bang, too, right?
Yeah, he was in the gang bang. But at first he was *so* mesmerised by seeing me with three different guys, that he just stood back and played with himself.

Would you call that 'reality porn'? In other words, was the gang-bang a fantasy which Patrick Collins pulled out of you?
Yes! He pulled that out of me in his office. When I first walked in there he said, "Pick as many guys as you want, and you got 'em." So it was Jon Dough, Peter North, and T.T. Boy. I've always wanted to work with them. And then Patrick threw my husband in the scene just to, you know, give it a fourth guy. If you remember, the whole foundation of the scene was me talking to my husband, saying to him, "I'd like to have a bunch of guys." So, basically it was reality.

Any male co-stars in porn you prefer working with?
Three or four favourite guys. Alex Sanders is one.

He's the one who slaps his dick.
Yeah. He taught my husband how to do it. My husband does it at home now.

Are you requesting that from your husband now?
Well, actually no. He just does that to pleasure me more because I tell him not to stop, and he just *has* to,

you know...

Does *he* like it?
I guess he does. He doesn't complain about it, so I guess there's nothing wrong with it.

Who else besides Alex Sanders do you like working with?
Alex Sanders, Peter North — T.T. Boy, he's fun to work with. He's an absolute doll.

What about Ron Jeremy?
(Laughs) Okay, okay. I got it, I got it. Paul Norman directing VCA's *Superstars Sex Challenge*. That was a take-off on American Gladiators. Tammi Ann and I were competing against each other to win the grand prize. So we're going through the little obstacle course, and I had to push Tammi, which meant I got thrown into the penalty box for three minutes with Ron Jeremy.

It's a penalty to be with Ron Jeremy?
But it was so cute. I wasn't allowed to do anything to him, but he could do anything he wanted to me. And I was like pushing him away and everything. (Laughs) I was like, "Oh my God, I can't believe I'm doing this to him." But he's a really nice guy. I like him. Besides, anyone who can suck his own dick is a real pro. Well, at least that's what I've heard — that he can suck his own dick.

Like they say, 'Practice makes perfect.' But getting back to girls, who's your favourite co-performer?
Debi Diamond. *Debi Diamond!* I haven't worked with her today yet, but I've worked with her before. I love Debi to death. I mean, she's the sweetest girl. After my first scene today, I took a shower and she soaked me down. She *washed* me. She's such a sweetheart.

It does seem as if there's more love in girl-girl movies than in girl-boy films.
There is... Debi Diamond, Bionca, Melanie Moore...

Bionca once whispered "I love you" to a girl in one of her features. The passion she exhibited, you couldn't find a more genuine display of love in, say, *Wuthering Heights*.
I know. When it comes to girl-girl, I think it's more natural than boy-girl, because the guys in this business... they're pretty much trained to get it up, keep it up, get it off.

It's much more technical for guys. Woman don't have to worry about that. They can just let the love soak through.
Right. That's the way it is. (Sighs) Oh, I love girls now.

I keep threatening to divorce my husband for a girl. (Laughs)

Speaking of marrying a woman, have you ever worked with Francesca Le?
Yeah, I did a layout with her. She's a sweetheart. Very nice. That was for *High Society*, the April '94 issue. But that was pre-boob job.

Are you happy with your new tits?
Oh, I love 'em. I went to Dr. Sherman down in Vista. He did Paula Price and Rebecca Bardoux.

Did you feel pressured by the business to go through with it?
No. I wanted to get it done, because if you see me in *Sodomania 6*, and even in the layout, I lost a lot of weight all at once. And my tits just *dropped*. So it's not that I felt pressured. I wanted to do it because I felt bad about myself. I was losing work over it, so I got it done. I was in pain for a little while, but I took a month off, and after that I just felt so much better about myself. (Aside) My parents didn't notice.

You say you lost a lot of weight? But you look really tight.
I work out every day.

Were you chunkier before?
(Whispers) Yes.

What do you do for a workout?
What *don't* I do? I use free weights, dumbbells, barbells... I also work with Nautilus, and do high-intensity step aerobics. In fact, they have this newly-engineered food out there called Metrics, and it has fat burners, proteins, minerals, vitamins, everything you need that's in a regular meal. So you take that twice a day — once in the morning, once in the evening — and you're set. It gives you all the energy you need without any fat.

Does that mean you don't drink alcohol?
I had one drink today — cranberry and vodka.

To help you unwind while you're working?
Not really. Um... the only reason I wanted that drink was because I was really tired, and I just wanted something to give me that boost for the first scene. Then I realised I shouldn't have drank anything for that first scene, because it didn't go the way I wanted it to. But, still, it's not what I usually do. It's just that... I don't know... lately I've been feeling a bit sluggish. Drugs, as well. I don't do drugs. I used to smoke pot, but only when I had PMS. And even then I'd smoke it very rarely. It just calmed me down because my parents used to smoke it just to relax. But, you know, they were never

Kaitlyn Ashley; *Buttslammers 6: Over The Edge!* Courtesy: Bruce Seven Productions

addicted to it. They never did it to get high. They did it to relax. That was what they taught me: after work, you wind down. Pot pretty much had the same effect on me as alcohol, except that I got hungry. The common munchies. (Laughs)

What about some of your hobbies?
Oh, there's a lot of things I enjoy doing. Horseback riding, rollerblading, scuba diving — I'm not qualified yet, but I'm going to be — cleaning my house (laughs) which is always dirty. I love to read, too. John Saul, I love his books. Dean Koontz. Anne Rice, especially her new series. I like horror, getting the shit scared out of me. (Laughs) And I like taking my dog out to the dog park, just letting him run wild. I run with him a lot of times, too.

Is that your Rottweiler out in Bruce's backyard?
Yeah. His name's Dahmer. He's eight months old.

Dahmer?
As in Jeffrey. There's a story behind that.

He eats people?
No! (Laughs) Well, actually, he does sometimes. The first day we brought him home, little fluffball, my husband was playing with him, and he took a chunk out of his finger. It's very effective when strangers come up to you and start harassing you. All I have to say is "Dahmer," and it's very effective. He's very protective of me. I mean, if I take him out for a walk and somebody approaches me, he's down by my side just looking at the person. And if they motion toward me, he'll start growling.

Do you get a lot of that?

Not lately, thank God. I did when I first came back from vacation, though. But it's calmed down. I've been keeping a low profile. I go to the gym, go to a movie once in a while, but I don't go out to bars or anything.

What kind of movies do you like?
Horror movies. And comedies, especially.

Seen any good comedies lately?
I just saw *Fatal Instinct*, the take-off on *Basic Instinct*, *Fatal Attraction*, and other films of that type.

Did you like *Basic Instinct*?
Oh yeah. Oh, I masturbated to that. I did. I masturbated!

Would you do a scene with Sharon Stone?
Oh, *God* yes! I would kill to do a scene with her!

How about Michael Douglas?
Oh yes. I love Michael Douglas.

How about Howard Stern?
No comment.

No, really, what do you think of Howard Stern?
(Out of control laughter) Oh shit, I've got to be careful.

He's a public figure. You can say just about anything you want about him.
I know, I know, but I don't want him to say anything about me because I know how he can be. Okay, let's just say I like him on the radio.

You just don't like looking at him.
Well, he's not that bad. But I saw his New Year's Eve special and I feel he went a little bit overboard.

Which segment in particular offended you?
The girl who came out with a jar of maggots and poured them into her mouth and all over her body. I almost puked. I did. And poor John Wayne Bobbitt... (laughs)... that poor guy, he was one of the judges. Howard Stern offered him $15,000 to show his dick, and he wouldn't do it, which I can understand. But there was $15,000 in his face — in cash! But they raised a lot of money for him on the show. Also, some of the skits that Howard did... a couple of them were funny, but the one with Michael Jackson and the boy... that didn't go over too well with me because I like Michael Jackson. (Giggles) I mean, he's an artist.

How about Janet Jackson? Do you like her?
Oh yeah. I'd do her, too! I *would*. Oh come on, she's got a killer body. ∎

Tabitha

Black Market Blues

Like Asians, black actresses are way too scarce in porn. For whatever reason, the 'selection' process is painfully slow. Newcomers replace the quitters… sometimes. Sometimes not. In turn, the long wait for black tail continues. Yet, in all honesty, the Nineties have seen a goodly number of negritas invade the cream screen. This much-appreciated lot includes Anna Moore, Sabrina, Climax, Kira, Kitty, Dominique Simone, Yasmine Pendavis, Onyx, Ice, Lana Sands, Shonna Lynn, Mahogany, Janet Jacme, Fonda French, Nyrobi Knights, and Tabitha. Ah, yes. Tabitha. In early 1996 I distinctly wanted to interview this 19-year-old gem because I considered her *the* best-looking black in porn. But she's not. Black, that is. Which, of course, simply meant she's still one of the best-looking *women* in porn.

Aside from her phenomenal looks, Tabitha truly presents a provocative case of marketing gone awry. And she's the first to admit it. Though she looks more mulatto than your average… mulatto, she is, in fact, a combination of American-Indian, Spanish, and (believe it or not) Scottish ancestry. Consequently, many producers have fully embraced this eye-pleasing ambiguity, tirelessly casting her in one black film after another. As a result, Tabitha feels typecast (yes, Virginia, even in porn, shit happens). Fully understandable, therefore, how she readily cringes when loosely referred to as "that black girl." Equally unfortunate is her in-house title of "Jake Steed's girlfriend."

Ah, yes, the ever-dreaded boyfriend-girlfriend syndrome. I can't tell you how downright *dull* I find this overall pattern — or should I say plague? And porn has surely seen its share of this epidemic, which basically boils down to a hot-looking bitch only fucking her real-life boyfriend on film. Just a few of these chauvinistic cocks 'n' cunts have included: Kascha & Francois Papillon, Blondi Bee & Tony Montana, Heather Lere & Rob Tyler, Janette Littledove & Buck Adams, Danielle Rogers & Randy Spears, Misty Rain & Chad Thomas, Raquel Darrian & Derrick Lane… and now (a flourish, please) TABITHA & JAKE STEED. Ta-*dum!!* C'mon. Do we *really* want to see the same couples fucking time and again? I certainly don't. Nonetheless, there's a group of hard-cash slingin' dudes out there more than willing to support a pair of shackled genitals. And it's their prerogative to do so. As it's mine to boycott such te-

dium. Of course, I'm frequently breaking my own rules, i.e., I'll regularly rent films featuring "loving couples" simply because there are also uno, dos, sometimes even tres females I wanna check out in the same feature. And when that Siamese porn 'pair' *does* rear its ugly two-headed mug on screen, hey, there's always the fast-forward button, right? Curiously enough, you'll find the Tabitha-Jake relationship is also a prime example of porn double standards (don't worry, you'll know what I'm referring to when you get to that point in the interview).

In all honesty, however, Tabitha's really in top form without Steed, who would justifiably be referred to as "Tabitha's boyfriend." Two shining examples are John Leslie's *Voyeur 5* and *Fresh Meat: The Series*. Her three-way DP in *Voyeur 5* — filmed outdoors, beside a pool, with almost no dialogue (except Tabitha breathlessly, subserviently asking T.T. Boy as she delicately sucks his manroot, "Is this okay?"; and later: "My asshole wants to come," just before getting a colonful of pork) is heartily sexual. Leslie's clever clipping of (almost) all speech helps amplify the primitive nature of the sex. And the climax is priceless, too, with Tabitha's mouth literally oozing over with the mixed cum of three men. *Fresh Meat: The Series* offers another much-welcomed DP. Darkly atmospheric, this vignette is undoubtedly one of Leslie's eeriest outings; the delicate combination of surrealism, violence (Leslie's obviously a Scorcese aficionado), and perversity making it a hideous treat.

So where did I meet Tabitha? Where did we conduct the interview?

We first met at the 1996 Consumer Electronics Show in Vegas. Somewhat demure, Tabitha was still highly approachable. So we had a brief chat (under the shaded, yet watchful, eyeballs of her 'boyfriend'), I gave her my card, and… never heard from her. While in Hollywood a month later, however, we crossed paths at Bill Margold's FOXE Awards. Tabitha appeared relaxed, meek, and — wearing a white cotton mini-skirt, magnificently highlighting her outstanding bubble butt — delectable as ever. No boyfriend visible, either. Hoorah! So I took a few photos of her with various fans, and, well, I suppose she remembered me, as she phoned a week later.

Intensely private, Tabitha called one evening from a cellular car phone while driving the streets of LA. The result is the following conversation. Hey, I agree with you: interviews conducted in-person are typically far more intimate, simply by the nature of eye-to-eye contact. But remember, Tabitha laid down the rules here. So it was either this… or nuthin', folks.

I know that you're not black… that you're actually American Indian, Spanish, and Scottish. But how exactly is that ethnicity broken up in your family?

I have Cherokee blood on both sides. My dad's the one

Tabitha in *My Baby Got Back! 8.*
Courtesy: Video Team

I'm taking a break from films, though… just doing magazine stuff for the next six months to promote my dancing. I'm gonna try to hit the road real hard.

What sort of sex do you prefer in the movies? For instance, I've seen you do a number of DP's.
Well, I don't like the DP's. You get good money for 'em, but they're not too fun.

In your DP's for John Leslie, you did them sitting down as opposed to bending over. Is that your preference?
Yes, it's easier on me. It's probably a little harder for one of the guys — like the guy on top — but it's much easier for me that way. I really haven't seen *Fresh Meat (The Series)*, but I thought my scene in *Voyeur 5* was kinda neat. John Leslie pays good money and he's nice. With sex scenes he's pretty open; I mean, he doesn't tell you exactly what to do. But with the dialogue and all the acting, he's very picky… pretty much tells you exactly how he wants it. I like that. I mean, at least he's trying to make good movies.

What's your favourite Tabitha scene thus far?
I think… umm… I don't know… I like my scene in *My Baby Got Back! 7* with Jake.

with Spanish in him, and his father was full Scotch. People don't believe me when I tell them I'm part Scottish because of my dark skin. But my grandfather actually had royal emblems from Scotland to prove it. I *have* starred in a lot of black films, but there's white in me. Kind of a big thing in the beginning — they wanted to use me as a black crossover but didn't think they could do it. Then it ended up where they… could do it. (Laughs) So it kind of put me in the position of doing mostly black movies.

And your feelings about that?
It doesn't really matter to me. I have no preference. It makes it hard dancing on the road, though, because certain club owners think I'm black and, since they have prejudices, I can't dance at their clubs. That's the only downfall. But I star in all kinds of films: black, white, Hispanic… kinda like Lana Sands. Right now

I realise the answer to this question might seem fairly obvious but… where did you and Jake meet?
Well, Jake was the first guy I worked with in the business. It was called *Hollywood On Ice*… the first thing I ever did. Tom Sawyer shot it. It was like a loop thing for Video Team.

Did Jake give you any help getting into the business?
No. I did it on my own. When I turned 18, I started dancing at Covergirl Studios in San Diego, I met Kelly O'Dell. She told me about porn because she was going to do her own porn film, and I wanted to be in it. But at that time, the boyfriend I was with didn't let me do it. But two months later I wound up breaking up with him, hooked up with Jim South, and just got into the business that way.

So how long have you been seeing Jake?

About seven or eight months.

Is he the only male you work with these days?
Yes. But I still do girl-girl scenes and magazines layouts. I've always liked girls. The first time I was with a girl was in junior high. There were younger girls before that… experimental stuff… you know, like with your best friend. When I was like eight years old, I had this little best friend and we used to play with each other in bed. But I didn't know I was bisexual until my junior year in high school, when I was able to really admit it. I physically touched girls at that time but never licked pussy or anything like that — not until I moved to San Diego.

Are you from California?
Um-hm. Native. I lived up in the high desert. In Apple Valley… near Vegas. Just a small desert town where you grew up with everyone from kindergarten all the way through high school. It's gotten bigger now.

And you said your first girl-girl experience was in San Diego. Was this at a club, in a film, in real life?…
In real life.

Can you set up the scene for us?
It was at a hotel with this black girl named Tomika — a threesome with her and my ex-boyfriend.

Did you like the taste of pussy?
Umm… I didn't like *her* (laughs)… I basically did her

for my boyfriend. I mean, I like girls… I just didn't like her that much.

What about a girl you really liked?
I like Nici Sterling. She was my second or third girl. Debi Diamond was my first… in *Debi Diamond's Dirty Dice*. I like her a lot. But my favourite actress for girl-girl is Alicia Rio.

Oooh, yeah.
I did her in *Borderline*. Stephen St. Croix was in the scene, too.

Forget about Steven St. Croix. Let's stick with Alicia. What did you like about her?
I like girls who are brunettes… ones with exotic looks.

Besides, Alicia's got that great ass, right?
Yes. I like nice asses.

And *your* best feature? — what would you say that is?
Actually, I'd say my breasts. Everyone likes my butt, but I like my breasts because they're so… I mean, they're large, but they're natural. They stand very erect. And my size changes all the time. It goes like from like a full C to a full D. I thinks it's the Norplant® — the birth

Voyeur 5; Tabitha prefers doing DP's sitting down rather than bending over.
Courtesy: John Leslie Productions/Evil Angel Video

control in my arm — that makes them fluctuate all the time like that.

So you and Jake obviously have an exclusive sexual relationship on screen.
No, he still works with other girls.

How do you feel about that?
It's all right for me because I know it's a job. I mean, he was in the business before meeting me. Sometimes you get jealous, but I was with other guys at one time, so I can understand it. It's just a job. But I make sure he doesn't go with girls who are real trouble. (Laughs)

Did you ever think about doing this type of work while you were in high school?
No. I never even *watched* pornos. To tell you the truth, they disgusted me. In high school I was probably what you might call promiscuous, but I didn't like watching pornos. I thought they were stupid. I was shy. My first sexual experience was terrible… just with the wrong guy, in the wrong place, at the wrong time. The first memorable experience was when I turned eighteen. It was with a boyfriend. That was much more romantic.

How do you feel about a title like *More Than A Whore*?
I don't like it. But there are a lot of movies that have *really* bad titles — like the one I'm on the boxcover of called *Poop Dreams*. I think that's the stupidest thing.

Poop Dreams?
Poop. They tried to copy *Hoop Dreams* but, I mean, why use 'poop'? That sounds disgusting.

By the way, where did you come up with the name 'Tabitha'?
A friend of mine gave it to me because of my nose.

Kind of slightly upturned?
Yeah. Like that girl on the old television show — her nose was the same way. You know, the baby…

Oh, you mean Tabitha on *Bewitched*.
Yeah. So my friend called me Tabitha. When I started

stripping I used that name, then after I got into porno I just decided to keep it.

I think it's a great nose, but it almost sounds as if you don't like it.
I never liked it in high school because people teased me. I guess in the business it's okay. A lot of people think I've gotten a nose job.

Hey, what did you think of the FOXE Awards?
I wasn't too comfortable there. I liked the CES in Vegas better because the fans there actually knew who you were. But at FOXE there were a lot of guys who didn't know who you were, who just wanted a picture with you because you were a girl in a dress. I stayed by the sofas most of the night with other friends. We just sat around on the couch. That way, if fans wanted a picture of me, they could just it of me sitting. (Laughs)

Do you get much recognition these days when you go out to buy milk?
Umm… not too much. The only time I ever get recognised is if I go into a video store.

What kind of videos do you rent?
I like psychological ones… like *Poison Ivy*.

Erotic thrillers?
Yeah! Drew Barrymore was in that one. Actually, I like watching the girls in them. The films usually have a neat psychological twist to them, too.

What are the positive and negative aspects of porn for Tabitha?
The only positive thing is the money. The negative thing is, if the girls aren't promoted right, they get used up. There's so many new girls coming in and out, that a lot of them get burnt out. And if they don't have their heads on right, they get kind of… fucked up in the head, you know?

Do you ever worry it might happen to you?
Not really. I pretty much stay away from that scene. I just hang out with my boyfriend at home, and we do normal stuff. When it comes to the business, we just do our scenes, take our money, and run.

Would you say your unique looks have been a plus to your career?
I think it's good to have a unique look. But I probably would've marketed myself better if I knew more, then it would be easier for me to do both sides, you know? — black and white movies. Then they could see I've got a unique look that's whatever I want it to be — in dancing, movies, all the other stuff. But a lot of people just say, "Oh, that black girl Tabitha." ∎

Market St Cinema
1077 Market St

TABITHA

WICKED XXX STAR

GETS IN THE HOT SEAT
AT 12:30 - 5:30 - 8:30 & 11:30pm

PLUS OUR FAMOUS S.F. LIVE & SIN CITY

Krysti Lynn

Evil Ways

K rysti Lynn died on December 5, 1995. According to combined reports from *Hustler Erotic Video Guide* and several of the starlet's close friends, Lynn — accompanied by a girlfriend — was driving a white Acura (belonging to John Stagliano) at high speeds along the Las Virgenes Canyon, one of many mountainous roads connecting Malibu with the San Fernando Valley. Driving at around 105 mph, Lynn lost control of the vehicle, swerved off the road, and slid across approximately 20 yards of flat ground before plunging down a 30-foot ravine. Neither woman's bodies were discovered on this more desolate section of road until two days later.

At the CES in Las Vegas a month later, John Stagliano — who'd been living with Krysti for two years — said his life was in a "state of turmoil". Just before Krysti's death, Stagliano was hard at work on the long-awaited *Lunatic Prima Donna*, a project custom-made for Lynn, who had become the Valley's new 'Buttwoman'. At a budget of $150,000, *Lunatic* would have been Evil Angel's most costly project, containing several songs written by Lynn (with music by Steve "Silk" Hurley). Stagliano was in the middle of shooting music videos for the feature before Krysti's tragic death.

Krysti's final porn scene ever was in Stagliano's *Butt Freak 2* (released May 22, 1996). In her swan song sex sequence, Lynn luxuriously plunges in and out of Stagliano's swimming pool, talks glowingly to the camera, and occasionally sips a glass of white wine. Her famed butt is cleverly highlighted by a white, veil-like, see-through dress which, after she emerges from the pool, clings to her cheeks like fuzz on a peach. Lynn eventually has sex in the pool with Nicole Lace and an unknown tattooed stud. But watching Lynn lounge about the pool in that homespun wet suit is the most unforgettable — and bittersweet — segment of the entire scene. Her last line ever on film is, "Krysti Lynn's evil ways," which she coos while smiling coyly at Stagliano's camera.

In retrospect, Krysti struck me as a perfectionist, a young lady who worked assiduously at each and every item on her agenda. Including porn. Her sloppy gang bang — combined with a screeching ass fuck — in John Leslie's *The Voyeur* is one of her finest moments of mad lust. And when I saw her get fucked by Bionca and Debi Diamond at Bruce Seven's home during the filming of *Buttslammers 6*, well, my balls were bowled over. Lynn took on the larger-than-life icons of Bionca and Debi Diamond and did *not* look back. During a break in the filming, while fellow porn scribe Percy B.S. and I were interviewing Kaitlyn Ashley in a bedroom, Krysti — butt-naked — strutted into the room pretending to look for something… twice! That marvellously jiggling, angel-food cake ass of hers seemed to *scream* for an interview. Krysti's silent overtures were nothing short of precious. Yet as Seven was eager to shoot the film's final orgy — which included both Kaitlyn and Krysti — any interview with the darling Ms. Lynn was inevitably put on hold.

Two months later, however, I made a point of dropping by the New Century to catch Krysti's first dance appearance in San Francisco. After Krysti's upbeat performance, I stopped by her dressing room and gave her some pictures I took on the set of *Buttslammers 6*. She was definitely ready to tell her story at that point.

The following interview took place at the New Century Theatre on July 9, 1994, a year and a half before Krysti Lynn's death.

How long have you been in adult films?
I was in the industry for the first six months of '93, took the next six months off, then returned at the beginning of '94. So added together, it's been about a year and several months.

That gang bang in Leslie's *Voyeur* is definitely one of your horniest scenes. Very intense.
It is. And I've heard the same thing from John [Stagliano], Patrick [Collins], and others in the business. I mean, John said to me the other day, "I have 200 videos here and I couldn't get the energy you gave in that scene." It was my first gang bang, actually. And I said I was never going to do that sort of thing when I first got into the business. Then I decided I wanted to do it for *The Voyeur*. But the story behind that was… Leslie, you see, *is* the voyeur… he's shooting through the camera. And in the film when we walk into this bar — a real bar — it looks like we're going to play a game of pool because we had something like 40 extras sitting around. See, in a typical porn situation you film

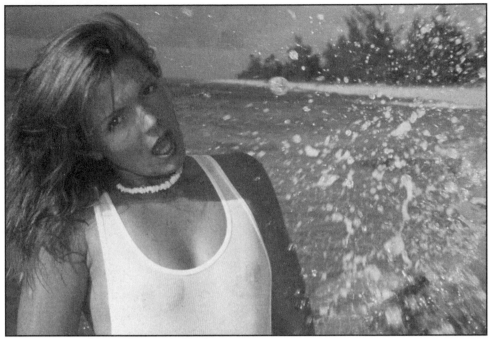

Krysti Lynn; *Buttman's Wet Dream*.
Courtesy: Evil Angel Video

the basic shots with the extras in the background and then, when you go into something heavy, you cut, excuse the extras, and go into hardcore. But that's not how this scene worked — which is why it's so good. So anyhow, we were getting into this petting, right? — and the dicks start coming out, and I look at Leslie like, 'Okay, you're gonna excuse everybody from the room,' and Leslie smiles and slowly shakes his head. That's why it's so incredible. I basically snapped out… it was a live sex show. There were 40 people sitting there watching me do the scene.

And that prompted you to go over the edge?
Oh yeah. I'm an exhibitionist. I got very turned on in those situations. And Leslie knew that. He didn't tell me, but I didn't care because I trust John explicitly. He's a friend of mine. I don't work with some directors in the business because I know they'd use a situation like that to pull the wool over my eyes. But I knew John was just trying to get the best from me.

At this point in the interview, the dressing room door slowly opens and a tall, wiry, black guy in his mid-twenties, who looks as if he hasn't slept in over a week, pokes his head inside.

Lynn: Can I help you?

Stranger: (scratching his stubbled chin) Yeah. I was

gonna ask… you know how I could get in da poe-no bee-ness?

Lynn: (politely) I'm in the middle of an interview right now for a magazine. We're taping live. Lemme talk to you when I come downstairs, okay?

Stranger: Aw-right.

Lynn: Thanks.

As if sleepwalking, the guy slowly backs out of the room, closing the door after him.

Lynn: (breaking up with laughter) Can we leave that in the interview?

Sure, why not.
Shit, that's brilliant. (Laughing)

So where do you live these days?
In San Diego. And then a lot of the time I live in Malibu.

Can you tell us a little bit about growing up in San Diego ?
Well, I was a straight-A student, a violinist, the very, very good little girl… a prima donna. Then I started my own little venture by opening up an outcall bachelor service dance company. After that I just kind of fell into porno, very accidentally, around the end of '92.

What about your first sexual experience?

My first sexual experience was with my neighbour, the boy next door. I was 12-and-a-half, and he was my little friend. I was leaving to go to the beach with my mother, and I went next door to give him a goodbye kiss. We had been dating for *quite* a long time. Mind you, I moved out of my parent's house when I was 14, so I've had a very long life. I'm 23 now. You can add it up. (Laughs) But my first sexual experience was very painful and *very* bloody. I remember being sweaty, hot, and in pain. I remember getting up afterwards, going to the bathroom, and kind of being in shock, and turning around and looking at the bed... and there was just this *pool* of blood. I also remember coming out of the bathroom and going to find my boyfriend. It had been his first time, too. When I found him, he had his back to this kitchen counter and was just kind of standing there... frozen. You know, it's like these two kids have done this... *thing*. And she's bleeding and... what do we do? Now our parents are going to know because the mattress is stained. (Laughs) And I remember thinking, 'Why do people do this?' And then, of course, it obviously got better over the years. (Laughs)

What about the blood stains? How did you two explain those?
My boyfriend took the sheets and put them in the washing machine, and I went and got bleach from my mom's house, and we washed them. But it was on the bed, so it was kind of like... there! Afterwards, his dad Roger came home and kind of said, "Oh... so you did her." And we're just like, "Yeah. We're not virgins anymore." But it really did *hurt*. Even to this day I have a very, very *tight* pussy. Like I took this dildo out there in the show, and this guy's going, "God, you can barely get that thing in there. Your pussy must be tight. " And I'm going, "Well, it *is*!" (Laughs) And when I'm doing films, people say to me, "How does your pussy stay so tight? You do these films... how does it stay tight?" And I just tell them the truth: "I don't know." So when I was a little girl, I mean, it must have been *really* tight.

I notice that you're a blonde in some of your features.
Um-hm. I'm a natural redhead, though. But at the beginning of '93, when I did all my Andrew Blake stuff for Vivid, I was a blonde.

So what was your attraction to X?
I'm an exhibitionist.

You must also like doing the private booth circuit then?
Yeah. Well, it's going to be my first time working booths (at the Regal in San Francisco). But, as I've been telling everyone, that's kind of like a whore or a dancer's mentality. It's a character. We all play characters. I'm an actress, and people say to me sometimes, "Are these scenes real?" Well, the truth of it is, some of them are, and some of them are just my job. My job is being an

X-rated actress.

When I watched you on the set of *Buttslammers 6*, that didn't look like acting. It looked real. Still, it must have been pretty scary working simultaneously with two gargantuan porn stars like Bionca and Debi Diamond.
The scene with Bionca and Debi *was* scary. I just had to really turn up. By nature I'm a very sexual person. And sometimes that energy intimidates other people. But with Bionca and Debi I knew I had to turn my intensity up all the way. And as it turned out, we got an incredible scene out of it. We met each other on the same plateau and blended perfectly with one another. We were all right there.

How did you like working with Bruce Seven?
(Smiles, reaches over to couch, picks up *Ecstasy of Payne* video box and reads from the back) He wrote this about me in his movie: "Also in this masterpiece of debauchery we have the *bitch*-goddess Krysti Lynn learn that she should keep her mouth shut. You've got to see this one." John Stagliano and I have been dating for quite a while now — about three months — and Bruce does business with John. So Bruce and I have a very... 'interesting' relationship. We're kind of tit for tat. Had there not been a connection between John and me, Bruce and I probably would not have worked together. But we've come to a common ground and we're friends now. I just finished filming a *Takin' It To the Limit* with Bionca and him. I did one scene with Sarah-Jane Hamilton, and then a little dance for Bionca and Bruce. I wish Bionca the best of luck with her directing. She's a nice woman... holds the set together... very good energy.

Is it difficult to befriend your co-stars in X?
The business is very strange between the women because you're there to work. Like you saw with Bionca, Debi and me... we got along to a certain extent, but that doesn't mean we go out afterwards or that we're friends. It doesn't mean anything like that. It means that there are certain people on your same wavelength. But we're all different people. And in that sense we're all on *different* wavelengths. I dig Alicia Rio a lot. I talk with her probably more often than with any woman in the business. She's a really nice girl.

Have you done any DP's?
Just for still photographs so far. Patrick Collins said to me the other day, "Are you interested in doing a DP?" And I said, "It's kind of like when you asked me if I wanted to shave my head (laughs)... it's all about money when it comes to something like that." Because sexually, it's not something that really interests me.

And I said, "For $2500, no. For 50 grand, I'll shave my head." (Laughs) I recently did *Sodomania 9* for Patrick. And despite our differences, I think we're very much alike. We're both aggressive types. I think he believes woman should be more submissive, more 'sit back and take your seat'. And I'm like (laughs) "No, no, no... here we go..." (Laughs) But I like him. I love Tianna, too. But getting back to your question about DP's, I mean, if there's a big enough demand in the public to see something, I'll give my fans what they want. But truthfully, I don't have any sexual cravings for DP's.

Anal doesn't seem to pose a problem for you — you've done a number of them recently.
This year I've done about six of 'em. But, you see, in the beginning with all the stuff I did with Vivid and Andrew Blake and all of last year's festivities, I never did any anal. I was the 'no-anal' girl. As a matter of fact, I did the very first anal movie in Ed Powers' *New Ends* line. He paid me an un*godly* amount to do that exclusively for him. No contract, just a verbal thing since Ed and I are friends. Around that time I didn't do any anal with anybody else because no one could meet his price. And my rate has pretty much stayed the same since I first got into the business. I've done like maybe 43 things. You can compare me to some people who have like over one hundred videos at this point. And I don't necessarily figure that's the right way to do business. I think you should pace yourself.

For instance, the drugs... that's one thing I always like to talk about. It's really unfortunate. A lot of the times the drugs really get to people. And I see people's lives destroyed. Women make irrational decisions; they start getting on blow, speed, decide to get boob jobs. This is our world right now, but in 20 years it might not be. People get so wrapped up in drugs that they make decisions they wouldn't make otherwise. Some go on the road and spend all their money. I mean, how many stories have you heard of porno girls, feature performers who were making 90 grand a year dancing, and now they have absolutely nothing, now they live on the streets? I mean, that's the result of drugs. I don't do drugs. I stay far, far away from 'em.

You obviously love dancing, though.
Well, I took dancing lessons for years when I was a little girl. And I've always been a performer. I'm a vocalist, as well. I plan — fingers crossed, knock on wood — to go on a worldwide singing tour next year. I write my own music, and I'm kind of going for a real big-band, Ella Fitzgerald kind of sound. But right now I have to keep on my false nails to do pornos, you know? (Laughs)

Prerequisite porn question coming up here: what's your favourite position?
(Thinking) My favourite position... my favourite position is doggie style. I think it's very animalistic. But it's

A decidedly sadistic Krysti helps 'the Mob' beat up her husband in John Leslie's *Dog Walker*. Courtesy: John Leslie Productions/Evil Angel Video

also a difference between when you're doing a sex scene or when you're with someone in your private life. But it seems like doggie style, from the rear, or whatever you want to call it, just has... I have this *ass* anyways, you know, and I do this arch thing, and I like looking into mirrors when I'm having sex, having my hair pulled to a certain extent. That seems to be a position which gives me all those things at the same time, you know.

Did you read the quote about your ass in *Hustler*?
No. (Smiling) Who wrote it?

Seth Roberts.
(Laughing) He wrote something about my ass, huh?

Yeah. I just wanted to get your impression about what he wrote. Here goes: "Buttmen will be lining up at their local video store for the unveiling of this Picasso-like butt sculpture. Her seat cushion is so big, so round, and so fully packed that porn producers should make a mould of her ass and paste this bumper on every girl who enters adult films."

(With broad smile) Thank you very much. I got shivers from that. That's very good. My joke which I always tell everyone is, "If you're not gonna use my face, you have to pay me more money," because everyone's big joke is, "Krysti, could you turn around and bend over?" So I always say, "Listen, (laughing) don't I have a pretty face? Are you gonna shoot my face today? If not, I want more money."

Do you get a lot of comments about looking like a young Jackie Onasis?
Oh yeah. Especially when she died. I'd be walking around the street and people's mouths would fall open and they'd say, "Do you know who you look like?" It was very riveting. I was dancing in Philadelphia at the time, about to go on stage, and sitting there, watching her funeral on TV. Tears were coming down my face. There was a certain grace about her. I really respected her attitude of like, 'This is me and no one's going to change that. No one's going to make me conform.' Picasso-type ass, huh? (Laughing) I really don't mind that. I could definitely relish it.

How do feel about women's position in porn? Do you feel men do, in fact, run the business? That there's no hope for the females to get some form of control?
Well I never ask for equal rights. I just ask for us all to have respect for one another. And I think that's what's important. I'm a business woman; I've managed myself since the day I stepped into this business. I have no agents, and no one's ever represented me. So from my perspective, people like Jim South, Reb... to some people, those are the guys that run the business. To me, they don't. They're the pimps of the business. I work with a very select group of people, and there's a reason for that. I mean, there's a bottom and a top of the barrel in everything in life. I'm not saying that the people I work for are the only good people in the business. I have a lot of respect for people like David Christopher, Bruce Berman, Stagliano, Leslie, Alex DeRenzy... I like those people. But, for instance, I don't like working for Buck Adams... just a different situation, you know.

As far as a stand for women, I think a lot of men in this industry feel they can get away with things. Unfortunately, some of the women — whether it's the money, or the schmoozing, or what they want from someone — are willing to give in to that. Women don't say, "This is what I told you I wanted. This is what I *want*. If you can't meet me, then we won't do business together." Men try to play on the weaknesses, or the naïvety, or the pliability of a woman. And then I hear about these girls who do six anals for $300 and I'm like going... (rolls her eyes, shakes her head)... you know, that's just bad business, all the way around. I charge way more for *one* anal. And I don't consider myself a Savannah prima donna. I consider myself someone who

Krysti highlights the ad art in *Fresh Meat: A Ghost Story.* Courtesy: John Leslie Productions/Evil Angel Video

keeps her rates at a certain price, and if you want to work with me, then we'll do business together. I just think woman need to stand up for who they are a little bit more.

But, no, I don't have as much a problem with women's position in porno as much as I do with their position in dance clubs where they might feature. [The Century] is one of the best clubs I've been in as far as management and how they treat their women. On the road, it's *very* unbelievable the shit these managers try to get away with.

Would you give some examples?
Well, it might have to do with trying to scam off your Polaroids, or scam off your commissions, or... scam you. Every place you go, there's some scam. This is the only place where I haven't been scammed. It's so refreshing. Everyone wants to scam you. I had to fire two agents. I'm suing a whole chain of clubs right now because I'm the type of person that says, "Hey listen. No, no, no. I don't think so. You may have been taking two bucks from everyone's Polaroids, but here, right on my contract, my special conditions are that all monies from Polaroids go to the artist. And that's that. If you want to do otherwise, I'll sue you for breach of contract," which is what happened. In other circumstances girls have said, "Okay, take my two bucks." But why are they giving away that money? It's your camera, your film, your life. I'm not saying women aren't manipulators. I'm the first one to admit women are master manipulators. But when it comes to business, I think women are a little more straightforward than men.

How long do you intend to stay in X? Or is it fairly hard to predict?

There's no way of predicting it. Videos are kind of sliding out of my life. Right now I'm at the beginning of a 20-week adventure in dancing. I've done plenty of videos… a substantial amount. But I always said in the beginning it was a means to an end, which it really is.

To the musical career you plan?

To the featuring, to being a headliner. That doesn't mean I *use* the industry for anything. I enjoy what I do in the industry. But people do business differently. Since I don't have an agent, I don't get sent out on all these little one-day wonders, you know. I try to be real selective about who I work for and what I do.

After watching you in action, it's obvious that you don't mind facials.

I think they're great. In *Dog Walker* I did this facial where Jon Dough got me in the eyeball and I remember I was so mad. (Laughing) I'm going like this, (with closed eyes and open mouth, starts wagging her tongue, quickly moving her face from left to right, as if hungrily accepting a splash) "Awww!" And he got me *right* in the eyeball… oh… and I wanted to beat him after that. (Laughs) Then I had to go do stills and John Leslie's taking water out of the sink and throwing it in my face and I'm like, "Get away from me! Geez! (Laughs) I can't open my eye, and now you're dousing it with water!?" Anyhow, my co-star said it was my fault, that I was shaking my head around. And I said, "Well I think that's *sexy* when you see pornos and a girl's trying to catch cum on her face." She's trying to get it, you know.

What about some of your newer films? Which would you like to talk about?

I loved doing *Buttman's Inferno*. The write-up it got in *AVN* was incredible. And every person that's come up to me in the last two or three weeks has said, "Buttman's Inferno! Buttman's Inferno!" There's this monologue in there where Tim Lake and I are just ad-libbing. And he's worshipping the butt, and I'm saying, "Fill my butt with this white light," and "I worship my butt, too." There's just some very *catchy* one-liners in there, you know. And someone in *AVN* wrote, "Krysti Lynn has this wicked sense of humour both on and off screen." And *Buttman's Inferno* really catches that wickedness. I mean, there's this one part where I'm standing by the mirror and I turn around and say, "I love to gallivant." And John always mimics me, you know, (whispering) "Oh, she loves to gallivant." (Laughs)

What about this title you've adopted: the 'Tease from Hell'? I mean, it's not like you're holding out. You usually give 150 percent.

I do — but only after a certain period of time. I tease.

It's a torture-type thing. I just don't throw myself right into the arena.

Where do you see the industry headed? Do you think the video thing is at its peak or on its way out?

I think in a lot of ways we're going in the wrong direction. When I go to a porno store, I'd rather buy something from 15 years back. I think we should cut all this glamour crap and get back to sex. We should stop shaving our pussies totally and completely, and the guys should stop shaving their ball hairs. What we're selling here is *sex*, and that's what I try to give people in my scenes. I'm giving you sex. I'm not giving you this attitude of 'maybe we're going to have sex', or 'well, I don't really want to be here.' A lot of the times I watch the stuff and it's so… unrealistic. That's why I like Stagliano and Leslie, to name a couple of names. Their films are very realistic. These guys are saying, "I wanna see *sex*." Like in *Buttman's Inferno*, I had no makeup artist, my hair is straight, and I'm having sex. Even in *The Voyeur*, I start off with a makeup artist, but by the end… I mean, I didn't *stop* every five seconds and say, "Could you powder my nose, and fix my lipstick, and put my hair up?" We're having sex. I want to regress *back*. I'd like to direct and produce some stuff that's black and white. Let's go back to the Forties and Fifties. Have you ever watched those old pornos that really weren't pornos?

You mean the grainy loops?

Oh yes!

Films where women had really hairy pussies, too.

And it turns you on because you're kind of like (whispers) "Wow, we're kind of sneaking." It's like total voyeurism. We're sneaking to look at this sexuality so we can get turned on, instead of this I'm-gonna-pop-in-a-computer-CD crap. I think we need to go the other direction. We're going way too high tech. We're having sex. Let's just have sex. ∎

KRYSTI LYNN
SELECTED FILMOGRAPHY

The Voyeur, Dog Walker, Buttslammers 6: Over the Edge, Sodomania 9: Doin' Time, Buttman's Inferno, Buttman's Wet Dream, Deep Inside Dirty Debutantes 7, New Ends 1, Randy West's Up and Cummers 11, Super Hornio Brothers 1 and 2, The Other Side of Chelsea, Night of the Coyote, Ice Woman 1 and 2, Steal This Heart 2, The Coven 1 and 2, Sensual Exposure, I Love Juicy, County Line, Fantasy Exchange, Indecent, Anal Crack Master, Anal Idol, Anal Hounds and Bitches, Butt Freak 2.

N◎ ⌐Sca⌐e F⌐◎m LA

On the Set of John T. Bone's World's Biggest Gang Bang 2, starring Jasmin St. Claire

"We're not making a fuck movie... we're documenting an event somewhere between a baseball game and a rock 'n' roll concert." **John T. Bone, director, WBGB2**

What would H.G. Wells think? A desert island. Naked men prancing about it like apes, jerking their penises, contorting their faces in strange, ludicrous expressions. Each visibly craving food, flesh, the taste of blood. All of them crowding about a primitive altar harbouring a female — nude, prostate — who waits for these baboons to systematically violate her.

What would Herbert George think? Well "Bertie" was, you may recall, a grand proponent of "free love" during the early Twentieth Century. And — at least in Hollywood, California — this was as free as it would ever get.

For here in LA, on a nondescript soundstage, along a seedier section of Santa Monica Boulevard, on Sunday April 28, 1996, men had gathered from all over the United States and Europe to have a shot (or two, or three) at porn star Jasmin St. Claire. These amateur studs would quite literally (almost ritualistically) fuck St. Claire 300 times before the day's end. The entry fee? All you had to do was fill out an application, mail it in with proof that you were HIV negative, and (since the event was being filmed) not be camera shy.

Think Herbert George would have filled out an application? Nah. He wouldn't go near a slime machine like St. Claire. But he might be inspired to write a sequel to *The Island of Dr. Moreau*. Hell, the beast-folk were definitely in full force (somewhere between 54 and 60 males), posing no problem for Wells to conjure up characters for his sinister follow-up. He'd even have a "god-like" figure to replace the larger-than-life image of Dr. Moreau. In this case, John T. Bone.

Bone, you recall, was the British ex-pat who'd become fairly popular in 1995 for filming one woman (Asian slut Annabel Chong) willingly taking on 251 dicks and thus setting a new world's record for gang bangs. "Willingly", of course, being *the* operative word here. For the Chong gang bang wasn't a rape. If you've ever viewed the four-hour tape, you'll know what I mean. The primordial sex was totally consensual. This woman

The line-up process; World's Biggest Gang Bang 2. Photo: Anthony Petkovich

visibly *craved* the experience of a massive multiple fuck. Consequently, this same wonderful whore from Singapore made the first-time-ever event just that... an event, ultimately shining as the true (cum-splattered) genius behind the project. Unfortunately I didn't witness it first-hand. But (although recorded at EP speed on cheap stock tape) the movie's pretty good. Chong, a superior tramp, did everything with incredible zest and incongruous politeness. She took cock in the mouth, cunt, ass. Some dudes wore rubbers. Some didn't. Guys sprayed all over her face. Guys banged her in any position they so desired. And it didn't matter if they were old, skinny, fat, bald, bespectacled, young, uggo... Chong loved 'em all! The slobs could even kiss her (if they so dared, with all that splooge floating about her mug). And Chong actually appeared to have real, unfaked orgasms.

But, of course, it wasn't 251 *separate* dicks that fucked her.

What's that? Did I hear someone say, "Hollywood Handjob"? I don't really know the *exact* number, but from what I read — and saw on the video — it was more in the neighbourhood of 70 to 100 dicks that invaded here... repeatedly... until the 251 number had been reached. Still, she was a dog in heat. Of course, as you'll later read, the animal kingdom has been Annabel's sexual inspiration since she was a kid in Singapore watching mangy dogs fuck in the graffiti-free streets.

And since we're back to the animal kingdom...

John T. Bone's Cock 'n' Hole Circus
Take Two

It's the last Sunday of April 1996 — the day John T. Bone will film his sequel to Chong's gang bang. This follow-up is simply entitled *The World's Biggest Gang Bang 2, starring Jasmin St. Claire.*

The day is overcast. Yet by 1 pm, it'll be a scorcher.

It's 8 am as I walk up to The Hollywood Stage on Santa Monica Boulevard, where Bone will film his fill-'em. As I enter the large, warehouse-like entrance, I come to a small registration table and identify myself as "press." Renae — publicity director for Metro Pictures (Bone's distributor) — warmly welcomes me, before handing me a lime-coloured press badge to wear around my neck. As usual, all the activity is taking place through a door at the end of a long-ass hallway. Through this same doorway, I see a bunch of burly men with baseball caps moving big lights and props. This is the actual soundstage whereon St. Claire will be communally fucked. To my right is a much smaller room, filled with lost, nervous-looking dudes getting their nails filed down by manicurists. These fellas are our amateur, mail-order studs. And the manicurists? What's their story? Well, Annabel Chong's cunt got pretty badly cut up during Bone's first gangbangathon due to the amateur beast-folk studs' untrimmed (and apparently uncleansed) claws pawing her orifice. Bone and his crew are trying to avoid that nasty mistake

Jasmin does the publicity thing with Annabel Chong during the press conference.
Photo: Anthony Petkovich

today.

There's heavy security all about the warehouse. Mostly seven-foot tall, all-shoulder, no-neck males (soul brothers and hillbillies most of 'em) carrying walkie talkies, hand-cuffs, and no fear of God.

After some small talk, Renae escorts me up to the press room on the second floor. A press breakfast will begin at 8:30 am, followed by a question and answer session with slut-of-the-day Jasmin.

The Stomach Is the Way to A Journalist's Fart

Believe it or not, the press conference is one of the more enjoyable parts of the day. Unfortunately, it's also cut out of the film. Why? Two reasons immediately come to mind: 1) the journalists' questions were too close to home (at times, just plain ol' weird), and 2) the producers didn't want to dilute any of the "journalistic genius" behind motor-mouth porn emcees Ron Jeremy and Tyffany Million.

As I walk into the press room, it's hard to avoid Ron Jeremy. He's by the buffet table stuffing the gut on his gut.

"Why didn't anyone tell me John T. Bone was Jewish?" Jeremy asks no one in particular, as he jams a slab of lox into his cake hole. "Is he Jewish? No one told me... about John... that he's Jewish, I mean. Why didn't anyone tell me?" No one bothers answering the ninny. We've been sick of his amorphous ass since 1978. Thank heavens for the food, though, otherwise the overstuffed kannish would *never* shut up.

Oh, yes, the food.

Talk about your impressive spreads. On an extensive buffet table we have bagels, cream cheese, champagne, orange juice (freshly squeezed... in those great big carafes), ham, sausage, melon, strawberries, grapes, capers, tomato juice, pastries. Very sumptuous. The folks at Metro really want to spoil the press, of which there are about 30 (writers, photographers, editors, cameramen) in the conference room.

As I wash down some grub with champagne, mondo-film compiler Nick Yale beckons me to the window with a wave of an oozing bagel. I walk over and

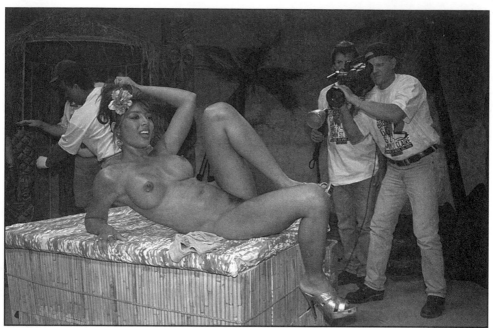

Jasmin poses on her bamboo island.
Photo: Anthony Petkovich

take a look. On the opposite side of Santa Monica Bou-
levard, Mexican labourers wearily stand waiting for work
outside the riot-proof fence of a small factory.

"Only in LA," says Yale. You got that right, brother.
And while the press gorge on all this gourmet food
(directly across the street from the hungry amigos),
what are the beast-folk downstairs served? Donuts.
Yep. Our finely-manicured friends — who comprise the
actual backbone of the film — are busting their chops
on donuts and coffee. Well, whaddya expect? C'mon.
It's Hollywood, Jake. Donuts or no, I keep eating. Fuck
it. I don't get that many free meals. So I'm a hungry
hypocrite. Fine.

Tyffany Million struts about the room, farting with
her mouth. A retired cunt (excuse me — retired "adult
film actress"), Million is desperately trying to show
Bone's roving camera — and us journalists — that she's
hardly your average film whore. Her endeavours are
failing. Badly. For rather than listening to her
interviewees, she takes every opportunity to pump her
own career (or lack thereof).

"I did one of these gang bang movies a couple of
years ago," she boasts to an amateur stud, "I won best
gang bang movie of the year award for that one... I did
15 guys..." Then, to another stud: "Oh you're from
Boston? Hey, that's where my husband's from..." And
to yet another: "Oh, you have kids? *I* have one, too."

Physiologically speaking, each time I see Million,
she looks more and more the grotesque. All that gra-
tuitous surgery has actually surpassed the Hollywood
limits of plastique. Million looks more alien and
mongoloid-like than ever. To know her — let alone lit-
erally *witness* her — is to loathe her. But don't listen to
me. Listen to former hubby (still married to Million

during the gang bang) Jef Hickey, publisher of *New
Rave* magazine:

"I spent all my time in the company of a sensitive
sex machine who wanted to fuck me... over," Hickey
reveals about Million the Monster in the February 1997
issue of *Hustler Erotic Video Guide*. "Little did I know
that Lady Luck had money-sucking fans, an inferiority
complex that all the plastic surgery in the world couldn't
remodel, and a vindictive temper that almost drove me
to an early grave. Selling your heart, soul, and wallet
to a porn star is not what it's cracked up to be. I bought
into one, and I want a refund. She sucked on screen,
but didn't want to do it at home. She drank a hundred
loads, but spit it back at me when she wondered why
the mainstream world wouldn't accept her. Save your-
self a life of hell — *don't* marry a porn star! I married a
porn star, and I wish I were dead. Someone kill me!"

There you have it, readers. The confessions of a
Bride-of-Frankenstein eater. Needless to say, I ignore
the inimitable (and freakish) Ms. Million as much as
possible during the day (besides, I hate writing her
lame-ass name).

Publicity director Renae is now talking with a small
group of us writers in the press room, just moments
before Jasmin's much-awaited arrival.

"Jasmin promoted the event on all the American
shows," Renae proudly states. "She was on Howard
Stern, Richard Bey, Charles Perez... there was a sign-
up sheet at this year's CES in Vegas... we published
announcements in many of the major adult magazines...
she left applications in many local adult bookstores,

and wherever she danced throughout the States."

The reporters continue to load up on free food as they listen.

"By the way," Renae continues, "Jasmin will send each one of you a present if you just put your business cards in the hat we're passing about." Thinking we'll receive a complimentary copy of the finished video, we yank out our business cards and deposit them in the upturned, spinning hat. (As it turns out, a month later the "present" reveals itself as none other than the studs' model release forms — a stack of 'em. Initially, this is a disappointment. Later, I find it helpful. The release forms tell me *exactly* how many guys participated in the gang bang. I count 54. Sorry. Didn't mean to burst your bubble again. But, as with the Annabel Chong gang bang, today's plan is for these 54 guys to continually, systematically fuck Jasmin until the 300 mark is met. Remember, she must first hit the 252 fuck mark to break Annabel's record.)

And (hooray!) it's just about time for the Lay of the Day to make her press appearance.

Just about.

Instead, we get "agent" Charlie Frey (pronounced "fry"), a thirtyish white dude with shoulder-length brown hair and pizza gut.

"For obvious reasons," Frey tells us, "Jasmin's a tiny bit nervous, so don't rip her apart." Yet Jasmin's nowhere to be seen. Nonetheless, the questions start gushing out like flatulence.

Did she volunteer for this?, a journalist bluntly asks. (Ah, that key question. Did I hear someone say "rape"?)

"This was Jasmin's idea, actually," Frey immediately responds. "Jasmin's like an… adventurer." He smugly smirks, as if espousing a witty remark FedExed to him directly from the English Restoration. "She thrives on doing something new and crazy. If you know her in her personal life, that's just the way she is. She heard about this Annabel Chong thing and she went, 'I can beat *that*.' It was that simple. It wasn't even like a long, creative process." (As we'll later learn, this is part of the inherent problem: while Annabel did her gang bang out of sheer horniness, Jasmin does it to merely break a record.)

At every conceivable press conference, you have the gauche American slob who simply *must* talk dollars and cents (as if he really expects an answer… let alone an honest one).

Can you give us a rough estimate of how much she's being paid for this? the writer asks.

"Roughly less than a million, more than a dollar," Frey responds. A well-rehearsed answer if ever I heard one. "Anybody here from the IRS?" Someone blows snot — loudly — into a handkerchief. "Very good."

Yet the same fag journalist is undaunted. *Like six figures?* he continues.

"Six figures?!" another reporter snorts with dripping cynicism. Yeah, six figures — if you count the two zeros after the decimal point. C'mon, this ain't no Spielberg production (thank the Lord) otherwise we'd *really* be bored.

Finally — after a few more kill-me-please-because-I'm-so-*fucking*-bored questions — Jasmin makes the scene.

Ms. Meat Puppet Meets the Press

A warm round of applause greets Jasmin as she enters the conference. Wearing an orange latex, zip-up mini skirt, and platform shoes, this dark-skinned (Portuguese supposedly), Florida-based, frost-haired slut (somewhere in her late-twenties) looks like a prostitute straight out of a *Police Woman* episode.

Jasmin seats herself on a bar stool in the middle of the room and courageously faces the press. (Sitting off in a corner by the window, John T. Bone calmly, modestly watches the proceedings, occasionally looking out the window at the unemployed Mexicanos.) Smiling warmly, Jasmin gladly accepts a glass of champagne. The journalists and photographers seem in strange awe of her as she delicately sips the bubbly. Perhaps it's the blood digesting their food. I take the opportunity to break the ice.

How are you feeling this morning, Jasmin?

"I feel great!" she replies perkily after a swallow of booze. "It's one of the biggest days in my life." (One of the biggest for your cunt, too, baby.)

(My turn, again.) *Have you been preparing for this in any sort of way? — exercising, resting, eating certain kinds of food?*

"I do what I normally do: I go rollerblading, play

Ron Jeremy tries to put the studs at ease before the World's Biggest Gang Bang 2 commences. Photo: Anthony Petkovich

pool, go walking, dancing… nothing's different."

Another reporter dives in. *You were talking with Annabel Chong downstairs. What was she saying to you? What were you guys talking about?*

"It's girl talk."

Was she giving you any advice?

"It's all girl talk," she defensively snaps. "I can't say."

Tricks of the trade?

Realising she's on camera, Jasmin momentarily buries her bitchiness. Yet, as we all soon witness, this façade rapidly crumbles during the course of the day.

"Annabel's being very nice about the whole thing," Jasmin says with syrupy smile. "She's actually happy that I'm doing this. She even gave me a couple of pointers here and there. And that's it."

(Long Pause)

Why did you decide to do this?

"I'm a very adventurous person and I love doing adventurous things." (Where have we heard *that* before?)

How long do expect to take to recover?

"I'll be back at my aerobics class tomorrow at 3 pm." (What? In a fuckin' wheelbarrow?)

What will you do tonight?

"I want to go dancing. I want to go to the Rainbow Room. I wanna celebrate."

Tonight?

"Yeah! I'm going to celebrate… with some friends."

How do you expect to have energy?

"Pardon me?"

How do you expect to have energy?

(Mumbling to herself) "How do I expect to have energy?… um…"

"Food," a reporter mercifully blurts out.

"Food," Jasmin answers in a blinding moment of inspiration. "I'll eat properly, drink plenty of water, annnnnnd… that's it!"

Are there some things you're not willing to do today?

"No," she flatly answers (meaning, "Yes, there are pa-*lenty* o' things I ain't doin' today").

Everything's game?

Jasmin gets defensive now. "Are there some things *you* don't do when you have sex?"

Probably.

Another reporter butts in. *Are you doing DP's today?*

"Unfortunately not. You have to remember, these guys aren't professional. And that's how people get hurt, because some people don't know what they're doing."

Anal sex?

"Why not?"

What does your doctor think of this?

"My doctor already clued me in on everything, and I've been taking care of myself. I'll be seeing him on Thursday." (Thursday?! Remember, folks, this is taking place on a Sunday. So why the wait?) "Everything

will be fine. I mean I don't think this is dangerous. I think it's more dangerous pumping gas in downtown LA."

Laughs from the press. Jasmin might be from Florida, but she knows LA pretty well.

Did you have time to go to church this morning?

"I have my candle downstairs and I've been praying, yes." Long pause. "How do you know I'm not Jewish?"

I don't know. I mean, with a name like Jasmin St. Claire…? The same journalist sarcastically rolls his eyes (Does this idiot *really* think that's her name? Yikes!)

Another journalist: *Were you disappointed knowing that Ron Jeremy's going to be on the sidelines today and not actually participate in the gang bang?*

"Of course not."

Big, BIG laughs from the press. We realise Jasmin is probably unaware of the satire behind her innocent answer.

Can we quote you on that?, I ask her.

Jasmin cranes her neck to get a better look at the journalists. "How many of you guys are joining in on the gang bang?"

A reporter from *AVN* jokingly raises his hand over my head, and points down at me.

"What are you?" she asks me in all seriousness. "Number one, three, three hundred?"

Is number one okay?, I answer.

More laughs from the press.

Hey, here comes Annabel Chong.

Strictly Cunt-to-Cunt

As she gracefully strides into the room, current gang-bang champ Chong receives far more applause than Jasmin. She's wearing a delightfully whorish pair of black nylon hot pants and black leather boots. Most of us are actually pretty amazed she's here. I mean, why bother? Jasmin's her cumpetitor, right? Hmm… Something's beginning to smack of fly-by-nite phoniness here, like some cheesy Hollywood dating service.

Annabel gives a sincere smile, though, taking her spot (almost dutifully) next to queen-of-the-day Jasmin. The reporters immediately begin bombarding her with questions.

Annabel, how do you feel about Jasmin surpassing your record?

"At the end of the day we'll see if she beats me," Chong says with composure, dignity, and a cute hint of an English accent.

Any jealousy, Annabel?

"Just curiosity mainly," she says, laughing girlishly.

Is it a turn-on for you to know that Jasmin's doing this based on your old record?

"Oh, I wish I could watch."

"Aren't you going to stay?" Jasmin says with the goo-goo eyes of feigned Hollywood surprise. Annabel shakes her head. "Well," Jasmin tells her, "you have to come back later."

Bone, in the guise of Dr Moreau, contemplates his next gang bang victim.
Photo: Anthony Petkovich

Jasmin poses by a number she can definitely live with.
Photo: Anthony Petkovich

"Yeah, I'll be coming back later." (She doesn't come back later.)

Were there any ramifications in your 12-hour stretch from last time, Annabel?

"Oh... let's see... I went home, took a shower, finished my essay, then went back to school the next day." (I don't think Annabel understood the question. Then, again, what the fuck *was* the question?)

What was your essay on?, I ask her.

"Human sexuality." (Sounds like a natural.)

Annabel then tells us that she's studying at USC, with a minor in photography. After graduation (hopefully within a year), she'd like to become a sex researcher.

Are you getting an A in sex studies? another journalist asks her.

"Of course," Chong responds with a giggle. "I could probably *teach* the course!"

One photographer asks Jasmin and Annabel to kiss. In a blatant show of superiority, Jasmin sticks her cheek out for Annabel to kiss. Rather than quibble, however, Annabel graciously gives her a peck.

"Time to go!" Agent Frey over-enthusiastically tells his money maker Jasmin.

As Jasmin is escorted to her downstairs dressing room, Annabel stays behind to talk with the reporters. She's great. Fascinated by her teeth, artist Steve Leyba Johnson and I take snapshots of her open mouth. Chong is incredibly accommodating. And being total "gentlemen", Steve and I soon get Chong on the subject of bestiality.

"Oh, I've always had this thing about dogs," Annabel says with the excitement of a budding teenager. "I mean, when I was a little kid, I'd be sitting in my room, looking out the window, and there'd be lots and lots of dogs *fucking* in the street. And they look as if they're having a good time." Then, in a semi-whisper, "And I wanna have a good time. It's just a fantasy. I'm prob-

ably going to do it, but, you know, it's illegal in America so it probably won't get on video. I've done a few dogs, anyway."

Your record is probably going to go down after today, Annabel, a reporter comments.

"Oh well. I was the *first*." True. She was the pioneer. And, unlike Jasmin, she had no one to compare gang bang notes with.

You seemed a little unsure that Jasmin would reach your record or break it, another journalist notes.

"Um-hm. Well, to get to 251 it wasn't that tough for *meeee* because I come from a marathon runner's background. I psyched myself two weeks before the gang bang, so I was really well prepared."

Renae informs us that the slime show is about to get underway downstairs. All of us — Annabel included — excitedly head on down.

This Uncharted Desert Isle

The actual soundstage is like an oversized basement. High ceiling, expansive concrete floors, dark corners.

As you walk into the soundstage, the actual fuck altar is in the far-left corner. On this platform is a smaller platform (about the size of a double bed) upon which Jasmin will do the deed. Flood lights hang from the ceiling, angled towards this central bang point. The 'bed' is sheathed by a somewhat exotic, sea-blue-coloured bedsheet. Apparently, the movie's motif is 'tropical'. Hawaiian desert island, palm trees, shit like that. The Chong gang bang (shot on the same soundstage) had a makeshift Roman temple for its set, complete with pillars, urns, and statues of gods and goddesses (signifying the no-holes-barred decadence of Rome, I suppose).

So why the tropical motif this time 'round? Before the cunt-stuffing gets underway, I ask director Bone.

"Jasmin," Bone says, "has a comic book coming out which is about sexual fantasies of porn stars. And

The cattle line-up.
Photo: Anthony Petkovich

her sexual fantasy was to make love to a lot of guys on a Pacific island. It's kinda like *Gilligan's Island* gone bad, gone crazy." The beast-folk today, of course, will only be doing what Gilligan, the Skipper, Professor, and Mr. Howell regularly did to Mary Ann. C'mon. Whydya think a hot bitch like little Mary Ann was always making coconut cream pies for the lads, hmm?

Keeping with this desert isle schtick, the fuck altar is surrounded by phoney palm trees and wooden tiki gods, some of which have glowing red eyes. To the right of the stage is a canoe, behind which is a painted backdrop of sky-blue, grapefruit-pink, sand-white, and banana-yellow, all to evoke that sunny, far-off, exotic Pan Pacific feel. It's still Hollywood, though.

The stage is headed by three roped-off aisles. Hollowed bamboo shoots (made of plastic) serve as the poles connecting the ropes which form the aisles.

The middle aisle is the main one: ultimately leading the human sausage (via a small bridge) to Jasmin's frying pan. Once the beast-folk have their shot at Jasmin, they exit the stage via a makeshift hut (located about 15 feet behind Jasmin's mattress). A large plastic trash can is located directly outside the hut. This receptacle is where the studs deposit their used rubbers (perfectly placed, too, as the horrific stench its mouth emits discourages anyone from lingering on-stage).

After the studs exit the "hut", they walk down a ramp which leads them to another roped-off aisle (at stage left), ultimately leading them back to the floor — and the middle aisle, where they can once again wait in line to fuck Jasmin.

And, finally, the aisle to the far right is for the press; this is where I spend much of my time today, taking pictures, getting quotes from Jasmin (as she carelessly blurts 'em out), and reaction from the amateur studs.

Throughout the day, Bone — a porn version of Wells' Moreau — sits at a throne-like console, television monitors before him, a mad scientist looking down upon his perverse creation. In all, there are four cameras — three plugged into the terminals, and one moving about the floor in freeform style. By the end of the day, Bone's crew will have shot 50 hours worth of tape (which will take seven months to edit).

While waiting for Jasmin, the soon-to-be-studs-on-film sit upon aluminium bleachers located on the opposite end of Jasmin's imminent dick trough. With his penis-like microphone, Ron Jeremy roams about the floor talking to the slightly nervous guys, trying to loosen them up, put them at ease. It's one of the more decent things Uncle Ronnie does today. Jeremy, of course, is basically Bone's hired sex therapist, casually counselling these newcomers, making them hard for Bone's camera (next to the much-more-physical fluffers on hand today).

"Don't worry about it," Jeremy tells a group of about 30 beast-folk. "You're here to have fun. If you can't come, hey, it's alright. No pressure. Relax. Have a good time."

I conduct a few interviews myself among the male talent. One conversation is with Dave Cummings, a 56-year-old professional porn star who, for the record, banged both Kristy Waay and Lana Sands in John Leslie's *Dirty Tricks*. Lucky fucker.

Do you perform fairly well with a rubber? I ask

Videographer Nick Yale is in awe of the fluff 'n' stuff. Photo: Anthony Petkovich

Cummings.

"I've been in 55 movies and never used a condom yet," Cummings says. "Actually that's the thing that's got me: I'm not certain if I'll even jump in because I've got an allergy to the latex. I usually suffer two or three days with itching. But I do what I feel like doing. It's fun. That's the only reason I'm here today."

What did the actual registration process for this event entail?

"Well, they first check to see if you were pre-registered... you had to have a pre-registration letter. Then you show 'em your HIV test. Jasmin herself personally checked the tests to make sure they were done within the last 30 days. Then you sign a bunch of model releases and forms, put this thing on ya (holds up wrist with plastic yellow bracelet on it), and I went in, combed my hair — all three pieces (laughs) — and here I am."

John T. Bone now addresses the studs who'll soon be fucking in his film — for free.

"Hello! Hooray! Let the Show Begin..."

"We're about to begin," John Bone blasts from a bullhorn to the boys in the bleachers. "The most important thing to remember is that this entire operation today is safe sex. Condoms are here." He points to a giant wooden plant pot (filled with rubbers, not dirt) at the start of the middle aisle. "You *must* wear them. We know that everybody here has an HIV test, and we know people were turned away at the door because they don't have them. But the condoms are here. These are for *all* of our protections."

Bone chats a short while longer then glances at his watch. "10:25 on Sunday morning. Let the games begin..."

The studs give a weak round of applause. Not enough jelly donuts, perhaps? Well, they're understandably nervous. Except for guys like Cummings (who finally decides not to participate) few are professional pigstickers. And speaking of porkers...

Jasmin suddenly emerges onto the soundstage wearing a shiny golden gown. A lady who really does looks better with her clothes on, Jasmin makes a nice figure posing by the number board (which currently reads "OO") to the left of the stage. Just before Jasmin disrobes, Bone gives her a hug and a peck on the cheek.

Time to fuck!

The line-up process is not unlike a bottleneck on the freeway. The studs want to get to that mattress, that's their destination. Haphazardly starting at the back of the middle aisle, they're (amazingly) quite orderly. No pushing. No shoving. No swearing. Lots of cranking among the male talent, though.

As the cattle move forward, they eventually make it to the small bridge, at which point two lines are formed. At the end of these two lines are fluffers who suck off the bum steers, makin' 'em hard for Jasmin (at least, that's the theory). Security guards let the freelancing studs onto the dias, five at a time. Each group of five amateur studs gets two minutes with Jasmin. No, not two minutes each. Two minutes *per group*! Ah, nowhere but in the Golden State can you get the royal Hollywood handjob. And after that two minutes is up, it's...

"Through the hut!!"

That means time's up — move your flabby ass off the platform and make room for the next five beast-folk.

It's like a buffet, really. The amateur studs might have eaten donuts earlier on, but now they can go back for as many helpings of pussy as they want — as long as those numbers keep clicking on the score board, and number 300 is a ways off.

"First five!" a security goon calls out.

The first five beast-folk to take a crack at Jasmin (lying on her back) include a wannabe super stud (flaunting a transparent ego worthy of George Clooney); a short, pudgy slob from Kansas wearing baseball cap and glasses, who looks like he'll soon graduate to serial killer; a buffed guy from New York who looks like an ex-Marine; a balding, fairly nondescript dude; and a young guy with curly red hair.

Clooney Wannabe and Marine Boy are the first to attack Jasmin's mouth. Almost.

"Please put a condom on," a security guard immediately tells them. "If you don't wear a condom, please leave, okay?" Obviously disappointed and slightly embarrassed, the two studs fumble with cockmeat and rubber. "If you have trouble getting it up," the security guard further informs (and embarrasses) them, "the two women right there will help you." He points towards two girls — one black, one Mexican — 'fluffing' at the Bridge of Sighs.

The fat fuck from Kansas is the first to attempt vaginal penetration. Quickly proving soft, however, he's replaced by 'Red', the curly redhead. The newcomer is successful at dick dunking. But it's a short-lived pleasure. For he no sooner gets a good, steady rhythm going when...

"Through the hut!!... Next five!"

Time's up lads. Off the stage. Better fuck next time.

The unpaid studs all have very good attitudes about the situation, actually. I haven't met one who wasn't decent or respectable.

If anything, it's the photographers who are the ruthless ones. Scrambling over one another like crabs on speed, they're all after that ONE GREAT SHOT. Ultimately they become united in their hatred of one photographer — a French dork in his late-twenties with beard and pony tail who's rude, pushy, and disrespectful. I don't know the cocksuck's name, but he's married to porn starlet Rebecca Lord. Undoubtedly she's the reason (the *only* reason) why this irritating Frog — no matter *what* the event — manages to get the best seat in the house. Nepotism at its worst — even in porn. If there *is* a common bond among the photographers, it's our intense dislike of Jean-Luc Faggote.

The next guy to stuff Jasmin is wearing a black leather bondage mask. Apparently he's afraid of tarnishing his reputation. "Don't fuck me hard," Jasmin immediately dictates to the 'Mask'. "And I mean it — don't!" Ah, here we go. The *real* Jasmin St. Claire.

The Mask obeys, gently pushing his long, berubbered linguica into her twat. "Oh yeah," he pleasurably gasps, before having a bit of trouble. "I think we're gonna need some lube here," he calls out. The goons give him a tube o' lube. He applies it. Soon fucking Jasmin with more ease, the Mask starts rubbing her clit. Jasmin glares at him.

"*Don't* play with my pussy," she hisses. He stops playing. Stops fucking, too — obviously turned off.

Next stud: a 23-year-old Mexican kid named Eric. Jasmin says he's the "cutest guy here today." Still on her back, she lets Mexican Eric fuck her very hard without complaining in the least. She's amazingly nice to him, drawing suspicion from the beast-folk and journalists. Many of us think Eric is her boyfriend. He says, for instance, that he's from Florida, as is Jasmin; that he's been out here for two years, as has Jasmin. Later on in the day, she even lets him stay on the platform after his fuck time is up. For the time being, however, Mexican Eric doesn't prove effectual. In fact, we've gone through 15 studs and not one has popped yet.

Next up to bang Jasmin is 22-year-old Mark from Iowa. Of average height, he's skinny, paleish, with a soft belly, buzz cut, and wearing granny spectacles. No one says it outright, but he's the quintessential nerd —

* The poor slob who goes around from booth to booth in cock-shooting galleries — i.e., peep shows — mopping up any blasted sperm.

Momo wipes the jazz off Jasmin.
Photo: Anthony Petkovich

and a pleasant, likeable guy.

"Take your glasses off," Jasmin tells Nerd of the Day as he's about to fuck her in the missionary position. He takes off his specs.

"Make the trip worthwhile," Jasmin presumptuously tells him. Yet the instant he slides his fleshy, semi-hard, latexed animal cracker in her fish cave, she reminds him of "the Law."

"If you come," she tells him, "do it over here (she points to her belly) or up by my tits. Not on my face, okay?" Nerd of the Day nods. And he's the first to blast spirit gum, too. After a minute of the ol' in-out in-out, he yanks his dick out of her cunt, fumbles with his rubber (eventually snapping it off like a wet dishwashing glove), and releases tapioca onto Jasmin's belly.

An overweight, faggy-looking Filipino in his early thirties — who was the "floater"* at Annabel's gang bang — wipes up any and all spunk sprayed upon Jasmin today. Wearing an actual pair of dishwashing gloves and an apron, Homo-Momo (as we'll call him) is also armed with sponges and towels to mop up the muck from Jasmin's cunt, ass, back, tummy, whatever. Blechhh! What kind of heterosexual would even *consider* doing this shit?... even for money?!! And as the day progresses, I can't help but notice Momo's eyes, which appear far more interested in cock than cunt. Fringe benefits, I suppose, for a thankless job.

Jasmin is bent over now. And she looks fine. Milk chocolate-coloured cunt. Healthy ass cheeks. Tight-looking butthole. But, whether she's on her back or on her knees, she makes each and every member of Bone's beast-folk fully aware of the Law.

Sayer of the Law

Much like the "silvery hairy man" in Wells' *Moreau*, Jasmin is the Sayer of the Law in today's gang bang. For, when it comes to her temple of a body, Jasmin (sometimes verbally, sometimes non-verbally) makes it painfully clear to the beast-folk that they are:

The beast-folk surround a fluffer.
Photo: Anthony Petkovich

1) *Not* to chew on titties.
2) *Not* to suck face (i.e., not to smooch, kiss, swap spit).
3) *Not* to eat cunt.
4) *Not* to finger fuck.
5) *Not* to screw without condom.
6) *Not* to sodomise, with or without condom.
7) *Not* to blast jamba juice in her face.

That was the Law.

If you didn't obey it, Our Lady of Cunt would not-so-politely remind you. And if you *continued* to disobey it, well, you'd probably be 86'd from the joint. All the beast-folk obey, however. Yet out of sheer horniness, some studs innocently forget about the Law — and promptly have their hands slapped. Other studs throw in the towel out of sheer disgust. (Don't worry, we'll be getting to *their* stories soon enough.)

A lot of Jasmin's intense paranoia obviously stems from health issues. After Annabel Chong did her gang bang, rumour has it she couldn't get any porn work. Many actors wouldn't fuck her because of the sheer number of guys she screwed without condoms, bringing the AIDS issue to a head. And, of course, a clean bill of health for Jasmin equates with steady work and — most importantly — good money.

But why no finger fucking? Sure Chong was cut. Sure she bled and hurt because guys kept sticking unfiled, dirty fingers into her vagina. Jasmin and Bone, however, learned from this unfortunate error, right? The guys in this gang bang had their nails filed. So why the intense paranoia on Jasmin's behalf?

I believe Jasmin's staunch adherence to the Law stems from her own anti-eroticism. Here's a woman who just *doesn't* like sex — at least, not in front of the camera.

Bitch, Bitch, Bitch

Bone comes up to Jasmin now with some good news:

"We're just past the 50 mark."

Jasmin removes cock from mouth to speak. "John, this is nothing. Why didn't you tell me this was gonna be so easy?" (The day ain't over yet, sweetie.)

A white guy whose penis is currently in Jasmin's face, tries making some lame small talk. "I'm from the San Francisco Bay Area," he tells her. "Got my bachelor's in finance. I work for AT&T."

"Bad company," she says, robotically sucking his manroot.

After a few more guys, however, Jasmin wants some *real* dialogue.

"Where's Ron Jeremy?" she asks, looking confusedly about. "I need someone to tell me a good joke right now."

"Hey, look!" someone calls out, pointing off-stage left. "There he is!" And, sure enough, there's Jeremy, seated in a fold-out chair, right in the middle of the slaughter — snoozing! He personifies beast-folk existentialism: fucking, eating, drinking, sleeping. Only today Uncle Ronnie's doing more talking than fucking. Then again, porking never stopped Jeremy from blabbing his blubbery butt off. He wasn't dubbed "the sound editor's nightmare" for nothing.

Slowly awakening, Jeremy rolls over to Jasmin like Jabba the Hut.

"So, did you get fucked in the bee-hind yet?" he asks her.

"Not yet," Jasmin replies. "But I *will* find one."

Jeremy himself is getting a tad disgruntled with this woman. "She hasn't even had an orgasm yet," he mumbles to the cameras.

"I'm going for 400!" she abruptly proclaims, obviously evading the issue of (ironically enough) sex.

Bill Caskie, a dude in his early fifties who participated in the Annabel gang bang, moves to the front of Jasmin. He's about to stick it in when she snaps at him like a mongoose.

"Your dick isn't even hard to go in me!" she snarls. "Are you trying to hurt me?"

Caskie is stunned by such cold-bloodedness. He doesn't even notice the hard black stud taking his place. Brother blood fucks her in the missionary with a steady Harlem rhythm, grabbing her by the thighs. He doesn't come, though. Eventually Cletus makes room for an overweight white boy. Whitey's about to stick it in Jasmin when —

"Next five!"

Whitey is incredulous. "Aw, no way!"

Yes way.

Security kindly move him along. Sorry, son. Back to the crank tank.

The Crying of the Man

Shortly after Jasmin embarrasses Bill Caskie on camera, I approach him to get his impression of the proceedings.

"I had a fantastic time at the last one," a bittersweet Caskie replies. "One of the best times of my

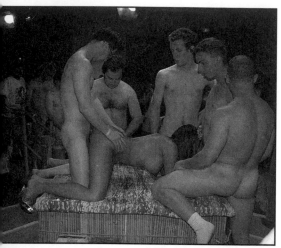

A group of five studs focus on LA's hot-spot of the day.
Photo: Anthony Petkovich

entire life. A *fantastic* experience. And I was expecting the same thing today. But it's just not here. I'm very disappointed in this one. I think it's a total fraud."

A fraud? Why?

"Well, Annabel was havin' us up there 10 minutes at a time. She was letting guys do anything they wanted, and let them take as much time as they wanted. In this one, Jasmin's havin' five guys up there at a time, and they're givin' 'em two minutes. One guy fucks her and the rest basically go off stage. If Annabel had done this, she would have laid over a *thousand* guys. But this woman here wouldn't even let me fuck her!"

That sort of rejection obviously affects a person's psyche.

"I am *very* turned off here today," Caskie continues. "Very turned off. I'm not rushin' up there for seconds, I can tell you that. I don't feel it's right, either, advertising this as a record. It isn't legitimate. I mean, you're comparing what someone does in 10 minutes to what someone does in two minutes. The guys are only up there for a fifth of the time than they were with Annabel. It's like apples and oranges. As far as I'm concerned, Annabel still has the record — no matter what this woman does."

Well, if Jasmin is alienating her harem of hoses, the fluffers are most definitely not.

These Girls Suck!

The fluffers are fascinating to observe. I continuously find my attention drawn to them — and away from Jasmin.

Not one of the fluffers is a total knockout. But erotically speaking, they comprise the best parts of the film. Their mouths are getting gang banged *without* condoms — making it all the nastier, all the hornier. Unlike Jasmin, they're true slaves to sex. Suck robots encased in real flesh. They like what they're doing. Or at least appear

to enjoy it. And they're *not* bitching about it.

There are five fluffers in all. Two plump Mexican gals, a thin black girl named Climax (who occasionally stars in porn films), and two white porn starlets: Candy Samples (a blonde with natural tits, big voluptuous ass, and an intense passion for dick chomping) and Chelsea Gold (a pale brunette with sleepy eye and flabby gut). They're all in their twenties, wearing skimpy tropical bikinis, and *very* available.

Candy Apples stands out as the fluffer too slutty for her own good. She's constantly upstaging Jasmin. That is, while Jasmin sucks hose as if she's being intubated with anaesthesia (and on the verge of nodding off), Apples sucks pecker as if the appendage were an aqualung and she desperately needed oxygen. Better still, Candy makes studs prematurely shoot their wads left and right before they make it to the fuck altar. She's a joy to watch. Her eyes are typically closed. Her head revolving 'round and 'round as her lips wrap around, focus on, *latch* onto each penis. She's intense. And with each prick, no matter whom the owner might be (even a homely ass like David Schwimmer, if he was present), it's obvious that nothing else in the whole fucking universe matters to Candy but that veiny piece of cockmeat between her filthy teeth.

Candy now makes a big black bastard spurt jizz seconds before he steps into Jasmin's bang boutique.

"Shee-it!" the brothah chuckles, wiping himself off. "This cheek sucks cock too good, main!" Still chuckling, he goes back to line's end, probation broken.

At times the fluffers find themselves surrounded by groups of five or six beast-folk, a veritable cocoon of cock. "Where are you from?" "What are you doing after this?" some studs ask the fluff stuff. And as the paid cocksuckers squat down to earn their money, many studs reach down to grab some titty (the skimpy bikinis making it easy for them to cop numerous feels).

Kiss And Tell? Like Hell

Some of the guys getting sucked off by Jasmin look as if they're going to cry. They're worried about coming. What with the long wait in line, the two-minute fuck limit, the lights, the cameras, the cost of a plane or bus ticket, and, of course, Jasmin's sour attitude, simply popping off once today makes many a lad a happy Jack.

Jasmin's in the doggie position now. It might be harder on Jasmin's knees, but the guys are certainly performing better this way. Since Jasmin's ass is her best feature, it's easier for the studs to get turned-on and spurt. A white kid now shoots on her ass. The crud dribbles down her crack, plunking itself in her chocolatey anus. Not bad, not bad. This thing's actually starting to become erotic.

We're up to 175 on the number board now.

"Take it easy. Take it easy," the security guys tell the beast-folk.

Truthfully, I don't observe any roughness from our amateur he-men. Actually, I think the security goons

are protecting the *guys* more than they are Jasmin. Security realise that anything, *anything* can incur the wrath of plastic Jasmin (and she's getting bitchier by the minute). So, by keeping the beast-folk in check, they keep Cunta Keenta at bay.

Presently, a black dude with a shaved head and gangsta-gold necklace is doin' Jasmin bow-wow style. He comes on her ass. Homo-Momo quickly wipes her down.

Jasmin's now sucking a white specimen, who gradually moves his hand around to the base of his cock. She immediately stops sucking. "Uh-uh," she says, using his dick as if a microphone. "Move your hand." He does so. I guess she's afraid of getting smacked in the shnaz. Can't blame 'er. Quite a hooter on her already.

"Any orgasms yet, Jasmin?" Jeremy asks her.

"I don't kiss and tell," she says. (She doesn't kiss, that's for sure.)

Jasmin is back to the missionary position now. And, as expected, the boys are having a hard (or not so hard) time. Erections are difficult to come by this way. Maybe it's due to Jasmin's ferret-like glare, her seething insolence.

She soon turns over, though. And, as predicted, the guys are popping off more steadily now, even when they're half limp. Cum dribbles down her crack, ultimately resting upon her a-hole. Some spunk remains on her butt cheeks like melted Velvetta for several minutes (Momo doing a tardy wipedown due to his awe of all those cunt pumps). You'd think Jasmin would mind

Rejection sucks; a satisfied customer?
Photo: Anthony Petkovich

this anal uncleanliness more than a hand on a dick, a limp dick, or even a tit feel. I guess her ass is numb from laying on her back so long.

Nerd of the Day is fucking Jasmin doggie style now. He's doing a good job of grabbing her cushy ass cheeks and lettin' go. And let go he does, gushing all over her booty.

"I was the first person to pop twice," Nerd of the Day excitedly tells me afterwards. "No," he happily corrects himself, "I was the *first* person to pop!"

What do you think of the gang bang so far?

"I'm havin' a *great* time. The first time I came on her stomach and the second time, just now, I came on her ass. Doggie was great."

Does her cunt smell bad at this point?

"It doesn't really smell at all. It just stinks of lubricant."

Back on-stage, another black dude is doing Jasmin doggie style. Ready to spout, he yanks his berubbered johnson out of Jasmin's snatch and fumbles nervously with the condom. He pulls it off and — just in the nick of time — pumps stucco over her cheeks and back. The jizz oozes down the curve of her spine like an albino parasite.

"Why don't any of you want to put your dicks in my face? My God!" Jasmin complains. (I think some fellers would much rather put their *fists* in your face, baby.) "Somebody's gotta put a dick in my mouth without pulling my hair out of my head, though." (This shrew makes Amber Lynn look like Shirley Temple.)

Jasmin calls out to a paleish, 20-year-old stud cranking his crank on the sidelines. "Hey, man, you're pretty hard. Why doncha come around here, bro'. Shit."

The security gorillas dismiss the current five fuckers, making room for Jasmin's newfound hard-on (who porks her in the mish pazish) and four more baboons.

Bad To The Bone?

I feel it's time to *really* talk to Bone — perv to perv.

I'm a bit beguiled, actually, by the criteria for today's stud-success rate. That is, if they can't even get hardons, if they can't even get a chance to slam Jasmin while they're on the fuck altar, how can they be considered statistics on the number board?

I meet up with Bone by the bleachers and slowly work my way up to that pivotal question.

What do you think of Jasmin's performance today?

"I think anybody who's prepared to do anything like this needs to be commended," Bone says. "It takes a lot of courage. It really does. Because bottom line: she might not do it. And in front of all the press in the world, she might *not* pull this off. She can be in every fucking newspaper in the free world tomorrow as the girl who *didn't.*"

Are the press more of an ominous presence to Jasmin than all these guys fucking her?

"No. I think you're more the reality. We're not making a fuck movie, we're not making an erotic movie, we're not making a porno movie. We're documenting

an event. Whether it's a good event or a bad event, whether it's dumb, whether it's awesome is in the opinion of every person who responds to the message that you put out. But the reality is, this is somewhere between a baseball game and a rock 'n' roll concert."

How was this one different from the Chong gang bang?

"I think the first one was very documentary style. I think the style of editing is going to be similar. It's just more daunting. Beatin' 251 I think is a pretty ominous thing. And I'm tellin' you, even at this point which is (looks at the number board)… 190, I still would not be layin' bets that we'll do it."

(Okay, time to pop the big question.)

What's the criteria for actually becoming a number on that board? Do you have to have a hard-on? Do you have to penetrate Jasmin? Do you have to come? What do you have to do?

"You have to be one of the group."

I know, but some of these guys don't get hard. I'm not knocking that but…"

"No, the thing is, here is your opportunity. Here is a porn star. Here is your opportunity to fuck her — that makes you a digit. You can go up there right now, drop your pants, and have an opportunity to fuck her in the face, the ass, the pussy, anywhere you want — that's your shot. If you fuck the livin' shit out of her, or stand there jerkin' off, your opportunity is there, you're still part of the gang bang. And the point is, it's not one guy at a time fucking her and coming. This is an *orgy* of guys. A *wall* of guys."

A wall or a war?

Bone laughs. "You call it."

It Isn't Broken, Don't Fix It

We're at the 220 mark now. Jasmin's just 31 fucks away from matching Annabel's record of 251.

Bone approaches Jasmin, tries to soothe her nerves by reminding her of an upcoming break. Everyone — including the studs and Bone's crew — will do lunch when Jasmin hits the 250 mark. At that point, the beast-folk will gnaw on pizza, Jasmin will shower, freshen up, and eventually return to break Annabel's record.

Once Bone delivers his SOS, he calmly saunters back to his monitors.

Jasmin's soon in a panic, though.

"I need an ice pack on my crotch," she calls out to Momo. "I'm starting to get really sore. Could someone relay the message to John?… I need an ice pack."

"We've got about 20 minutes to go before we break," a pony-tailed security monkey informs her. "But we'll get you something."

"*Fuck* you, Kyle!" she snarls at the guy. "Go ta hell!" Misery personified, folks. This woman obviously does *not* want to be here.

Which brings us back to that ever-present issue of rape.

Jasmin, according to her agent Charlie Frey, *wanted* to do the gang bang. It was consensual. Therefore,

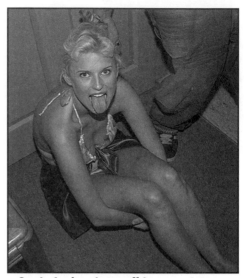

Candy Apples shows off her secret weapon.
Photo: Anthony Petkovich

there was no question of systematic, forced sex. But the evidence pointing towards rape — in general terms — is somewhat eye-opening. Namely, Jasmin's unending complaints, her highly-visible irritation, and her intense displeasure of it all. How the hell can one avoid at least *thinking* "rape", if not blatantly shouting it out aloud?

After the film's release, I phone Bone and asked his opinion of the whole gang bang/rape connection. He's amused. But hardly lacking in opinion.

"Well, basically a gang bang of this nature is one of the most degrading things you can do to a woman," he said. "But when you say that word 'degraded', there's a distinct overtone that the women is doing something that she doesn't want to do. Jasmin wanted to do the gang bang. But a lot of women *are* sexually stimulated by being degraded, and a lot of women have rape fantasies. While rape is quite obviously illegal, there are no legal restrictions on what you fantasise about.

"But, from my experience, the two biggest fantasies women have out there are: 1) making love to a man on the beach at midnight, and 2) being raped. There's this fantasy many women have of the animalistic male who takes them down against their will. Look at it this way: how many guys fantasise about doing 20 or 30 women at one time? A lot. So isn't it totally understandable that women have the same fantasy? Every swing party I've gone to, there's always been one slut who was fucking every guy in the place." (Well, Jasmin's definitely doing that — if reluctantly.)

Back to the actual gang bang, Our Lady of Cunt is (once again) nagging about her cunt. Momo gives Jasmin an ice pack to cool down her money maker. After she presses the pack against her pussy for a few minutes, she draws a few more fly guys into her sticky

web.

She's presently switching to the missionary position.

One white dude in his thirties is being extra white today. Standing two feet from Jasmin's saline-preserved titties, he shoots jam onto her chest aliens. Good shot, mo-fo. Another white hole brothah lumps custard upon her twat. While Jasmin wipes the honky cum off her cunt, she zeroes in on something off stage.

"Why does that guy over there have just a regular camera?" she bitches.

A security guard tries to chill her out by picking on the photographers.

"Let's go!" he shouts at them. "You're crowding the stage!" But Jasmin's *not* to be fucked with.

"No, hold on a second," Jasmin insists, pointing at her latest scapegoat in the press section. "The guy with the white shirt?... is he with the press?... the one who has just a regular camera back there?... a little disposable one? 'Cause he shouldn't be taking pictures. What the fuck does he think he's doing? He doesn't speak English or something?" She punctuates her disgust by drilling a cum-soaked towel at the floor.

A white guy in his early forties wearing a *Gang Bang 2* T-shirt is soon fucking Jaz in the mish pazish. There's a puddle of spunk, however, lingering about Jasmin's stomach like an unflushed turd in a men's room. And the poor jamoke's T-shirt keeps threatening to soak up this nasty fluid. "This is a tough business here," he mutters as he struggles with the elements, trying to keep his toast from dipping into the egg yolk.

"Do I get to go to the bathroom, or not?" Jasmin barks at the camera folk, oblivious of the stud's chivalrous struggles with the puddle of protozoan playdough.

We break for piss.

"I feel like I have a rope burning my crotch," Jasmin winces as she's nearly lifted off the stage.

Curious about her state of health, I follow her (from a safe distance) to her dressing room. After Jasmin empties her bladder, she lingers outside her dressing room door. I casually approach her. Very casually. Her disposition, however, has markedly improved. She's actually... nice!

How many guys have sprayed on you? I ask her.

"You know what, I haven't been counting them," she says with a sleepy smile. "But there's been a lot. I can feel it 'cause I'm sticky."

Are you more comfortable on your back or bent over?

"I like both ways... all different ways."

Any anal sex yet?

"Yeah. The thing is, the guys have been trying real hard. They've been gettin' there and just been switchin' back and forth." (I'm not sure I understood that one.)

Are you getting hungry or thirsty?

"No. I'm just fine. I keep having my water every two seconds."

Are you sore yet?

"Talk to me after another hundred or so."

Hey, that wasn't too bad. She was pretty cool. I'm beginning to believe she ain't half that bad — at least with the press. But I'm tired of Jasmin. So I turn to the fluffers. And *that's* no chore at all.

Cocksucker Blues

The fluffers, of course, are the angels of the day. What respect Jasmin takes away from Bone's amateur penisauruses, the fluffers give back to them.

As Jasmin heads back into her dressing room, I saunter into the fluffers' lounge and chat with my two favourite dick mistresses: Climax (the black girl) and Candy Apples (the white porn starlet who keeps making the beast-folk unexpectedly ejack).

How do you feel about that title 'fluffer'? I ask Climax, who's cosily seated in a heavily-cushioned sofa chair.

"I don't like it," she sweetly answers. "I mean, when you have a job as a gopher in a business or whatever, people don't like that. And I don't like 'fluffer', either, because it's like... I'm just here to suck dick basically. I don't like that title."

What do you think would be a better title?

(Smiles) "I can't think of one. I'm just doing this strictly for the money. I have two children to take care of. The pay isn't well, but I have to do what I have to do right now. I have a two-month old and a 17-month old at home. Diapers are a bitch." (Laughs)

Are you turned-on by any of this?... By any of these guys?

(Smiles, shakes her head.)

None of them?

"No."

Videographer Nick Yale pokes his head in the door. *Do you like men?* he asks Climax.

"Oh, I love men," Climax smiles. "But not *these* men. (Laughs) I haven't found one dick out there that looked normal. I mean, some are hung to the side, some are... I mean, you're thinkin', 'What the fuck *is* that?!' One guy — I don't know if he was shavin' it or something — he had some little bucks on his dick that were bleeding, and I told him I couldn't suck it."

Are you tired?

"My feet hurt. And my knees hurt."

Because you're doing a lot of kneeling?

"Yeah. And my jaw muscles hurt. If I could just have a pillow for my knees I think I'd be all right."

I turn to Candy Apples, who's stoically seated on the floor against the door.

And how are you doing? I ask her.

"I'm doing wonderful!" Candy jubilantly chimes.

You seem to be enjoying your work today.

"I'm having a grrrr-rate time!"

You really give a mean blow job.

"Why thank you. I think it's great. Kinda fun, something different."

Are you girls paid by the cock or by the hour?

"I wish!" Climax laughs. "We're not getting paid very much."

Chelsea Gold (the pale fluffer with lazy eye and beer gut) adds her two cents to Climax. "I'm sorry that he's not paying *you* girls a lot," she haughtily states. (Oh right. Like Ms. "Golden Girl" here is getting paid more than the other fluffers? Gimme a break, Sister.)

Get the Lead Out

As Nick Yale and I depart for lunch, we catch Bill Caskie and John T. Bone in the middle of an argument right outside the manicurists' room.

"You can't compare it, John," Caskie tells Bone, in obvious reference to last year's Chong gang bang.

"You know," Bone says, jabbing an index at Caskie, "maybe if you could get your *dick* out, you wouldn't have a problem." Bone then storms away.

"Well watch the film from last year, John!" Caskie yells back at him. "You'll see how much I got my dick out!"

"C'mon down," Bone calls to Caskie without turning around. "We're about to start again."

Considering that Bone could have easily ousted Caskie with a mere jerk of his thumb, I think the director responded well. Then again, I came in on the tail-end of the beef.

"She' a total bitch!" Caskie snaps to lingering journalists. "And I'm supposed to go up there and fuck a *bitch*?!"

Jasmin — immediately after having beaten Annabel's record — posing here with her five record-breaking studs, several modest fluffers, and Ron Jeremy. Photo: Anthony Petkovich

I agree. I agree. But I'm hungry.

All That Jazz

An hour later — after eating some tasty Thai food — Nick Yale and I return to the Hollywood Stage.

As you enter the soundstage, the sickly sweet stench of semen mercilessly slams you in face. You get used to it pretty quickly, though. I mean, it's not like you're breathing in the poisonous gases of Venus. Oh, it's nasty, sure. But not unlike the communal stink of a porno theatre.

I move to the press section, next to the fuck altar.

"It's something I've definitely never seen," fellow porn writer Percy B.S. remarks to me about the gang bang. "I'm amazed by the proficiency of all the participants." As Percy gives me his commentary, I notice he's stepping on a dirt-encrusted, used rubber. Laughing, I call attention to this fact. He's not amused. Standing nearby the stage, we see a black guy jerking off near Jasmin's tits. Bruthah Blood suddenly yanks off his condom.

"This guy is… comin' on her chest," Percy notes with mixed mirth and disgust. "I've seen enough." Laughing, he moves away from the stage and towards the exit for some air. Hmm…

I suppose this brings us to the "homo factor."

In other words, are gang bangs great places for fags to soak in lots of dick?

Well, one cunt's all you really need. Just one slut who loves what she's doing. She might not even look 100% beautiful. Passion is the key. And if you're a

homo who likes watching a bunch of supposed hetero's bang a bitch, go for it. But drop the convince-me-please-that-I'm-a-closet-turd-burglar treatment. Have you noticed that about certain queens? Since they can't look at themselves in the mirror for sucking cock, they have to accuse everyone else of wanting to suck cock. But to me — cocks 'n' cunts inclusive — this particular gang bang is just one great freak show.

The big one *is* coming up now. That's right. Jasmin's about to break Annabel's record.

"Staff off a da platform... off da platform..." a New Yawk security goon warns the anxious colony of photographers.

The five jamokes who'll bang Jasmin at this pivotal point are a Lee Van Cleef look-a-like, Nerd of the Day, Mexican Eric, Hillbilly-turned-serial-killer, and Red Boy.

"Look at these happy campers!" Jeremy irritatingly screams through his bullhorn at the 'chosen' beastfolk. "You don't feel much prrr-RESSURE do ya'? Ha! Ha!" Then — just as the Fantastic Five file onto the fuck altar — Ronnie jokingly blabs, "Last guy to come has ta' tongue kiss her. Ha! Ha!"

Ha! Ha!

Whether Jasmin is refreshed or not, Bone and his crew aren't taking chances: they make her fuck in the doggie position.

Lee Van Cleef is the first to make insertion. It's not too long before he's really heatin' up Jasmin's butt cheeks, getting them puppies gyrating, grabbing Jasmin's bent-over ass-cheek crease points.

Next up is Mexican Eric. He also fucks her doggie style. His dick is #252 (ta-dum!) which (cum or no cum, according to Bone's rules) breaks Annabel's record (ta-dum!!). Eric jerks off over her crack for about a minute before dribblin' his manjuice onto her booty. Eyes closed, tongue hanging from her mouth, Jasmin looks, by golly, just like a village idiot unknowingly being raped in the woods.

And the record is broken.

Claps, whistles, grunts. Photographers crowd around Jasmin like ants on a squashed insect.

Cameras snap. Lights flash. Photographers holler.

"Look this way, Jasmin!" Flash!

"Over here, Jasmin!" Flash! Flash!

"Jasmin!" Flash! "Right here! Right here!" Flash! Flash!

Holding her trophy, Jasmin poses with the Fab Five, along with Climax, Candy Apples, and Jeremy.

"How do you feel, Jasmin?" an unseen reporter calls out from the swarm of journalists.

"Sore," she bluntly states. "I feel like my uterus is about to fall out." (Now *that* I'd like to see.)

Eric Es Mas Macho

About 10 minutes later, a handful of writers speak with Mexican Eric about his fateful place in porn history. Wearing a beach towel around his waist, Eric is stoked about being *the* dick to break Annabel's world record. (So excited, in fact, that sometimes he barely makes

sense.)

"I got hard right when I walked up there," he says with all modesty. "I was lucky. I went up there and I was like, 'Oh man...' and then I thought I was finally going to come, so I pulled off the rubber and I'm like, 'Oh shit!' and everybody's like, 'C'mon! C'mon!', and the cameras were like crowdin' in on me and stuff, and I'm like, 'Oh damn,' and then I just closed my eyes and just... ahhh... fuck it, dude. Then I opened my eyes, and I felt myself, and I'm like, 'Goddamn... I blew shit...' Pretty cool. I was kind of out of it after that. Everyone was tryin' to tell me to calm down and I was like, 'That's fuckin' gnarly.' I was trying to calm down. I was all wrapped up in coming. Actually, having an orgasm was really memorable because I've been trying allllll day...

"I wanted to bring this friend of mine who's a virgin, but he chickened out. And, you know, I didn't really want to tell anybody at first about me being here because I didn't know how it was going to turn out for me. Now I'm going to tell everybody, 'Hey, check out this video... I was there... I wasn't bullshittin', you guys.'"

Glazed and Cumfused

After all the hoopla, Jasmin goes back to fucking. But she's simply out of it. Totally uninspired. The quintessential dullard of porn. But when you think about it, why should she be excited? She just wanted to break Annabel's record, right? And she did. Hear, hear. So where's the remaining challenge, excitement, thrills? I'll tell you where: in that horrifically stinky garbage pail with 251 used and gushy condoms, that's where. For now, more than ever, each dick is just a number to Jasmin. And as she mechanically sucks and fucks to get way past that 251 mark, Jasmin looks as about as animated as William F. Buckley on morphine.

Right now a Chinaman — in his late-twenties, wearing sunglasses — is really pounding away at Jasmin in the doggie position. I take my hat off to him. He's the best rapist in the house, adding that much-needed vigour to this rapidly deflating event. The Chinaman already had about three cracks at Jasmin. But on this, his fourth attempt, he's so horny that his dick is in her for about a minute when he suddenly pulls out, rubs it against her cunt lips, yanks off his rubber, and jabs his semi-hard chopstick against her pussy.

"What are you doing?" she hisses. The randy Chinaman responds by splooging rice pudding across her left butt cheek. Now *that's* one horny dude.

An older, grizzled dude from Indiana steps up to fuck Jasmin doggie. He rapidly gets into it ("Oh, yeah, Jasmin baby") and just as quickly whitewashes her uplifted booty. After he rubs his dick up and down her crack, he starts slowly moving a hand all over his chest, massaging it, as if he's having some sort of out-of-body experience. He's obviously diggin' it.

Not Jasmin, though.

"Don't put your finger in my fuckin' asshole," she

Jasmin — brimming with enthusiasm?
Photo: Anthony Petkovich

snaps at him. "What the fuck do you think you're do-ing?"

"Oh, baby," he gasps, unaware of her rude remarks. "Thank you." He then happily steps off the mattress area.

"Can you get the towel here," Jasmin hisses to Momo with a look of utter repugnance. "Just... *clean* it all off me, please." Then to the grizzled guy walking towards the hut: "That wasn't fuckin' smart... leaving a condom in me." But the crew find no condom. She's losing it. In the meantime, the grizzled older guy (who heard Jasmin this time) is visibly affected by such insensitive remarks. He stumbles through the hut — rejected, broken, middle-aged, and bare-assed.

Vengeance is at hand, however.

Next up: Wolfgang the German.

Wolfy's been quite the hit today, too. He's one of the few beast-folk possessing an enlarged penis. No, not a hard-on. But a *surgically enlarged* wrinkled sax. According to an interview I overheard earlier between Wolfy and Uncle Ronnie, the kraut had his dick elongated and injected with fatty tissue to make it all the thicker. Tall, trim, in his mid-thirties, with long, slicked-back brown hair, Wolfy is intensely proud of his new "friend." Throughout the day he's walked about the proceedings, flaunting his monstrous member like a peacock displaying its rainbow of feathers; yet another man-made freak on Bone's far-off isle. Actually, the "thing" is so grotesque, so big, it looks permanently hard, and appears to lead Wolfy himself about, like a parasite separate from his body.

Now Wolfgang is trying to stick this extraterrestrial appendage into Jasmin's bent-over cunt. No such luck. It just won't fit. This same dilemma has haunted Wolfy all day, warranting a desperate act. That's right. Wolfy decides to break the Law. He sticks a few (naughty! naughty!) fingers in Jasmin's pussy to spread her lips (and make way for his mutated knockwurst). Jasmin instantly yelps.

"OUCH! You stupid fuckin' *moron*!!" she shrieks at him.

As if shocked by an electrical fence, Wolfy jumps off the altar. He holds his hands up to the security goons who slowly close in on him. "Sorry. Sorry. Sorry..." he says, bowing repeatedly, as if staving off an army of brass knuckles in a dark alley. Fully aware of Jasmin's mongoose temper, however, the goons kindly (almost pityingly) escort Wolfy off the stage, making nothing more of it.

"He fuckin' got his nail into my crotch," Jasmin winces. (Wait a minute. Didn't he have his nails manicured?) Momo is immediately on the scene, pressing an ice pack against Jasmin's abraded vadge. She's angry at first, but quickly shrugs it off and continues languidly fucking.

The End Is Nigh

It's mid-afternoon. And we're swiftly closing in on 300. At this point in the game, I'm interested in Bone's reaction to the event.

Is this thing ending sooner than you thought it would? I ask him.

"No. No. No," Bone politely answers. "You know what's *really* interesting is I expected to go much later — predicated on the last gang bang. Last time, after every 20 or 25 guys, Annabel had to take a break. Part of it was fatigue. But the main problem was the thing with the fingernails. I'm tellin' you, the hero of the day is the manicurist. The last time we put five, 10 guys up on stage. Annabel was gettin' cut and was in pain. Jasmin's taken, what, two breaks? — all day. The manicurist is the hero of the day. A tiny, little girl sittin' there cuttin' fuckin' fingernails since 8 o'clock this mornin'."

Are you pleased with this happening?

"Oh yeah. And I'm especially happy with Jasmin. Absolutely. I just renewed her contract last week for a further two years. She's got about seven features with us in the can now."

I didn't see any anal in this gang bang, though.

"There was some. Not as much as I expected. She was complaining at one point that she wasn't getting fucked in the ass. I saw a couple of people do it, but not as many as I anticipated. And it wasn't her fault... she was asking for it."

Bone then excuses himself, as we're rapidly approaching fuck #300 now.

Is He Or Isn't He? Did He Or Didn't He?

Twenty-six-year-old Jordan from upstate New York is Jasmin's 300th fuck. Jordy apparently won a contest in *New Rave* magazine. His prize? "Sloppy seconds multiplied by 150," is how Ron Jeremy best describes it. I *guess* that's an honour, being the last guy to fuck St. Claire after she's been pummelled and sprayed upon for nearly six studio hours. Yet as studly as this moment *should* be for smooth-skinned pretty boy Jordy, he looks like he'd much rather be servicing a rich old

chickenhawk on Santa Monica Boulevard.

Okay. It's time. Time for Jasmin's 300th.

And what's most "arousing" about this particular human sex act is Jasmin's animation. As Jordan bangs her from behind, she looks as if she's actually enjoying this thing called fuck. Her eyes are closed as if she's takin' a shit. She lets him bang her hard, pull her hair, slap her ass, anything he wants. Nothin' in the butt, though.

"Pull my fuckin' hair!" she snarls at Jordy. How touching. Rape of the lock. Saving all that fluffy, frosted hair just for Jordy. Too bad little JoJo looks like he'd much rather yank the gray curlies on Uncle Ronnie's butt. On the other hand, Jasmin seems to like it. Not bad, really. I mean, only 300 fucks and the ice queen is finally getting warm.

So did JoJo come? Did he give Jasmin one last blast of coconut juice on Sunday, April 28, 1996?

Well, despite what you may see on the video, Mr. Stud Muffin did not — repeat, did *not* — come. He was slamming away at her, yes. Slappin' her ass. Yankin' that hair. Losin' that hard-on. That's right — losin' that woody. Not surprising that *this* part of the sex was cut from the film. When Jordy's balloon deflated, our he-man stepped off Jasmin's podium and had Candy Apples chew his pud for a spell (while Jasmin gulped down bottled water). Jordy managed to re-stuff St. Claire again... for a few minutes... before completely losing it and throwing in the crusty towel.

Yet what's most usual (and downright phoney anyway ya' fuckin' slice it) is that a JoJo "come shot" was later inserted into the film. A come shot in which you (conveniently) *don't* see his face. We don't even get a faked JoJo "reaction" shot in the final cut. What you *do* see is a full shot of a cock fucking Jasmin in the

missionary position, pulling out, and spraying onto her belly. But wait a minute! JoJo and Jasmin fucked doggie style, not in the missionary position. Was this standard come shot some sort of "divine vision" everyone — except for Bone's crew — missed?

Later Jeremy himself asks Jasmin point blank about JoJo's glossed-over humiliation.

"Did he come?"

"I don't know," she tells Jeremy. "I didn't see."

Ah-ha! Further proof of the hoax. I mean, if JoJo *did* spurt on Jasmin via the missionary position, how come Jasmin *not* see it? I'll tell ya' why not. 'Cause he *didn't* fuck her missionary. 'Cause he didn't come... period.

Yet Bone apparently felt obligated to insert a pop shot to properly "punctuate" the film. According to Bone himself, however, it didn't *matter* if you came or not, right? You got your shot. You were one of the team. So why the plagiarised spurt? Hollywood drama... that's the best answer I can give.

Of course, I'm not the only one who witnessed the tragic fall of JoJo. Other journalists saw it. As did Mexican Eric.

"I feel bad for the guy because I know how it is," Eric admitted shortly after Jojo's short cummings. "You're up there and you're like, 'Fuck!' You're trying to come. I was trying to do it all day, and I was lucky to do it. It's really hard, dude. And when I did it, I was... euphoric. I wanted a beer so badly right afterwards. I was really nervous at the beginning, but I got used to it because the guys were just bullshittin' each other, playin' with their dicks. 'This is all a lot of bullshit,' we were tellin' each other. It was kind of comfortable after a while."

And This Cum, Too, Shall Pass

A press conference after the show is promised earlier in the day. No such luck. Jasmin is simply (under-

Shortly after the 220 mark.
Photo: Anthony Petkovich

standably) exhausted. She does have a brief conversation with Jeremy (and me) after the shoot, though.

"Suppose," Jeremy hypothesises with Jasmin, "one of the guys you go out with tonight wants to have sex with you?"

"What would *you* do," replies the ever-cantankerous Jasmin, "if someone wanted to have sex with you after 300 guys?"

"After 300 guys?" Jeremy rhetorically asks. "I assume I'd been in prison." Good for you, Ronnie.

I manage to corner Jasmin in a room after she (amazingly) does a brief photo shoot for an English-based syndicated magazine.

"I feel fine," she tells me, a look of pain bearing down on her like a hand ruthlessly moulding a mannequin's face. "I'm going dancing tonight at the Rainbow." Man, after all that pumping, I'd be surprised if she can sit on a toilet seat without screaming bloody murder.

The syndicators and I congratulate her and go our separate ways.

Lays end.

Not bad, either. The gang bang started at 10:30 am, and concluded at 4:30. Six hours. Many of us were expecting to stay all night.

Of course, the speed at which the shoot concludes is yet another issue which brings the legitimacy of this particular gang bang into question.

If you break it down by numbers (see Cum Bath Math tables), Annabel was fucking for a total of over eight solid hours. By contrast, Jasmin was only fucking for a total of two uninterrupted hours. Quite a difference. And, in absolute agreement with Bill Caskie, there really *is* no comparison between the Chong and St. Claire gang bangs. In this pervert's blood-shot eyes, Chong is *still* the reigning queen.

"Well, Annabel was so turned on about doing it," Bone later told me after his sequel's release. "She was *so* turned on. But Jasmin was… well, it wasn't the same. And I was very tempted to edit around the negative stuff. Then I thought, 'No, I'm going to show the warts on this thing.'

"But the amount of *money* Jasmin gets for doing this gang bang," Bone further admitted, "is minuscule, *minuscule* compared to the amount of money she's going to make on the dance circuit now. She's already making four times what she did before she made the gang bang. And Jasmin is a very smart girl. If she makes the right moves, she'll make $100 grand on the dance circuit as a result of her notoriety from this gang bang. And that's *real* money."

Well, there you have it, friends. Plain 'n' simple. Bone's sequel was merely an advertising scheme for Jasmin all along. A far cry from Annabel's freaky slut-fuck fest. Again, Jasmin was competing against Annabel's record, while Annabel — *the* pioneer — was competing against her own stamina, her own horniness. And if ever there was a whore with a heart of gold, only Annabel could be that lady. Jasmin, how-

Jordan, lucky number 300.
Photo: Anthony Petkovich

ever, was more the whore with the hollowed tin heart. Which brings us back to the issue of consensuality.

For again, *in certain terms*, Jasmin *was* a rape victim. No, she was not pinned down against her will. No, she was not mercifully sobbing or screaming bloody murder. No, she was not violently slapped with open blows, barbarically pummelled with fists, or animalistically bathed in hateful spit. BUT…While being systematically poked 300 times, she made no sighs of passion, had no orgasms, and gave *very* few smiles. Rather, she bitched and bitched and bitched. Indeed, if, as Bone states, his sequel is loaded with warts, then Jasmin makes up the majority of 'em. She belly-ached, nagged and screeched about soft dicks, hard dicks, old dicks, unprofessional dicks. You couldn't touch her tits, eat her cunt, fuck her ass, spray on her face, even give her a peck on the cheek. Distant. Cold. Passionless. That was Jasmin. Okay, sure. So she might *not* have hated every second of this gang bang. But she most certainly loathed every minute of it.

Sure, it's good to get paid for sex — but where does the fun end and the financing begin? Patrick Collins put it quite nicely: "Even if (porn starlets) really like getting fucked, when they have to do it for money, they start feeling like a piece of meat. Any girl that gets in the business should only do it for the fun of it. It's gotta be fun, because really you're dealing with your soul. It's an emotional thing. You start compromising your principles, your values because you need money

for rent or something; and once that integrity starts to go, then you're not feeling good about yourself…" And that's just how Jasmin felt — ugly.

Likewise, St. Claire projected that ugliness (i.e. her monstrous dislike of her *means* of attaining fame and fortune) onto her amateur studs. The end result? Maximal anti-eroticism. A hideous prima donna. A JAPP (Jewish American Portuguese Princess) who should be flushed down the toilet like a disgusting bowl ˙of murky, brown-tentacled diarrhoea.

So I have to agree with Bone: this film is more documentary in vein than pornographic. And the fluffers, if anyone, should get full credit for making the movie horny. *WBGB2* is, therefore, really more of a suck film than a fuck film.

Yet even though some things are definitely questionable about this gang bang, I had a good time. A blast, actually. Good food, weird people, slutty fluffers, lots of willing people to interview… What can I say? Bone threw a great fucking party. My recommendation? Rent both films for the pure novelty of 'em. But if you really wanna pound your poodle to some sleazy, animalistic sex, get the Chong tape. Its originality, rawness, and passion make it a minor classic.

But wait. We're not *quite* through with this thing. We've one or two more "warts" to uncover.

Lost In Hollywood

The last image I see in The Hollywood Stage is a toothless male Mexican slowly, methodically sweeping the

concrete floor of obliterated rubbers, spunked-out tissue, and soggy paper cups. Who knows? Maybe he was an out-of-work labourer whom Bone spotted earlier this morning during the press conference. I just hope there's a security goon around. You never know. This same labourer might stick to the cum-splattered floor like an insect on fly paper, and there remain — totally forgotten for weeks behind the heavily-bolted, vault-like doors of the soundstage… starving to death… perishing in the dark… his bloodcurdling screams unheard by human ears.

Leaving the sound stage, I run into black fluffer Climax waiting for a taxi cab on the desolate sidewalk. Climax is as sweet and accommodating as ever. She tells me she's 18, a native of Maryland, and a runaway who left home at age 13. I'm interested in her impressions of LA.

"Man, it's kind of dangerous," she says. "I was so naïve when I came out here. During the riots I was livin' in a youth shelter. Luckily they wouldn't let me out."

Climax is so dizzied by the sheer number of cocks she sucked today, that she gives me a tally of 30. Thirty?!! That's all?

"I really can't remember," she laughs. "It wasn't thirty but… I have no idea. This is the first time I've ever done this. I haven't been shooting any movies lately and I needed the work. Anal, DP, blow jobs… I really don't have a speciality. Everything is good. I haven't done any DP's yet, though. When I first started in the business, I was pregnant so I had to be careful about what I did. But while they were filming this movie, I was like, 'I'm never gonna get this outta my face if I don't do it right.' But I did gag a couple of times."

John T. Bone gloats thinking about the money he's going to make off his loaned flesh, who, at number 299, looks like she's about ready for the stretcher. Photo: Anthony Petkovich

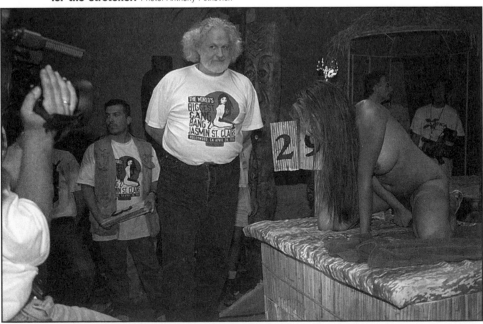

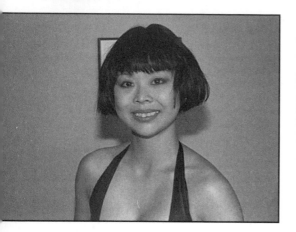

Rumour has it that the sweet Annabel Chong wasn't paid for her gang bang.
Photos: Anthony Petkovich

And where are you going now?

"I'm going home to play with the children," she says with mixed sadness and relief. Porn starlet Lovette had a similar story on the set of *Sex Freaks*, where she described the overwhelming loneliness a gang bang leaves a girl with.

A taxi arrives and Climax is off, disappearing down Santa Monica Boulevard.

And speaking of sad stories, I almost forgot about Annabel.

No Escape From LA

What? Didn't I tell you? Ms. Chong never got paid for her "world's biggest gang bang."

Hey, I am *not* shitting you.

After fucking 251 times on film — and getting her cunt carved and bloodied from unwashed, untrimmed claws — she walked away with squat. Nothing. Niet. Nada penny. I couldn't believe it when I heard. Sure, I wanted to ask Bone and Chong about this horrible rumour. But as a guest at the sequel, I felt the question might be too indiscreet.

So I phoned Bone after the shoot. Oh boy, *did* he put the nightmare to rest.

"No. She hasn't been paid," Bone flatly stated. "And I feel terrible about it. But she never wanted money. She wanted the financial security of using the company (i.e., Fantastic Pictures) as a bank. In other words, she'd receive $100 in cash from the company if she needed to pay her tuition or school books for her studies at university.

"You see, when I was leaving Fantastic Pictures, Annabel was owed about $16,000. I owned part of Fantastic Pictures, and I was selling that part out. And when I was leaving, I called Annabel into my office and told her that I'd sold my part of the company. And as I felt a responsibility to get her paid, I strongly suggested that she talk to the accountant at Fantastic Pictures about getting everything that was owed her before I left. But she didn't want to do that.

"As it turned out, Fantastic Pictures cut a deal with her to pay her x amount of dollars every month until she was paid out. She received about $1500 for three months, then nothing after that. That $1500 was the last she's seen of any of her money. Fantastic Pictures expressed a 'fuck-you' attitude and basically screwed her out of 12 grand. I talked to her recently and she's still upset. She feels she has nowhere to go to get her money back."

And what did the folks at Fantastic Pictures have to say?

Chuck Zane (manager/owner of Zane Entertainment) called me a week after I spoke with Bone.

"I'm confused," Zane told me in a deep, unnaturally calm, distinctively New Yawk accent. "First off, Fantastic Pictures no longer exists. John [Bone] and I used to own it. Then when we went our separate ways, he and I pretty much split the videos between us. I retained the name of Fantastic Pictures to continue the *Starbanger* series, and John still has boxes with the name 'Fantastic' on it. John and I are still friends, though. I mean, we still work together."

But was Annabel ever paid for her work? I asked him. *John says she wasn't.*

"Well, this is why I'm confused," Zane replied, still not directly answering my question. "See, Annabel was a really unusual girl. While John was at Fantastic Pictures, he paid the cost for Annabel's tuition and university books. And when we split up, John and I paid everybody. Everybody was paid. And when John *left* Fantastic Pictures, he left with Annabel. And they're still friends. I mean, to this day they still make pictures together."

So Annabel was paid? I asked once again.

"I tell you what I'm going to do," Zane continued, *still* evading the question. "I'm going to call up John right now — I think he's working on a set in North Hollywood. — and have him call you to clear up this entire matter once and for all. Sound good?"

That'd be fine.

Less than five minutes later, I get a call from Bone.

"Just go with Chuck's story," he replies in a pained voice.

But, I reminded him, *you told me just a week ago that Annabel was never paid.*

"Let's just say," Bone methodically states, as if pre-programmed to the letter, "that Chuck and I came to an amicable split with Fantastic Pictures. We paid everyone, and all parties involved are happy."

Whatever you say.

Five minutes later, I get a 'follow-up' call from Chuck Zane.

"Did you talk with John, Tony?" he asks me. "Did he clear everything up for you? See, I don't care what you write. Write what you want. But it's really an old issue, don't you think? It's already been covered by the magazines." (It's also never been cleared up.)

Well, I don't know... maybe I should speak with Annabel about it.

"That's a good idea," Zane says. "But I think she's married now... sort of retired from the business."

(I know it's useless, but I gave it a shot, nonetheless) *Do you have a phone number on her?*

"Nope, sorry," Zane instantly replies. "Actually, you might have a hard time locating her. But, sure, maybe someday when she resurfaces she'll talk to you and clear it all up. But, I mean, it's really a side issue. Why don't you just write about the gang bang itself and leave this stuff out? Nobody wants to read about it. They just want to read about sex. By the way, how often are you down in LA?"

About once a month, I tell him.

"Great. Here, let me give you the number of our public relations person at Zane Entertainment. His name is Eric. He'll be able to get you on the sets of some of our pictures."

Great. Thanks.

The next morning I get a call from Eric, aka "Mr. Publicity." From the perky quality of his voice, he sounds like he's in his twenties. Very excited, too — in a happy way. Almost too happy, too nice. So nice, in fact, that I can't get a word in edgewise.

Eric tells me about Zane's new Generation X adult movies. About "the youngest director in porn" (24 years old) who's currently working for Zane. About the music, clothes, clubs, "attitude" that's all Generation X. About how this new line is aimed for young adults aged 18 to 29. Eric then gives me a bunch of dates during which Zane will be filming the Generation X series, asking me if I'd like to come down and cover the shoots, asking me if I'm attending the 1997 FOXE Awards, asking me if I'd like to have dinner with him.

Amazing. The other day I was ready to print how Annabel wasn't paid for her world's biggest gang bang. Now I'm being courted by the company that didn't pay

"This is just about the only thing that didn't happen at the Annabel Chong gang bang."
Art: Maxon Crumb

- EXECUTION OF WOMAN STUDENT
By REACTIONARY KUOMINTUNG
POLICE. WUHAN, CHINA. 1928 -

her.

I thank Eric, informing him that I'll call him back on all this stuff.

But I *still* want Chong's side of the story.

I contact writer David Aaron Clark, who interviewed her for *Spectator* magazine several months earlier. Unfortunately, he tells me, Annabel's number has been disconnected (fairly typical in this fast-paced business).

So, to recap: John Bone initially stated that Annabel Chong was never paid, that Fantastic Pictures still owed her $12,000. Chuck Zane then stated that Fantastic Pictures no longer exists, and that Bone basically paid Annabel. In response to Zane, Bone later stated Annabel *was* paid quite some time ago, totally discrediting his story from only a week previous with this new, contradictory statement.

In essence, Bone blames Zane, Zane blames Bone. Meanwhile, Annabel still hasn't been paid. And if she *was* paid, why hasn't she come out in the open and said so? Wouldn't it benefit the credibility of both Bone and Zane?

So, who to blame? Who to blame? Bone or Zane? Zane or Bone?

I got it! Let's not blame anyone. Let's just blame... LA! That's it. Why ruin a person's reputation when we can use a city as a handy scapegoat? After all, a city is just a city. And LA is... well... LA. That veritable microcosm of life. That place of heavenly highs and devastating lows. That land of riches and rags. Bitches and fags. Beauties and beast-folk. A city, an island not unlike Wells' fictional world of Moreau. Ah, I can almost hear Wells now, talking about the good doctor: "His is the hand that makes/His is the hand that heals/His is the hand that wounds/His is the House of Pain."

C'mon, Jake. It's Hollywood.

No one escapes. ∎

Annabel Chong

Fucked five guys per session,
for 10 minute intervals,
until she reached the 251 (dick) mark.
So,
251 (repeated) dicks
equals 50.2 sessions,
times 10 minutes per session
equals a total of 502 minutes which
(divided by 60 minutes)
equals 8.3 hours of fucking.

Total times fucked: 251
Total hours fucked: 8.3
Total time per dick (if penetration was accomplished): 2 minutes
Total approximate time in studio (inclusive of photo sessions, lunch, and breaks): 9 hours

Jasmin St. Claire

Fucked five guys per session,
for two minute intervals,
until she reached the 300 (dick) mark.
So,
300 (repeated) dicks,
divided by five guys per session
equals 60 sessions,
times two minutes per session
equals 120 minutes which
(divided by 60 minutes)
equals 2 hours of fucking.

Total times fucked: 300
Total hours fucked: 2.0
Total time per dick (if penetration was accomplished): 24 seconds
Total approximate time in studio (inclusive of photo sessions, lunch, and breaks): 6 hours

Comparing Gang Bangs

	Annabel (did 251)	Jasmin (did 300)
Anal	Yes	No*
DP's	Yes	No
Facials	Yes	No
Condoms	Optional	Mandatory
Kisses	Yes	No
Cuntsucking	Yes	No
Titsucking	Yes	No
Fingerfucking	Yes	No
Orgasms	Semenly many	Not a hint of such

* Jasmin let one black guy fuck her in the ass with a rubber.

Index

If you have enjoyed this book, send an SAE/2xIRCs for our full publishing catalogue:
Headpress, 40 Rossall Avenue, Radcliffe, Manchester, M26 1JD, Great Britain